Contents

Sommaire

Inhalt

Contenido

Indice

Copyright © 2007 Goliath Verlagsgesellschaft mbH, Eschersheimer Landstraße 353, D 60320 Frankfurt/Main
© for the illustrated works: the respective photographers, VG Bild - Bonn, Goliath GmbH and authorized representatives.
Distribution US & Canada: Goliath; P.O. BOX 136; New York, NY 10035; USA
Goliath™ is a registered trademark in the United States and/or other countries.

Editors: Miki Bunge, Stephanie Kuhnen; Art Director: Tanja Oberst; Assistant: Ulrike Schmidl;
Cover photo: Richard Warren

contact@goliathclub.com; contact@goliathbooks.com

ISBN-13: 978-3-936709-31-5

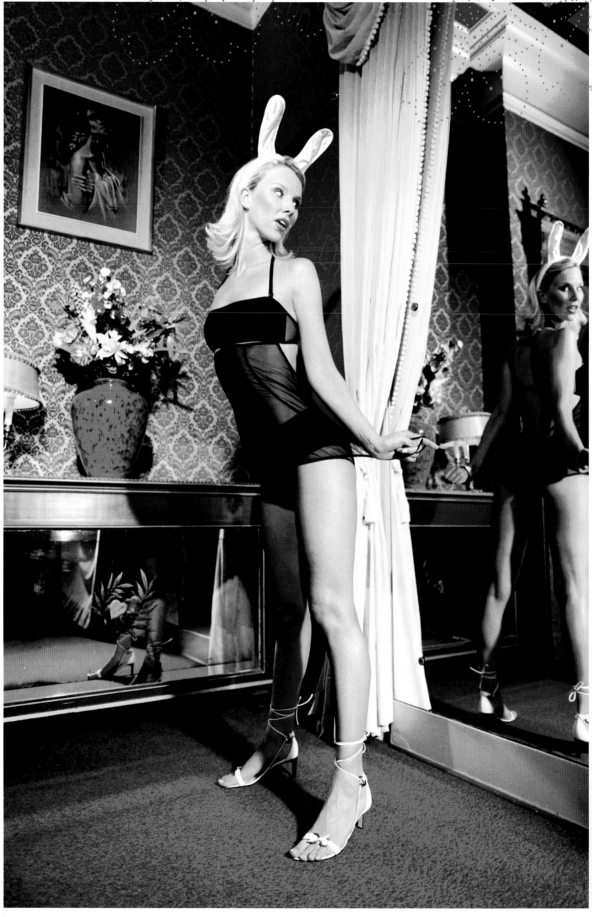

Beauty is in the eye of the beholder
Stephanie Kuhnen

As soon as we open our eyes in the morning, we begin to see things. Our brain is constantly processing images, only a few of which remain in our memory. Yet every image we take in through our eyes generates a reaction, no matter how imperceptible it may seem. We scan the world around us with our eyes, and our vision stops only to take in the exceptional, since the ordinary does not impress enough to bring about an emotional reaction.

This is why photographers, like all artists, are always in search of exceptional images. They search for, find and accentuate those images which may remain hidden to us in everyday life. They wish to show us the exceptions to the rule.

In public areas of our society the naked body of a beautiful woman is often visually and emotionally blocked on account of complex regulations. Nudity is still a moral minefield, especially for women. An inadvertently revealed nipple at a sports event involving a ritualised trial of strength among men can cause a national scandal and bring about the end of a career, while no-one will question the scantily dressed and deliberately sexy cheerleader team, since they are part of a legitimized convention within society.

A great deal of freedom has already been won via art, and a naked wrist no longer ignites discussion, since we have become used to this image and no longer consider it to be anything special. However, we still live in a dictatorship of bland conventionality. Each new visual experience removes us from the concept of the familiar.

Artists not only show us the extraordinary, they are also continuously seeking to shift the limits of conformity into new spheres. This does not involve the 'harder, faster, further' approach of sport - we are talking here of art and not of commerce - but of creating emotional worlds in which the rules of everyday life are abandoned.

Artists have always been inspired by beauty, since it represents a rarity in the variety of nature, and it is no coincidence that beautiful women have often played an important role. It is therefore quite natural to let that which inspires become the protagonist of one's own aesthetic opinion. And this is what erotic photography involves. Models are modern muses. To perceive them simply as anonymous areas of projection of erotic yearning, or as puppet-like, empty screens, and to censure them for the reactions their appearance can bring about is not only incomprehensible, it is also sexist.

There is never an anonymous relationship between models and photographers. A creative and reciprocal relationship always develops between them over a certain period of time. The photographer can only portray that which the model is willing to give to the image. And he reveals what he sees in the model. It is unfortunately a convention in erotic photography, which has been caused not least by moral restrictions towards the women photographed, that these models often remain without a name or voice, even though we, as observers, only experience beauty from looking at them. A certain form of anonymity, e.g., by naming the model name instead of the real name, continues to exist of course. Proud and public, natural interaction with the ,representation' in erotic photography remains an ideal worth striving for - for models, photographers and observers alike.

As the title, My Favorite Model, already suggests, very special muses are entering the stage here. It is a best-of-best of this tribute to these women. This illustrated book also honours the variety of physical beauty. We took great care when making our selection to include the different stylistic interpretations of photo artists. And, of course, we would also like to thank the models for supporting this concept with their interviews.

So, can beauty be a sin? Of course not! It is rare, it is valuable and should therefore always be admired and celebrated, because it interferes for maybe just one short moment in our visual routine, and enables us to enjoy being human. We owe this to the wonderful complicity between models and photographers, whose cooperative work enriches our lives so much.

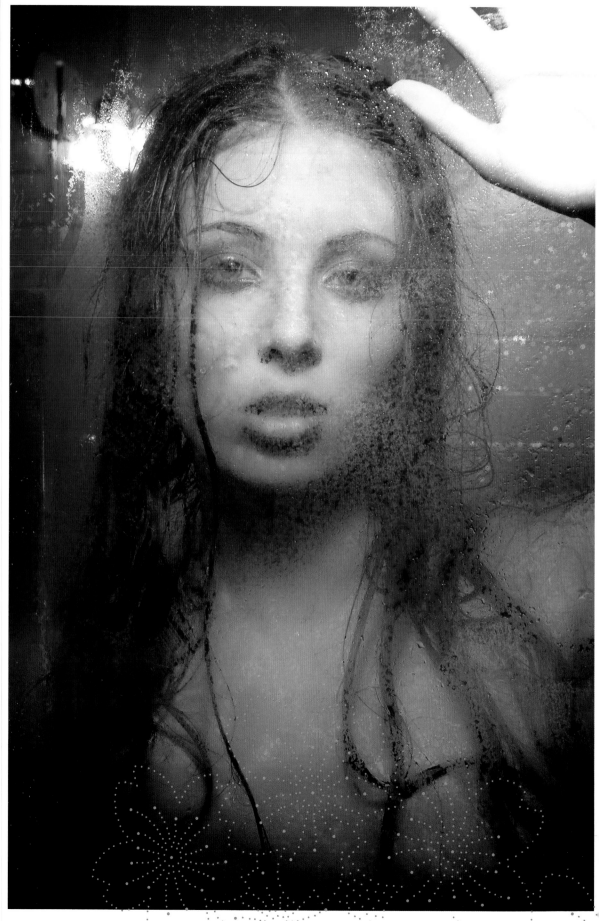

Michaela
Photos by Richard Murrian

Name: Michaela

Birthday: December 19

Birthplace: Karlovice, Czech Republic

What was your childhood ambition? To own a flower shop, and compete in flower shows.

Where do you live? Still in Karlovice!

Where would you like to live? California, near the beach.

How did you become a model? I entered competition when I was 16 through an agency.

Where do you see yourself in ten years time? I would like to be a journalist writing about psychology and have at least one child, and maybe married, or just have a nice boyfriend.

VIP from movie or music biz would you like to date? Nobody really... Al Pacino maybe, he is really sexy!

What vice can you never forgive? Drugs are terrible, but I think everything can be okay in moderation. If someone has a problem like this, I'd rather want to help them.

Daily sins, I cannot resist: Nothing

Favorite Band: Arctic Monkeys and Maroon 5

Turn-ons: Older men, strong personalities, and a nice face with a nice smile.

Turn-offs: Selfish, closed minded, boring people

Is there anything you would never do again? I would never date my last boyfriend again, he is an idiot!

What good advice could you give to other models? Modeling should be just a hobby, not a job, not just for money. If it becomes a "job", it won't feel nice and won't have any "magic" anymore.

Democrat, Republican, Green Party or other? Czech politics are terrible, it's all about money. So I don't participate.

Things that make me happy: People who smile and are optimistic. Photographs. Oh, and I love Cinderella.

Website/Myspace: www.supermuse-misi.com

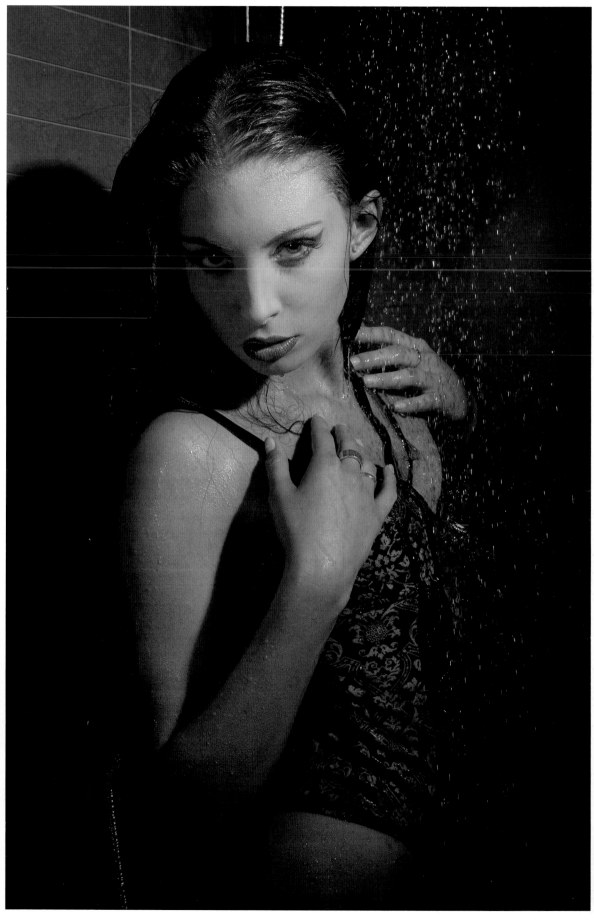

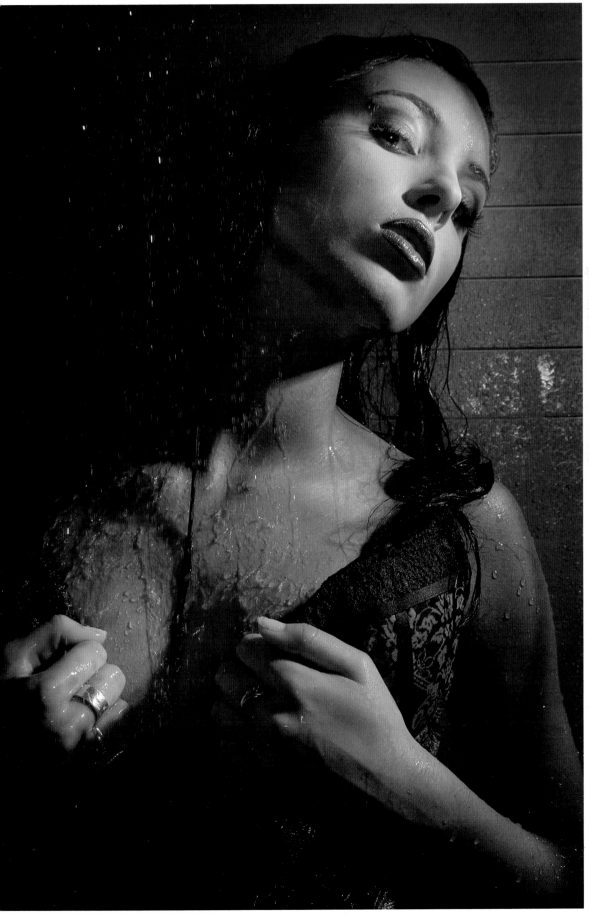

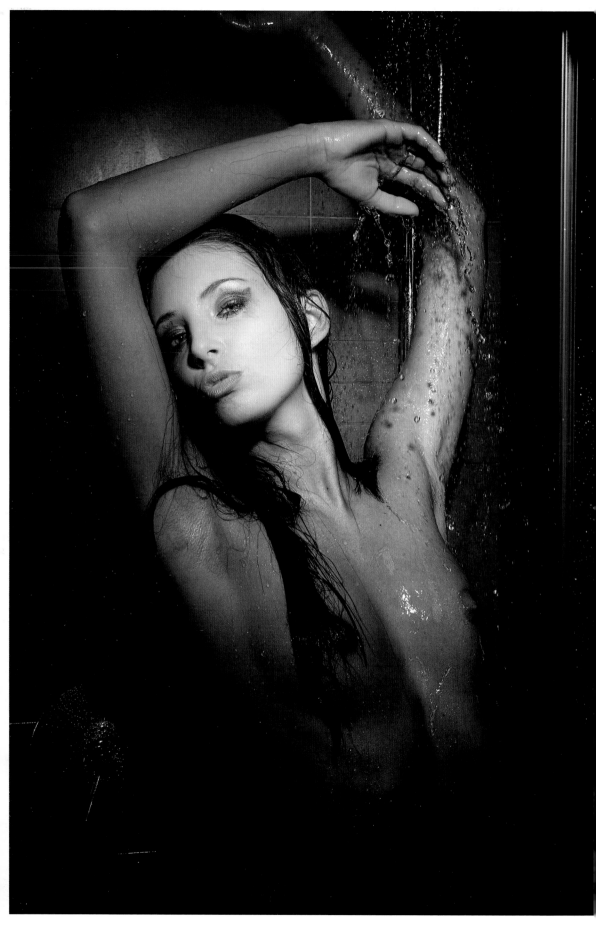

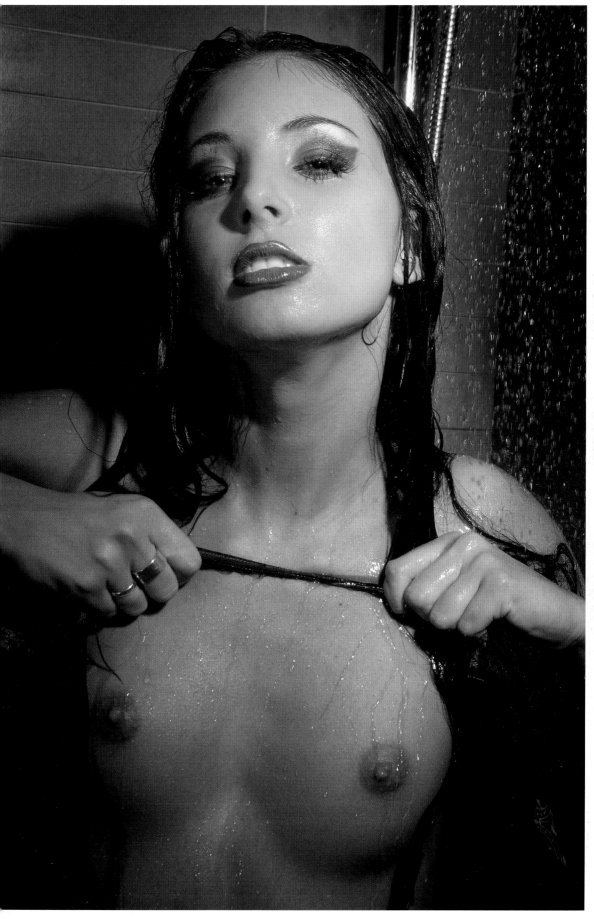

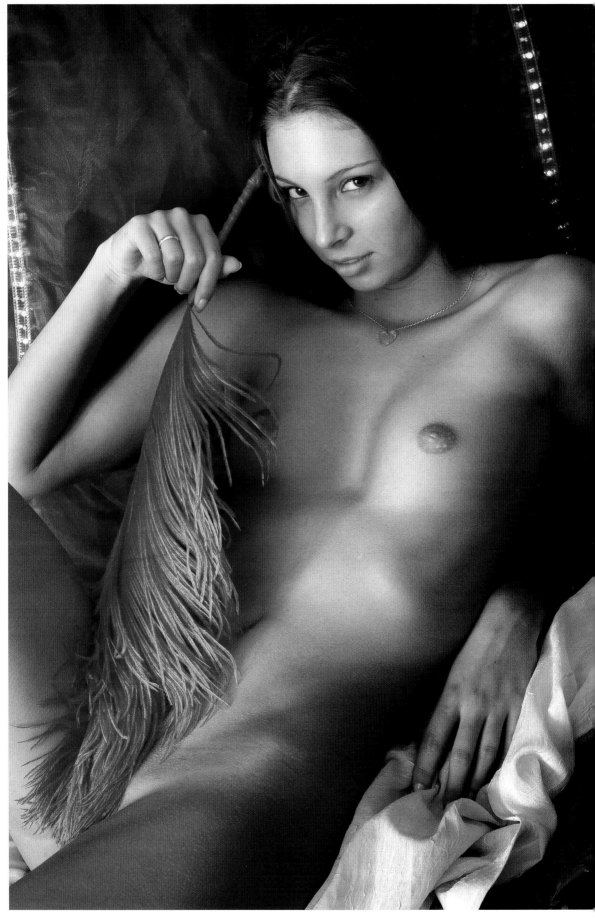

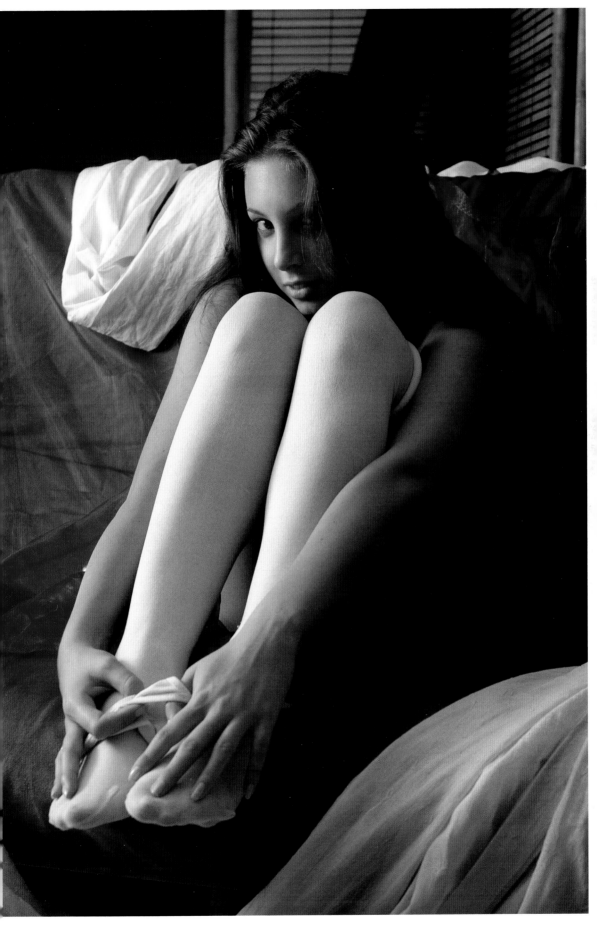

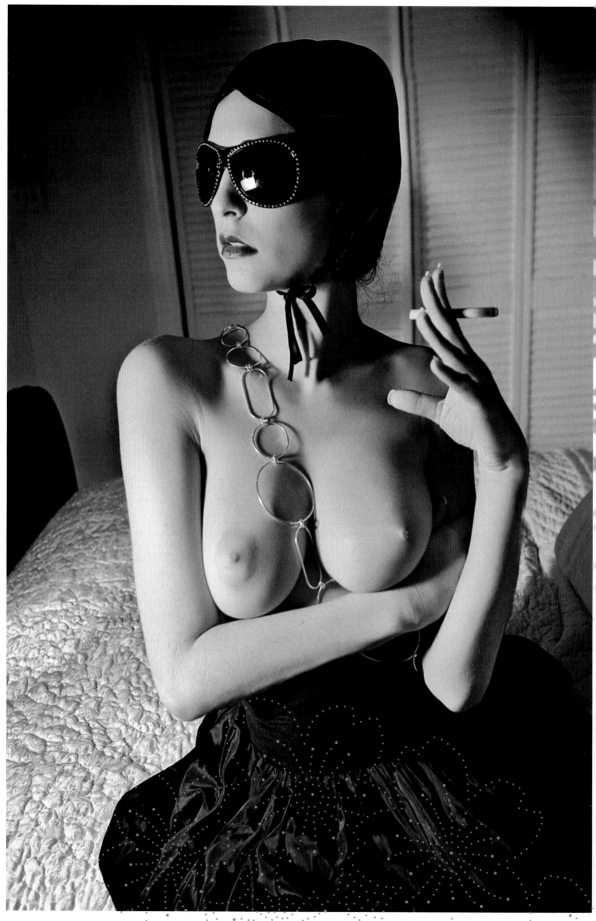

Carlotta Champagne

Photos by Richard Warren

Name: Carlotta Champagne

Birthday: June 4, 1983

Birthplace: Miami, Florida

What was your childhood ambition? I don't remember.

Where do you live? Florida

Where would you like to live? California

How did you become a model? I was working with some local artists and some friends from school in the art department who were taking pictures of me for figure work.

Where do you see yourself in ten years time? Not a clue, but hopefully I'm very happy.

VIP from movie or music biz would you like to date? If I were to ever date a movie star it would be Julian McMahon from Nip/Tuck

What vice can you never forgive? Forgive?

Daily sins, I cannot resist: Candy... generally all sugary foods.

Favorite Band: Blackfield

Turn-ons: Intelligence

Turn-offs: Ignorance

Is there anything you would never do again? No, I'm pretty happy with my decision making.

What good advice could you give to other models? Don't be a flake. Good business skills are essential if you want to succeed.

Democrat, Republican, Green Party or other? I think I'm listed as "other" but I'm generally liberal.

Things that make me happy: The internet, puppies, traveling, meeting fun unique people who are open minded.

My Myspace/Website: www.myspace.com/carlottachampagne

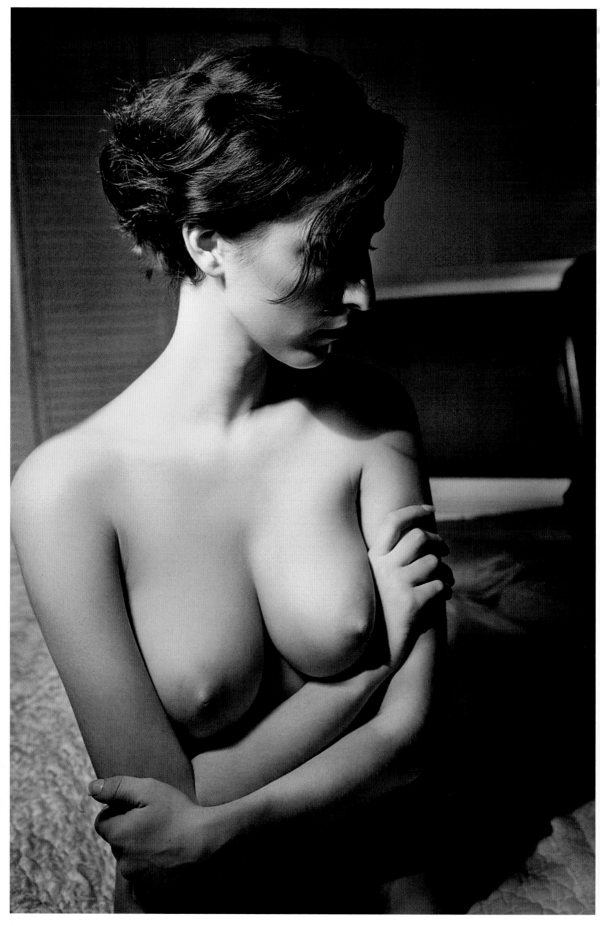

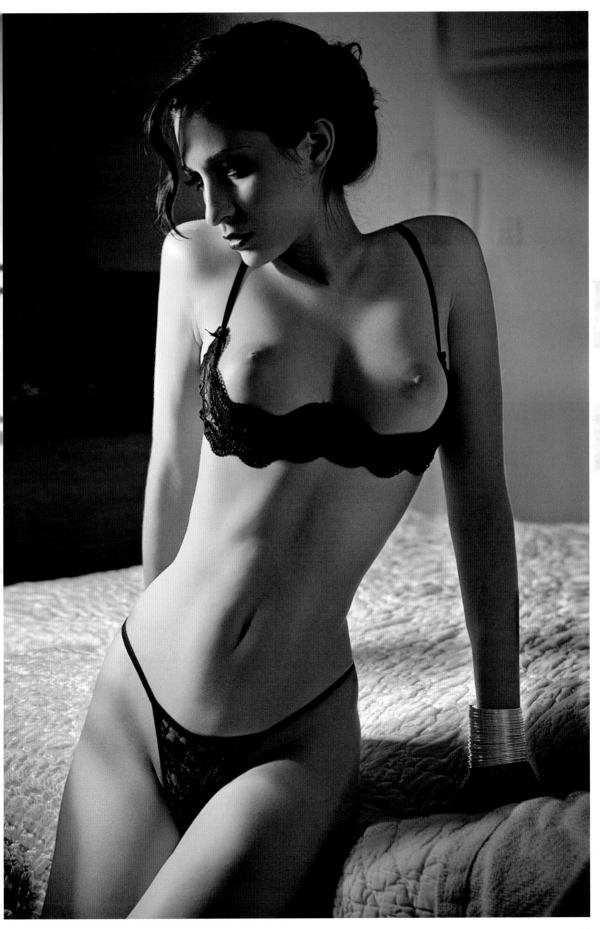

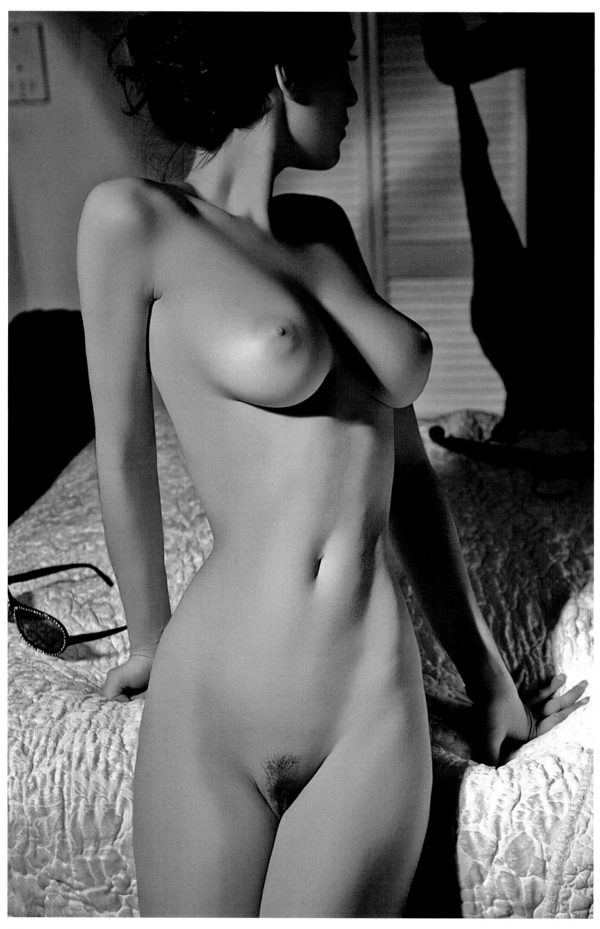

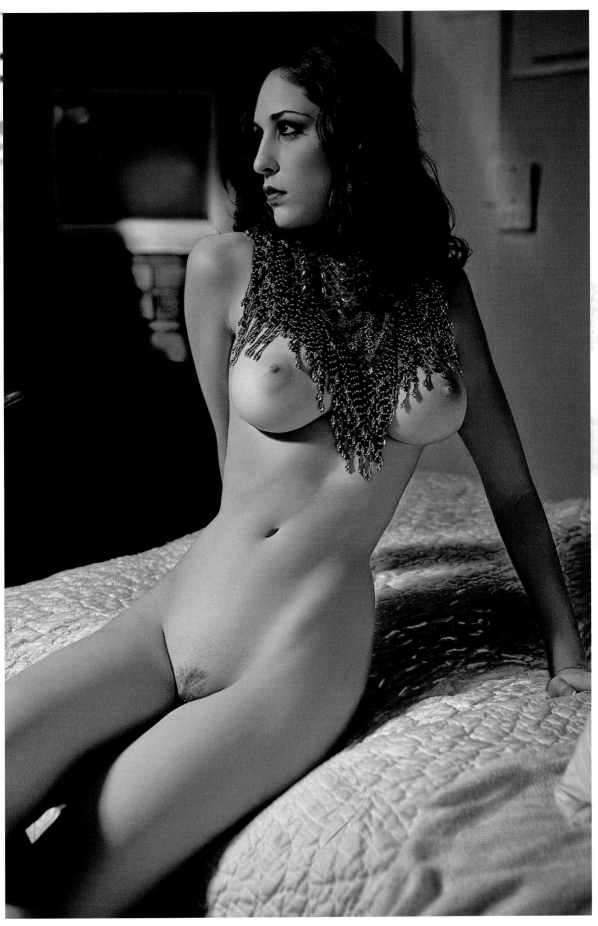

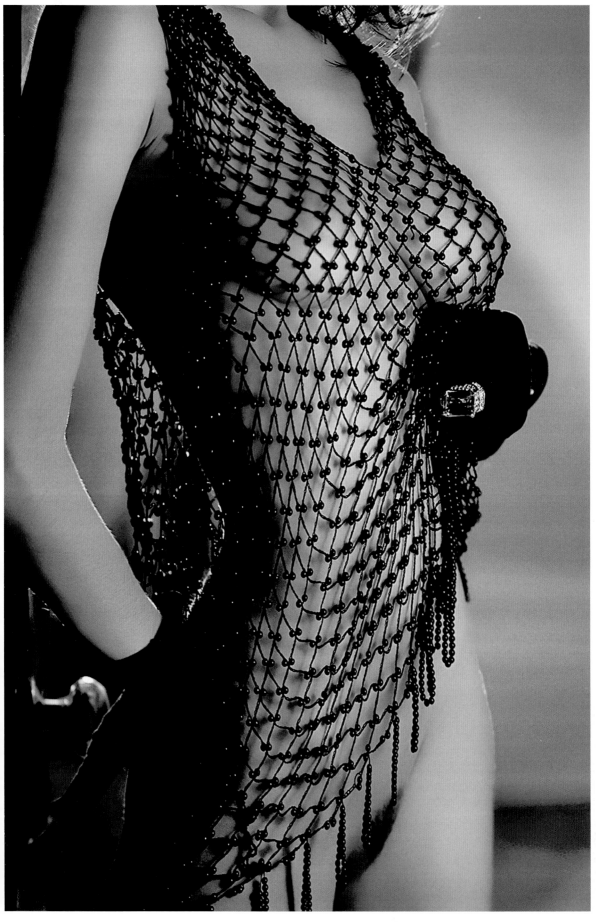

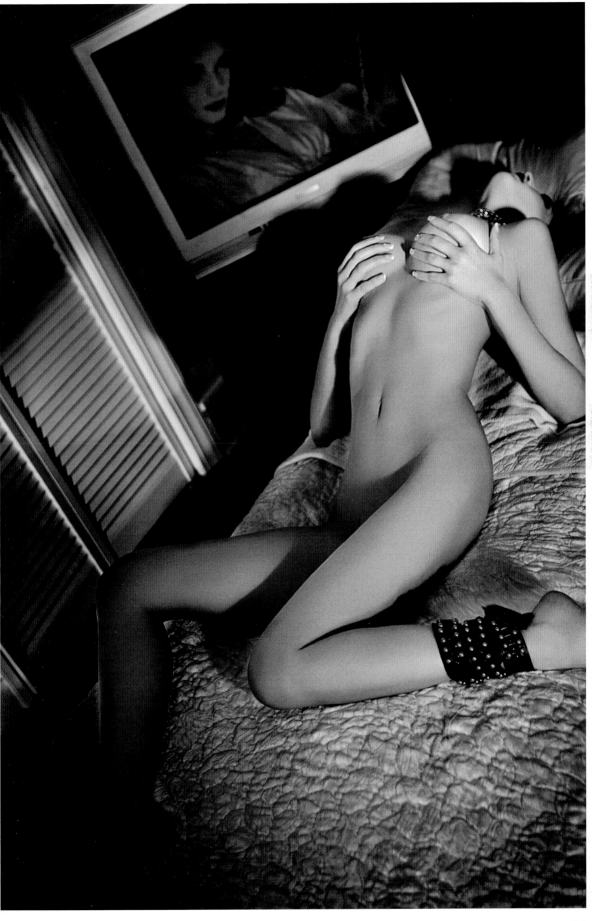

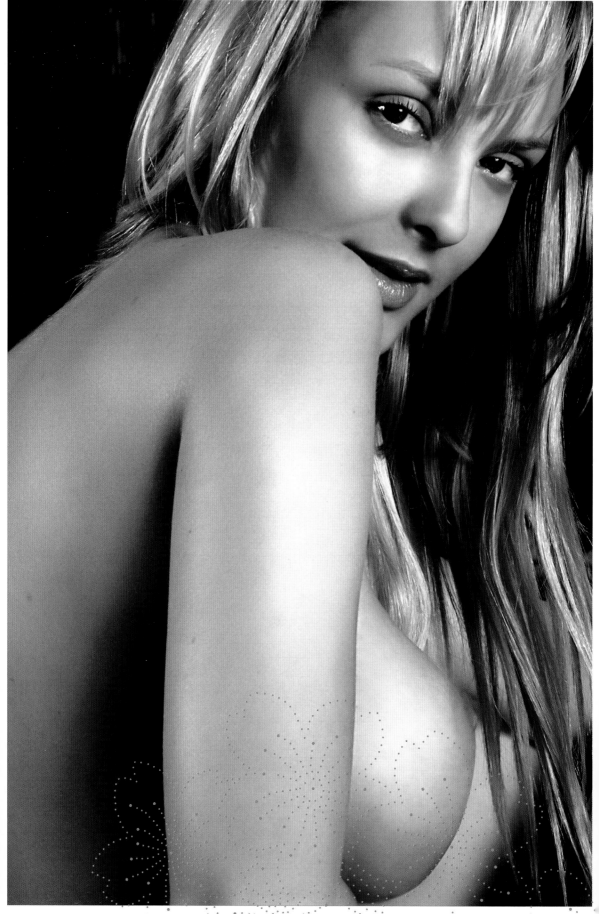

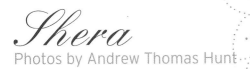

Shera

Photos by Andrew Thomas Hunt

Name: Shera

Birthday: September 14, 1983

Birthplace: Kapuskasing, Ontario, Canada

What was your childhood ambition? Didn't have any. I was too busy being a kid... :-)

Where do you live? Toronto

Where would you like to live? London, England

How did you become a model? A local photographer in my hometown "discovered" me. Andrew saw the photos and invited me to Toronto, and I never left. That was five years ago now.

Where do you see yourself in ten years time? Living in Europe running my own perfume business.

VIP from movie or music biz would you like to date? Hugh Dancy

What vice can you never forgive? –

Daily sins, I cannot resist: Chocolate and my jack-rabbit... ;-)

Favorite Band: Death Cab for Cutie

Turn-ons: A good smelling man with good oral hygiene.

Turn-offs: A bad smelling man with bad oral hygiene.

Is there anything you would never do again? Get so drunk that I puke.

What good advice could you give to other models? Don't kiss ass!

Democrat, Republican, Green Party or other? Social Democrat

Things that make me happy: Swimming in the Caribbean, eating Sushi, getting a massage, and camping.

Website/Myspace: www.myspace.com/sheramodel www.sherapix.com

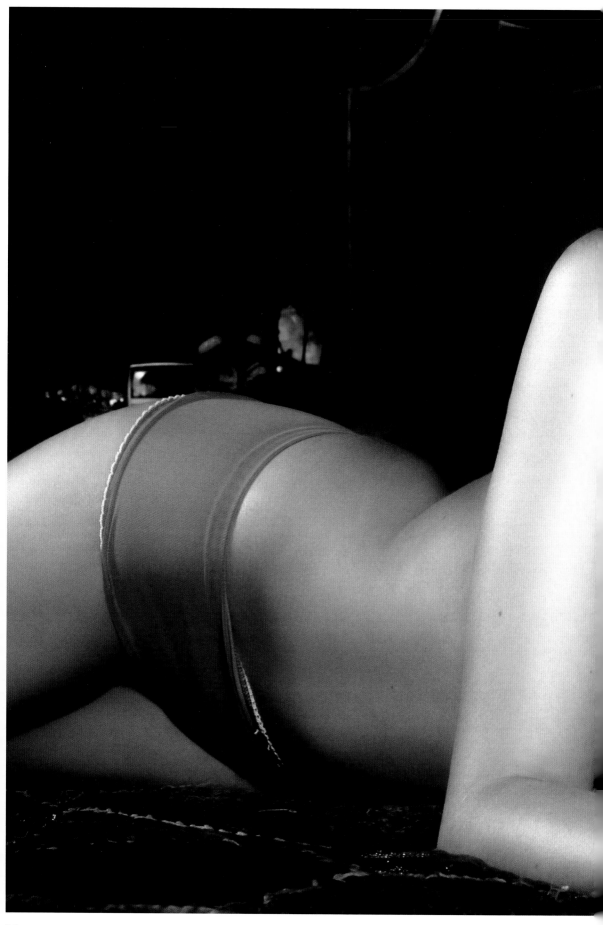

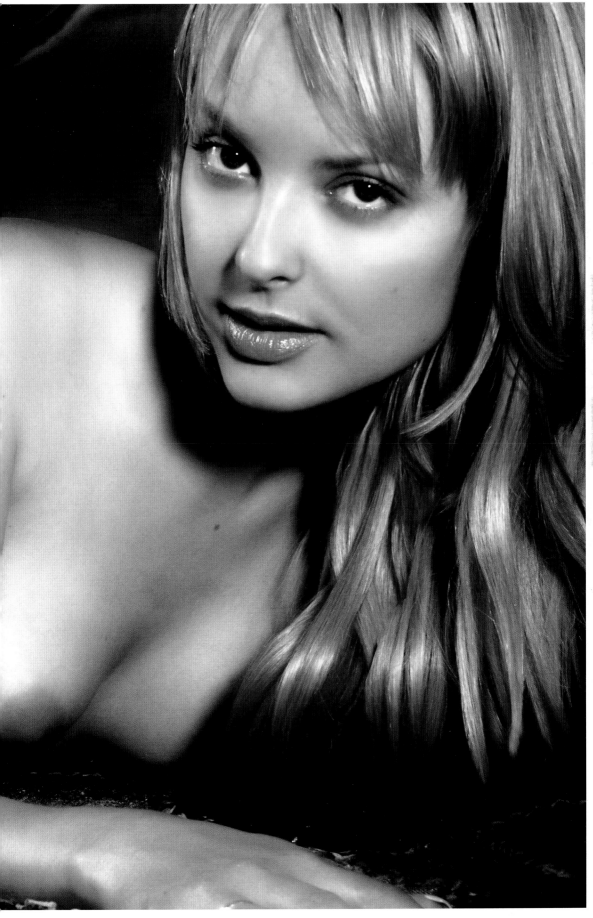

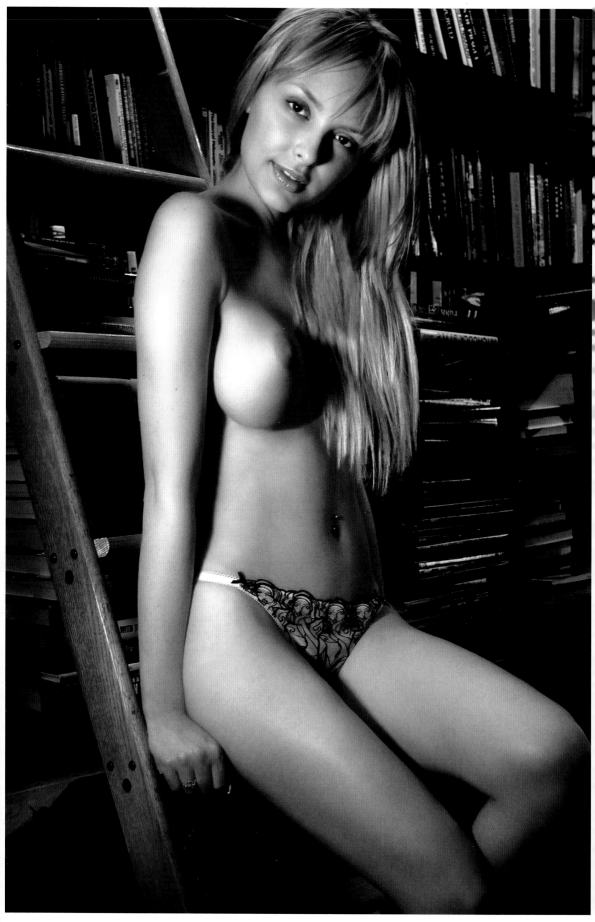

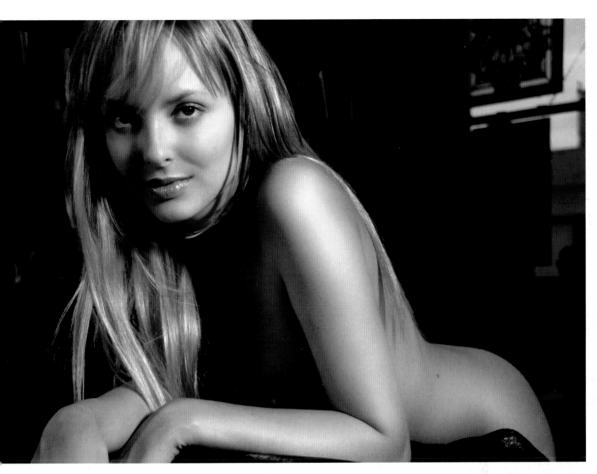

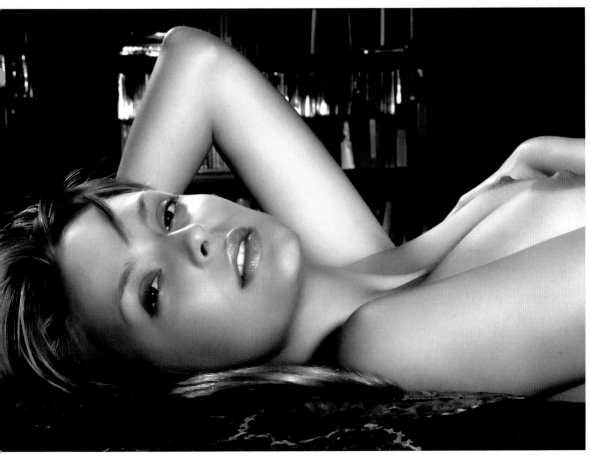

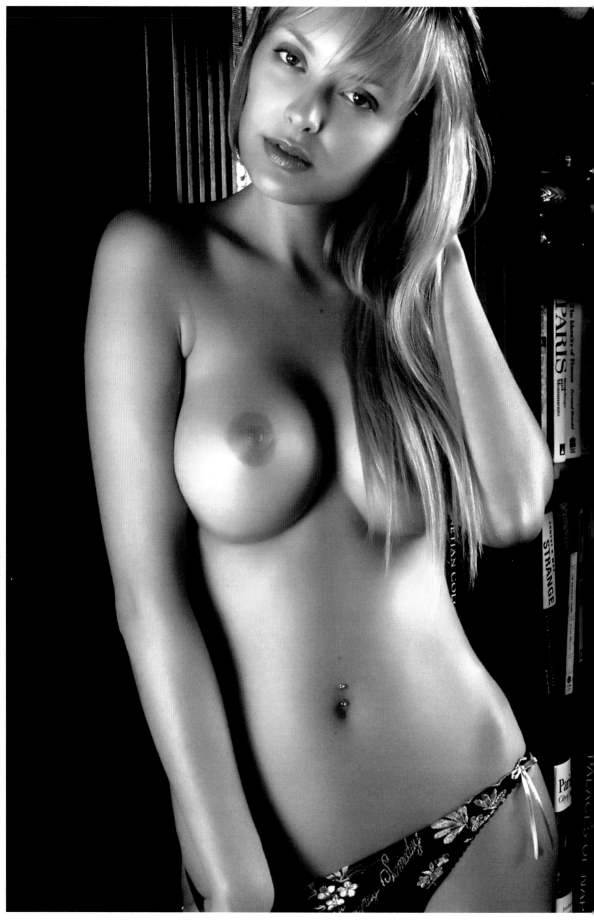

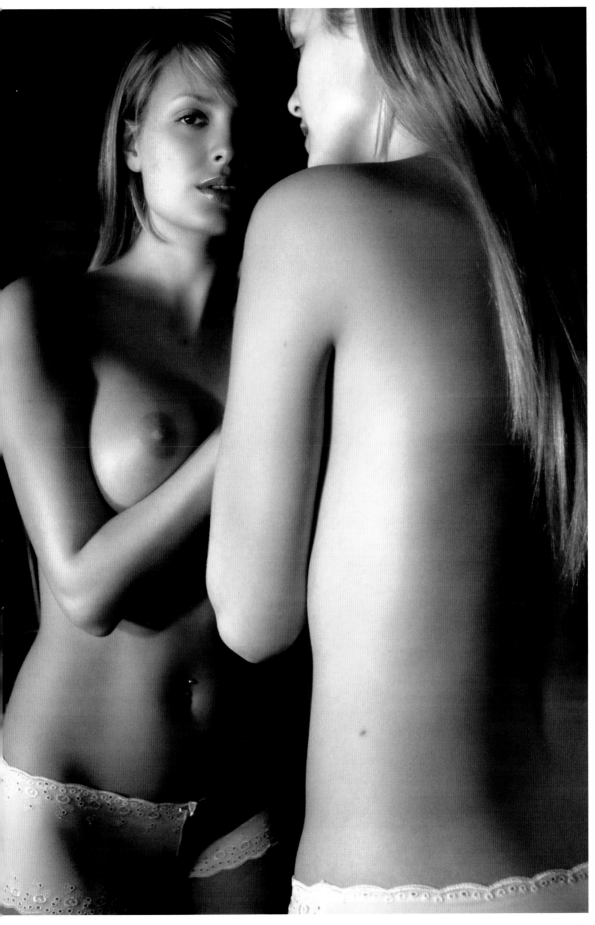

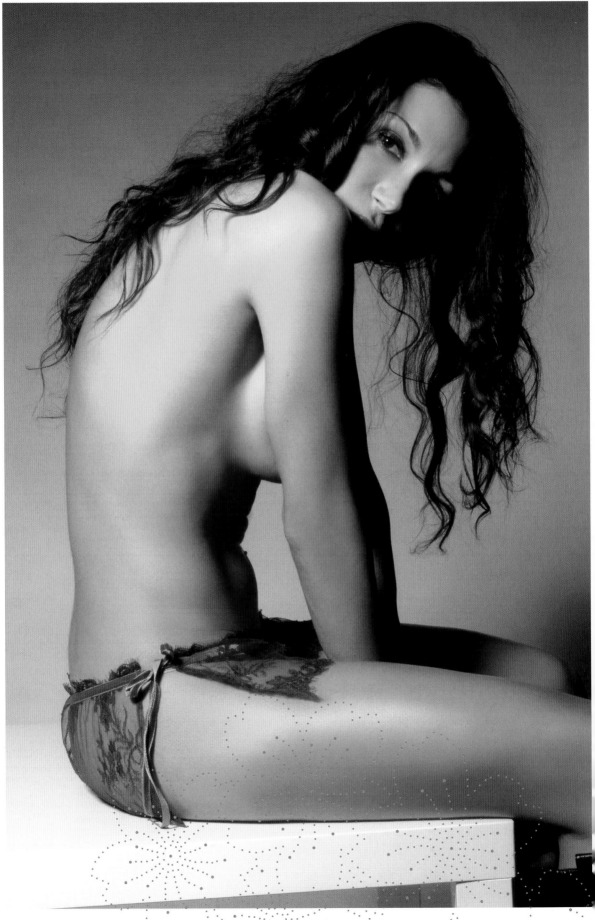

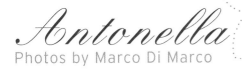

Antonella

Photos by Marco Di Marco

Name: My name? Well, which one do you prefer? O.K. I will stop joking, my name is Antonella.

Birthday: Sorry, I'm too old to remember ... It was a sunny day in June in 197...Time sure flies!

Birthplace: When I was a kid, I lived in a little town (Riposto) at the Mediterranean sea, in Sicily.

What was your childhood ambition? I hoped to become a millionaire to make all the people I love happy.

Where do you live? I live in a small, but very comfortable flat in Rome.

Where would you like to live? In a big house with glass walls on a hill that falls sheer to the sea in S. Barth.

How did you become a model? Other people decided for me. My wish was to become an actress, but every time I went to a casting for a trial, I was told that I was too beautiful and too sexy for acting, and that I appeared more like a model ... so, here I am!!

Where do you see yourself in ten years time? I see myself in the leading role in a Steven Soderbergh film.

VIP from movie or music biz would you like to date? I'd like to date Hugh Jackman.

What vice can you never forgive? I don't know, I don't think there is something I could never forgive, maybe betrayal by someone I love.

Daily sins, I cannot resist: I can't help to spoil myself with a daily little bar extra dark chocolate.

Favorite Band: The sounds of New Order make me crazy.

Turn-ons: I think self-confidence is the key to attraction.

Turn-offs: I think that everything, hence, everyone can be attractive, it's only a question of bearing, a fashion of being.

Is there anything you would never do again? No, nothing. Fortunately I can say I would repeat all my life, even my mistakes that make me grow and become what I am, it's worthwhile!

What good advice could you give to other models? Youth doesn't last forever.

Democrat, Republican, Green Party or other? No comment!

Things that make me happy: My job, I just love it.

Website/Myspace: None

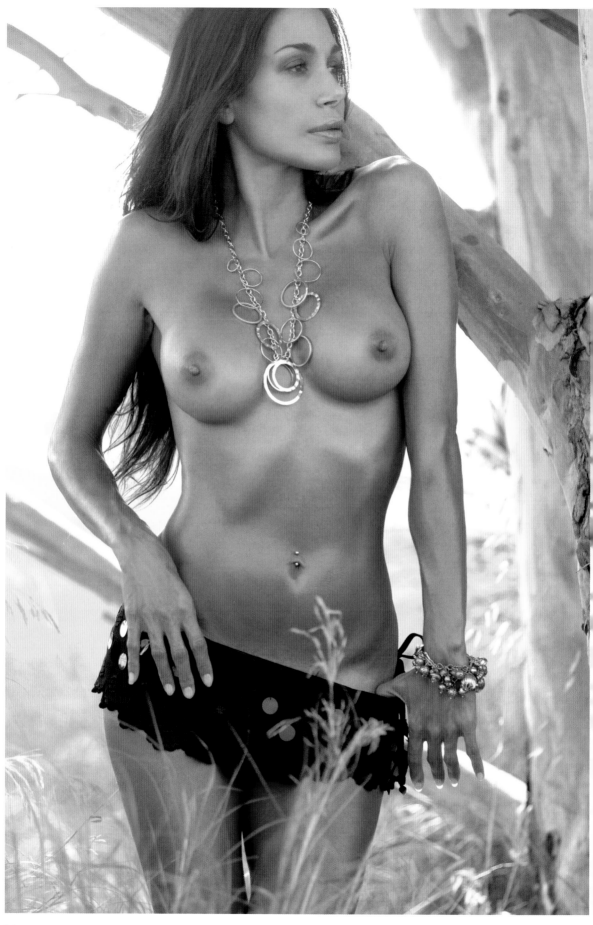

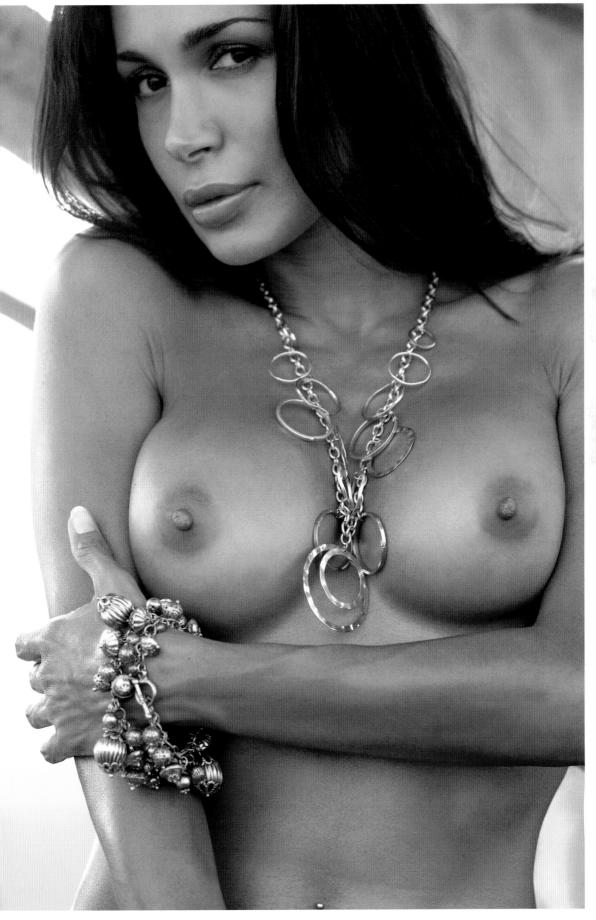

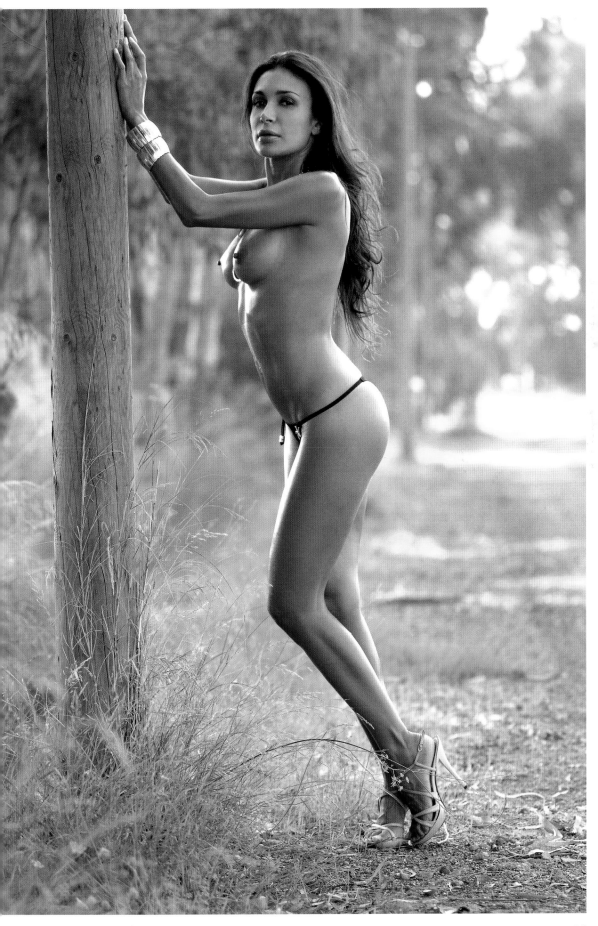

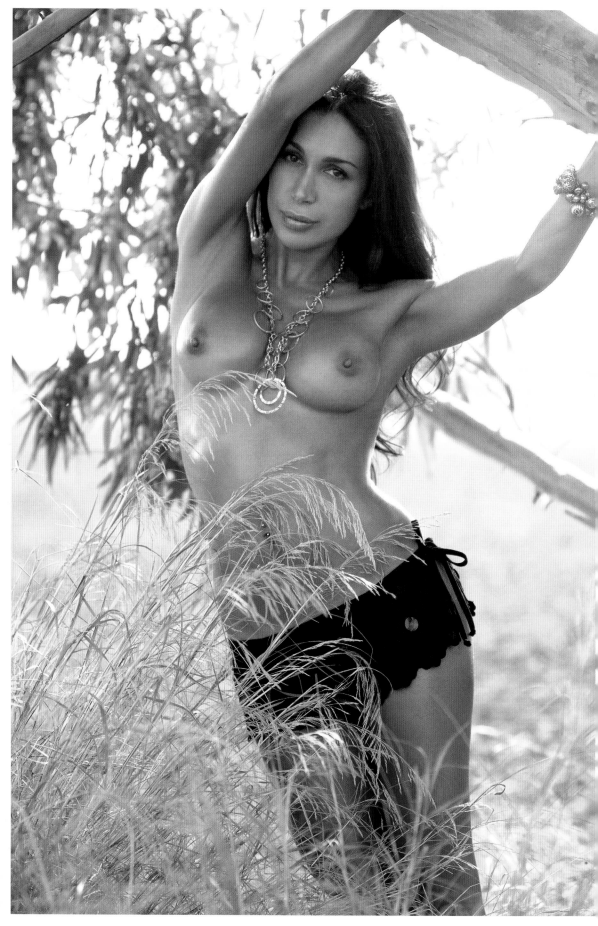

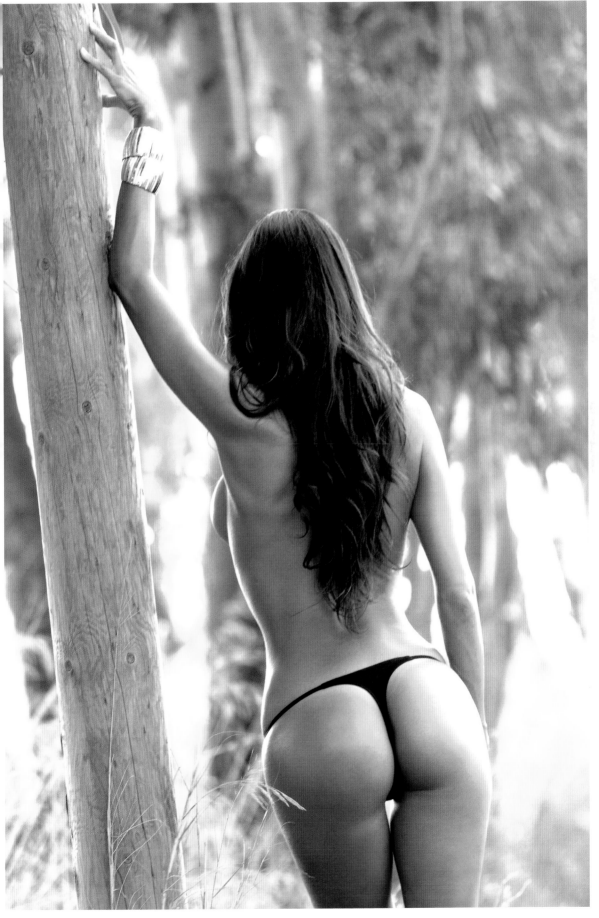

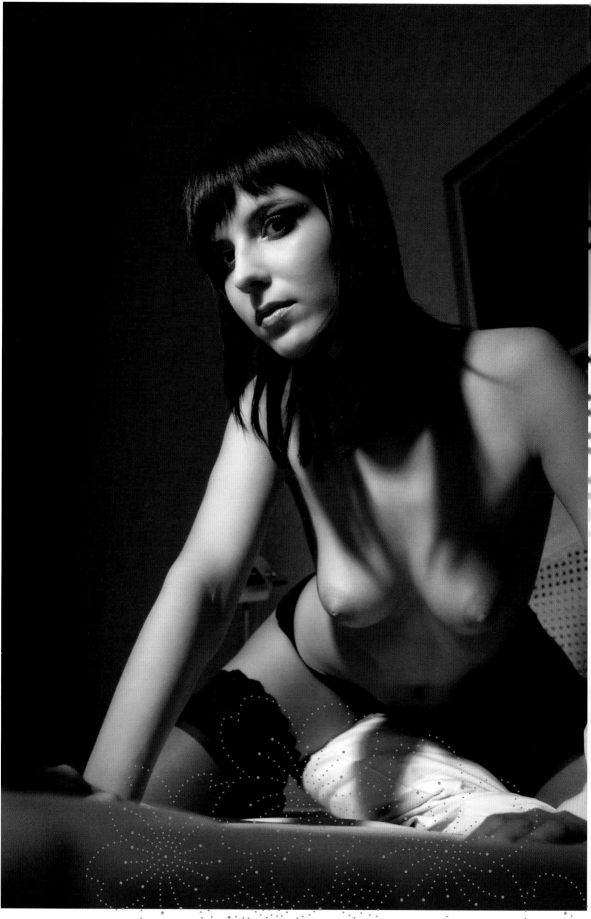

Estella

Photos by Martin Pelzer

Name: Estella

Birthday: August 8, 1982

Birthplace: Szczecin, Poland

What was your childhood ambition? I wanted to be a pharmacist.

Where do you live? I live in Szczecin, but I spend a lot of time in Berlin.

Where would you like to live? Any big and modern city, but it does not matter where I live, as long as I keep traveling.

How did you become a model? I wanted to have some pictures taken of me by a professional photographer. Typical story I guess.

Where do you see yourself in ten years time? I don't make such plans, I like surprises.

VIP from movie or music biz would you like to date? I don't like VIPs. Everyone is important.

What vice can you never forgive? Insincerity, hypocrisy

Daily sins, I cannot resist: Laziness and sweets

Favorite Band: I like many, but I love Nelly Furtado the most: fabulous voice and performance!

Turn-ons: Travels, changes, meeting new people and situations

Turn-offs: Boring, sad and envious people

Is there anything you would never do again? I vote for President Kaczynski (just kidding, I did not).

What good advice could you give to other models? Try to put yourself in the photographers situation, always keep positive vibrations and respect the job.

Democrat, Republican, Green Party or other? None, thanks!

Things that make me happy: Pets, parties, my man, my job (photo model),..., too many to list

Website/Myspace: www.E-Stella.com

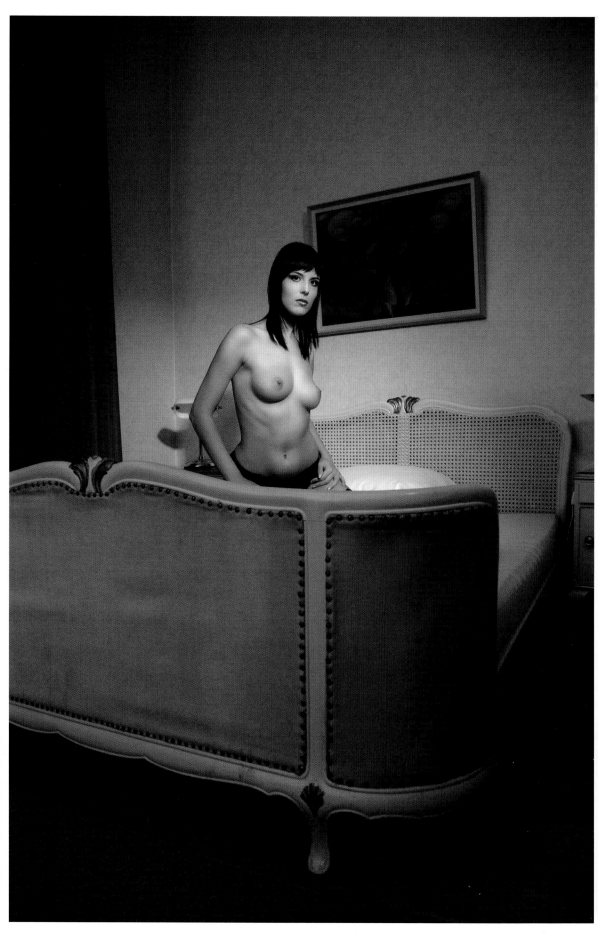

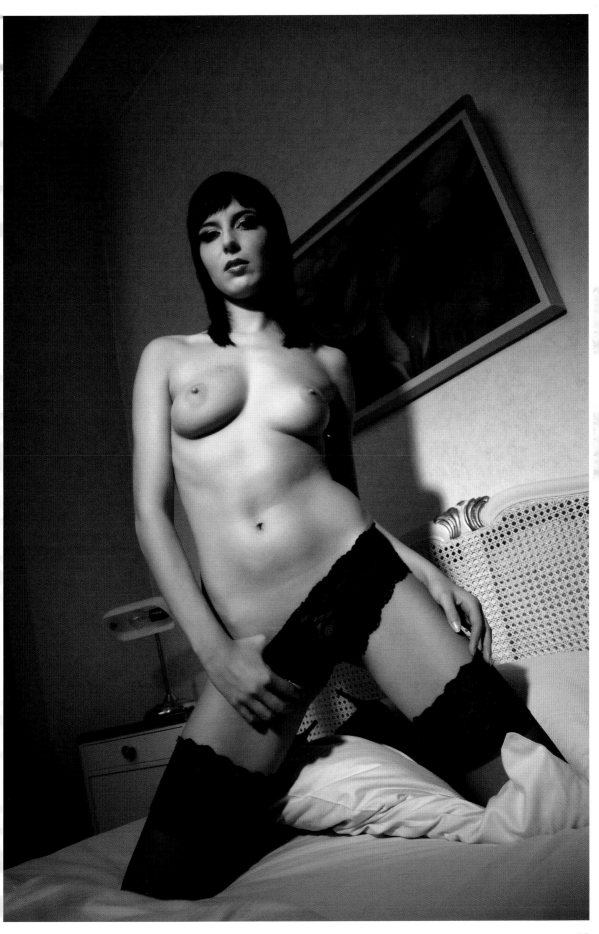

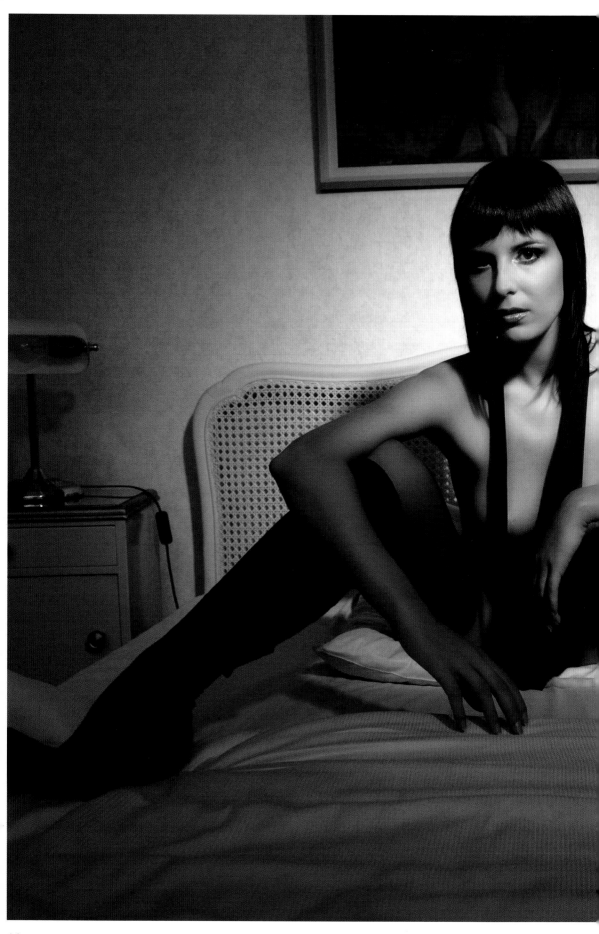

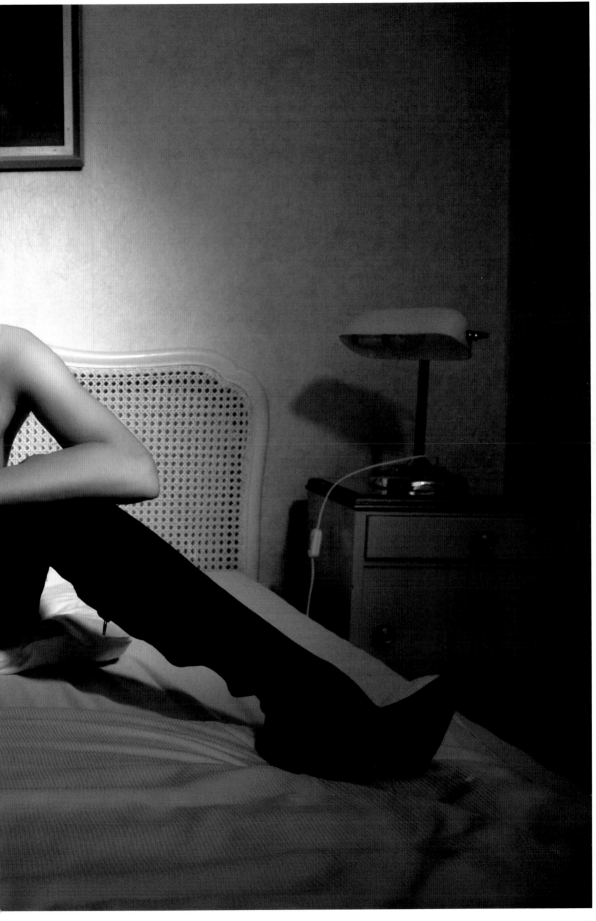

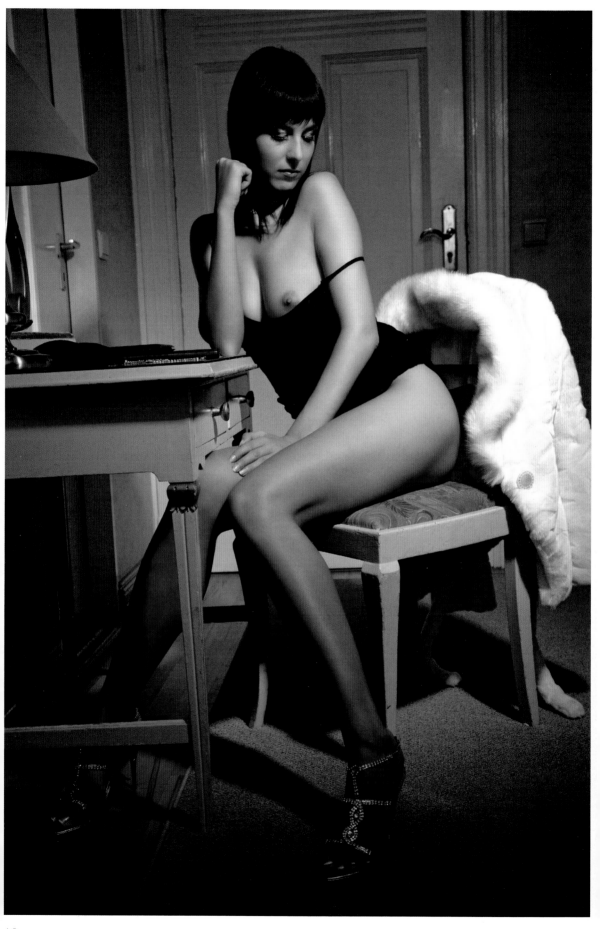

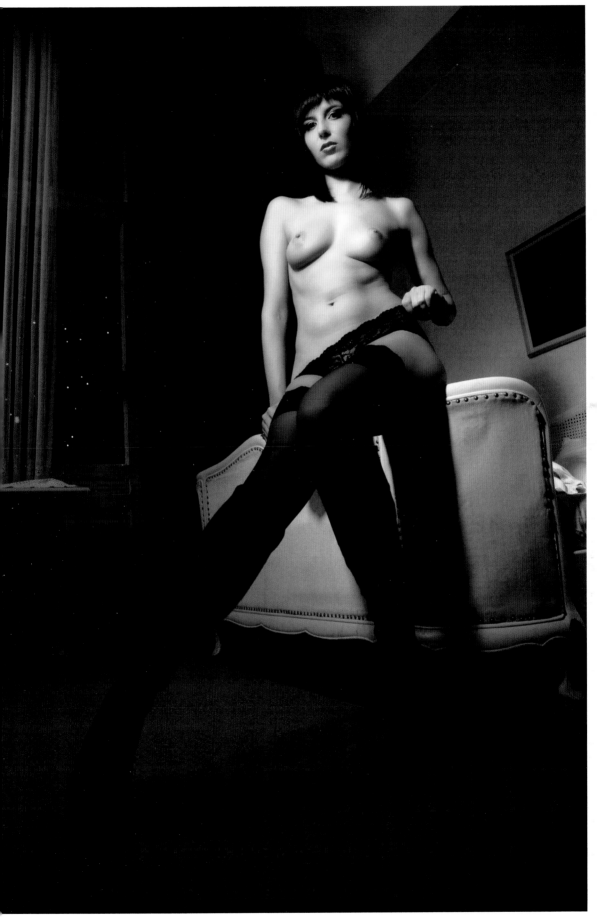

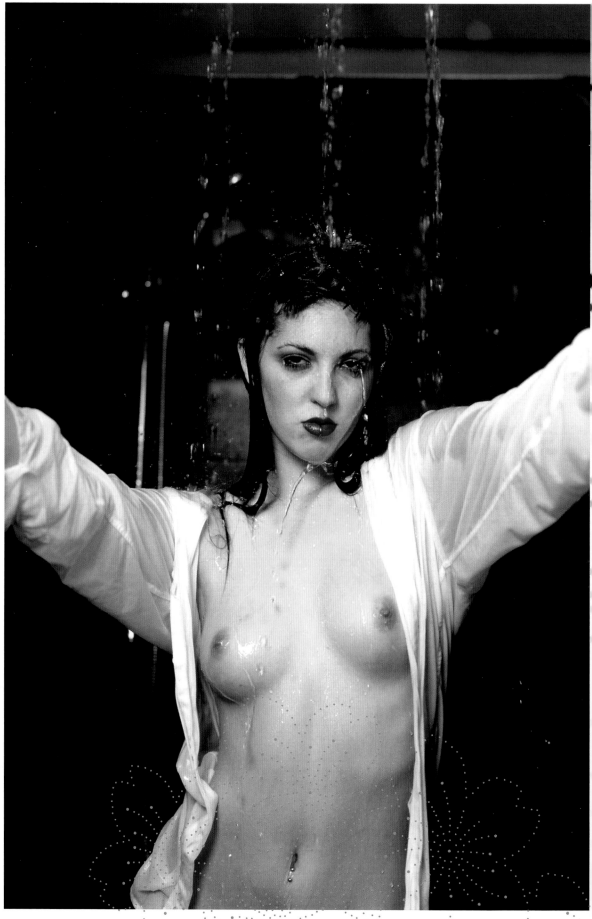

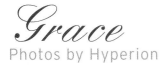

Grace
Photos by Hyperion

Name: Grace

Birthday: July 15, 1984

Birthplace: Stafford UK

What was your childhood ambition? To go to the moon

Where do you live? Leicester, UK

Where would you like to live? It's the people that make the place. At the moment. I have some fantastic friends in Leicester, so I'm quite happy here. I just travel for work which I love.

How did you become a model? I've never really thought of myself as a "model", more a collaborator. The best images are created when there is a perfect harmony between photographer and a "model"

Where do you see yourself in ten years time? Still helping to create beautiful and emotive imagery, although I mainly work on the other side of the camera then - except for exceptional photographers such as Hyperion.

VIP from movie or music biz would you like to date? Rhys Ifans, Christian Slater, Simon Pegg, Choi Min-sik and Gerard Way

What vice can you never forgive? People who abuse children and animals

Daily sins, I cannot resist: Doing everything to excess. I have quite an obsessive personality.

Favorite Band: It changes on a regular basis depending on my mood. At the moment I'm listening to a lot of Johnny Cash and VNV Nation.

Turn-ons: Dirty talk, sad films, spontaneity, naughty texts, water, switching places, violence in tenderness, arrogance

Turn-offs: Arrogance, sleazy people, lack of manners and common courtisy, selfishness, materialism

Is there anything you would never do again? Work with photographers who have no skill or innovation, no interest in photography other than to shoot hot girls and generally take advantage of a new model's innocence.

What good advice could you give to other models? Always get references from other models if you're intending to work with a photographer who you haven't met before. Never get pushed into shooting anything that makes you feel uncomfortable.

Democrat, Republican, Green Party or other? None

Things that make me happy: Food, films, friends and photography

Website/Myspace: www.myspace.com/threeeyesphotography

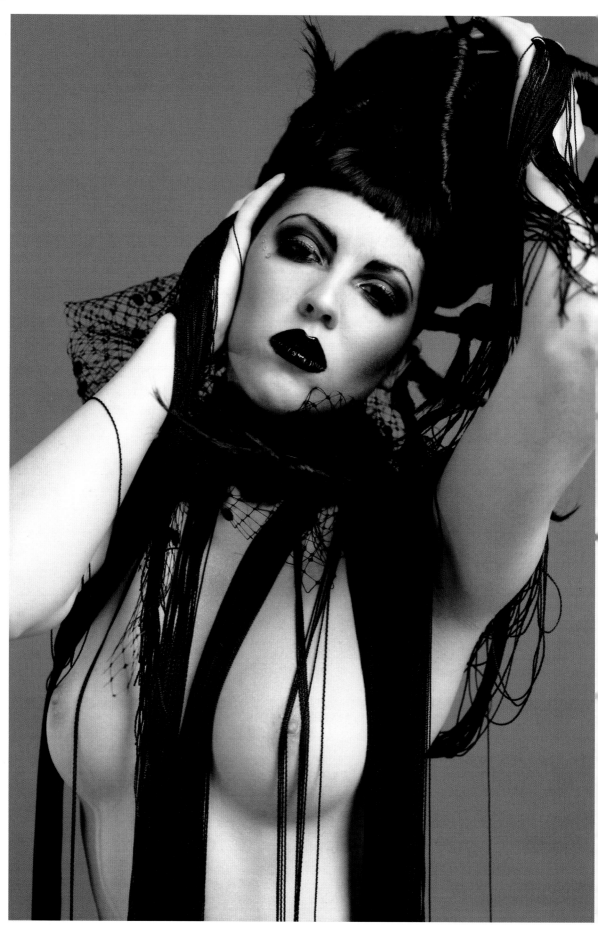

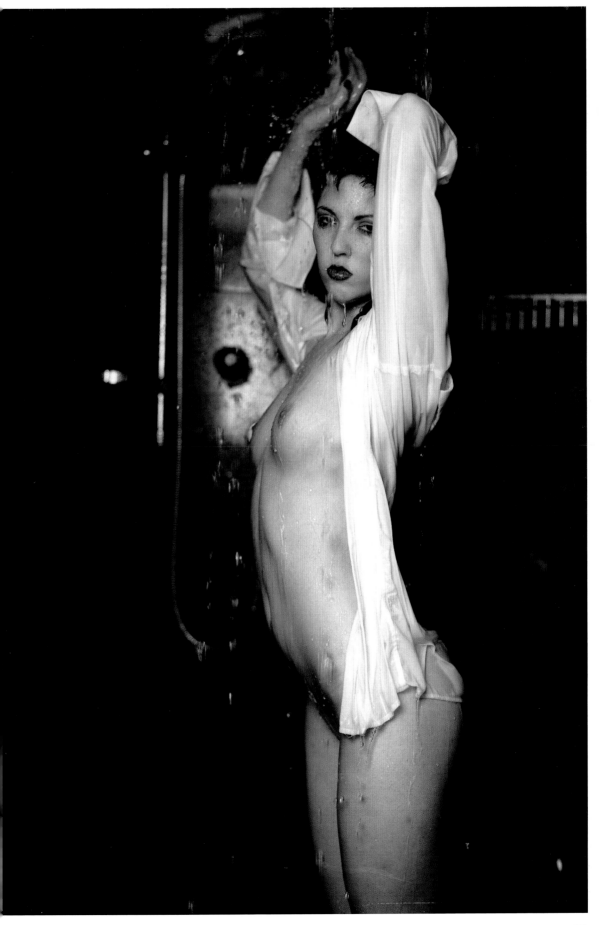

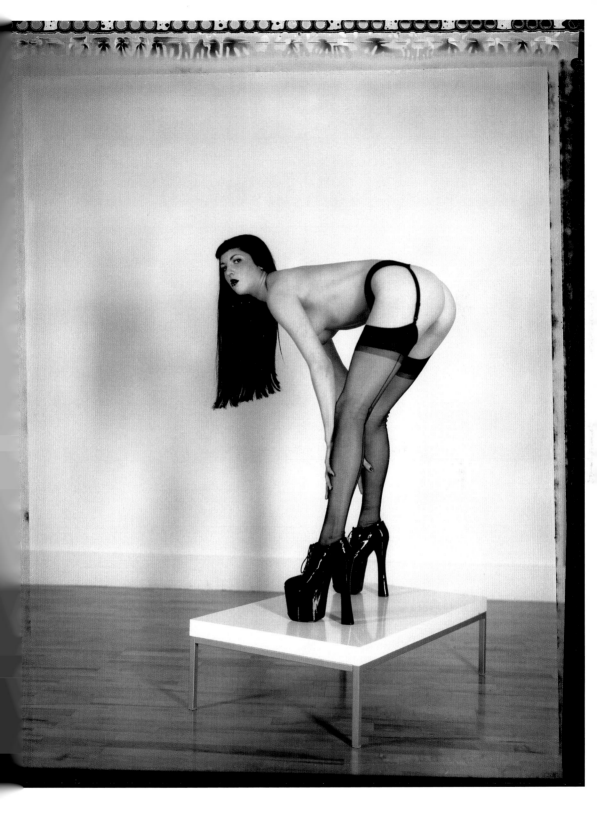

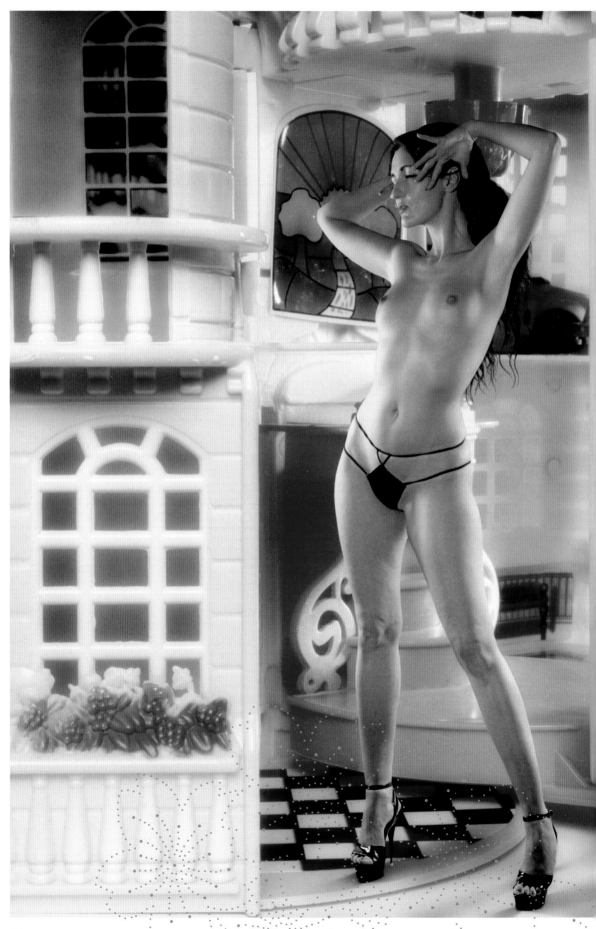

Mary Latexa

Photos by Rüdiger Schestag

Name: Mary Latexa

Birthday: April 30, 1972

Birthplace: Stuttgart

What was your childhood ambition? Becoming famous

Where do you live? I live near Stuttgart.

Where would you like to live? I want to live by the sea.

How did you become a model? A photographer asked me, if I wanted to model for him.

Where do you see yourself in ten years time? This is difficult. Well, I am married and I am a mother.

VIP from movie or music biz would you like to date? Sean Connery

What vice can you never forgive? Murder

Daily sins, I cannot resist: Smoking, drinking tea

Favorite Band: Marilyn Manson

Turn-ons: Flowers, Chanel Mademoiselle, high heels, rubber

Turn-offs: Sneakers, false people, alcohol

Is there anything you would never do again? Going back to a lousy job

What good advice could you give to other models? Go your own way

Democrat, Republican, Green Party or other? Green Party

Things that make me happy: My boyfriend

Website/Myspace: www.myspace.com/marylatexa

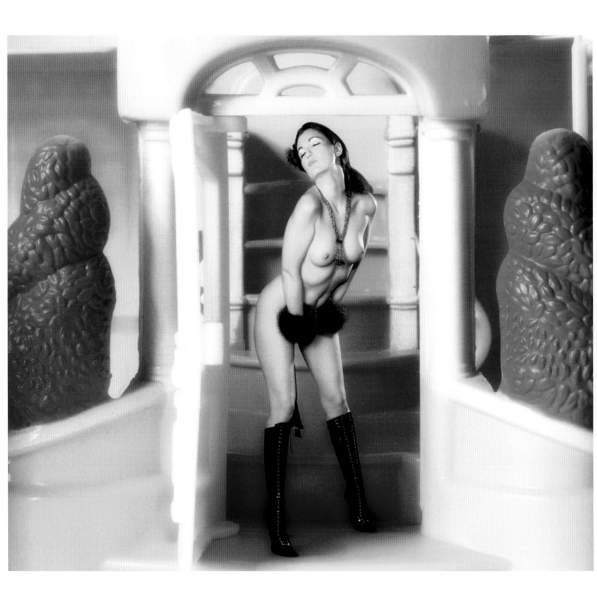

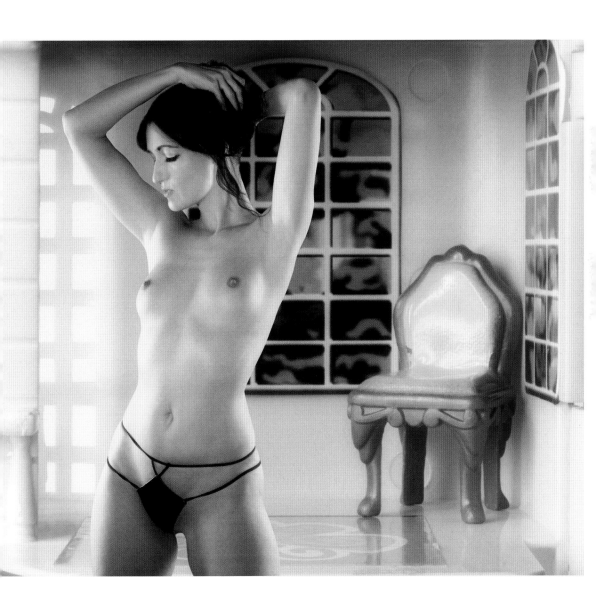

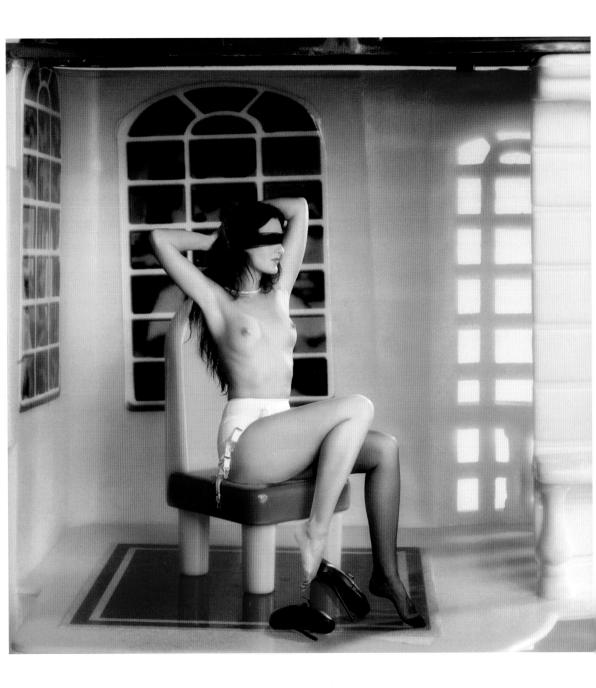

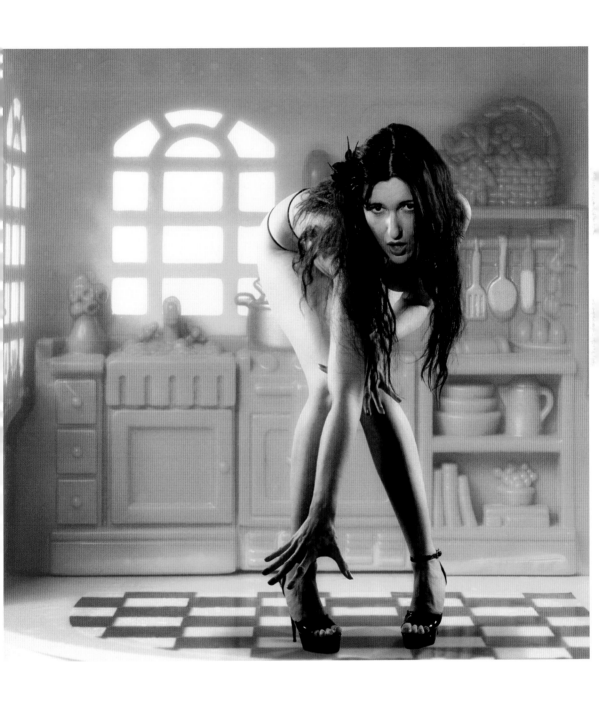

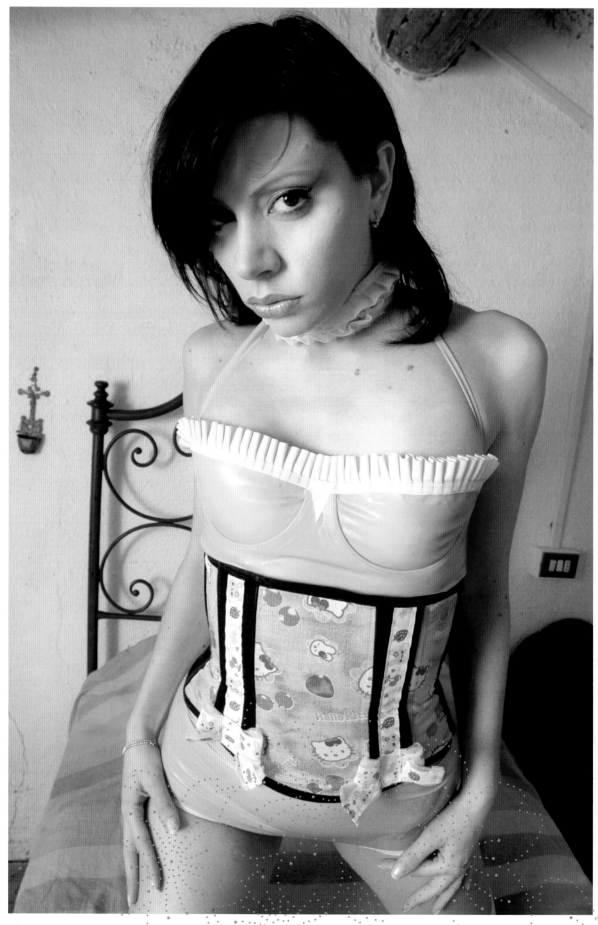

Pinkie Pain

Photos by Thomas Sing

Name: Pinkie Pain

Birthday: –

Birthplace: Italy

What was your childhood ambition? I wanted to become a geologist, but I wasn't good enough in natural science, so I had to change my mind.

Where do you live? In rural Bavaria, the land of Lederhosen & huge beers

Where would you like to live? In Utopia – that's a place where creativity counts, the weather is mild and my best friends are.

How did you become a model? By chance. 4 years ago I was at a party and was aproached by a photographer. I thought "Why not?" but didn't expect to become a model. I always thought my brain is the best part of me.

Where do you see yourself in ten years time? I hope I will still be involved in a creative process. There are so many things I'd like to realize and are dealing with visuals.

VIP from movie or music biz would you like to date? Actually there is nobody I'd like to date. But I'd love to go for a drink with Asia Argento.

What vice can you never forgive? –

Daily sins, I cannot resist: Coffee in the morning, beer in the evening

Favorite Band: Placebo

Turn-ons: Intelligence, androgyny, bad girls, extroverts, sense of humour, imperfections

Turn-offs: Ignorance, lack of hygiene, fakes, faces without expression, body builders, bananas

Is there anything you would never do again? Trying to be average

What good advice could you give to other models? –

Democrat, Republican, Green Party or other? I believe in principals, not in parties. Anyway, I live in a foreign country where I cannot vote.

Things that make me happy: Music, high heels, everything in pink or green, good books, surprises, dancing

Website/Myspace: www.pinkiepain.com

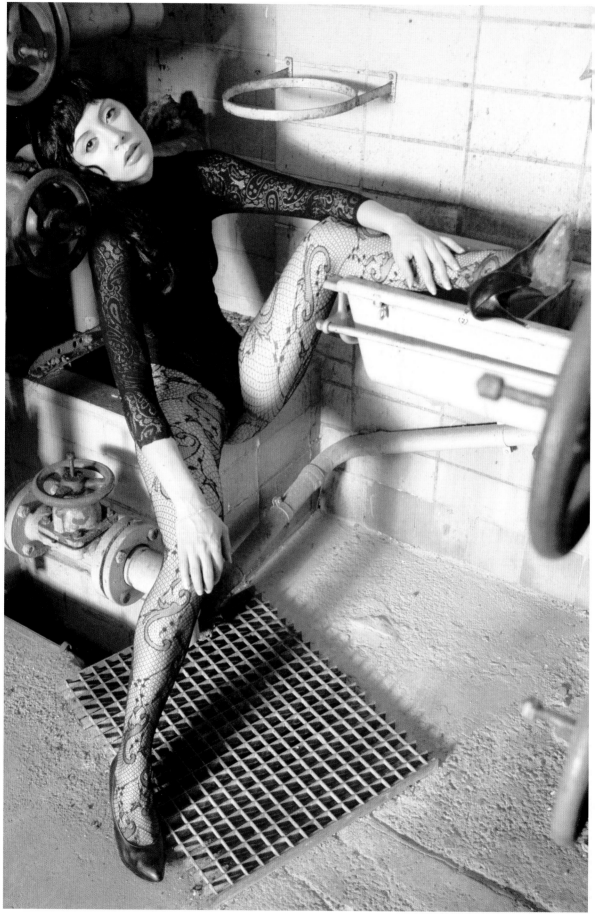

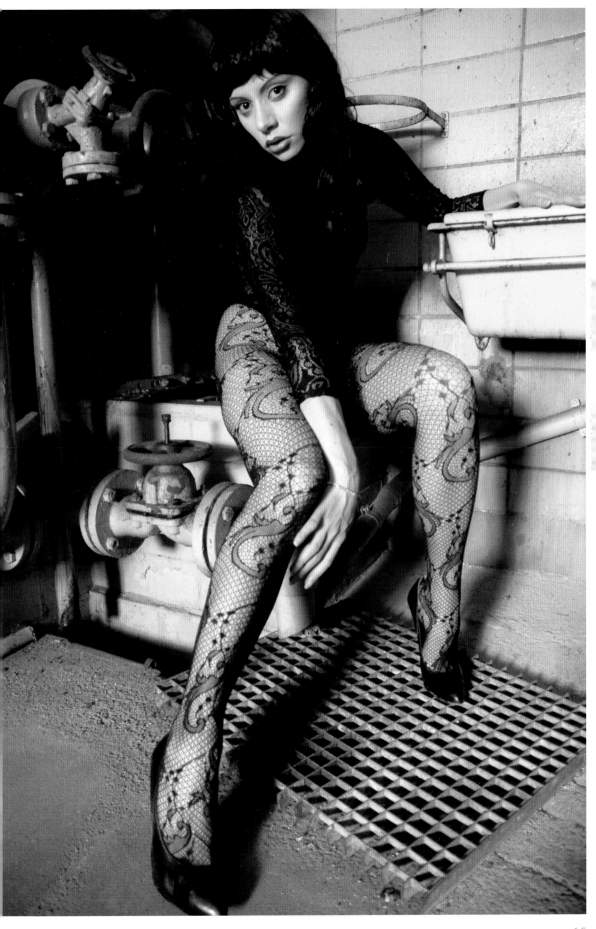

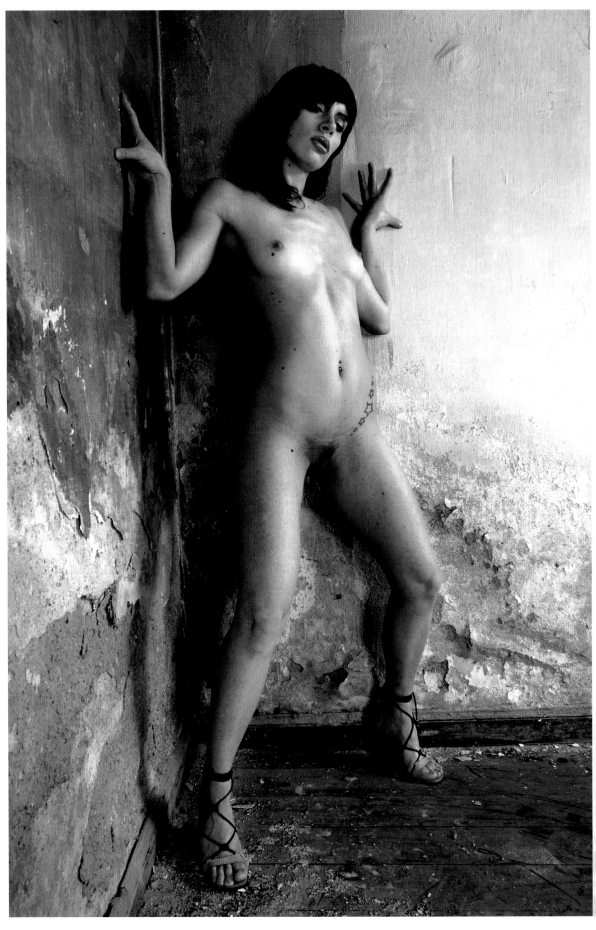

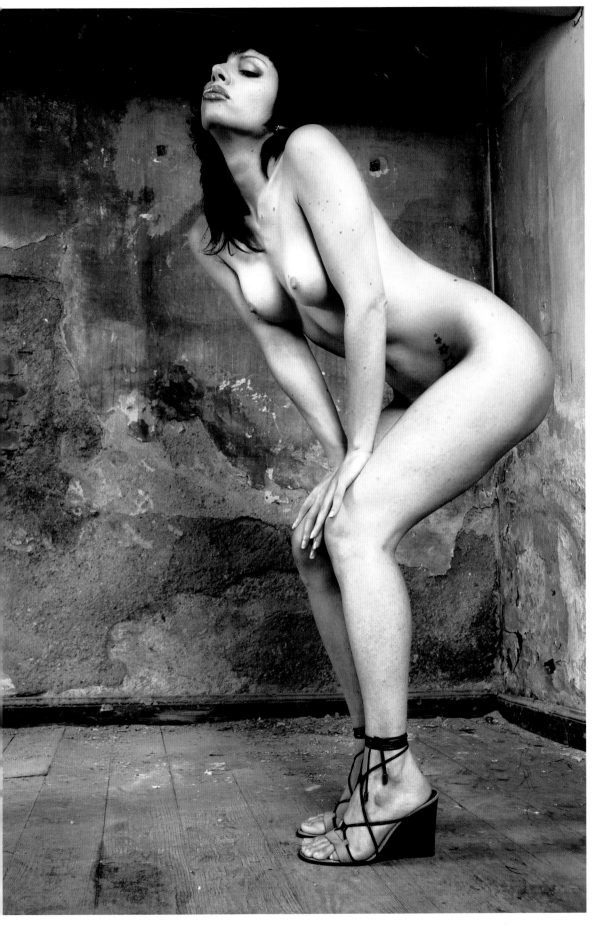

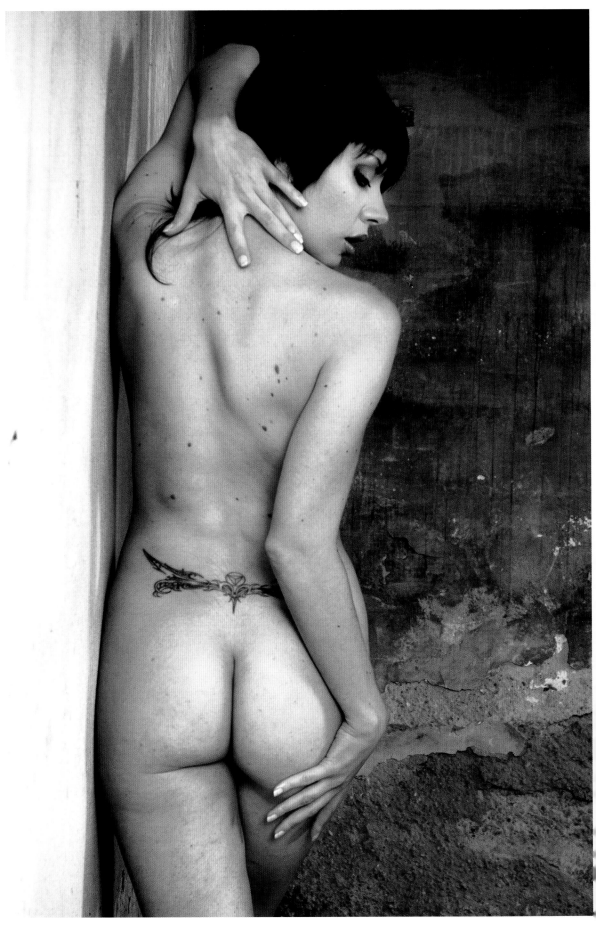

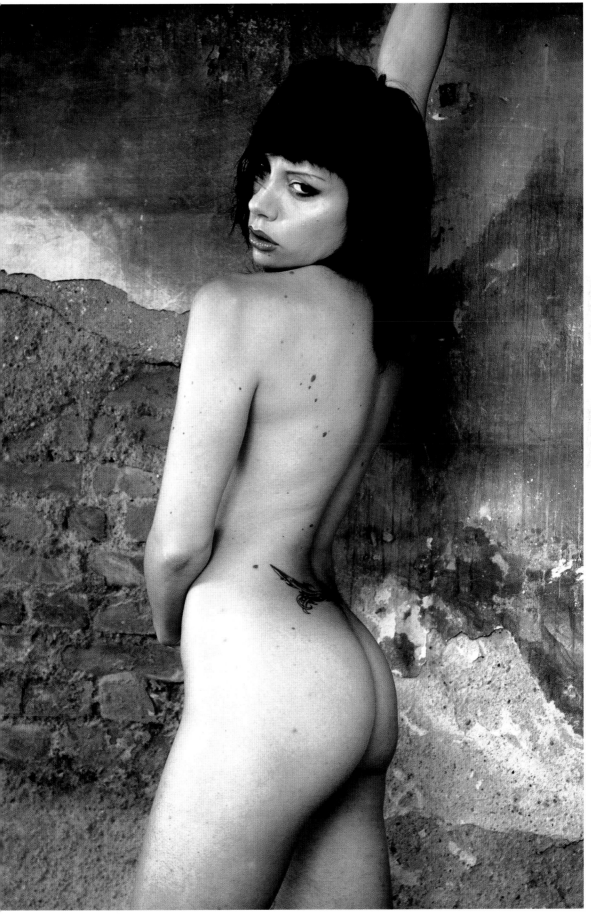

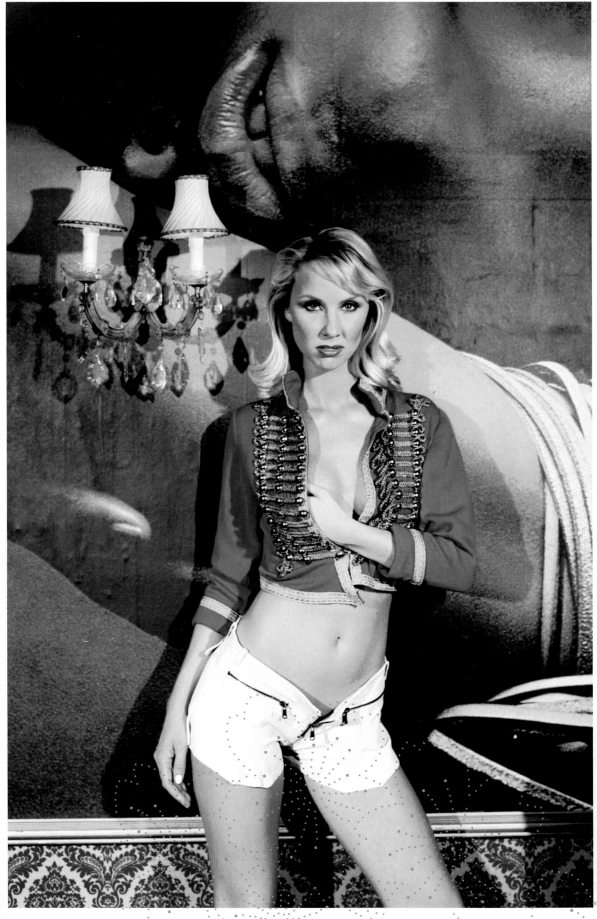

Silke

Photos by Jean Cleemput

Name: Silke

Birthday: October 26, 1978

Birthplace: Aalst, Belgium

What was your childhood ambition? To become an F16 pilot

Where do you live? Aalst, Belgium

Where would you like to live? Bahamas, need I say more?

How did you become a model? I won the "Discover the look 2005" contest.

Where do you see yourself in ten years time? Botox, here I come!

VIP from movie or music biz would you like to date? Jack Nicholson

What vice can you never forgive? Aggression

Daily sins, I cannot resist: Chocolate

Favorite Band: Snow Patrol

Turn-ons: A little belly, humor

Turn-offs: White socks and nose hair

Is there anything you would never do again? Regrets, I have a few, but then again, too few to mention.

What good advice could you give to other models? Take the money while you're still young and beautiful!

Democrat, Republican, Green Party or other? Victoria's Secret!!!

Things that make me happy: Symmetry

Website/Myspace: none

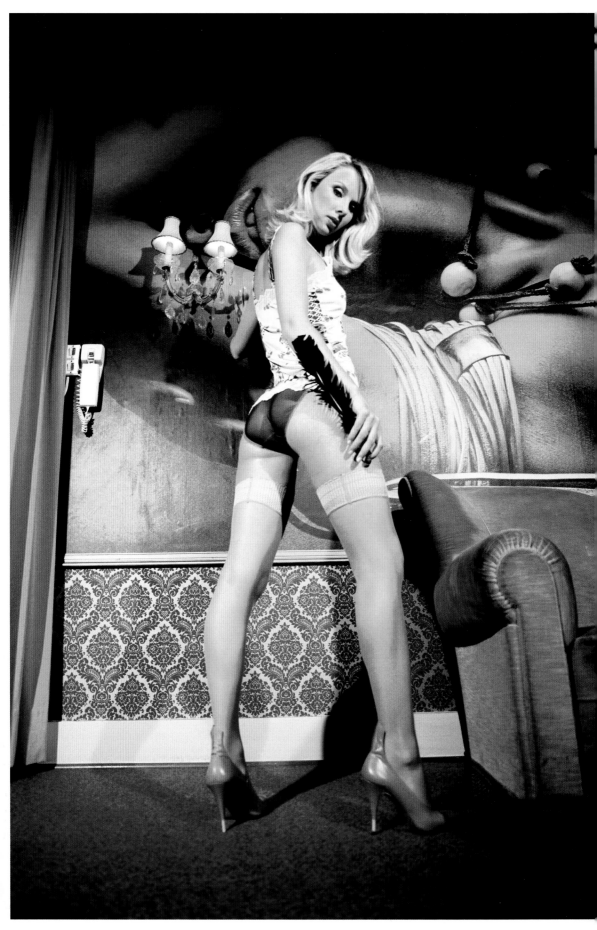

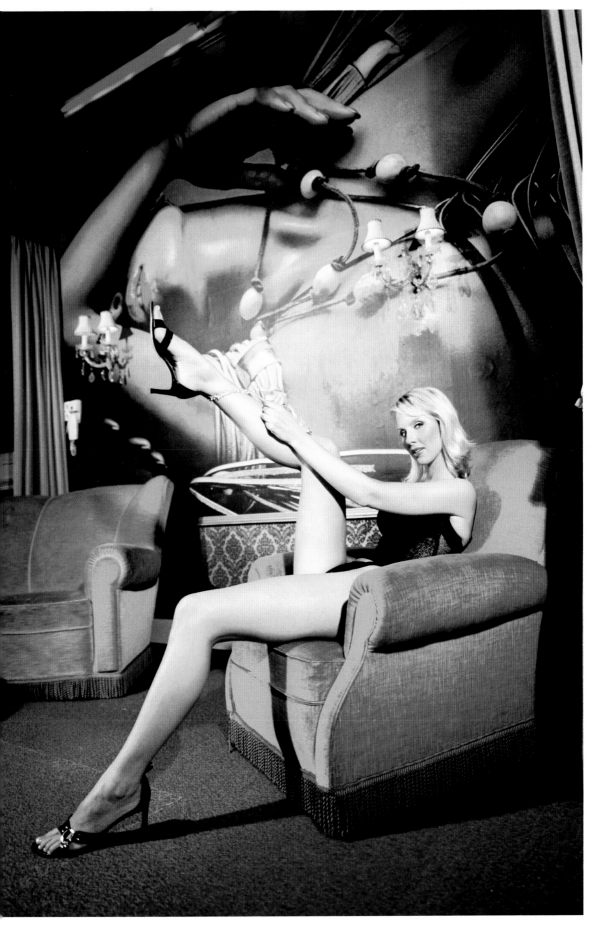

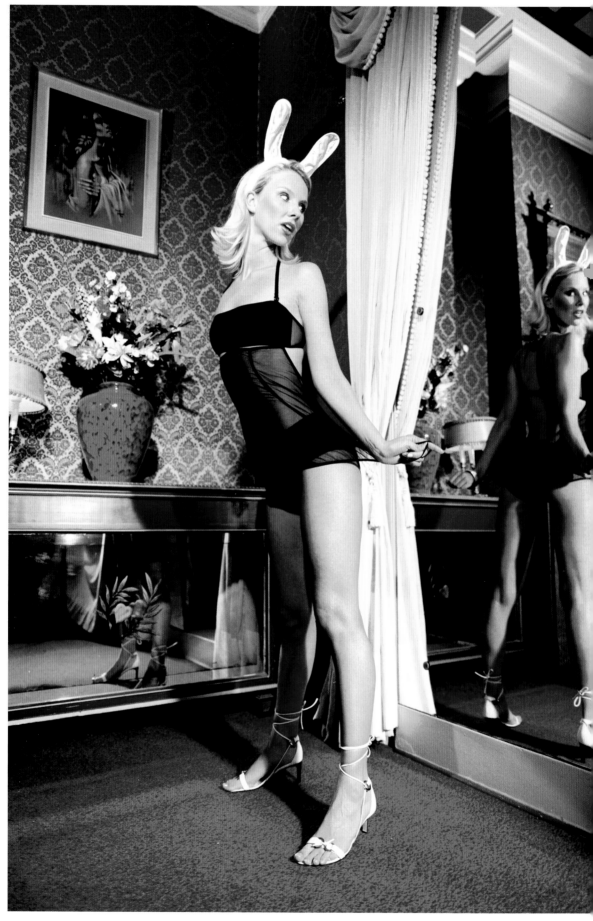

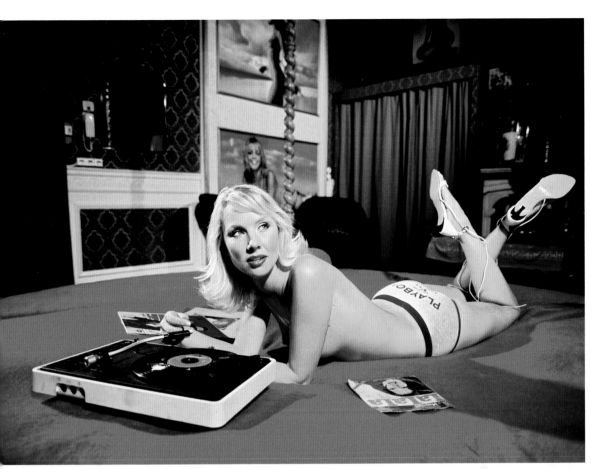

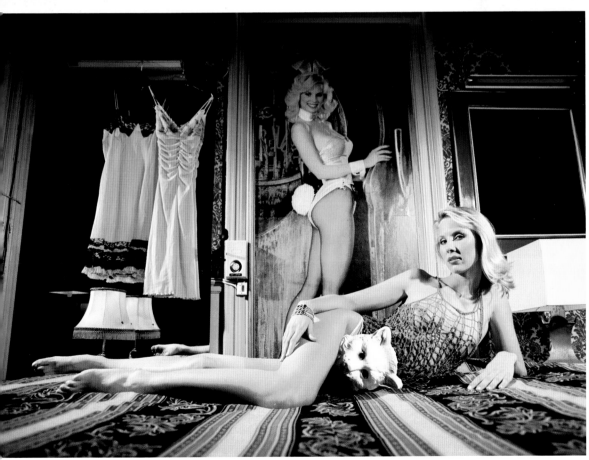

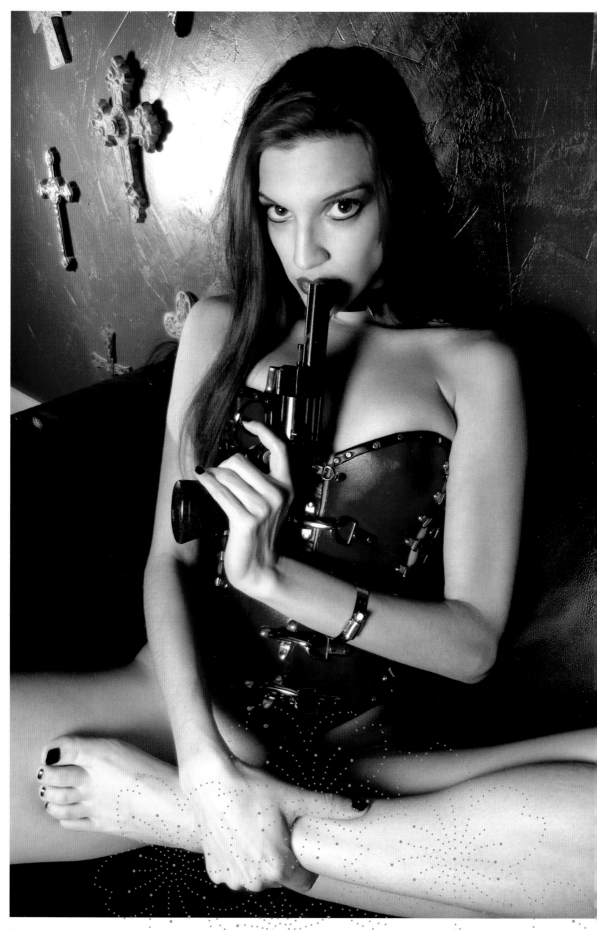

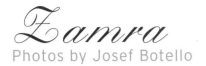

Zamra
Photos by Josef Botello

Name: Zamra

Birthday: March 18, 1982

Birthplace: Dallas, TX

What was your childhood ambition? Orchestra superstar, scientist, sallerina

Where do you live? Texas

Where would you like to live? I should probably travel more before I decide.

How did you become a model? I started out just posing for friends, but decided modeling is what I really wanted to do after seeing my pictures in Josef Botello's book "Girls, Guns and Ropes".

Where do you see yourself in ten years time? Still modeling, but with a degree in Physics and my own line of latex clothing

VIP from movie or music biz would you like to date? I would have to meet some first! Personality is very important to me.

What vice can you never forgive? Miami Vice for starting some bad fashion trends

Daily sins, I cannot resist: Sloth – I've got to get my beauty sleep.

Favorite Band: It's hard to choose a favorite since I like everything from Cradle of Filth to the Bee Gees

Turn-ons: Wearing latex and corsets, getting my toes licked, and people who get my bizarre sense of humor.

Turn-offs: Body hair, bad tattoos, smokers

Is there anything you would never do again? Let Josef Botello tie me to a tree for a shoot while there are Texas-size mosquitos flying around my head... and other parts!

What good advice could you give to other models? Be persistent!

Democrat, Republican, Green Party or other? I usually vote Democrat... even though I'm against gun control (obviously)!

Things that make me happy: Kitty cats, sugar-saturated products, shopping

Website/Myspace: www.myspace.com/zamrakills.com

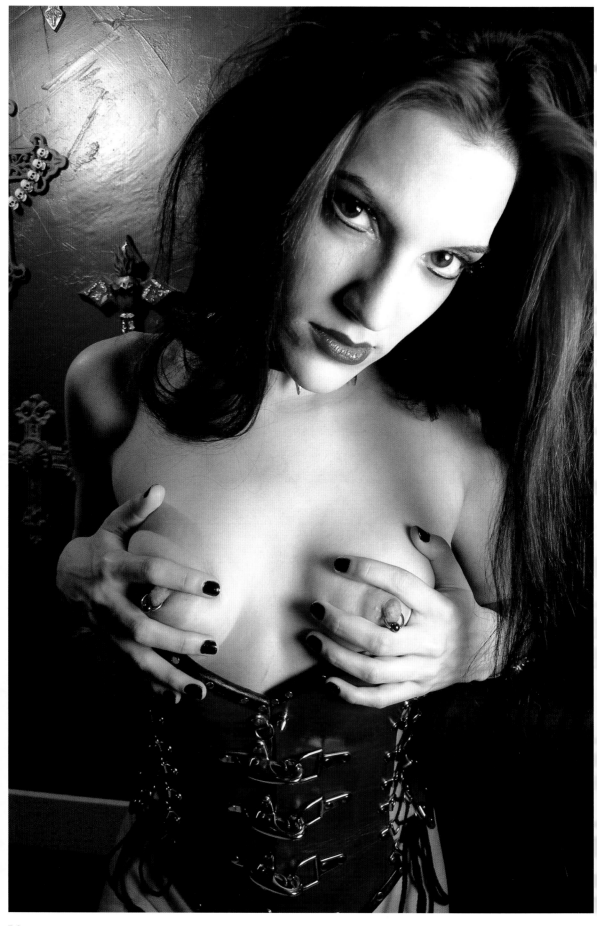

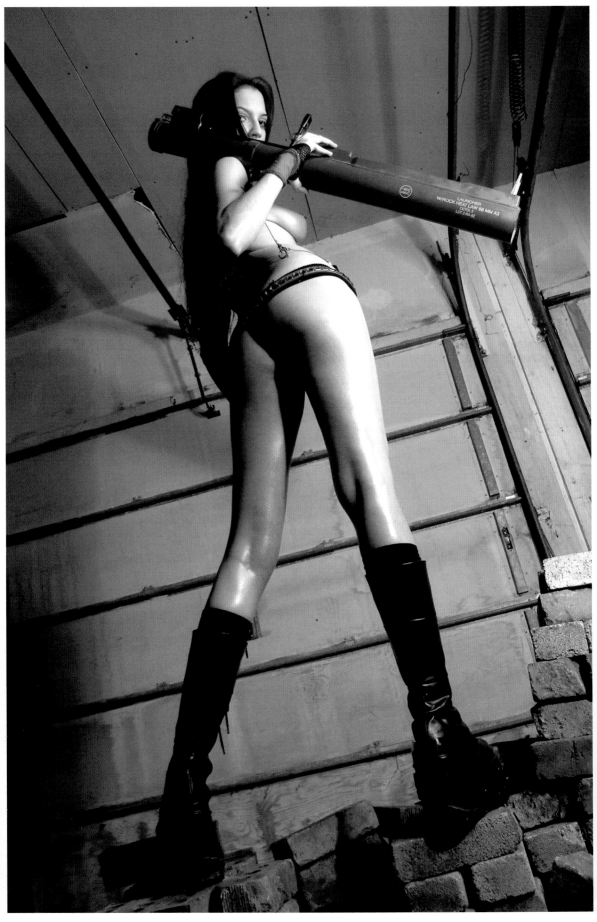

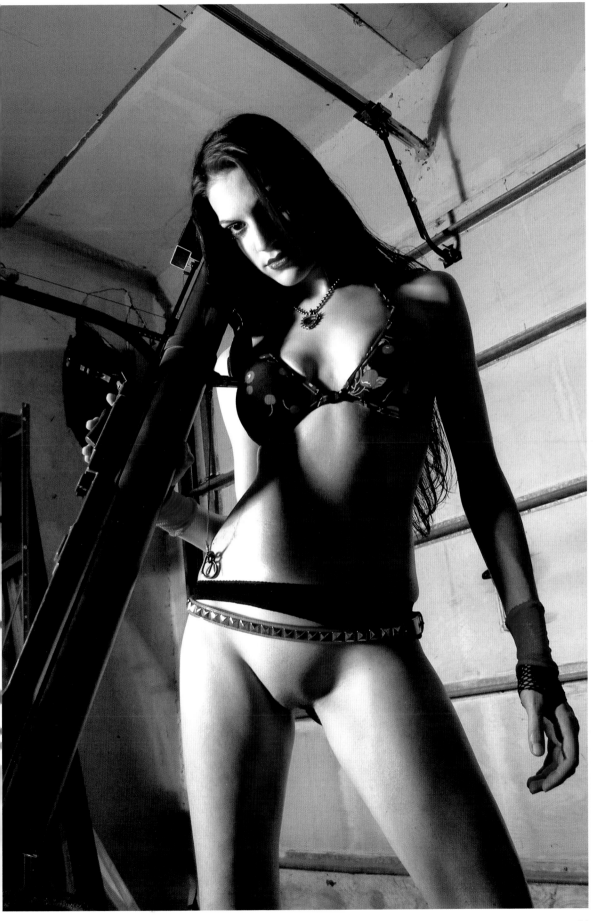

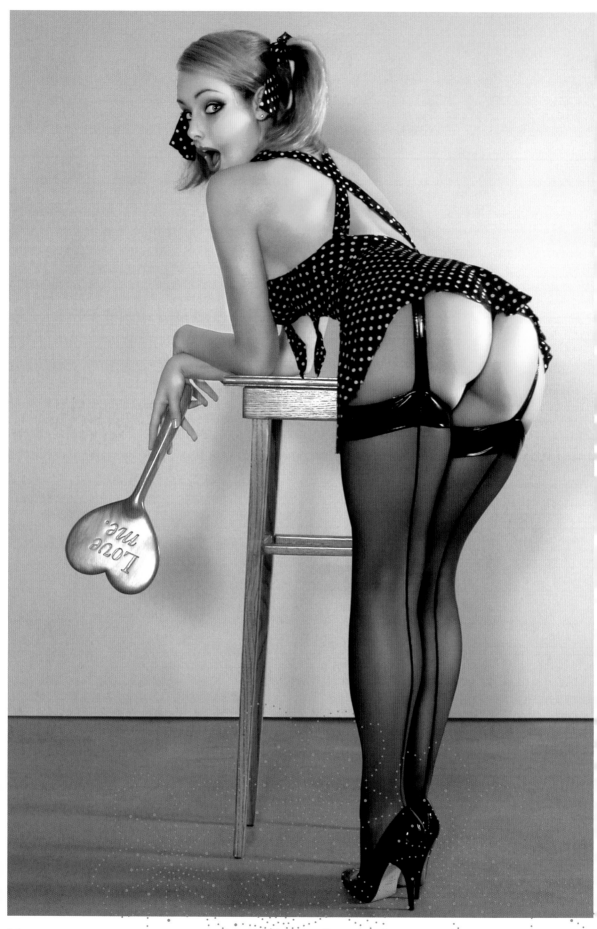

Mica

Photos by Mike James

Name: Mica

Birthday: January 23, 1987

Birthplace: Perkasie, Pennsylvania, USA

What was your childhood ambition? To be an actress

Where do you live? –

Where would you like to live? California, USA

How did you become a model? My first job are these pics with Mike James.

Where do you see yourself in ten years time? Nice country setting with lots of land and money.

VIP from movie or music biz would you like to date? Jude Law

What vice can you never forgive? Lying

Daily sins, I cannot resist: Chocolate ice cream

Favorite Band: Breaking Benjamin

Turn-ons: Poise and confidence

Turn-offs: Undeserved egotism

Is there anything you would never do again? Plenty :-)

What good advice could you give to other models? Don't give up after rejection!

Democrat, Republican, Green Party or other? Green Party

Things that make me happy: Family, warm sunny days and vacations!

Website/Myspace: None

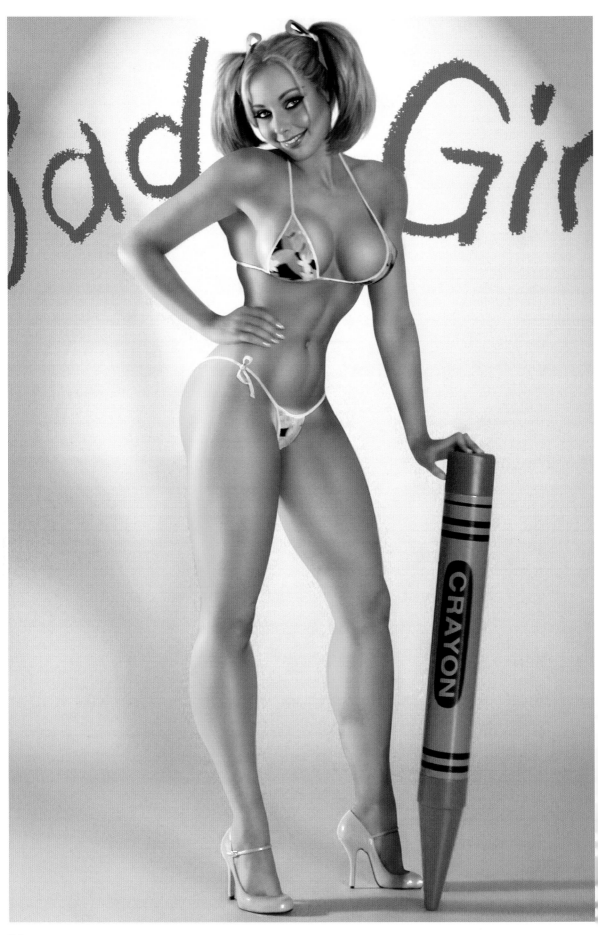

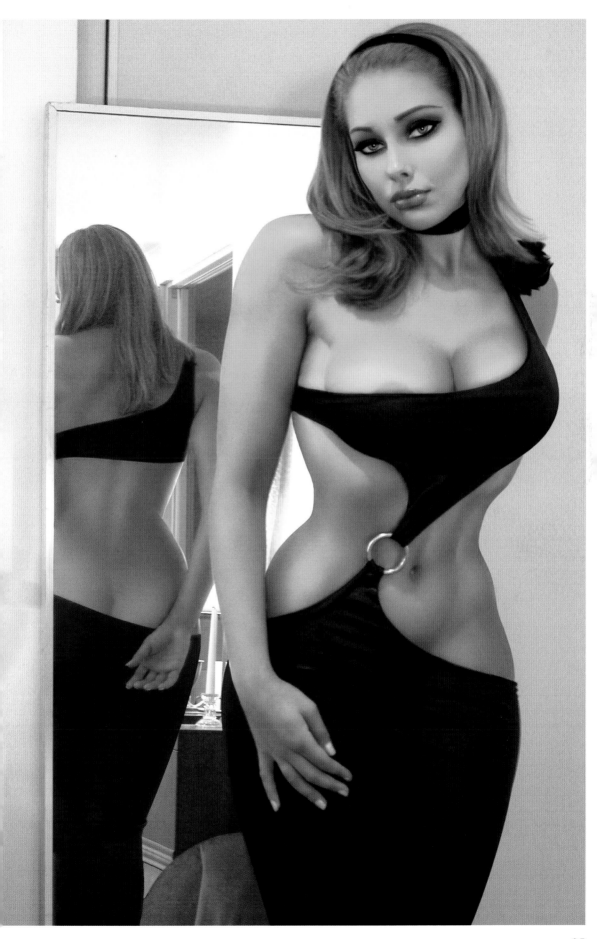

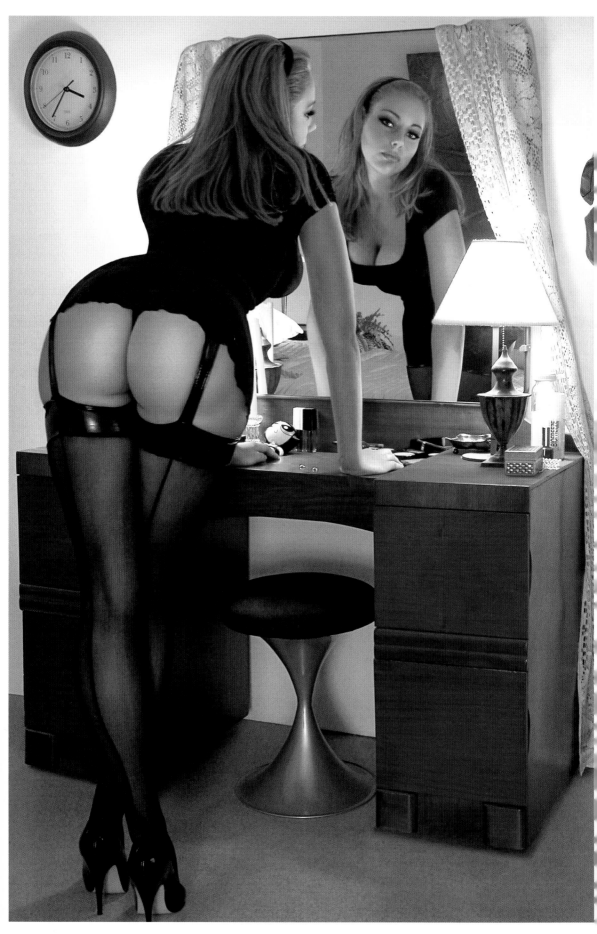

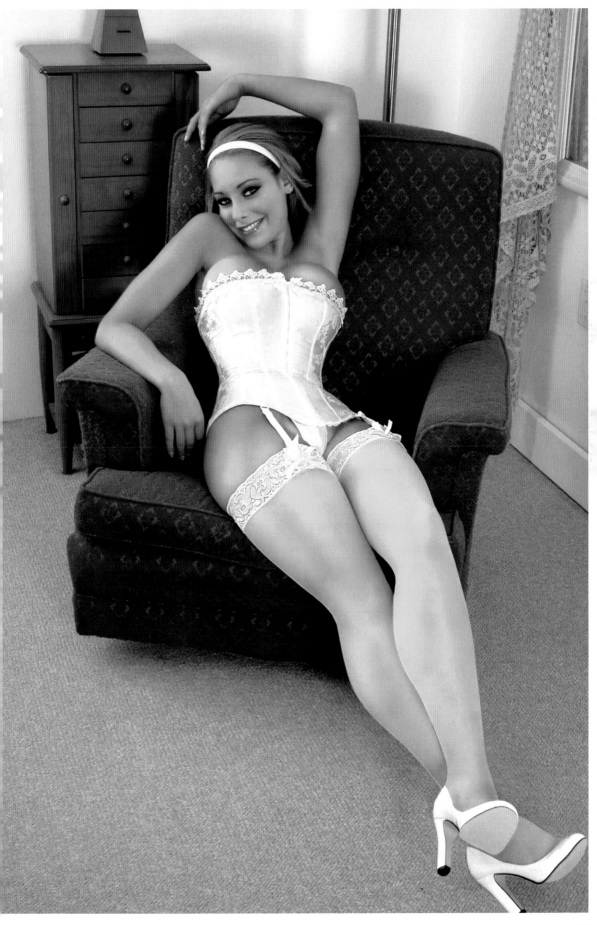

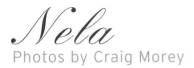

Nela
Photos by Craig Morey

Name: Nela

Birthday: January 1988

Birthplace: Ostrava, Czech Republic

What was your childhood ambition? To travel the world.

Where do you live? Prague

Where would you like to live? New York

How did you become a model? My boyfriend dared me to try.

Where do you see yourself in ten years time? Working as a chef in New York or Paris.

VIP from movie or music biz would you like to date? Johnny Depp

What vice can you never forgive? Dishonesty

Daily sins, I cannot resist: Smoking and swearing

Favorite Band: Break of Reality

Turn-ons: Long dark hair, deep voice

Turn-offs: Dirty hands, bad teeth

Is there anything you would never do again? Go to the beach at Normandy.

What good advice could you give to other models? Don't look back!

Democrat, Republican, Green Party or other? None

Things that make me happy: Good food, good kisses

Website/Myspace: None

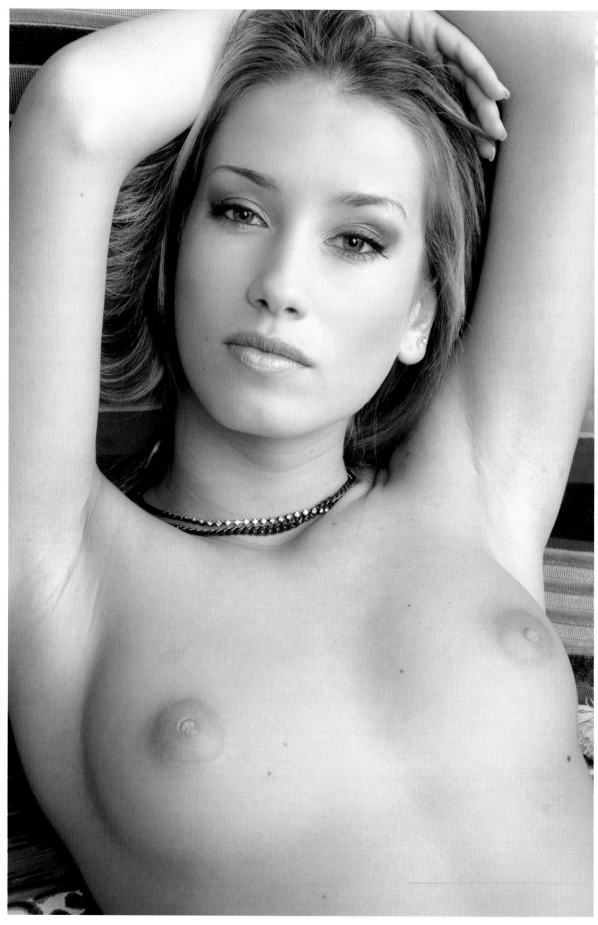

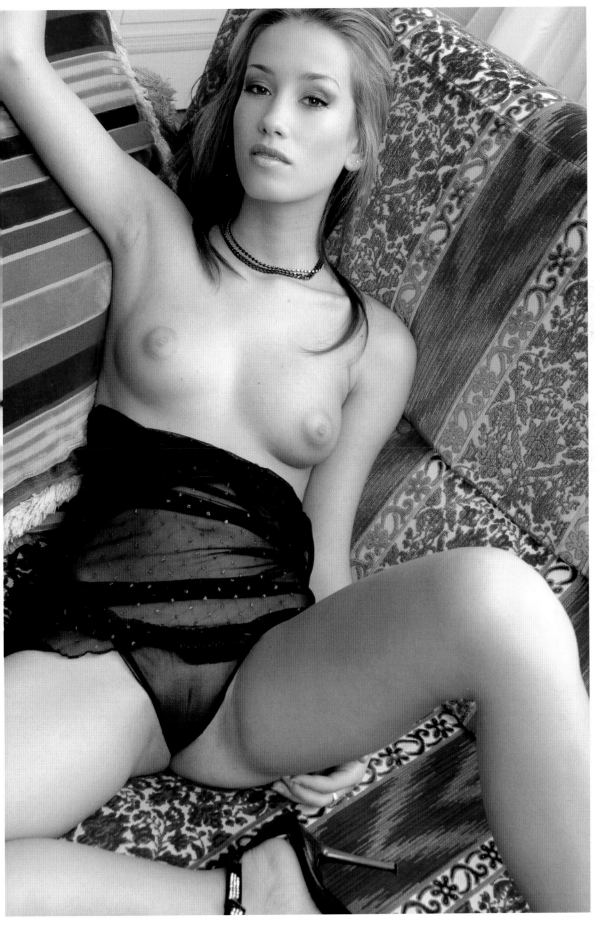

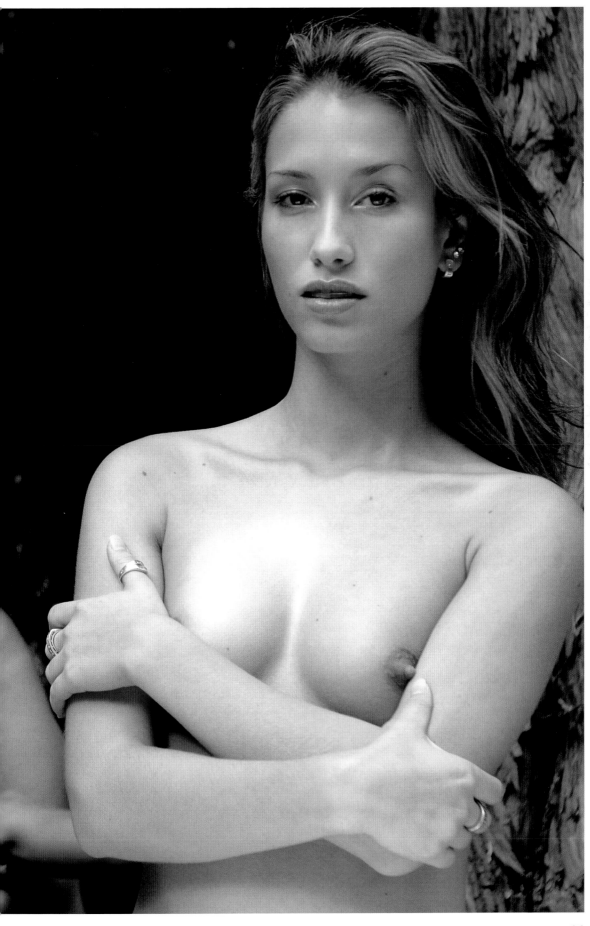

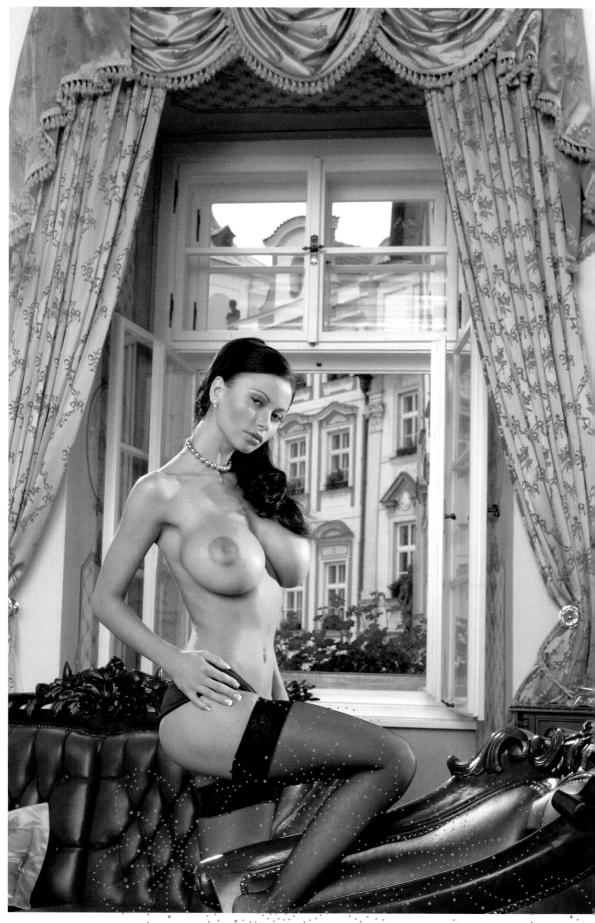

Veronika

Photos by James Green

Name: Veronika

Birthday: April 14

Birthplace: Ceske Budejovice, Czech Republic

What was your childhood ambition? To become a vet

Where do you live? Switzerland

Where would you like to live? –

How did you become a model? I started as a photographer and make-up artist. Then I became a model.

Where do you see yourself in ten years time? Not sure. I do not plan.

VIP from movie or music biz would you like to date? Nobody

What vice can you never forgive? Arrogance, faddism, intolerance, racism, insensibility

Daily sins, I cannot resist: My dogs and my husband

Favorite Band: U2

Turn-ons: Spontaneous ideas, working creatively, to visiting new beautiful places, sunset light, fresh air

Turn-offs: Boredom, too much of daily routine

Is there anything you would never do again? Ignore my instincts

What good advice could you give to other models? Believe in yourself, respect yourself; do not let others bring you down; be professional and always give the best you can; do not work just on your looks but also on your personality and education.

Democrat, Republican, Green Party or other? I am not a member of any party, but the Green Party has my sympathies.

Things that make me happy: –

Website/Myspace: –

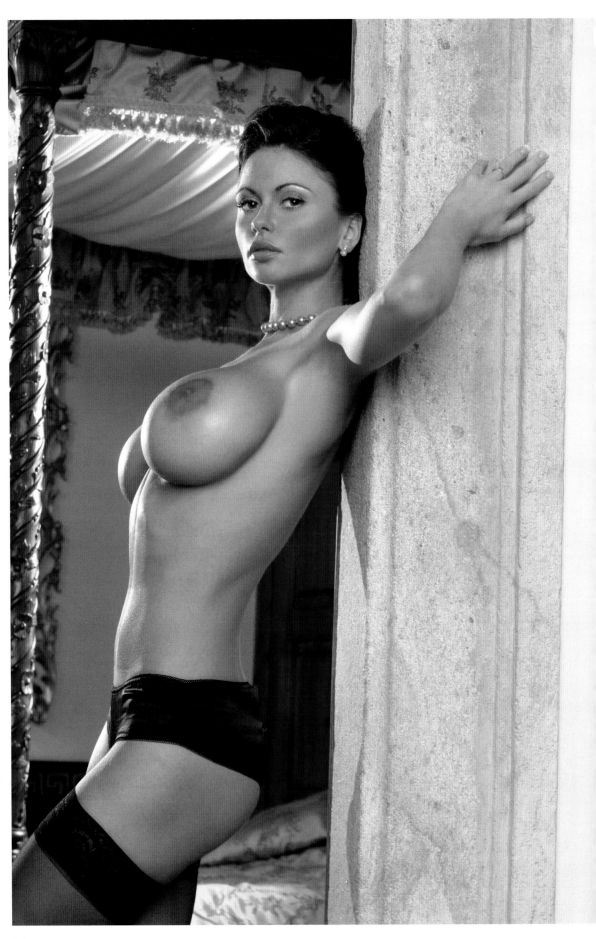

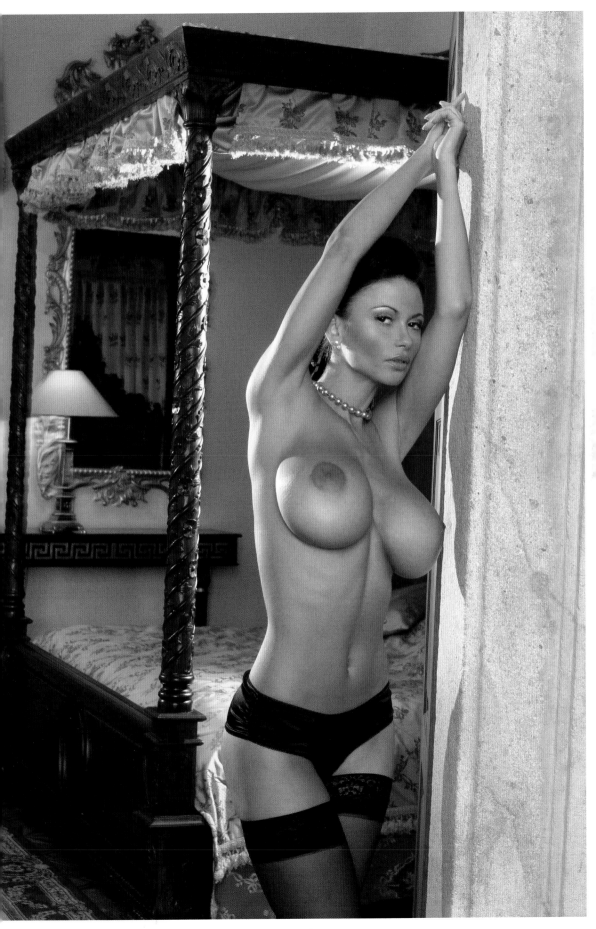

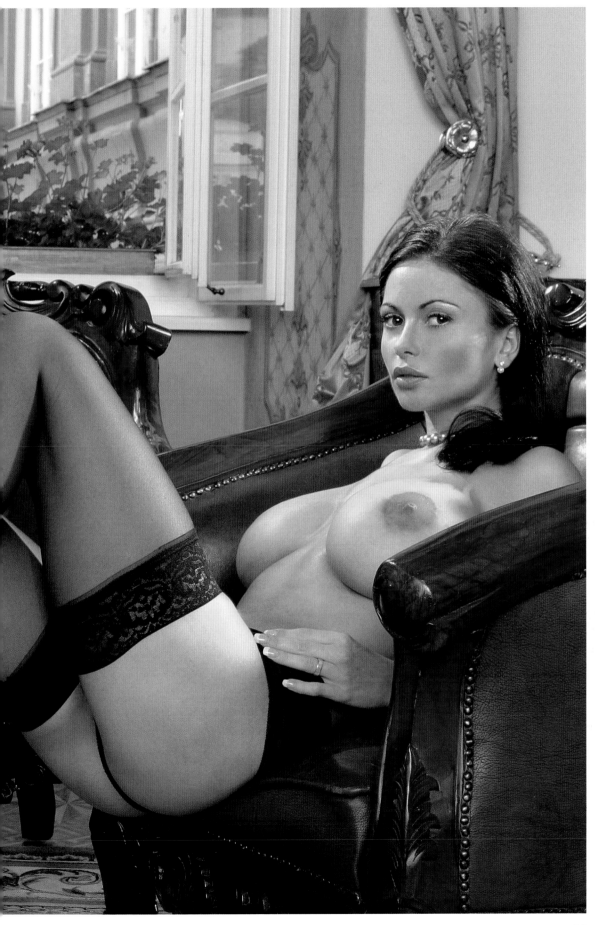

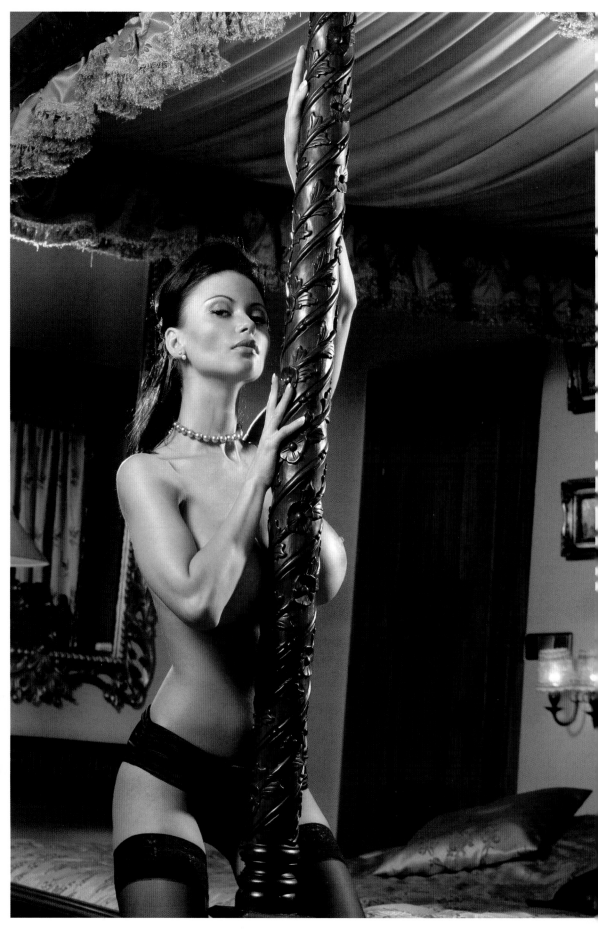

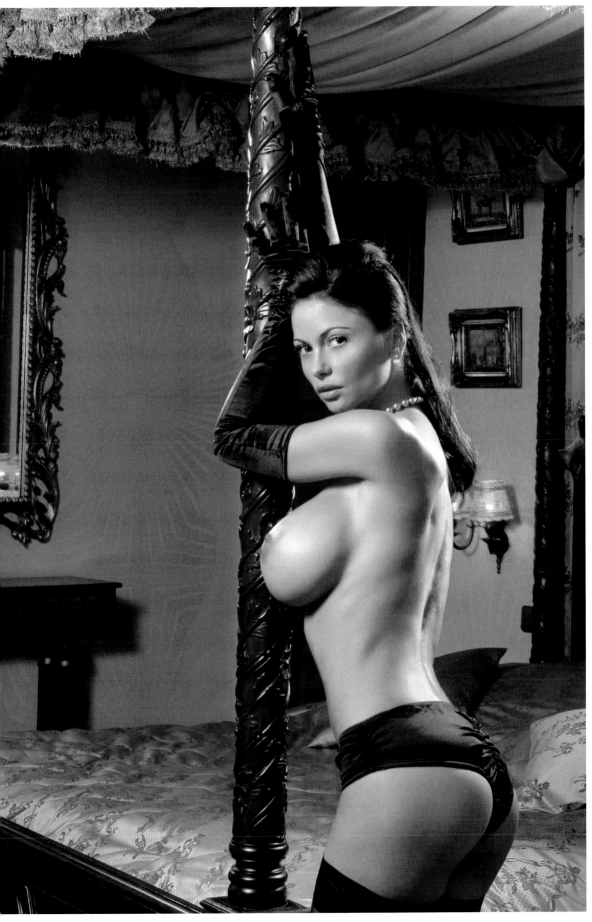

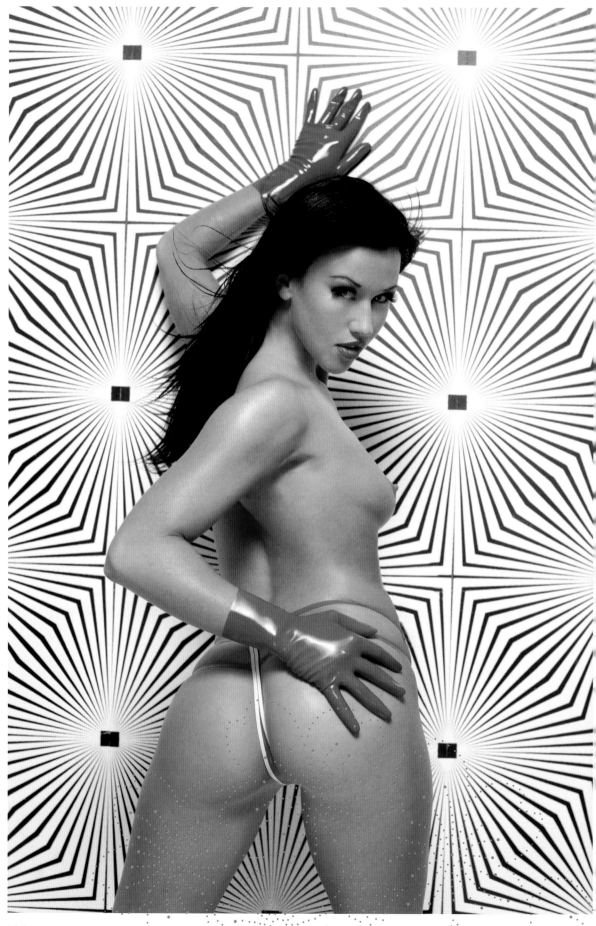

Kathy Lee

Photos by James Stafford

Name: Kathy Lee

Birthday: August 12, 1981

Birthplace: Prague, Czech Republic

What was your childhood ambition? To become a fashion model or a singer

Where do you live? In the Czech Republic

Where would you like to live? In Paradise

How did you become a model? I just had a lucky day.

Where do you see yourself in ten years time? Any place where I can feel happy and satisfied.

VIP from movie or music biz would you like to date? –

What vice can you never forgive? Lying

Daily sins, I cannot resist: Ice cream

Favorite Band: –

Turn-ons: –

Turn-offs: –

Is there anything you would never do again? Of course, but...

What good advice could you give to other models? Be strong and smart!

Democrat, Republican, Green Party or other? Independent

Things that make me happy: My family, work, hobby...

Website/Myspace: –

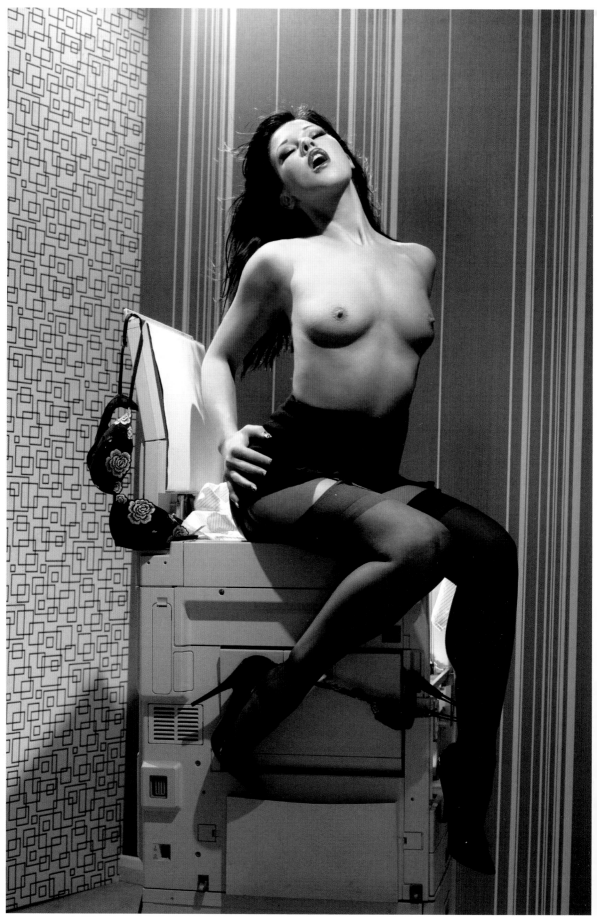

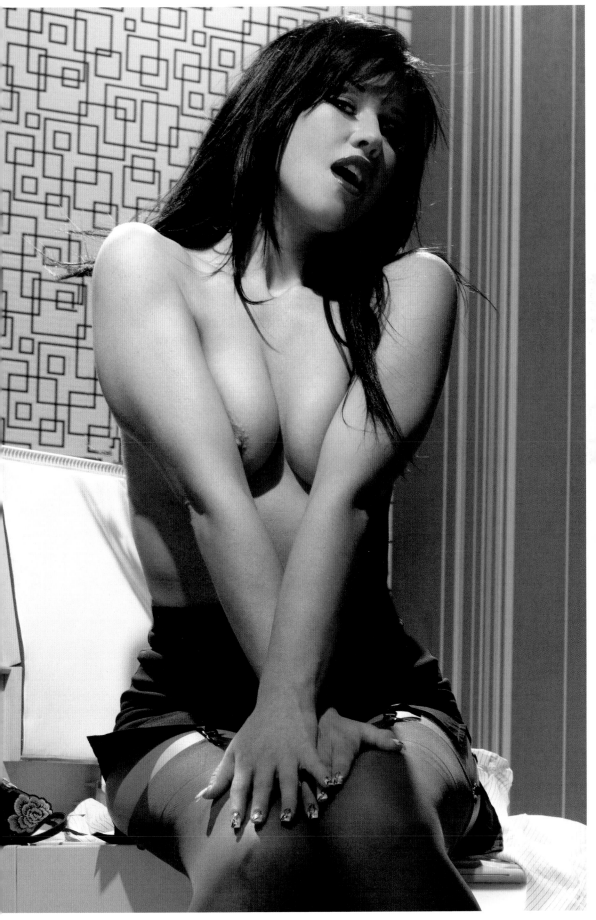

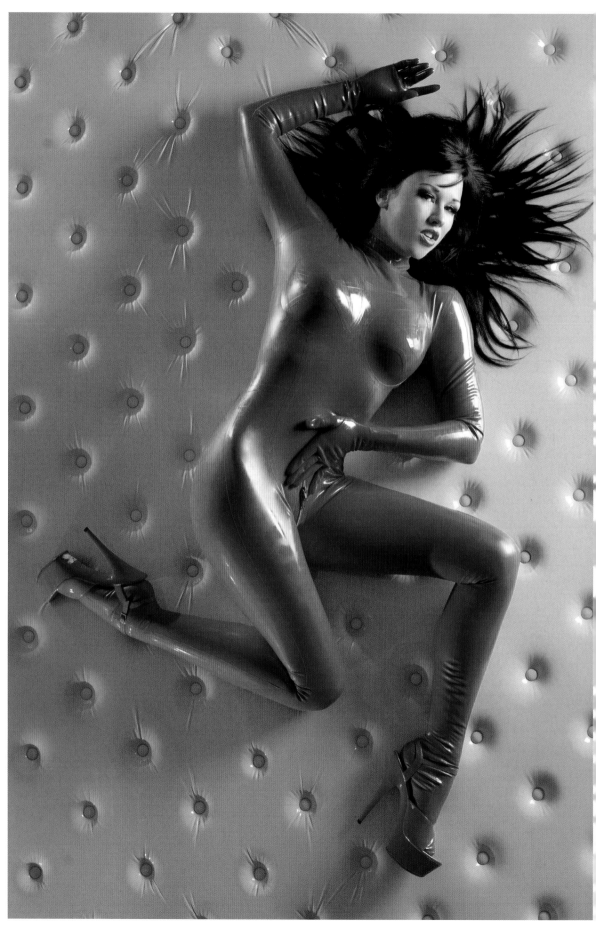

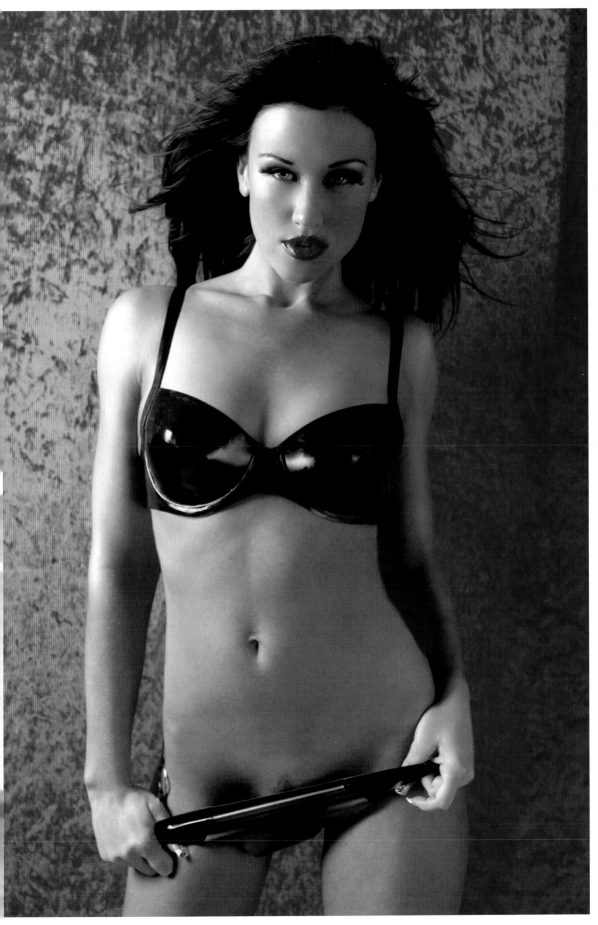

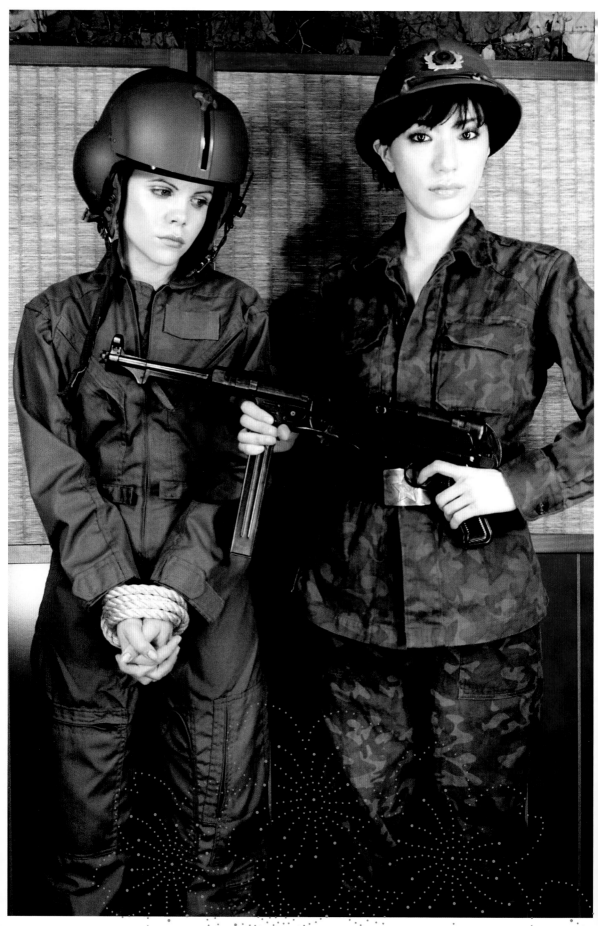

Muse and Mie

Photos by Fred Berger

Name: Muse | Mie

Birthday: March 29, 1981 | October 11

Birthplace: Earth | Yokohama, Japan

What was your childhood ambition? Music | To become an entrepreneur

Where do you live? Planes and trains | Manhattan, NY

Where would you like to live? A new world | Paris, France

How did you become a model? By being photographed many times. | I was scouted in NYC and Japan.

Where do you see yourself in ten years time? Touring the world | I will be a CEO of a fashion & art related company (really!) called cocoanewyork.com.

VIP from movie or music biz would you like to date? I married them. | Brandon Routh (2006 superman Returns) & Eminem

What vice can you never forgive? Vices are only a matter of perception. | Misogyny, aggression, ingratitude

Daily sins, I cannot resist: Tea, running, making love, creating | Japanese sweets, chat with friends online

Favorite Band: Heavyweight Dub Champion | Gevil - a friend of mine, a cool Japanese band

Turn-ons: No ego, no judgement, open hearts | Long bong hair, intelligence, morals, cigarette, flowers

Turn-offs: Closed minds, closed hearts | Infidelty, insincerely, dishonesty

Is there anything you would never do again? Yes, many of them, but I learned by doing them first. | Unhealthy diet, party all night

What good advice could you give to other models? Photographs are for eternity. | Study hard as much as you can. :-)

Democrat, Republican, Green Party or other? The government is controlled by money, sadly not votes. | I am liberal democratic & romanticize socialism.

Things that make me happy: Music, art, yoga, meditation, sunrises | Travel to Europe, opera, museum

Website/Myspace: Go to myspace, search electronica artist in San Francisco, and you will find me. | www.myspace.com/miemyspace, www.cocoanewyork.com

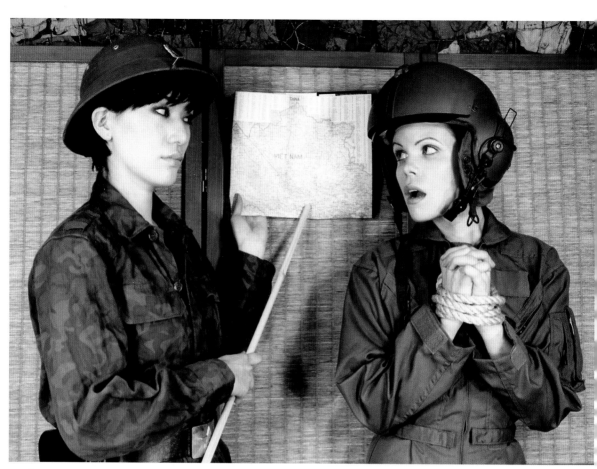

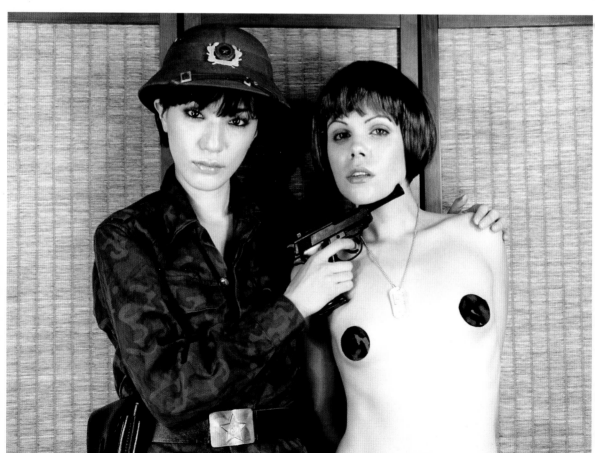

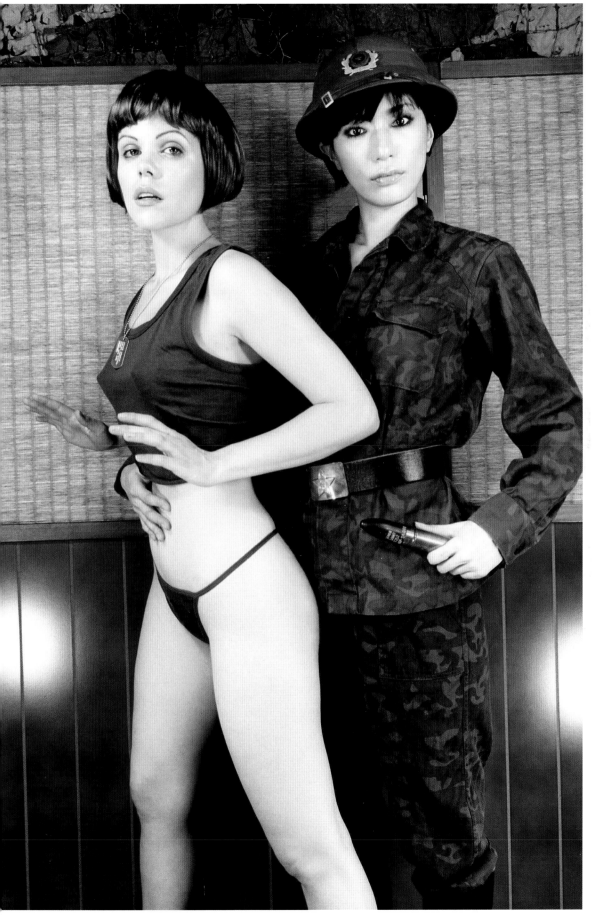

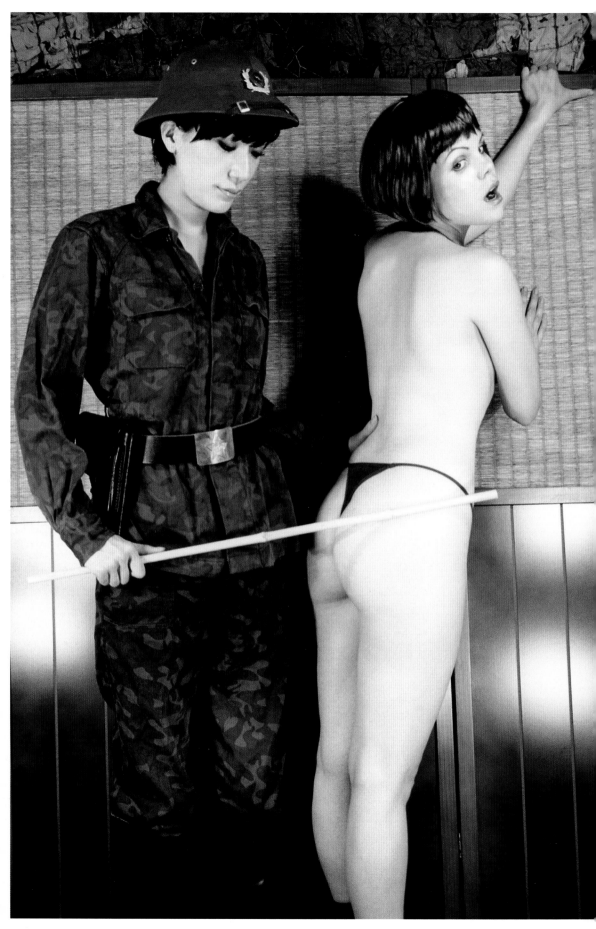

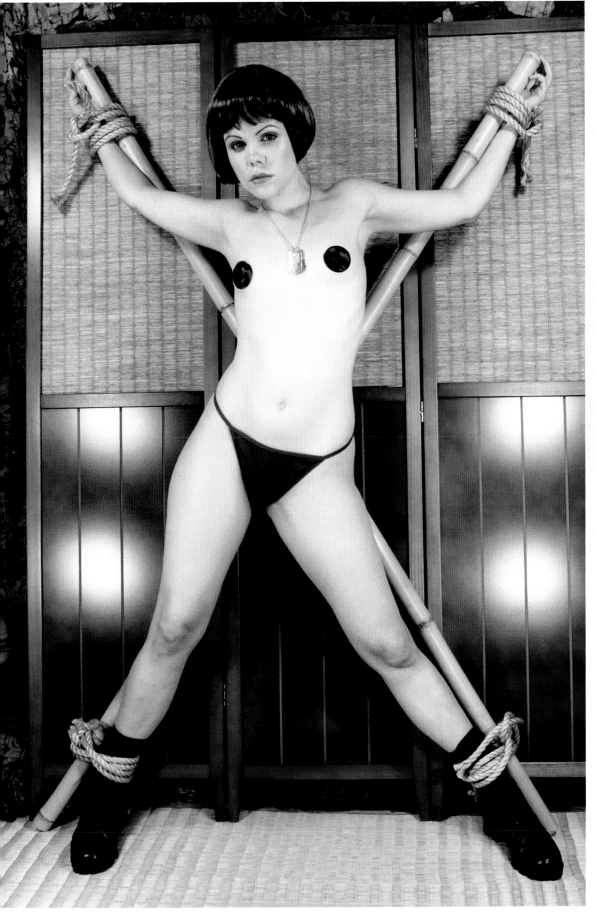

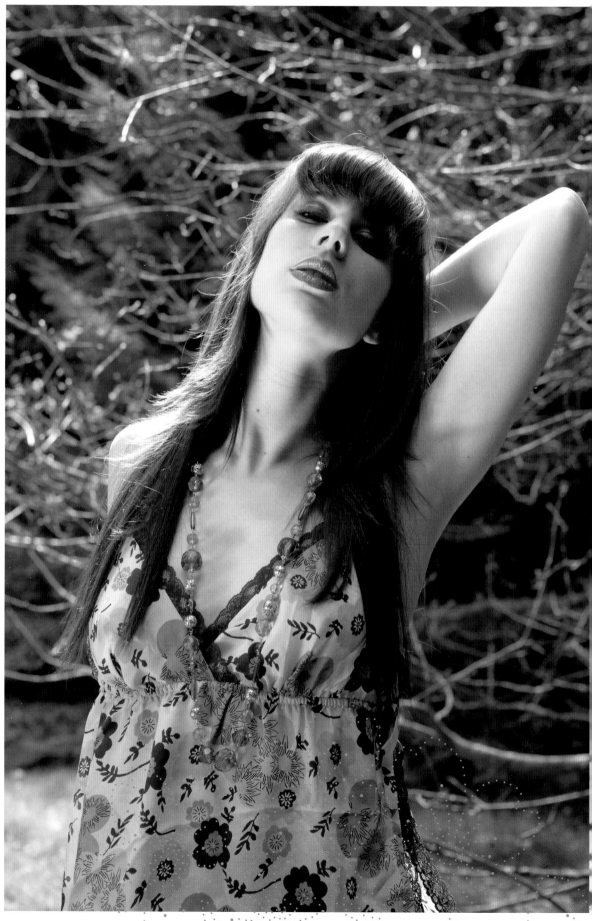

October Noire

Photos by Emma Delves-Broughton

Name: October Noire

Birthday: January 14

Birthplace: Portsmouth, England

What was your childhood ambition? I always wanted to work in psychology. I actually finished a psychology degree a few years ago, so maybe one day I will.

Where do you live? London, England

Where would you like to live? I love to travel and really enjoy exploring new places... but I love London and can't see myself living anywhere else.

How did you become a model? I've been modeling for years. I started by helping out a photographer friend of mine. We got some fantastic images and really enjoyed it, so I decided to continue.

Where do you see yourself in ten years time? Hopefully happy and healthy, and surrounded by wonderful, interesting people.

VIP from movie or music biz would you like to date? Mark Lanegan

What vice can you never forgive? There's not one thing I could never forgive. People always have their reasons for doing things. I try not to judge.

Daily sins, I cannot resist: Sweet things. I have such a weakness for dessert.

Favorite Band: Pearl Jam

Turn-ons: Unspoken chemistry, filthy eye contact, rough kisses, power and confidence

Turn-offs: Arrogance

Is there anything you would never do again? I don't think I have any major regrets.

What good advice could you give to other models? It can be a tough industry. Believe in yourself, but have something to fall back on. Modeling's not something you can do forever.

Democrat, Republican, Green Party or other? n/a

Things that make me happy: Good food, good drink, and good company

Website/Myspace: www.octobernoire.co.uk, www.myspace.com/octobernoire

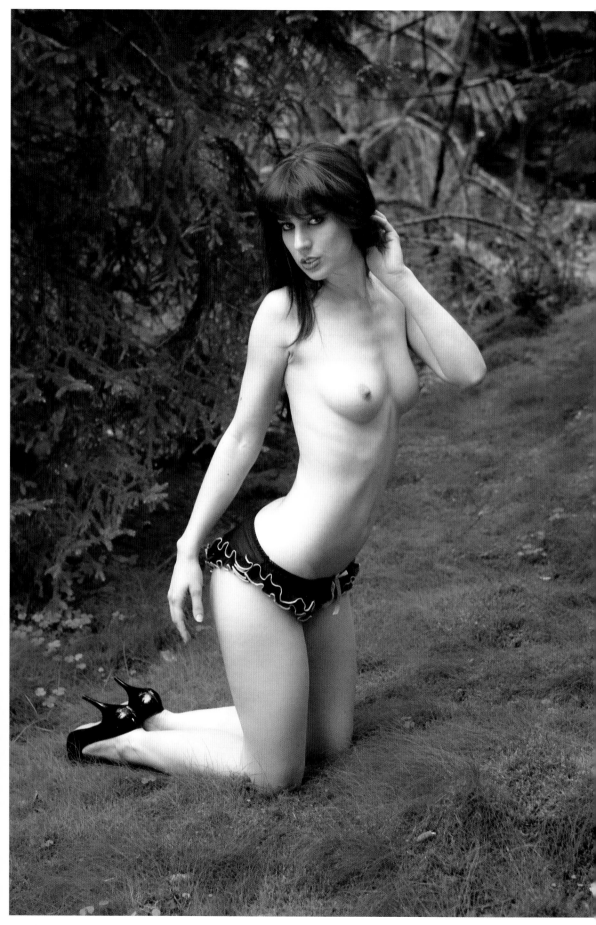

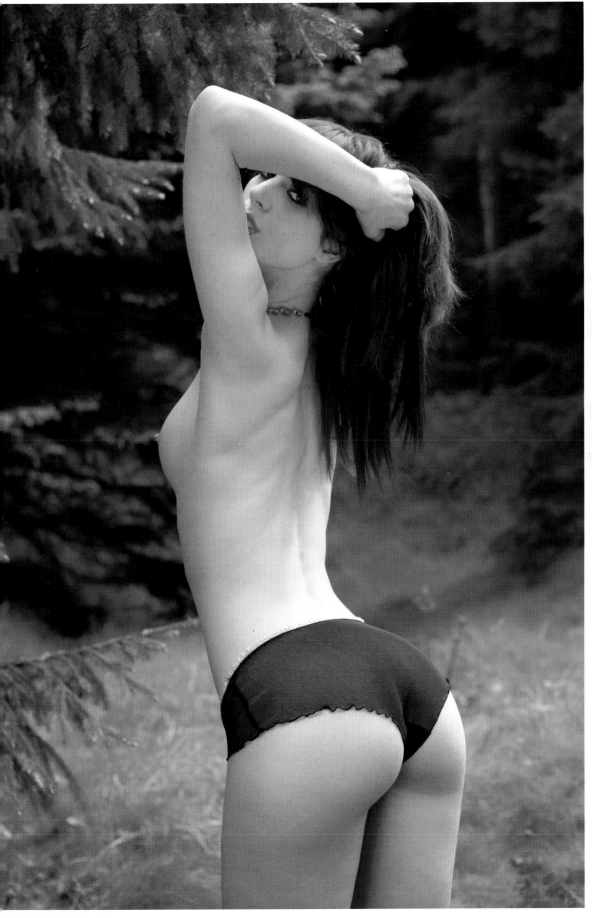

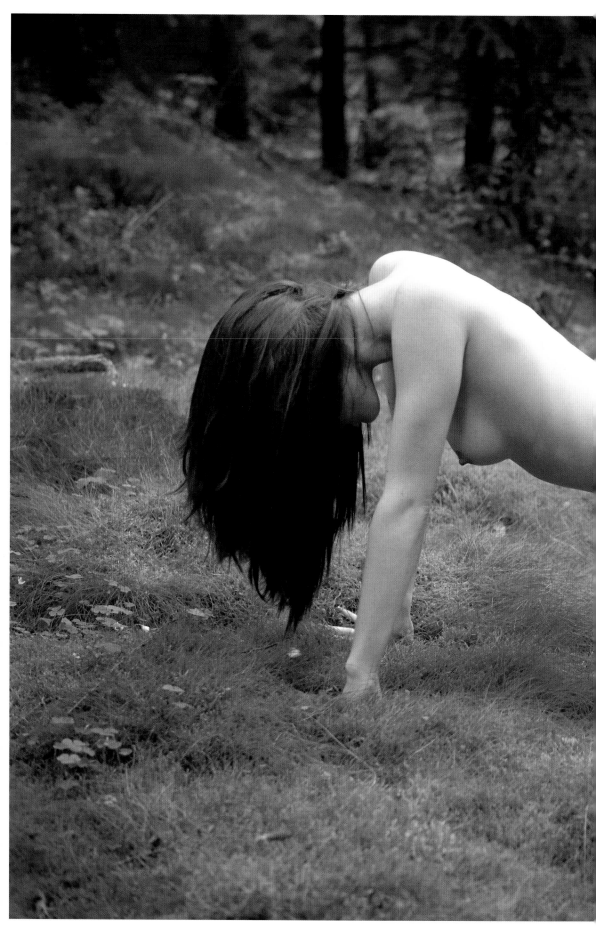

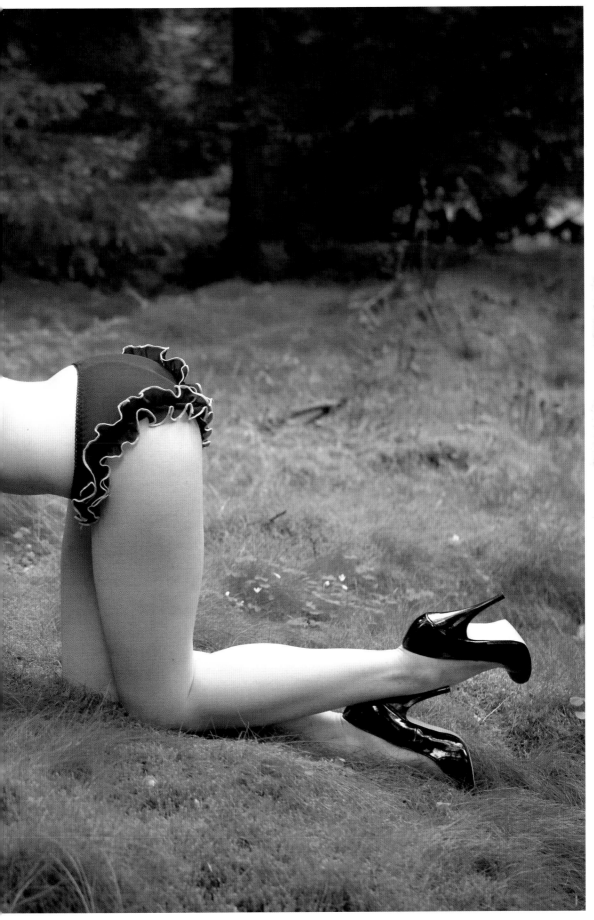

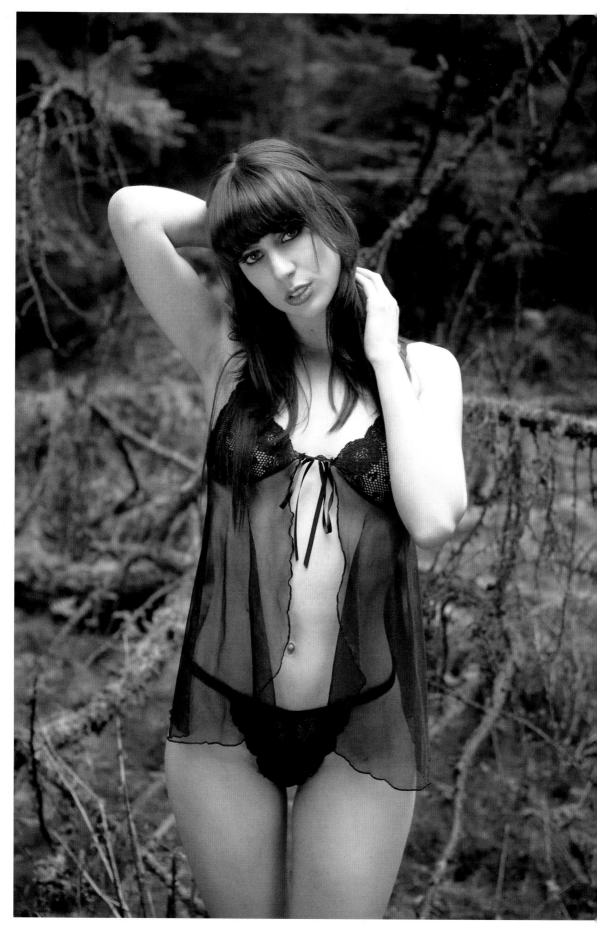

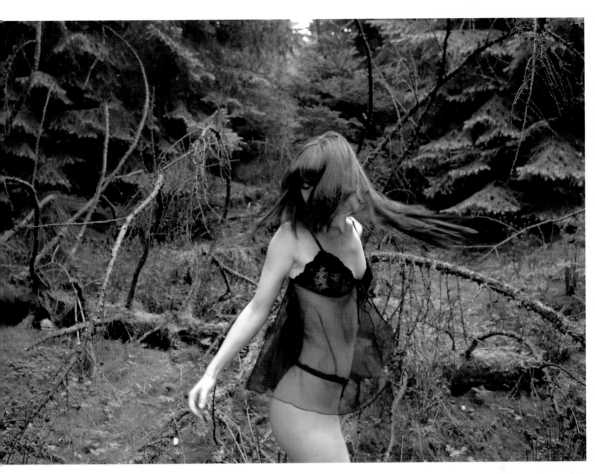

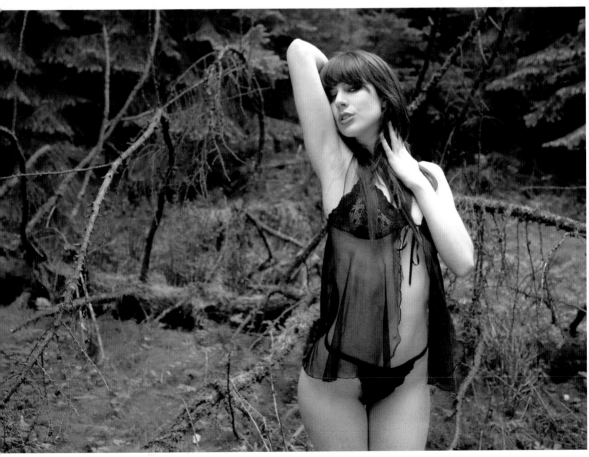

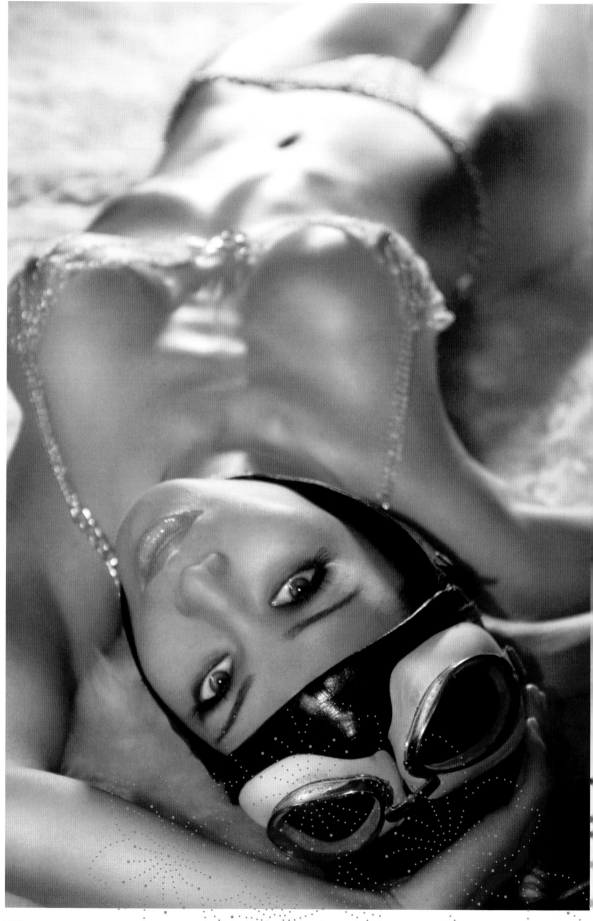

Eiko Nijo

Photos by Derek Caballero

Name: Eiko Nijo

Birthday: Aquarius

Birthplace: Kyoto, Japan

What was your childhood ambition? I wanted to be an artist. Each day I would paint and draw.

Where do you live? Los Angeles, California, USA

Where would you like to live? I want to live in a quiet house by beautiful trees with an ocean and garden view.

How did you become a model? When I was in High School, a friend of mine became a model. She said I should be a model, too. I wasn't sure but I tried. I contacted a modeling agency in Sapporo where I lived at the time, and they liked me. The first job I got was for school uniforms.

Where do you see yourself in ten years time? I try not to predict my future, but I believe I will be happy and content with my life.

VIP from movie or music biz would you like to date? Ridley Scott is an intelligent director and extremely creative artist.

What vice can you never forgive? Snoring

Daily sins, I cannot resist: Coffee

Favorite Band: Audioslave

Turn-ons: Candle lights while being kissed on my neck by my lover.

Turn-offs: Guys with big ego

Is there anything you would never do again? Mixing tequila with Martinis

What good advice could you give to other models? Have faith in yourself!

Democrat, Republican, Green Party or other? –

Things that make me happy: Sleep, good food and exercise

Website/Myspace: –

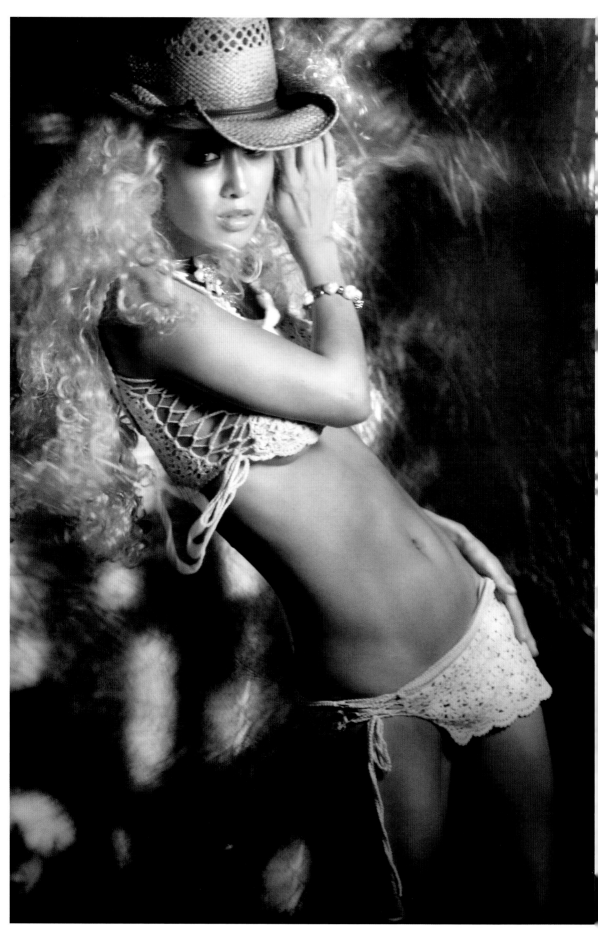

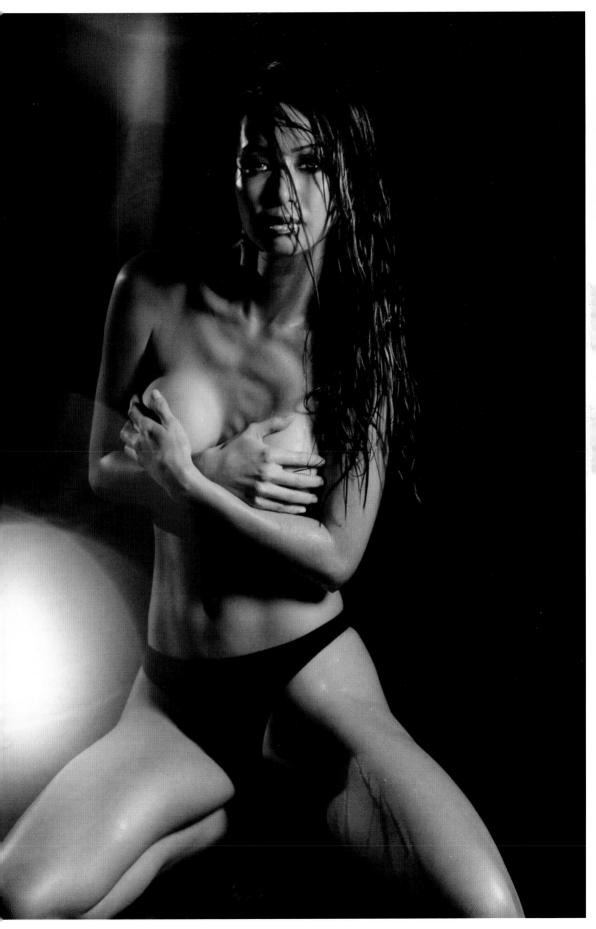

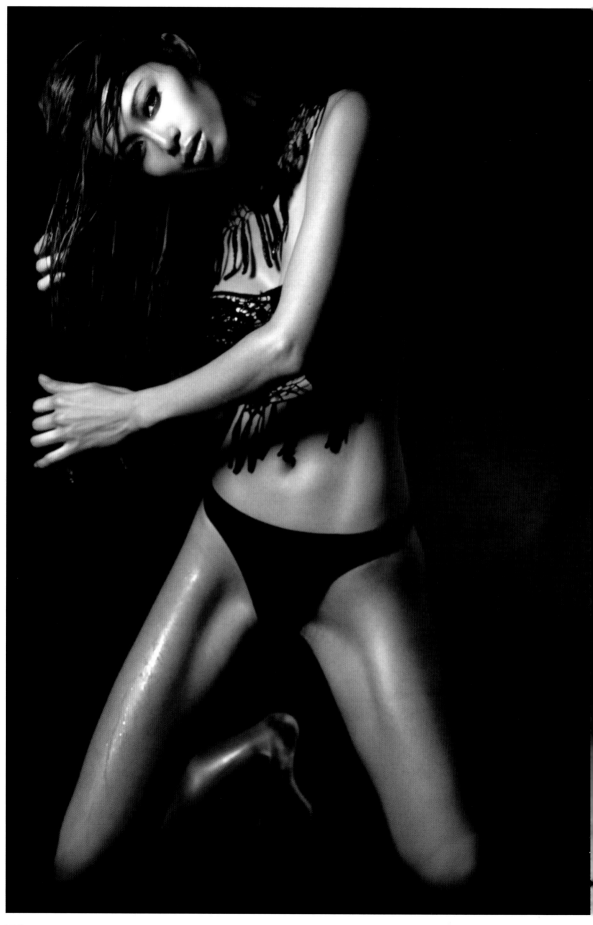

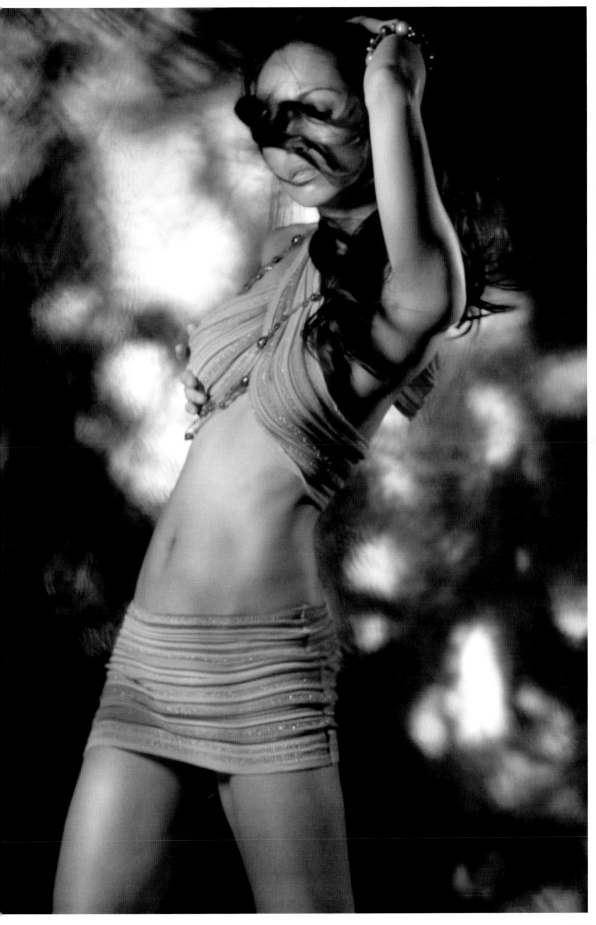

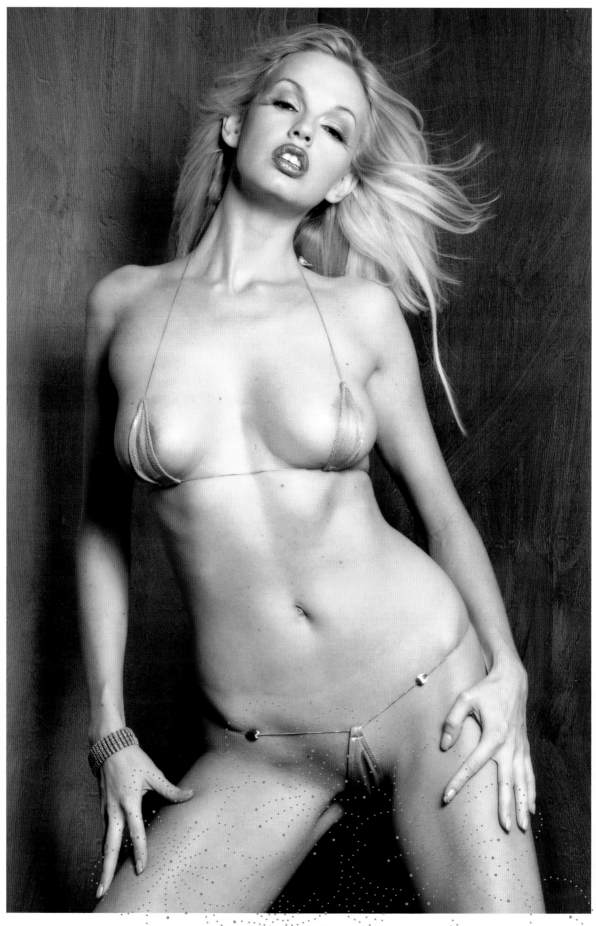

Lorraine Sisco

Photos by Christine Kessler

Name: Lorraine Sisco

Birthday: June 14, 1978

Birthplace: Kettering, UK

What was your childhood ambition? To become an olympic equestrian, like some in my family.

Where do you live? Los Angeles

Where would you like to live? Los Angeles, but with more travel opportunities

How did you become a model? The internet... it was 1998. I took my chance.

Where do you see yourself in ten years time? I really don't know. Hopefully healthy and happy

VIP from movie or music biz would you like to date? Oh, please

What vice can you never forgive? Deceit, hate, violence, lies, animal cruelty

Daily sins, I cannot resist: Sweets and cigarettes

Favorite Band: None in particular

Turn-ons: Eyes

Turn-offs: A whole lot of things

Is there anything you would never do again? Yes. Once I took part in a survivor thing on a uninhabited island in Malaysia. For a month. I wouldn't do that again.

What good advice could you give to other models? Keep in shape

Democrat, Republican, Green Party or other? Democrat / Liberal

Things that make me happy: My work as a director / producent for Michael Ninn / Ninnworx

Website/Myspace: www.tallgoddess.com

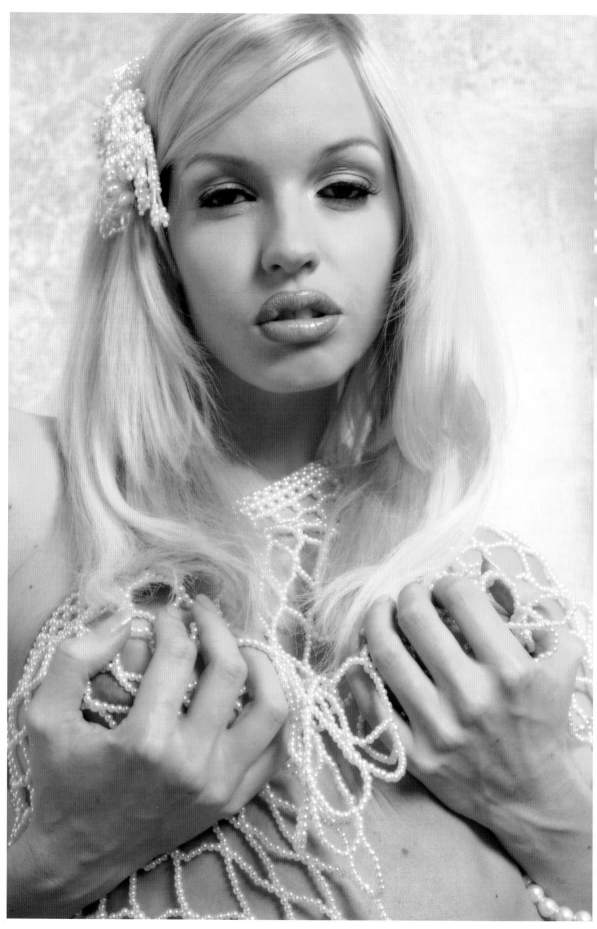

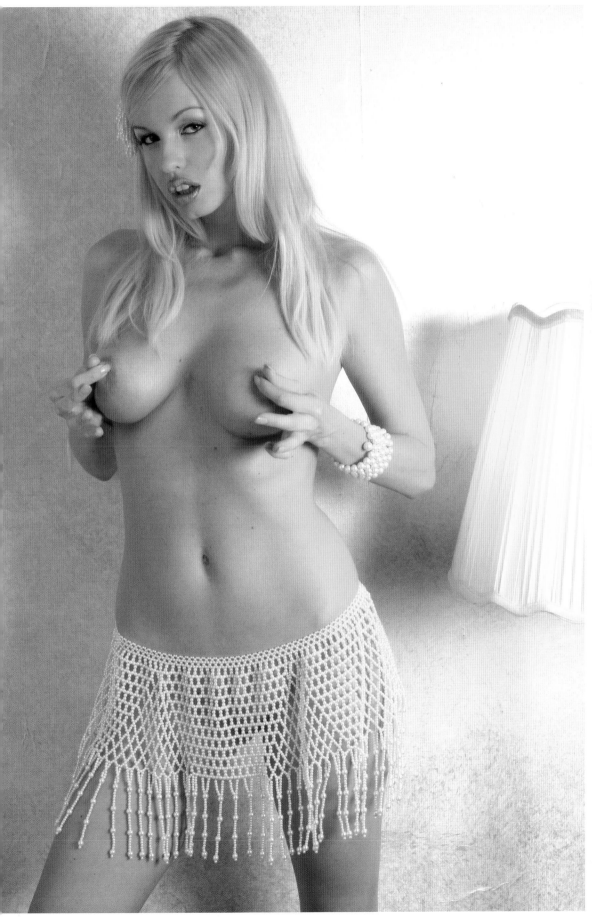

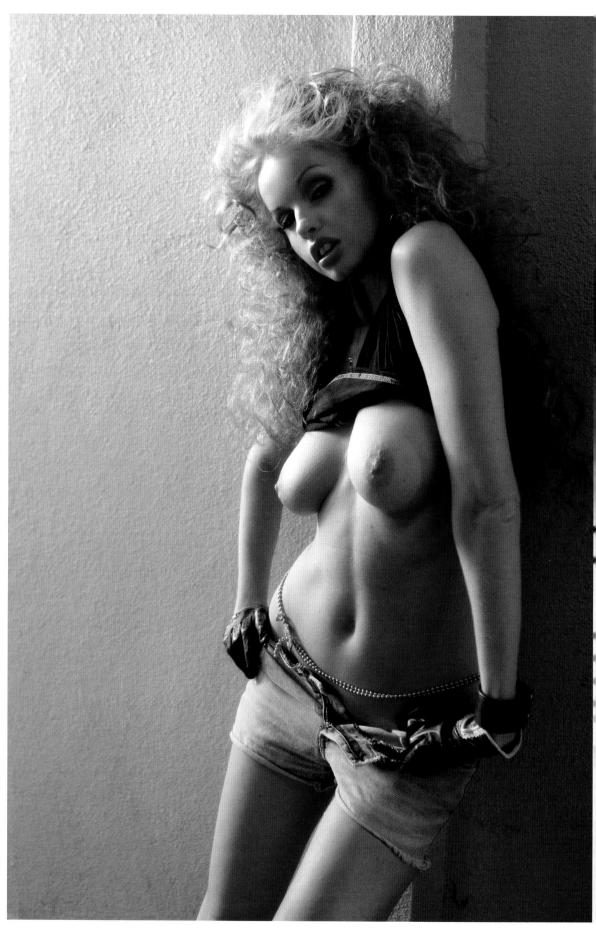

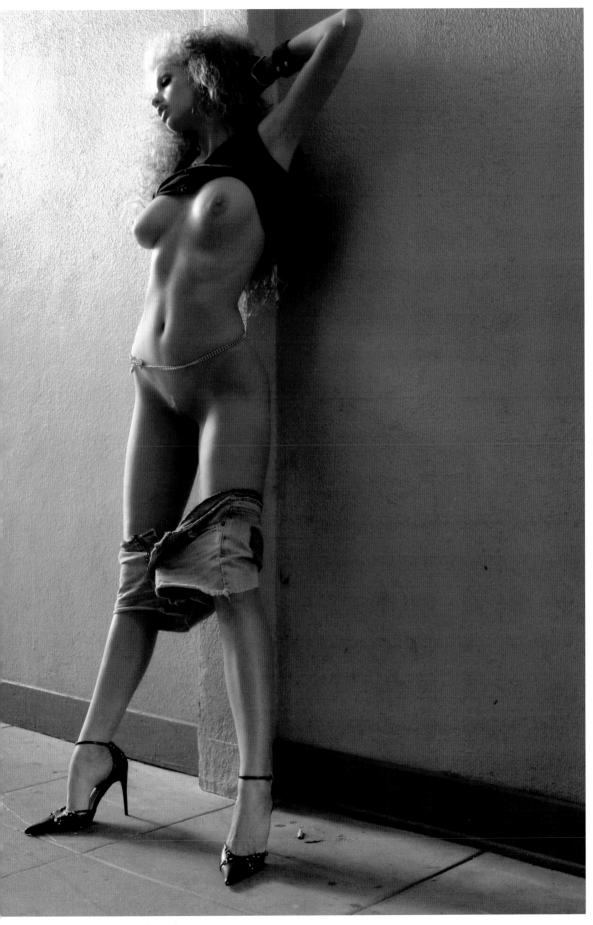

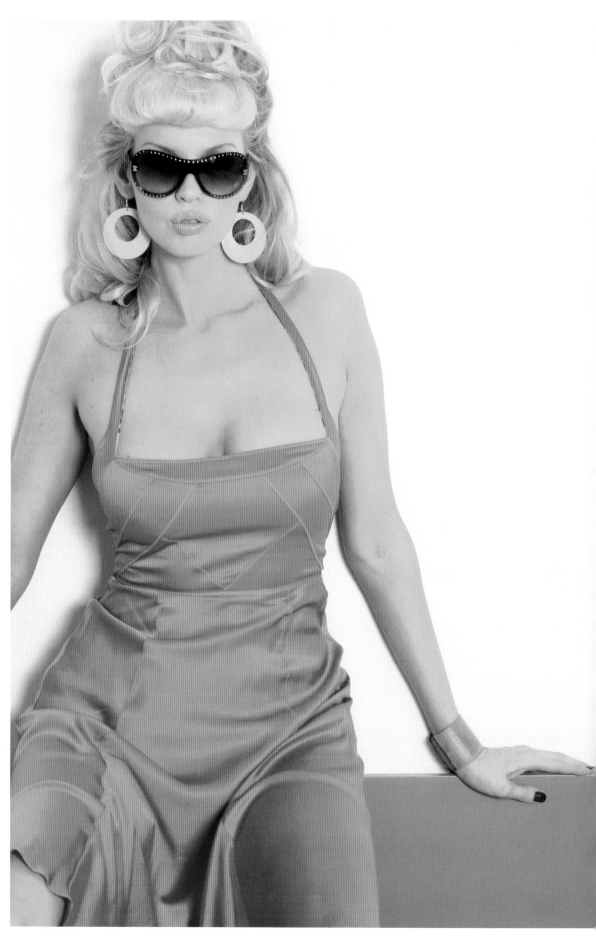

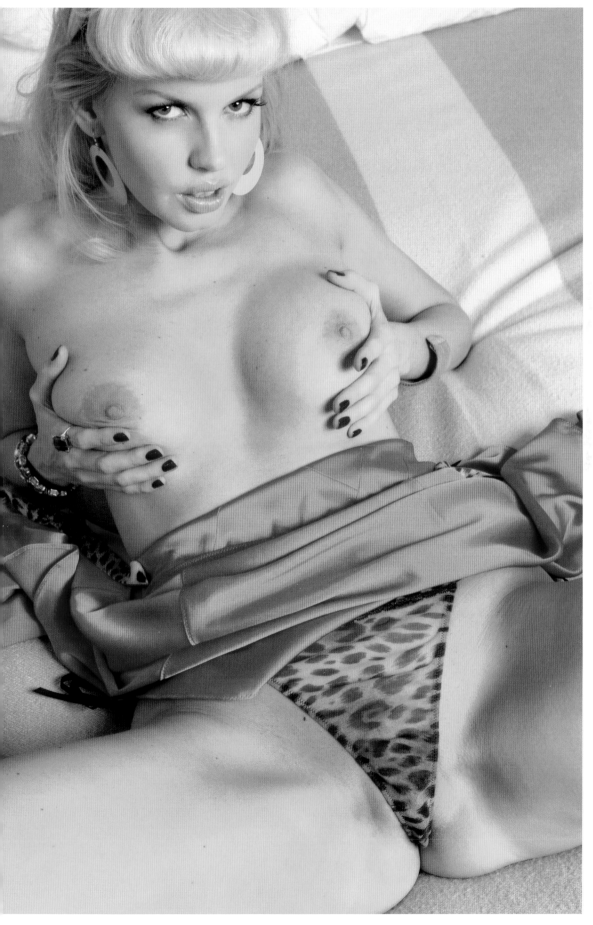

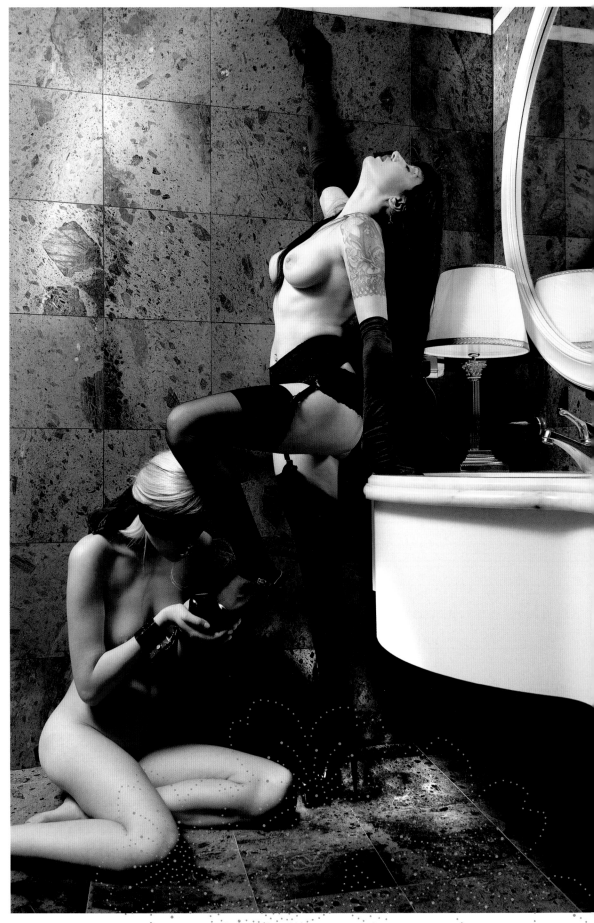

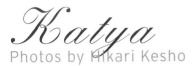

Katya

Photos by Hikari Kesho

Name: Katya

Birthday: March 9, 1982

Birthplace: Leningrad (Sankt Peterburg), Russia

What was your childhood ambition? To become a model and work for famous designers

Where do you live? I live in Florense, Italy

Where would you like to live? I love Italy, but my desire is to go to New York.

How did you become a model? A talent scout stopped me on the street and asked me,if I would like to work as a model.

Where do you see yourself in ten years time? Maybe in New York ... who knows...?

VIP from movie or music biz would you like to date? Madonna

What vice can you never forgive? Hypocricy

Daily sins, I cannot resist: I can´t live without mobile, and I love fast food.

Favorite Band: Red Hot Chili Peppers

Turn-ons: –

Turn-offs: –

Is there anything you would never do again? No

What good advice could you give to other models? Don't stay in diet! Eat heartily!!

Democrat, Republican, Green Party or other? Democrat

Things that make me happy: Life

Website/Myspace: www.katyakruglova.com / www.myspace/katyakruglova

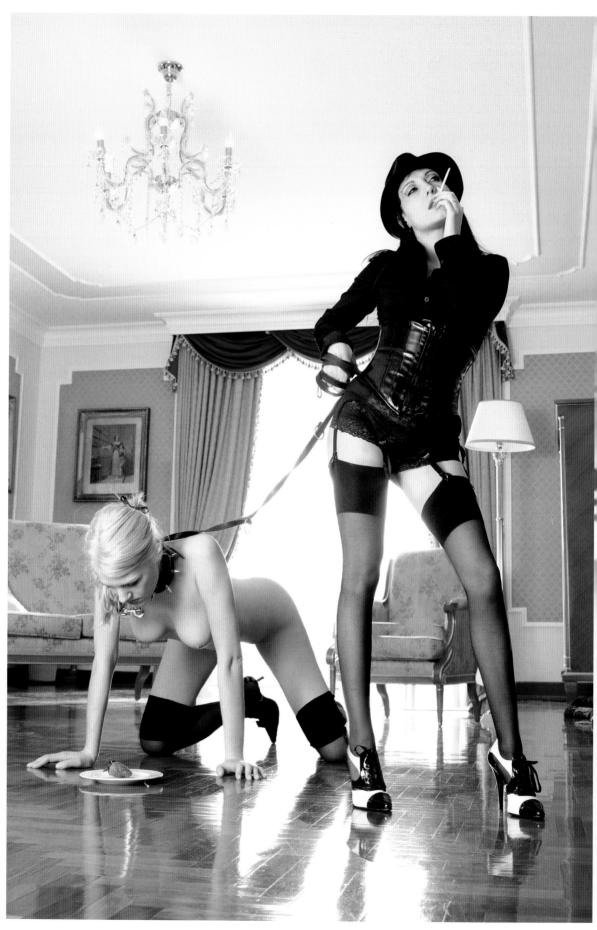

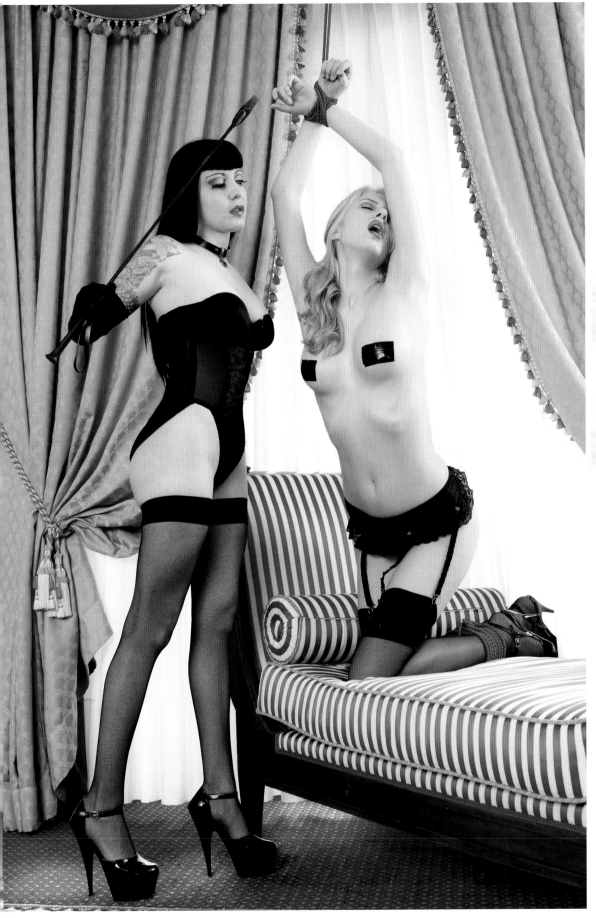

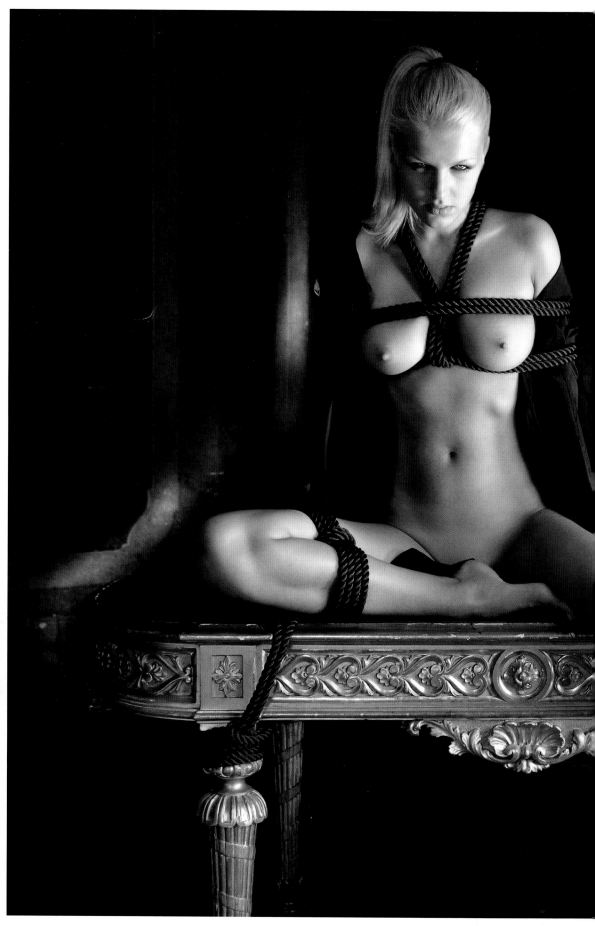

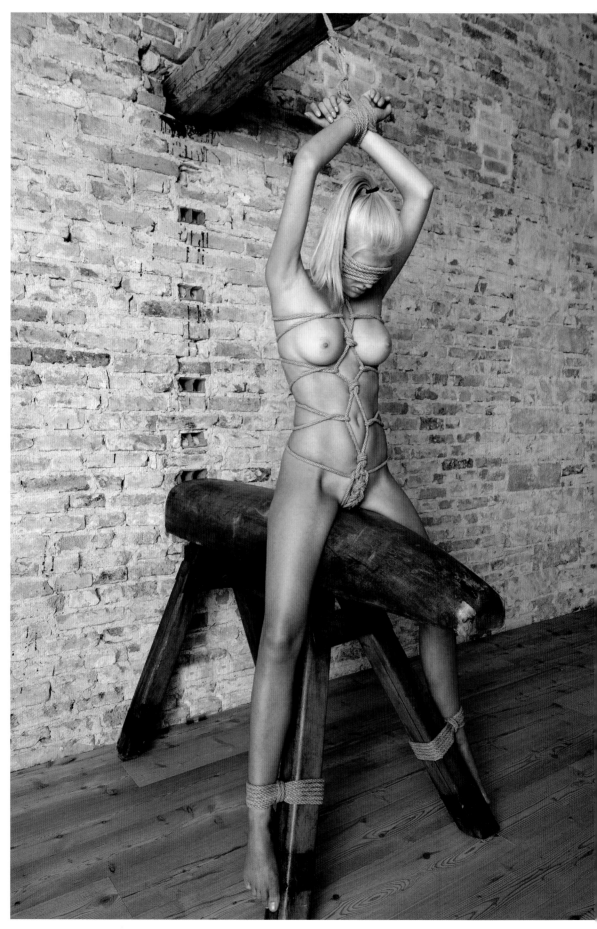

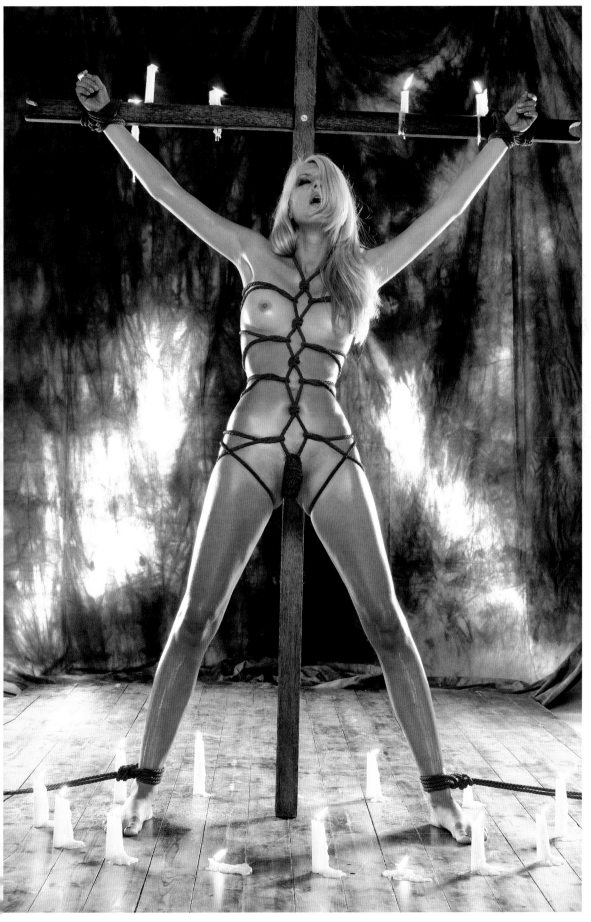

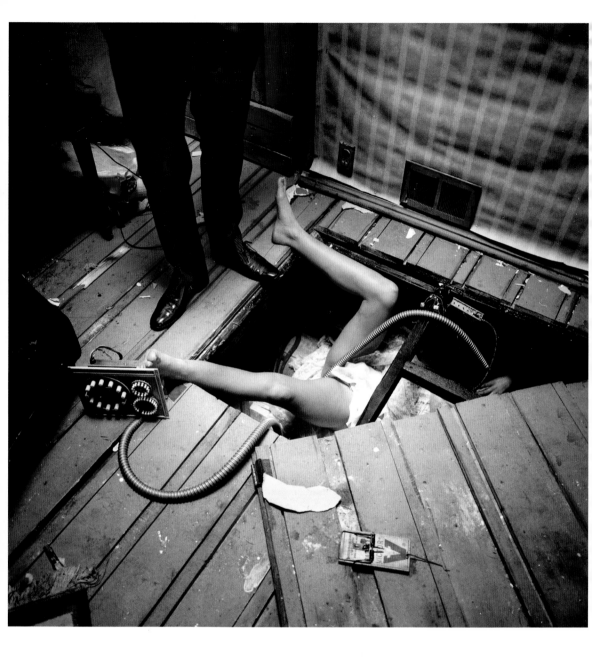

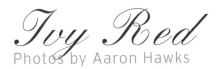

Ivy Red

Photos by Aaron Hawks

Name: Ivy Red

Birthday: October 5

Birthplace: San Francisco

What was your childhood ambition? Forensic Anthropologist

Where do you live? San Francisco

Where would you like to live? I love where I live, but I would very much like to do some extensive travel through India, Thailand, Africa, South America & Iceland.

How did you become a model? A drag queen friend of mine introduced me to Eric Kroll & Charles Gatewood — it snowballed from there.

Where do you see yourself in ten years time? Horseback somewhere warm green & quiet

VIP from movie or music biz would you like to date? I am very happy in my current relationship, but if I wasn't: Gael Garcia Bernal, Djimon Hounsou, Johnny Depp and U2's The Edge are at the top of my list.

What vice can you never forgive? Dishonesty

Daily sins, I cannot resist: Nicotine, caffeine

Favorite Band: To many to choose... I love music by Depeche Mode, U2, Massive Attack

Turn-ons: Attitude, humour, latex, smile, black eyes

Turn-offs: Bad breath, bad attitude, too much cologne, POOR HYGIENE!!

Is there anything you would never do again? –

What good advice could you give to other models? I am sure there are several. Don't be a flake. Come with your own ideas but be able to take direction.

Democrat, Republican, Green Party or other? Decline

Things that make me happy: My family!!! My horses, animal rescue, volunteer work, the ocean, travel, a good photoshoot, latex...

Website/Myspace: www. ivy-red.com

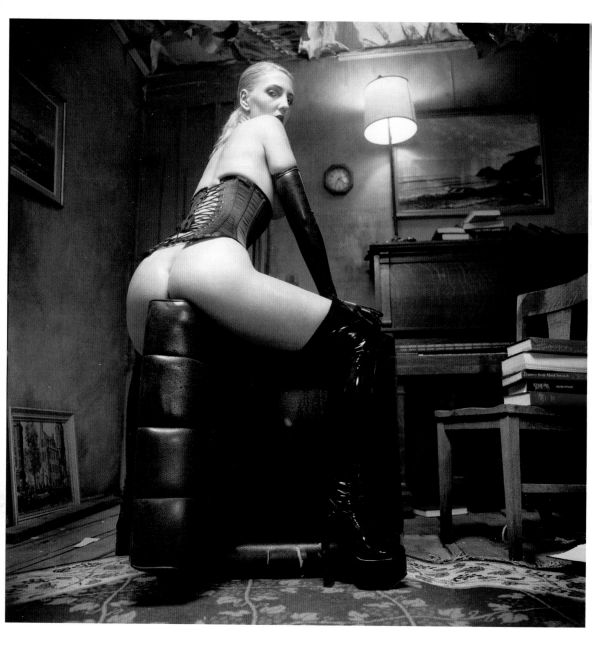

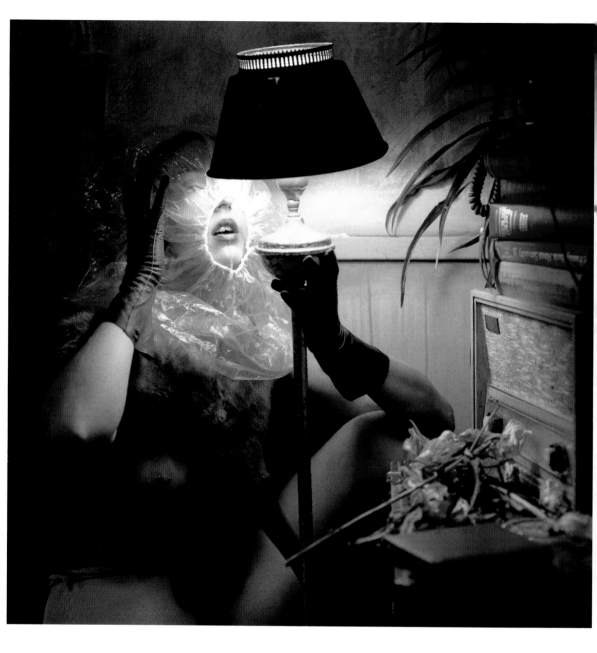

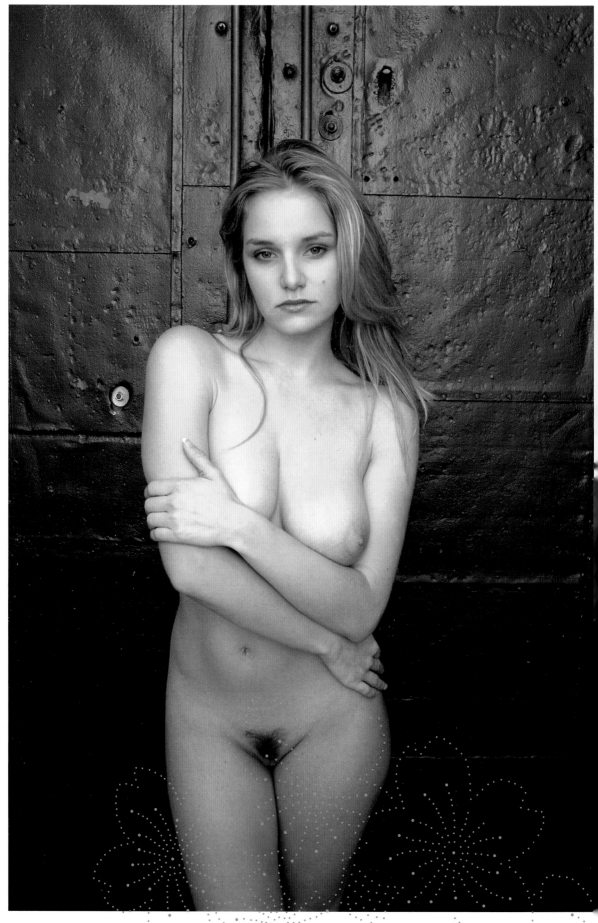

Liz Ashley

Photos by Rafael Fuchs

Name: Liz Ashley

Birthday: April 17

Birthplace: Louisiana

What was your childhood ambition? To be an artist

Where do you live? Texas

Where would you like to live? Texas

How did you become a model? I posed nude for a friend and loved the freedom & liberation I got from the experience.

Where do you see yourself in ten years time? Who knows... traveling & seeing the world

VIP from movie or music biz would you like to date? I'm not into "titles", I like someone that turns me on... emotionally, physically and mentally.

What vice can you never forgive? My Espresso – undoubtedly...

Daily sins, I cannot resist: Espresso, Chocolate, my man...

Favorite Band: Chris Isaak

Turn-ons: Honesty, generosity, loving, talented, intelligent, masculine yet sensitive... a man who can rub my feet & fix anything... It all spells out the special one in my life: Derek...

Turn-offs: Men who are: insane, selfish, cocky, too proud and cannot fix a fire...

Is there anything you would never do again? Never say never ... ha! ha! I would say I'd never dongle from a pyramid for a shot again... But I would! :-)

What good advice could you give to other models? Be yourself. Be on time. Be professional.

Democrat, Republican, Green Party or other? I don't talk about politics. Just think of me as Switzerland.

Things that make me happy: My 3 cats Frousy, Niles, Jade, and my parrot Scooby, ... ice cream, traveling, my friends...

Website/Myspace: www.thelizashley.com

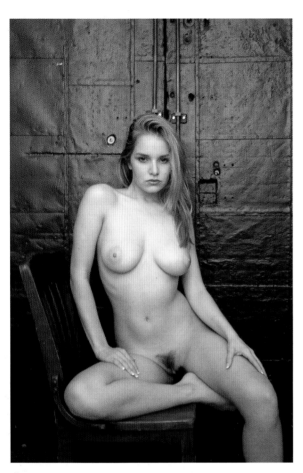
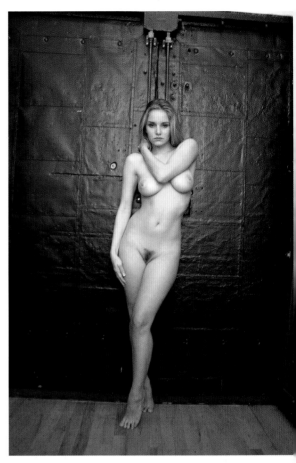
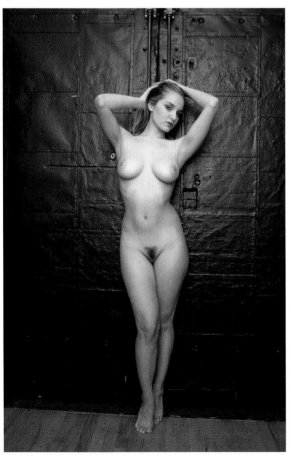
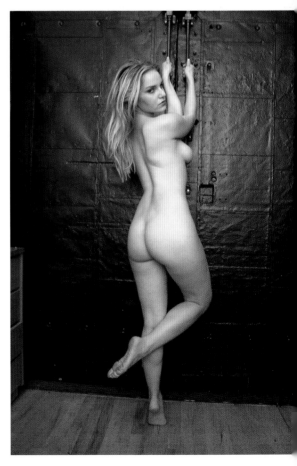

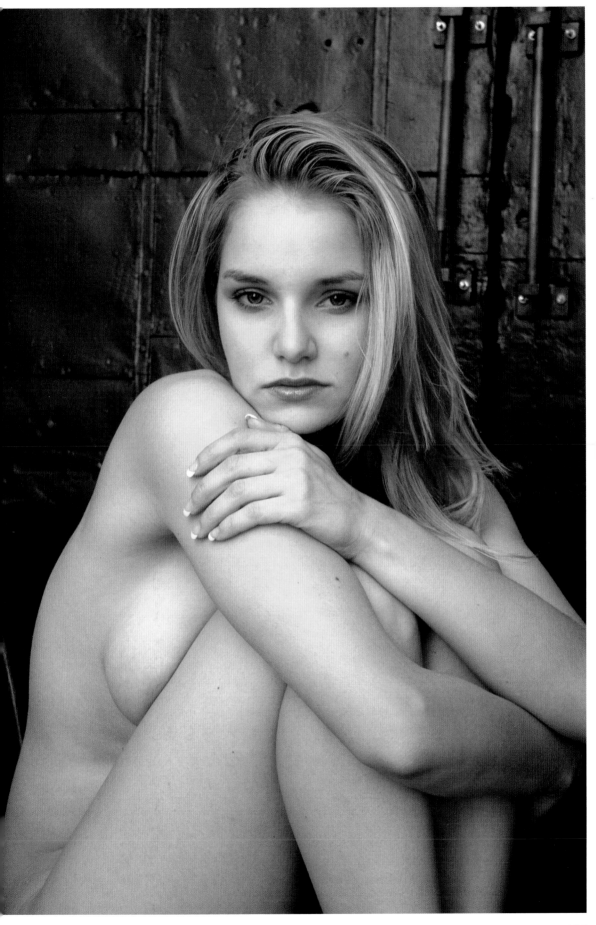

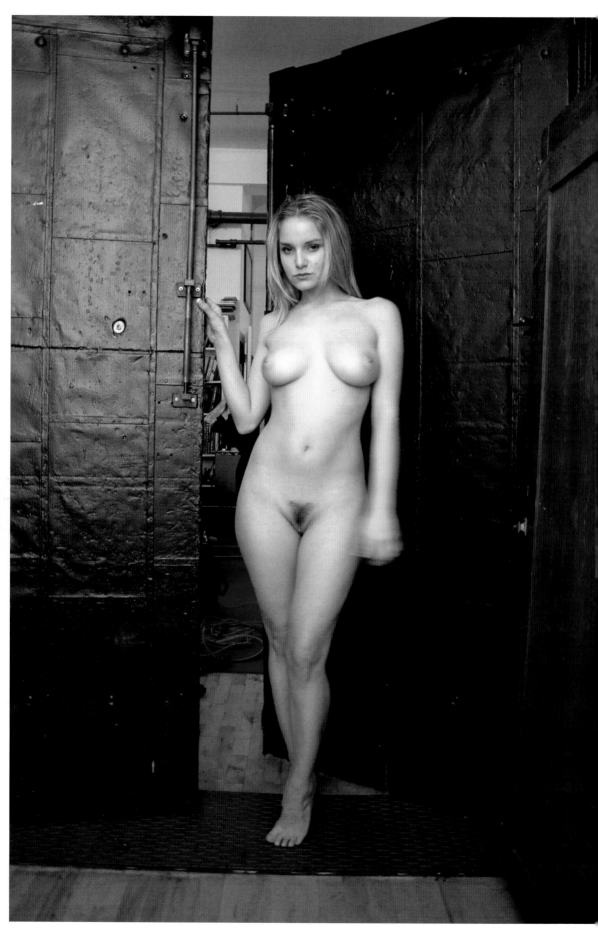

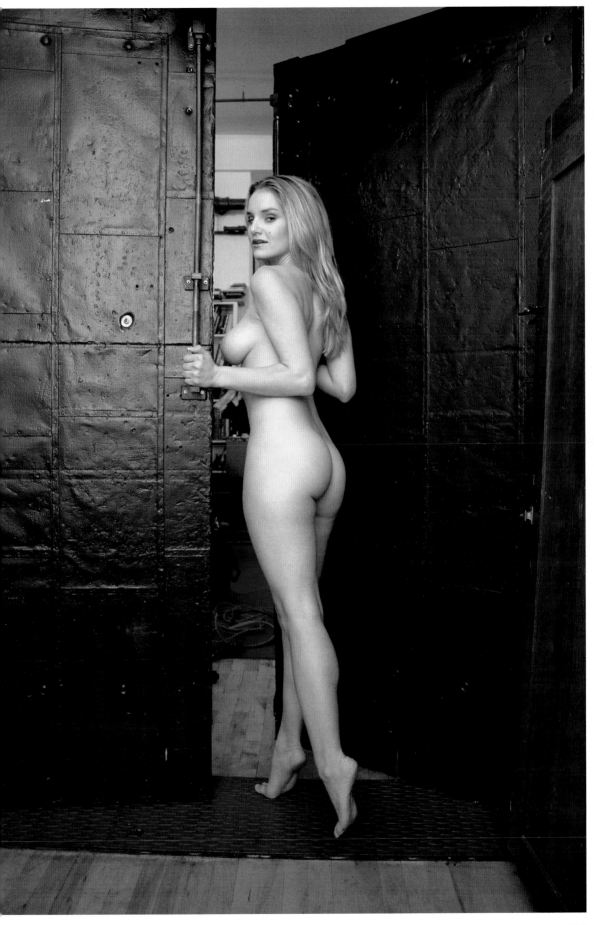

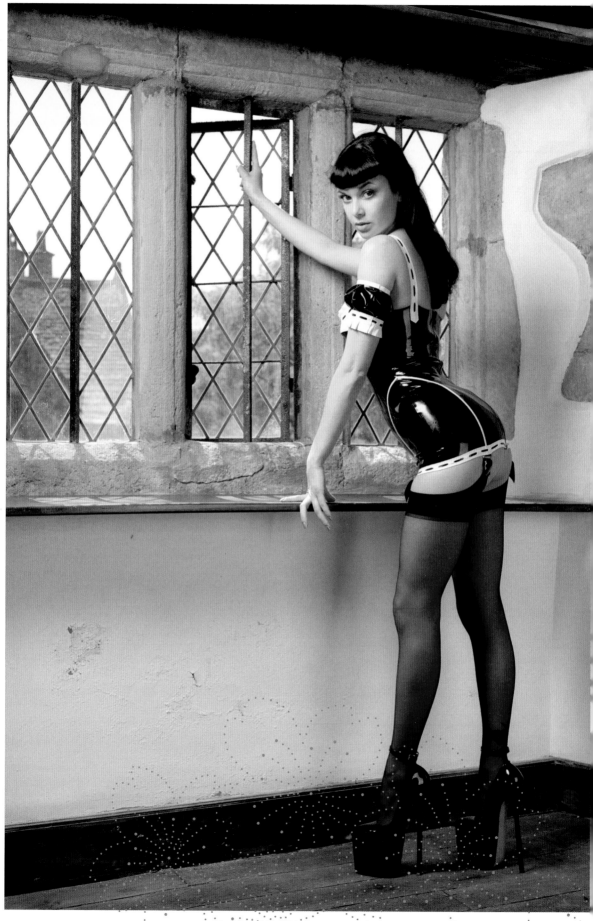

Valeria

Photos by Emma Delves-Broughton

Name: Valeria

Birthday: December 5, 1976

Birthplace: Norrköping, Sweden

What was your childhood ambition? To be a ballerina

Where do you live? London, UK

Where would you like to live? London, I'm a jerk

How did you become a model? Hanging out with creative people, fashion designers, stylists, artists...

Where do you see yourself in ten years time? Flying the world and taking beautiful pictures as a travel photographer...

VIP from movie or music biz would you like to date? I'm happy with my dates...

What vice can you never forgive? Pub crawling, stupidity

Daily sins, I cannot resist: I cannot resist champagne.

Favorite Band: Muse at the moment, but changes on mood, and I like classical music.

Turn-ons: Intelligence, passion, creative ideas, and height...

Turn-offs: Machos with no real balls

Is there anything you would never do again? Yes, of course, I learn everyday.

What good advice could you give to other models? Have something other than modeling in your life to hold on to...

Democrat, Republican, Green Party or other? S&M

Things that make me happy: My friends, my home, my family, my cats, my Ducati Monster

Website/Myspace: www.valerias.net

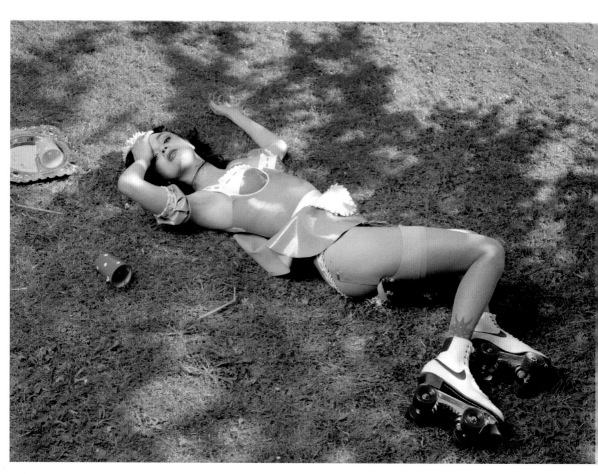

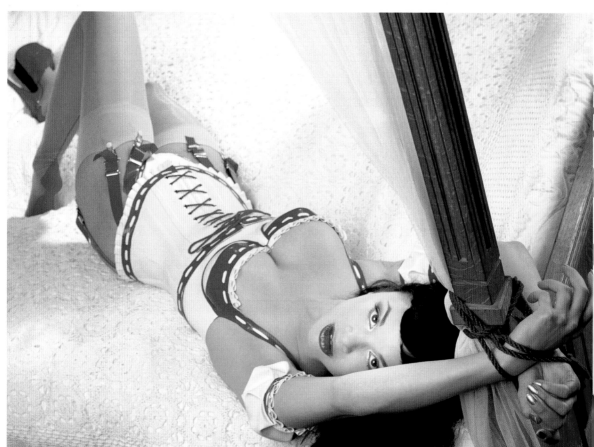

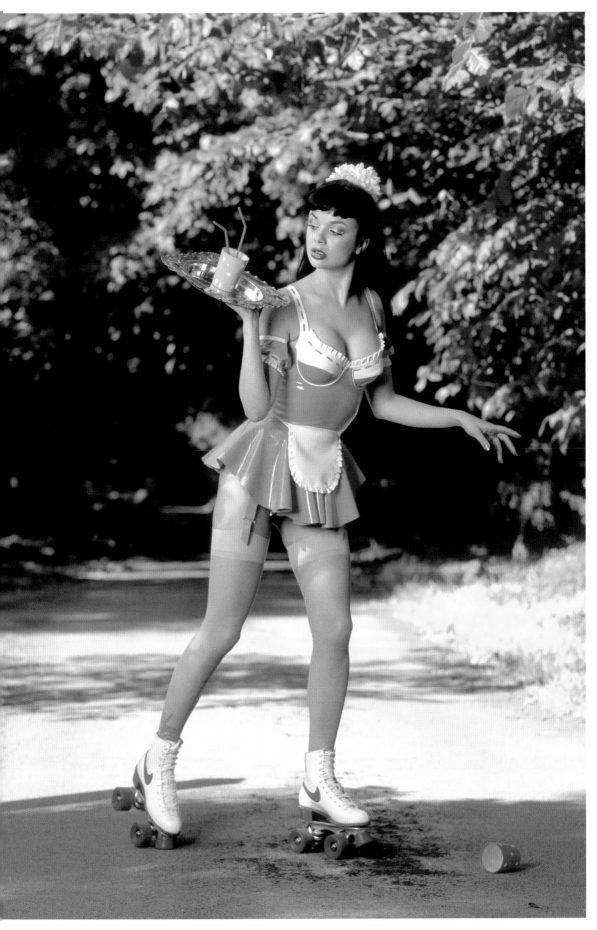

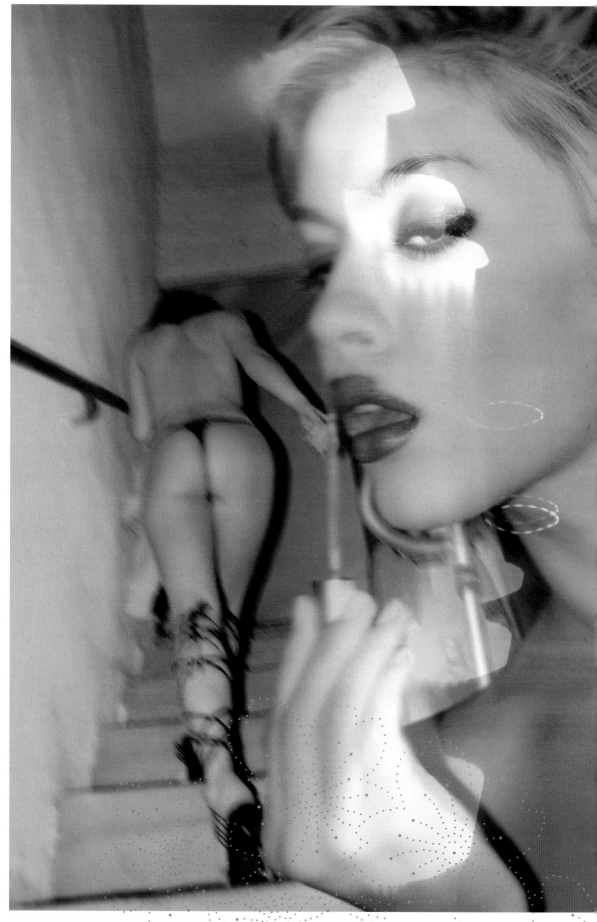

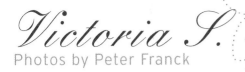

Victoria S.

Photos by Peter Franck

Name: Victoria S.

Birthday: November 3, 1980

Birthplace: Tiflis, Georgia

What was your childhood ambition? I wanted to become an actress

Where do you live? Tübingen, Germany

Where would you like to live? Somewhere by the sea

How did you become a model? I still ask myself the same question...

Where do you see yourself in ten years time? In a house with a kid, a dog and a husband. :-)

VIP from movie or music biz would you like to date? I've never been interested in any VIPs.

What vice can you never forgive? I can forgive everything. I rather can't forget.

Daily sins, I cannot resist: –

Favorite Band: –

Turn-ons: –

Turn-offs: –

Is there anything you would never do again? No, I learn and like it.

What good advice could you give to other models? Relax!

Democrat, Republican, Green Party or other? I've lost my faith in politics.

Things that make me happy: Everything can make me happy or sad.

Website/Myspace: –

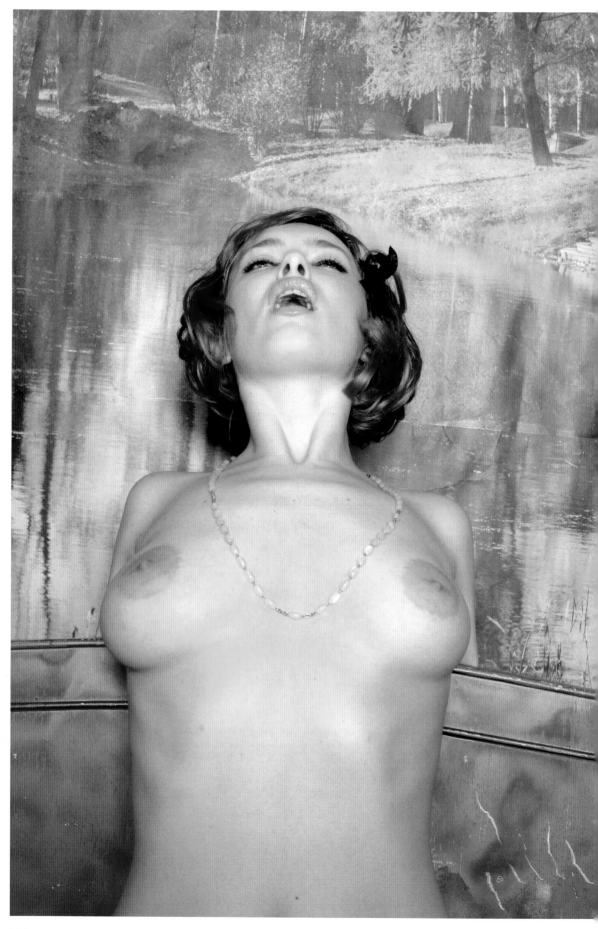

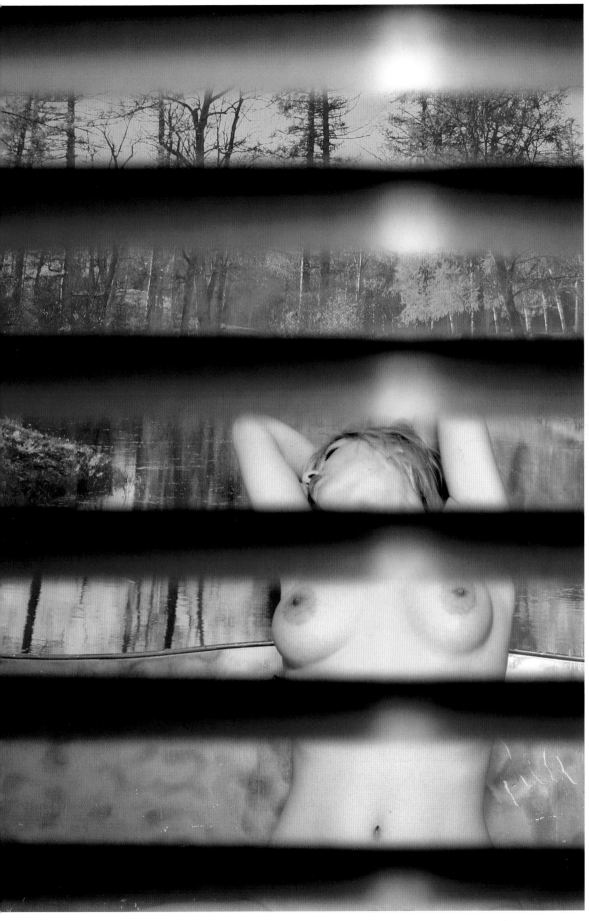

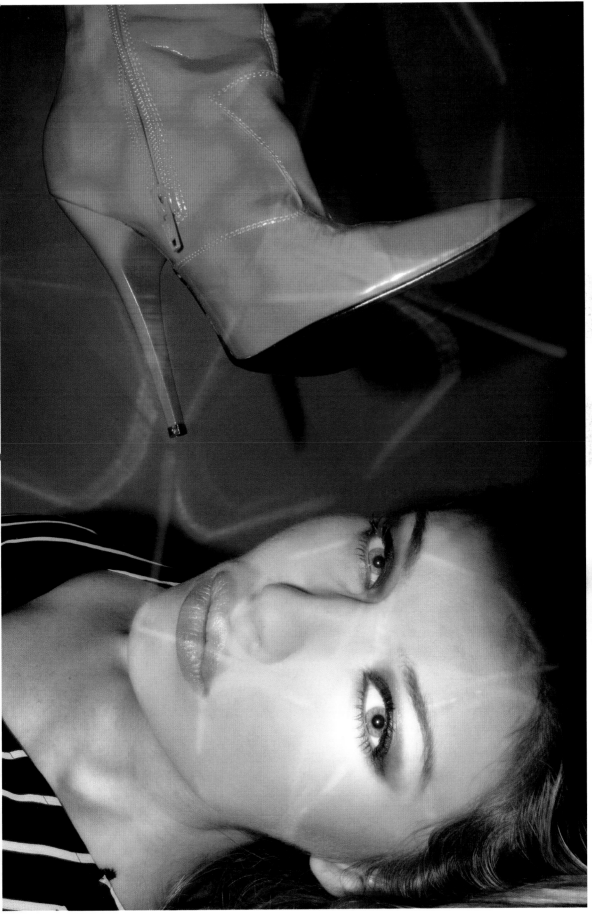

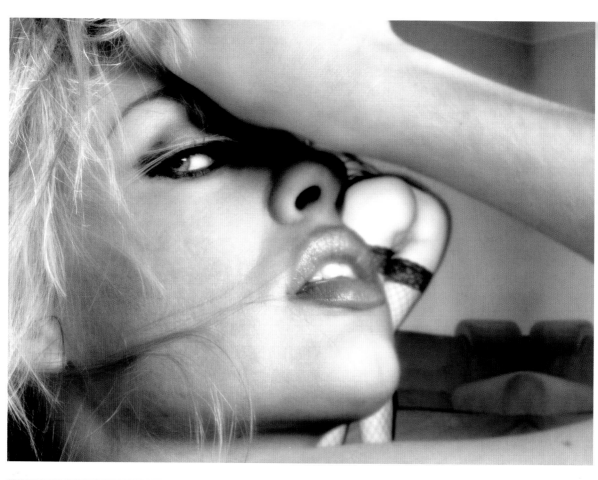

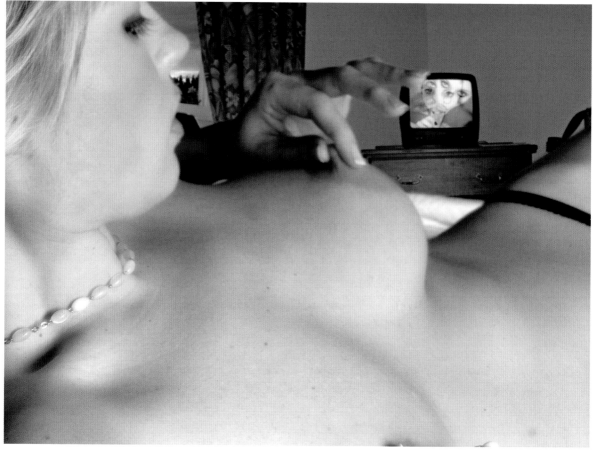

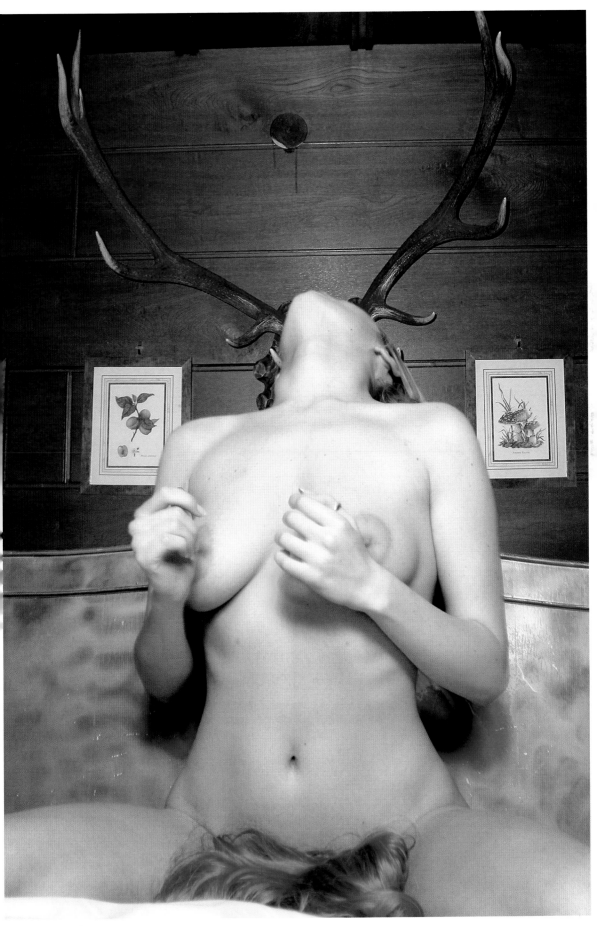

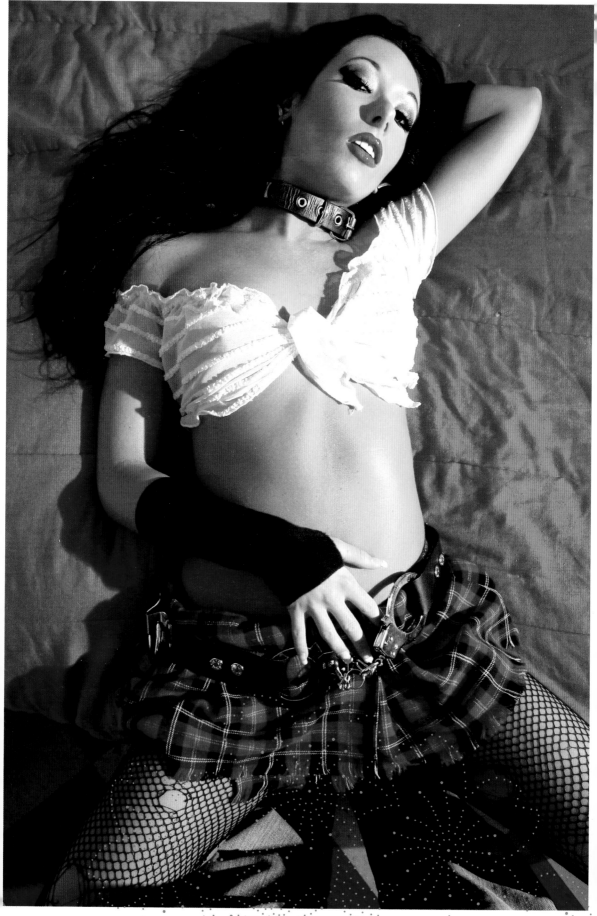

Nadia Nitro

Photos by Bob Coulter

Name: Nadia Nitro

Birthday: February 24, 1983

Birthplace: Pittsburg

What was your childhood ambition? I wanted to be a ballerina or a circus performer in Cirque Du Soleil.

Where do you live? Tampa/Miami, Florida

Where would you like to live? Miami, Florida forever!

How did you become a model? I used to watch the fashion channel a lot and loved fashion and cameras. I started working at Hooters when I was 18, and they chose me to be in the calendar.

Where do you see yourself in ten years time? I see myself in 10 years having millions of dollars due to investing in real estate and having my own production company.

VIP from movie or music biz would you like to date? I think Colin Farrel is pretty hot. And T.I. the rapper, too.

What vice can you never forgive? I have an obsession for buying shoes and sunglasses.

Daily sins, I cannot resist: Smoking, drinking, masturbating

Favorite Band: Deftones

Turn-ons: I like good looking, confident guys, who are good in bed and also have a sense of humor.

Turn-offs: Small dicks, lack of confidence, no sense of humor, arrogance, lack of respect for women

Is there anything you would never do again? I will never never do business with friends or family again, it can lead to fighting or lost friendships if there are money problems involved.

What good advice could you give to other models? Be yourself, be confident, have faith in yourself, never give up!

Democrat, Republican, Green Party or other? I don't really vote.

Things that make me happy: Love — when two people love each other so much it hurts. The beach, my Escalade. Techno music

Website/Myspace: www.myspace.com/nadia813, www.nadiaslair.com

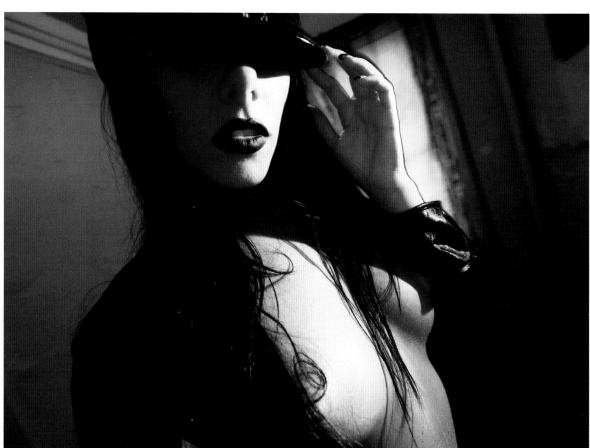

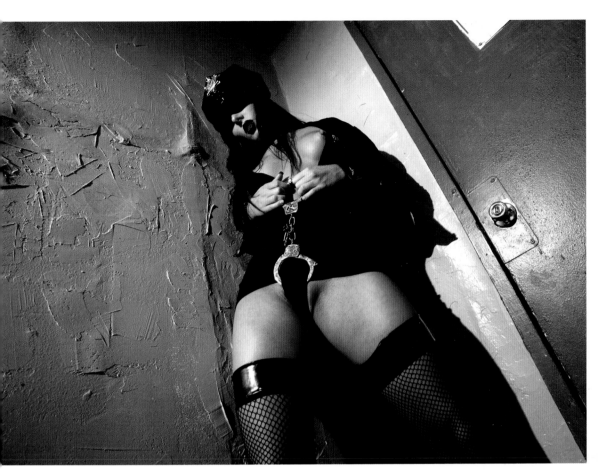

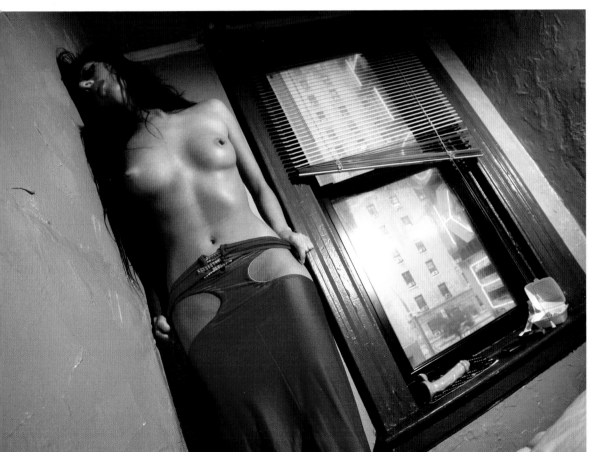

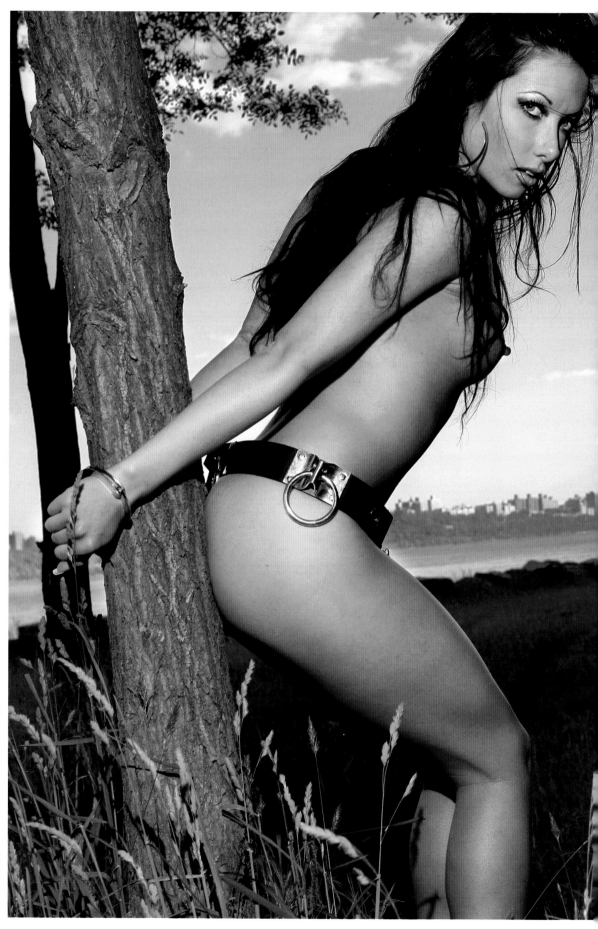

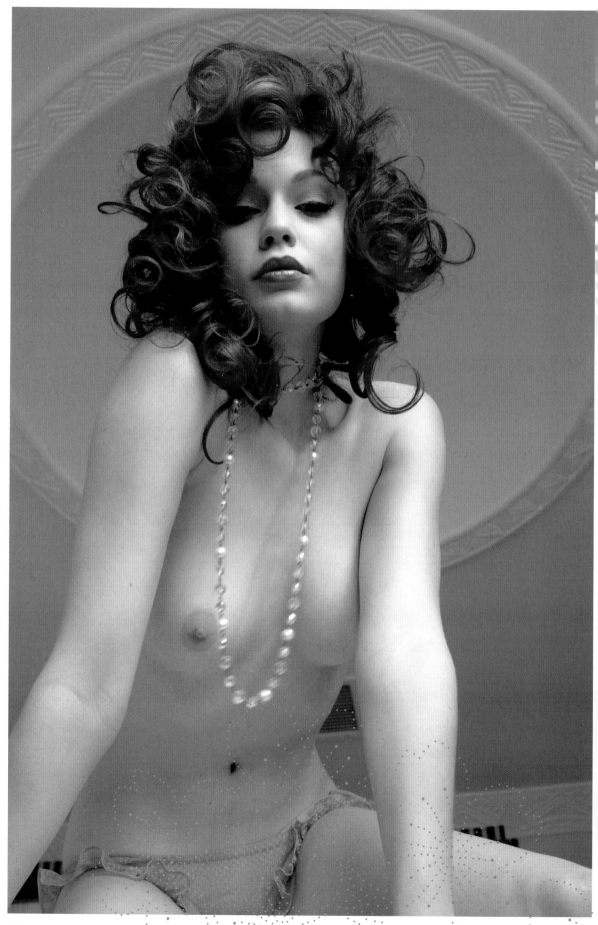

Justine Joli

Photos by Nathan Strausse

Name: Justine Joli

Birthday: June 16, 1980

Birthplace: Jackson Hole, Wyoming, USA

What was your childhood ambition? Ballet dancer or meteorologist. I couldn't decide.

Where do you live? California

Where would you like to live? All over the world.

How did you become a model? A producer and his girlfriend picked me up working at a mall in CA. They took naked pix of me then sent them off to 5 agents and one responded. That was a Saturday. Monday I did my first solo shoot.

Where do you see yourself in ten years time? Out of the public eye and helping others

VIP from movie or music biz would you like to date? Too many...

What vice can you never forgive? –

Daily sins, I cannot resist: My computer, Nano Greens, iPod, cell phone, and a book

Favorite Band: At the moment: Cell

Turn-ons: Funny, someone who doesn't take themselves too seriously. Someone who likes to laugh. Someone who's adventurous, loves a great meal and a night on the town in Europe. Straight to the point and knows what they want enough so to verblize it, and can shag till dawn.

Turn-offs: Lies, hiding under false pretences. Bad teeth and smelliness. You don't need THAT much cologne.

Is there anything you would never do again? Hire a male agent

What good advice could you give to other models? Invest, buy homes, and have fun while you do it. If you're not having fun throw in the towel. Quit.

Democrat, Republican, Green Party or other? Democrat

Things that make me happy: iPod, PSP, a good bottle of white wine, a great meal, anime, and movies

Website/Myspace: www.JustineJoli.com

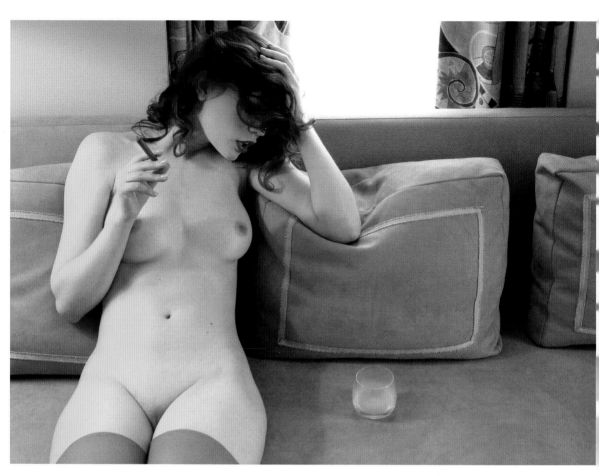

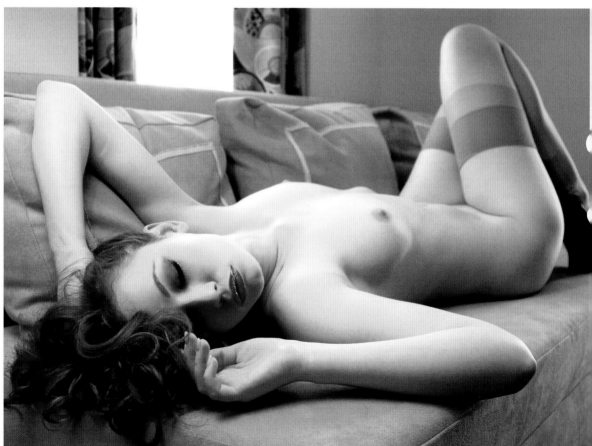

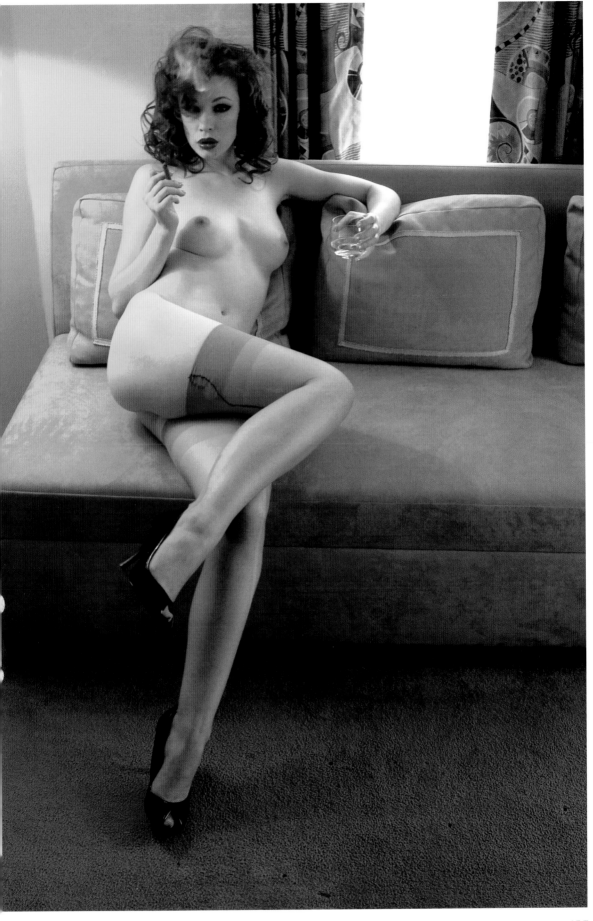

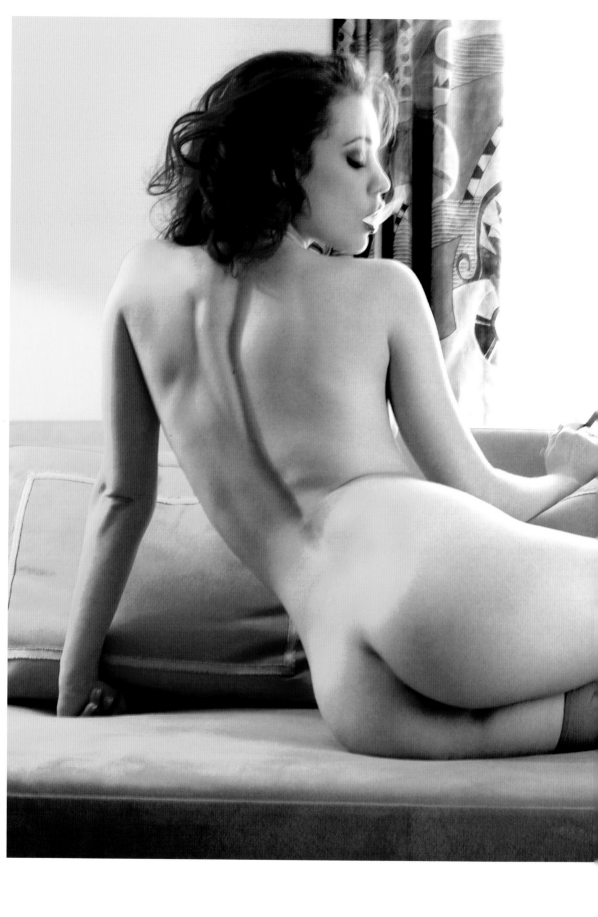

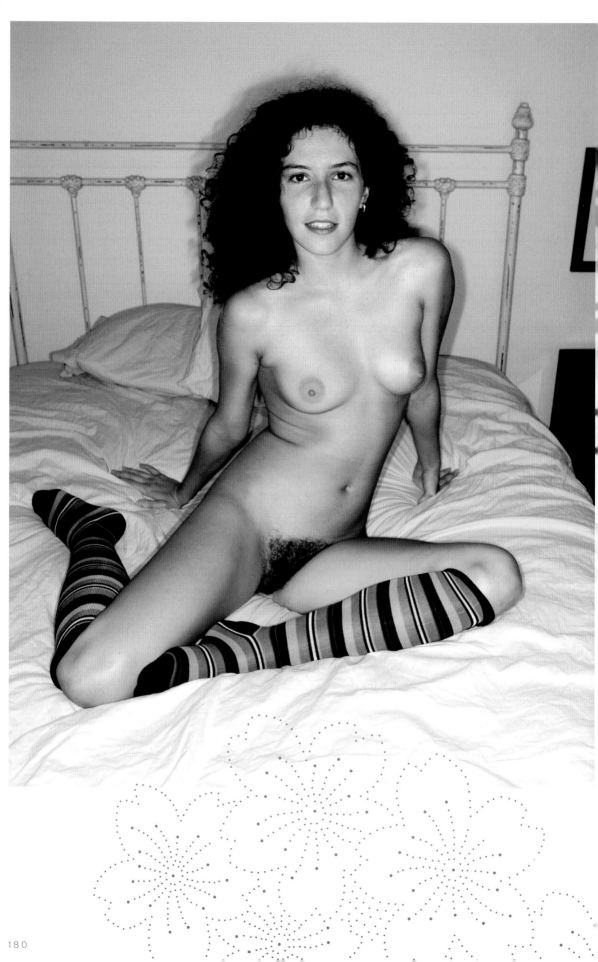

Sativa Verte

Photos by Mark Frank

Name: Sativa Verte

Birthday: February 29, 1948

Birthplace: Youngstown, Ohio

What was your childhood ambition? To live in a big city

Where do you live? Long Island, New York

Where would you like to live? Vancouver, Canada B.C.

How did you become a model? I was hired by my college to model for the Student Guide. Then I looked online for models I could learn from and met two bi-sexual roommates who traveled around the US modeling. I watched their shoots and they helped me start my freelance career.

Where do you see yourself in ten years time? Living on the West Coast of the US or in Europe

VIP from movie or music biz would you like to date? Maggie Gyllenhaal - I just fell in love with her in the movie Secretary

What vice can you never forgive? Lovers that betray me in one way or another

Daily sins, I cannot resist: Masturbation

Favorite Band: Led Zeppelin

Turn-ons: Hygiene, nice teeth, smart, friendly, courteous, security. This may sound superficial, but I'm rather fond of guys that dress wild, in Kenneth Cole/CK/Guess, or with a metro sexual twist.

Turn-offs: People that are lazy, ignorant, and racist

Is there anything you would never do again? I would never again be the first person to fall asleep at a party! I woke up with my hand in warm water and...

What good advice could you give to other models? Dear wandering stars, keep exploring and don't give up!

Democrat, Republican, Green Party or other? I use to care, but once Bush was in office I decided my vote was useless

Things that make me happy: Orgasms, kissing, laughing non-stop, and the great outdoors

Website/Myspace: www.myspace.com/sativaverte, www.sexysativa.com

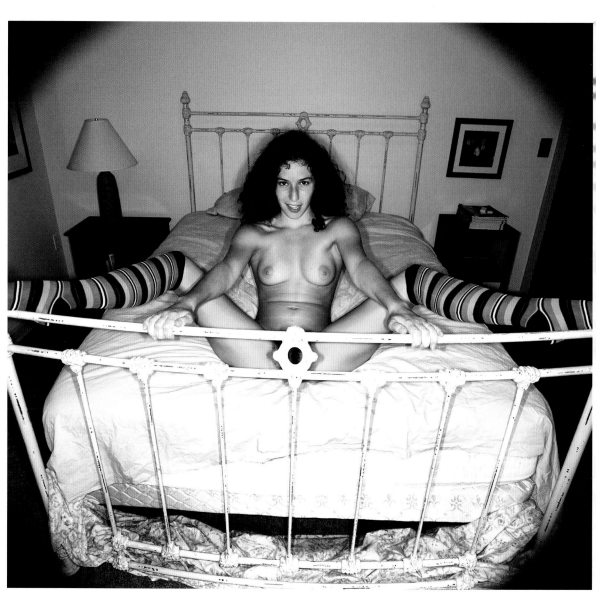

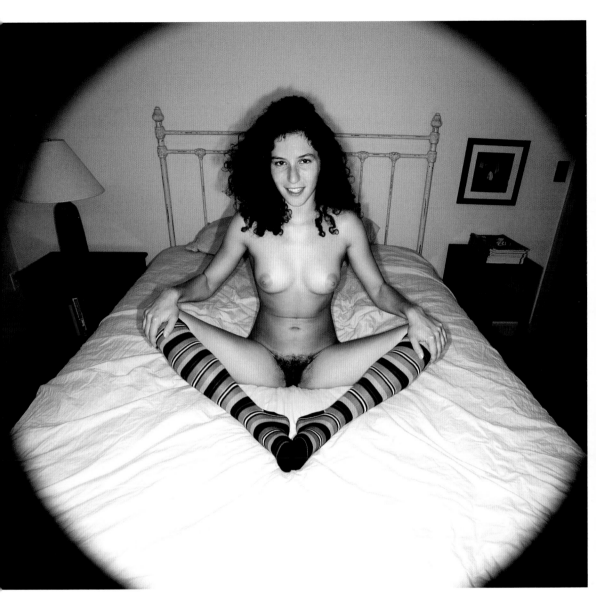

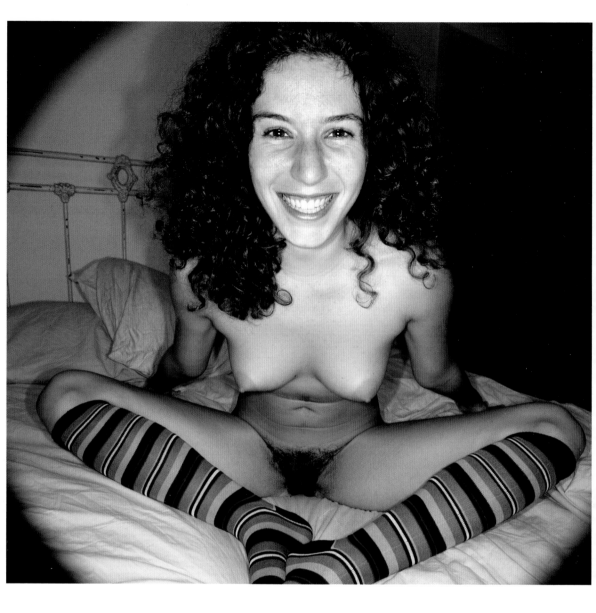

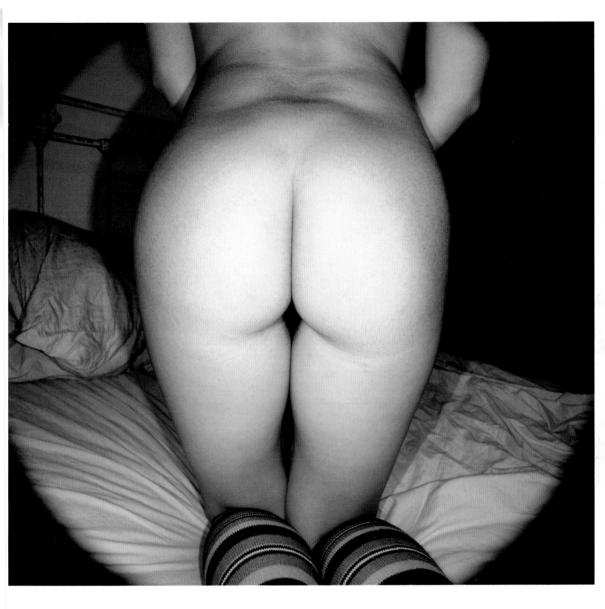

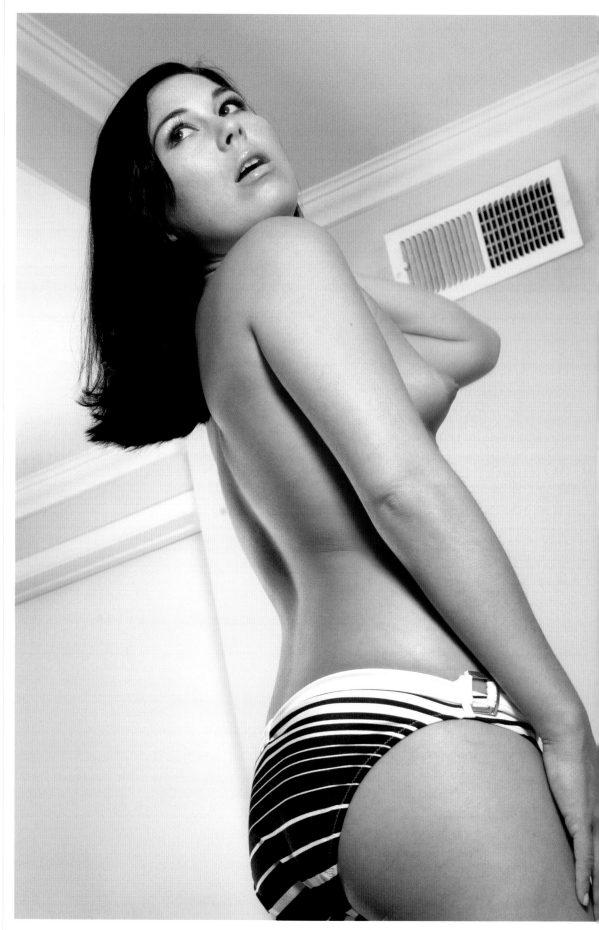

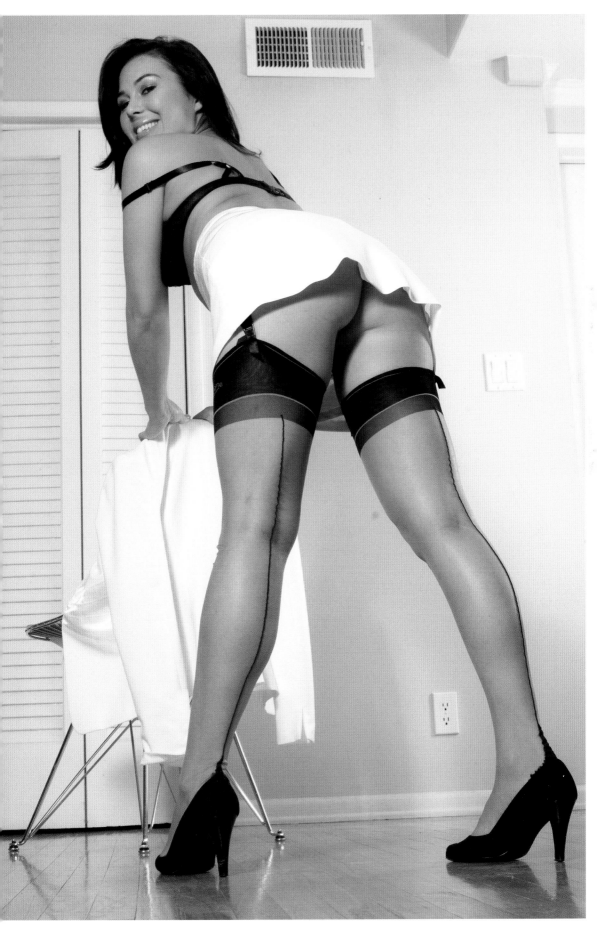

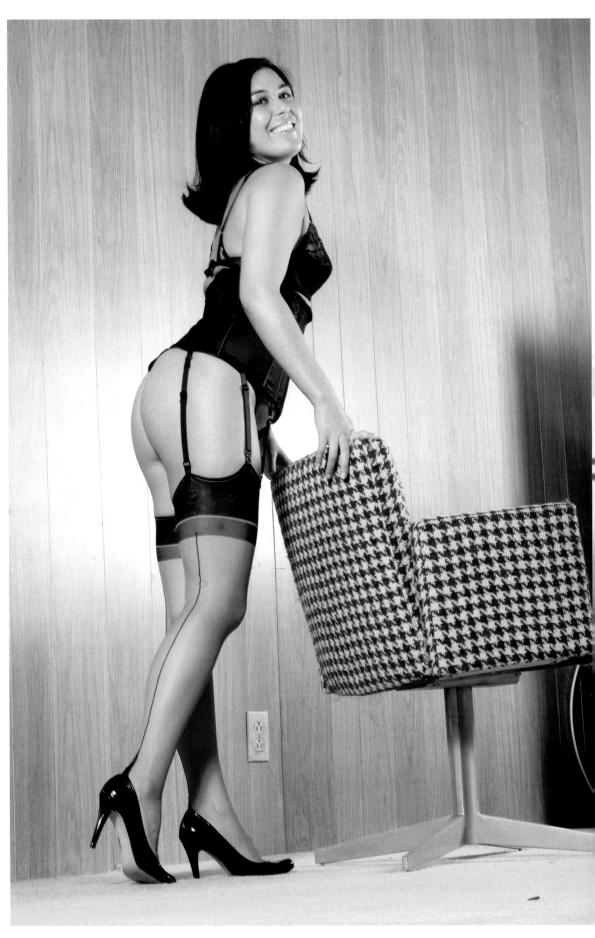

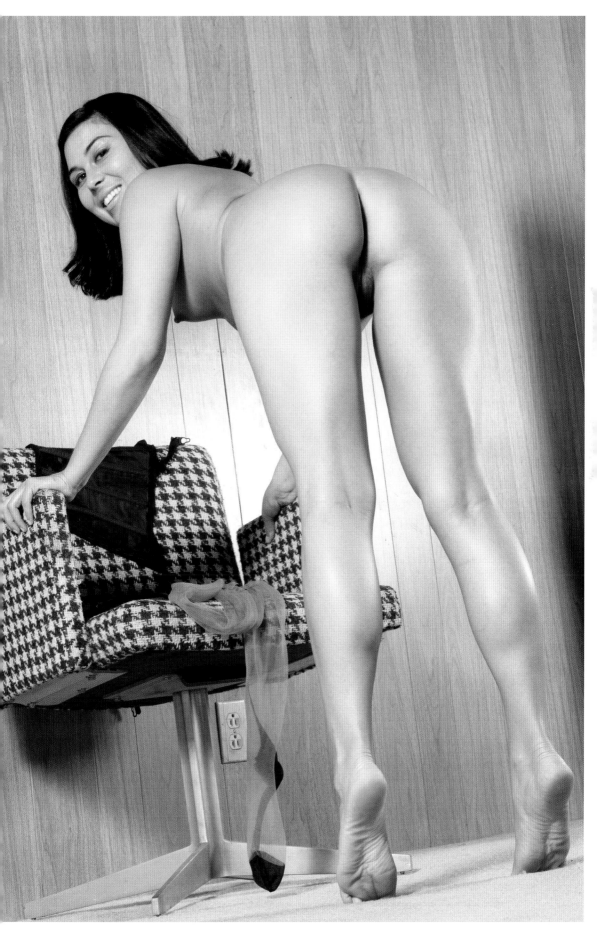

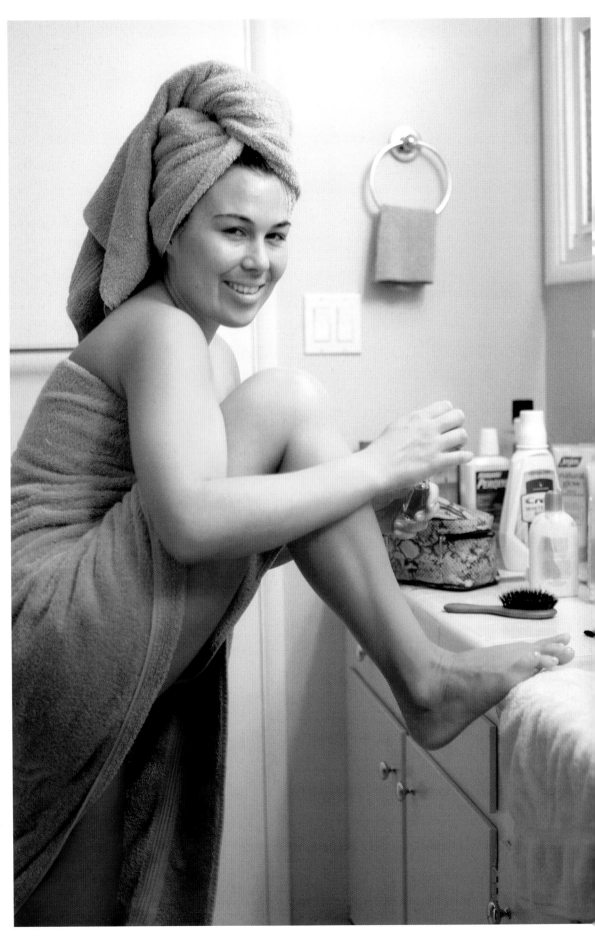

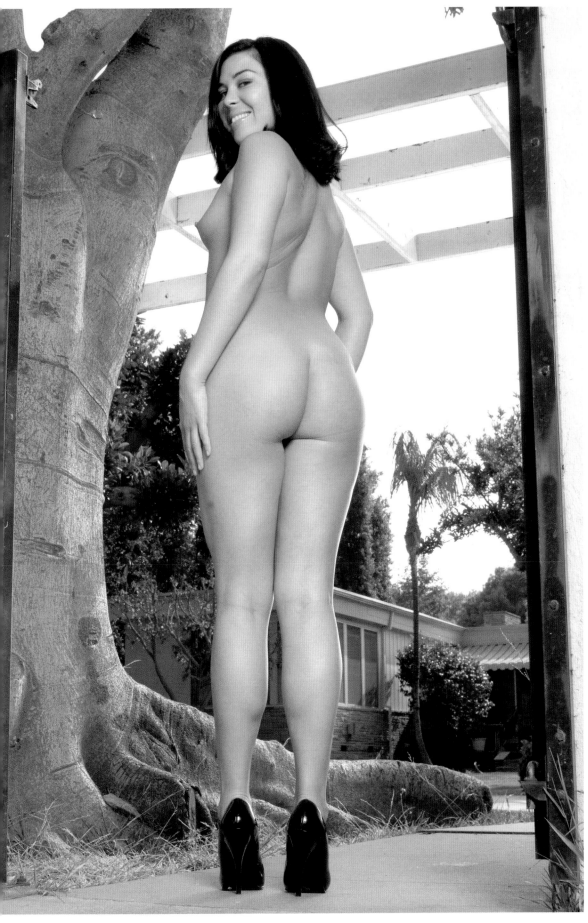

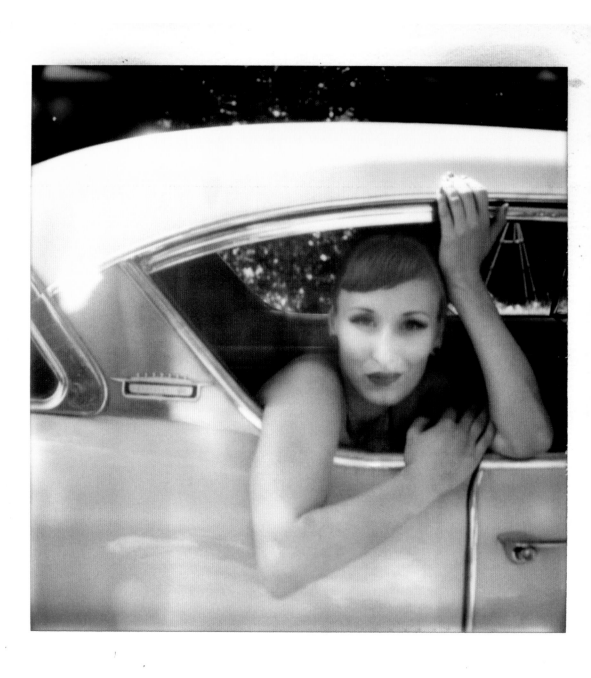

WildatHeart

Photos by Julischka Stengele

Name: WildatHeart

Birthday: May 19, 1982

Birthplace: Near Berlin

What was your childhood ambition? Addicted to mystery, I always imagined myself becoming a detective, later I got fascinated by medicine.

Where do you live? My home is the city for the wild at heart: Berlin!

Where would you like to live? I am exactly at the right place, no doubts about that.

How did you become a model? Am I a model? Don't think so. I am just an exhibitionistic mind who loves to produce art and beauty, on both sides. But the photographer who first got me in front of a camera was Marcus Ewers.

Where do you see yourself in ten years time? Still taking pictures, still loving the same man, hanging out with the same awesome friends, just having a phd, a well-paid job and hopefully still being healthy.

VIP from movie or music biz would you like to date? The only VIPs are my friends and my partner in crime. I don't give a shit about this whole star-thing.

What vice can you never forgive? Betrayal

Daily sins, I cannot resist: Beer and cigarettes... guess, I am boring. ;-)

Favorite Band: Pothead, Dresden Dolls, Laibach, Beatsteaks, Joint Venture, Therion, Dead Can Dance, Leonard Cohen, Johnny Cash

Turn-ons: Humour and brain – works best if combined

Turn-offs: Superficiality and ignorance. Bitchiness, jealousy, back-stabbing

Is there anything you would never do again? Yes, there is. But changing the past would lead to a different present – and my present live is just perfect.

What good advice could you give to other models? NEVER take yourself too seriously!

Democrat, Republican, Green Party or other? I never discuss politics with strangers.

Things that make me happy: A smile in the morning, a barbecue in the park with friends, a hug and a kiss, little things that show affection.

Time is pure luxury for me – having a free day without any commitals is what I really appreciate.

Website/Myspace: www.wildatheart-photo.de / www.myspace.com/wildatheart-photo

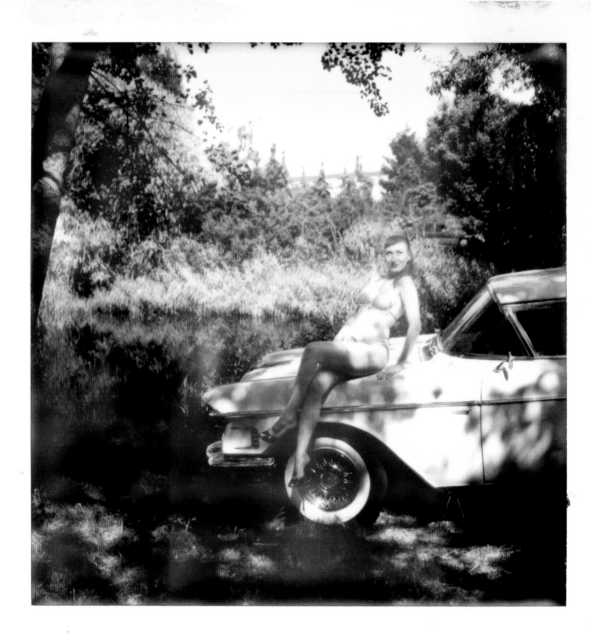

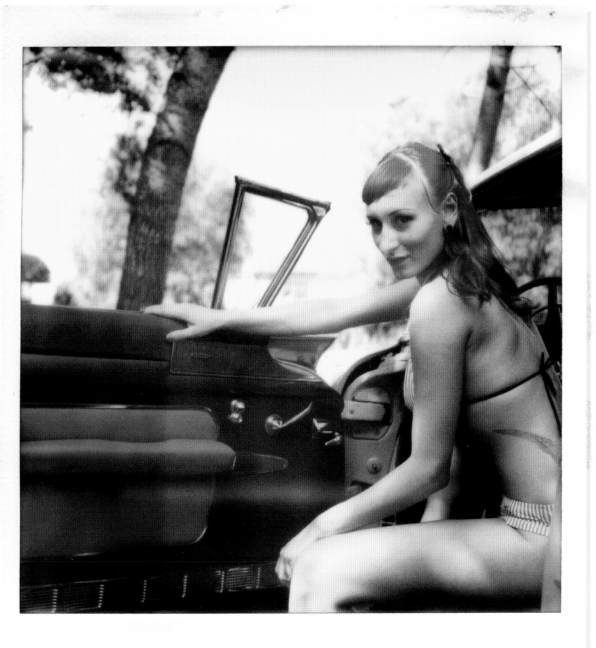

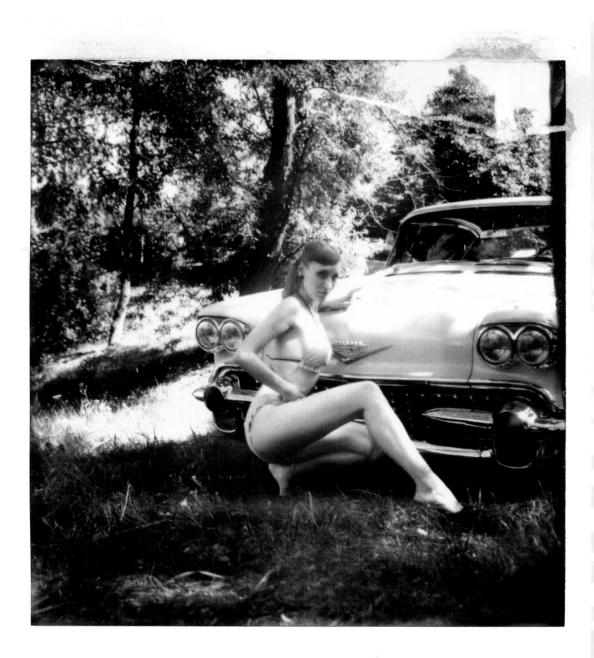

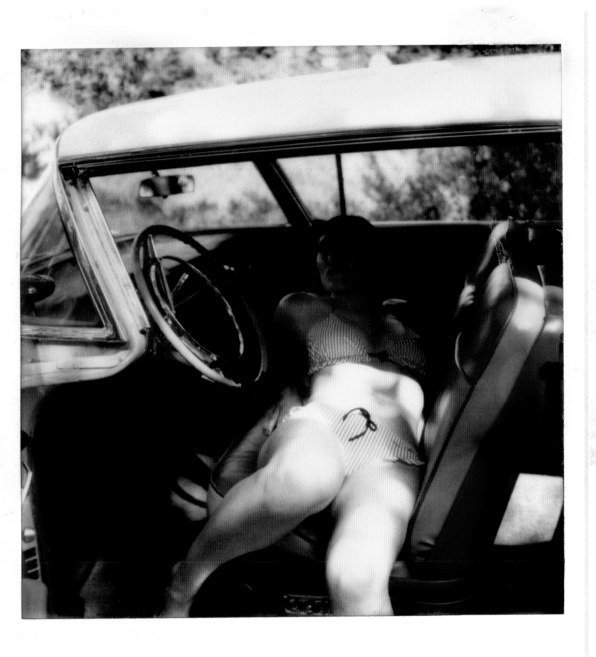

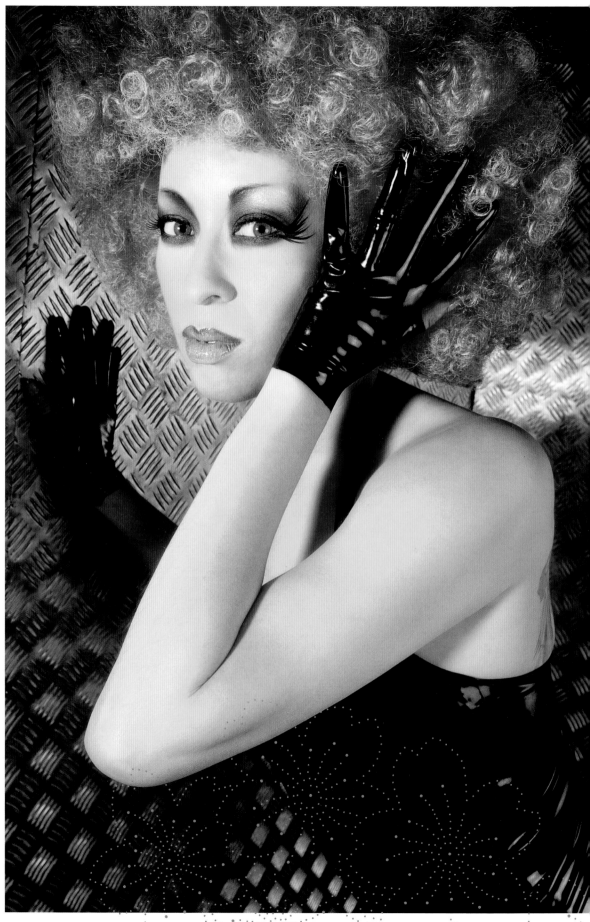

Kumi

Photos by Eric Martin

Name: Kumi

Birthday: March 17, 1970

Birthplace: Palo Alto, California, USA

What was your childhood ambition? To be like Bruce Lee - only female

Where do you live? On an airplane.

Where would you like to live? I want to be able to travel the world without sticking to one place - like I do now!

How did you become a model? A long story, but to make it short, I started meeting some interesting people in San Francisco which allowed me to discover a more alternative/fetish scene

Where do you see yourself in ten years time? Hopefully still doing what I am doing now, not necessarily modeling full time, but being able to participate in performing and working at fetish events around the world. If not, then I'd like to start teaching.

VIP from movie or music biz would you like to date? -

What vice can you never forgive? Disloyalty

Daily sins, I cannot resist: Cigarettes (for now), internet, and sometimes Jack Daniels (but not daily!)

Favorite Band: Ryuichi Sakamoto, Les Rita Mitsouko, Indochine, The Pogues, The Clash, David Bowie

Turn-ons: Good latex! High heels, fancy stockings

Turn-offs: Betrayal, bad quality latex, platform heels

Is there anything you would never do again? Yes, but I don't remember, and I probably would just do whatever it was again, until it was too late and realized that I didn't want to do it!

What good advice could you give to other models? I've already tried to, but they rarely actually pay attention, but otherwise, learn how to do your own research.

Democrat, Republican, Green Party or other? Definitely other!

Things that make me happy: Helping out and designing new great latex to add to my collection, traveling to new and old places to meet new friends and visit with old ones, and working with a great team of people to produce super images.

Website/Myspace: www.kumimonster.com

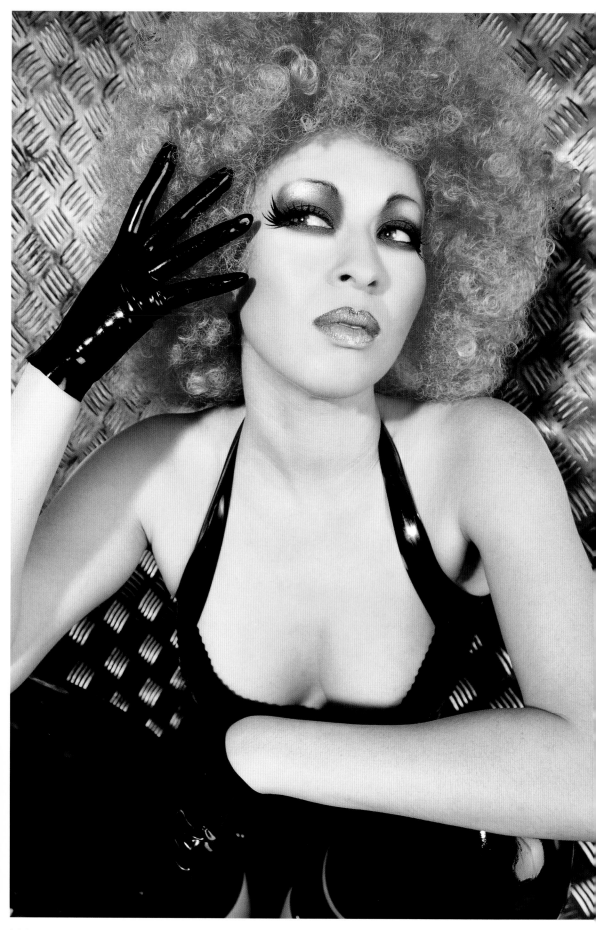

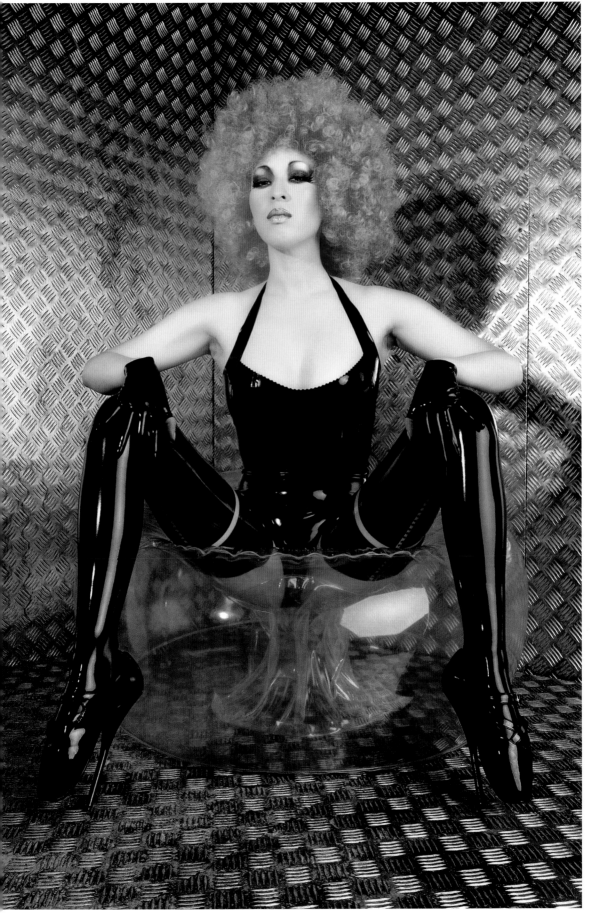

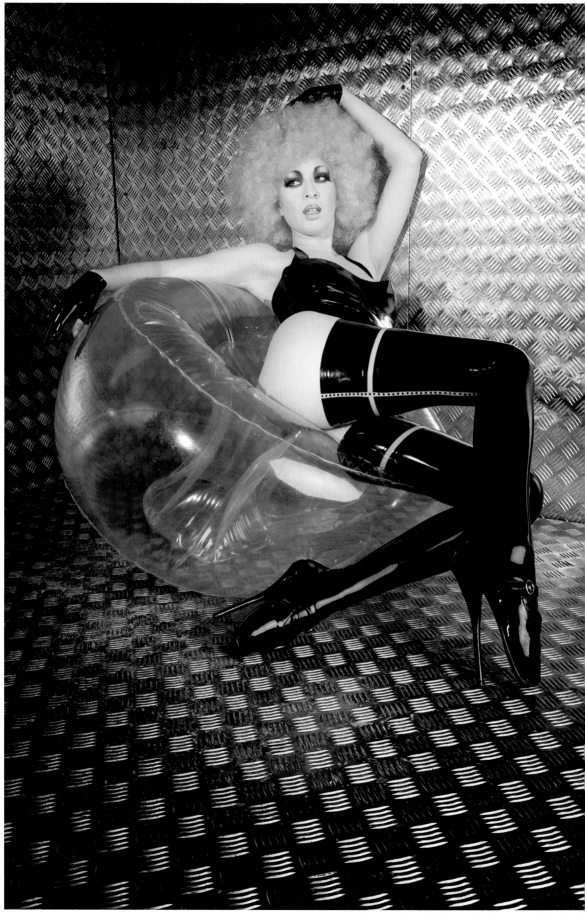

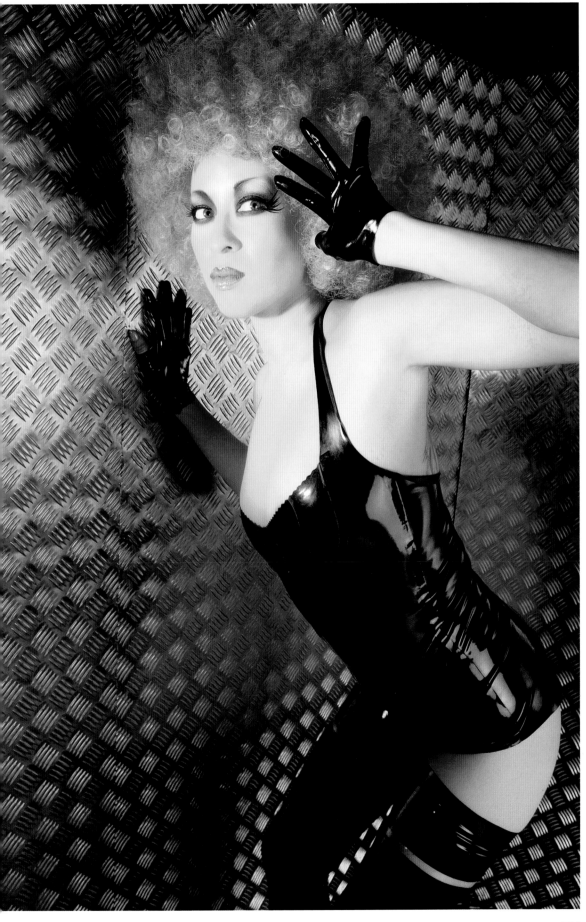

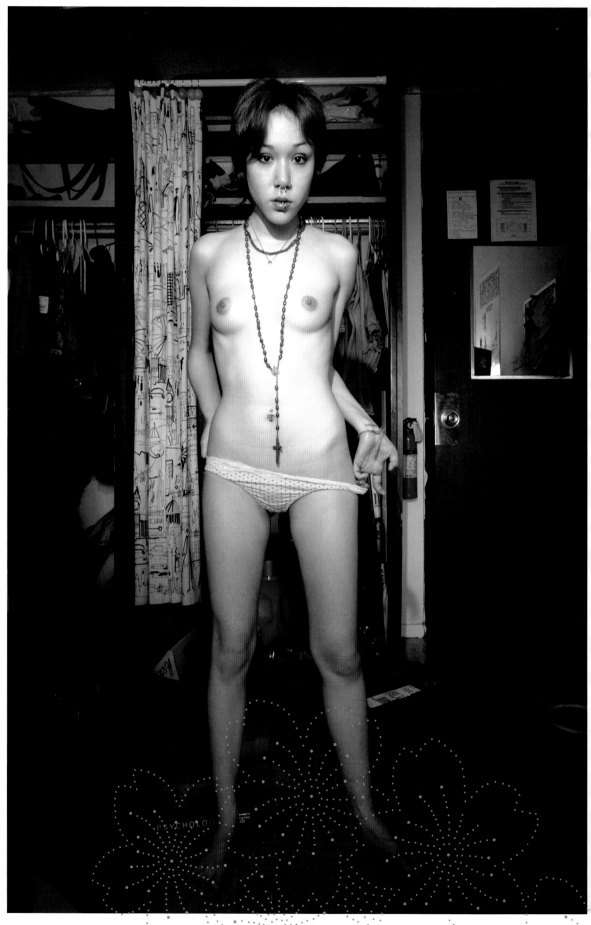

Hanna Jane

Photos by Peter Gorman

Name: Hanna Jane

Birthday: July 8, 1987 - a textbook cancerian

Birthplace: Yonkers, NY

What was your childhood ambition? That's still my ambition.

Where do you live? New York City

Where would you like to live? 6 months in NY and 6 months in Tokyo

How did you become a model? I actually started out as a child model which I ended up hating and quitting after a year. I contacted Peter out of desperation for money and then we lived happily ever after.

Where do you see yourself in ten years time? Barefoot, knocked up, filling up sketchbooks like it's my job, although it probably won't be.

VIP from movie or music biz would you like to date? Tim Kasher of Cursive

What vice can you never forgive? I'm a pretty forgiving person. It's forgetting that's the hard part.

Daily sins, I cannot resist: Stopping on the street to pet cute animals and then squealing like a little girl.

Favorite Band: Man Man, The JonBenet and An Albatross just to name a few

Turn-ons: People who can laugh at things that probably shouldn't be laughed at, like disgustingly politically incorrect topics that most people think are too taboo to discuss let alone crack jokes about.

Turn-offs: Lateness, music snobs and people who fall on the subway, they are the worst.

Is there anything you would never do again? Go to the senior prom. The whole thing was like some sick joke coated in hairspray, sequins and Mike's Hard Lemonade.

What good advice could you give to other models? Trust the photographer, be yourself and get paid!

Democrat, Republican, Green Party or other? Let's just say I'm extremely liberal.

Things that make me happy: My mother, people who find me intriguing, drawing, antidepressants and having people around me speak French because unbeknownst to them I know exactly what they're saying.

Website/Myspace: www.myspace.com/hanajane, www.livejournal.com/users/ifancylust

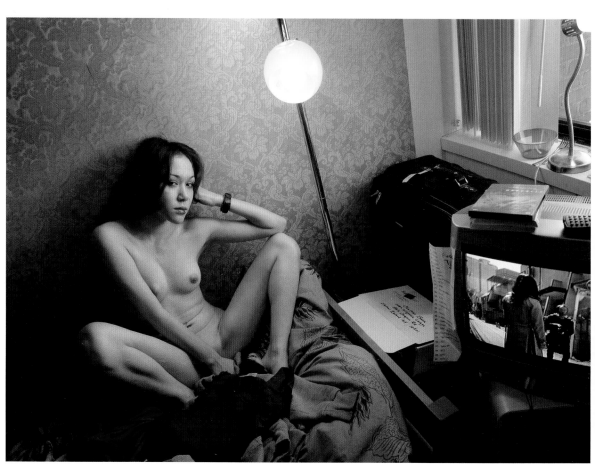

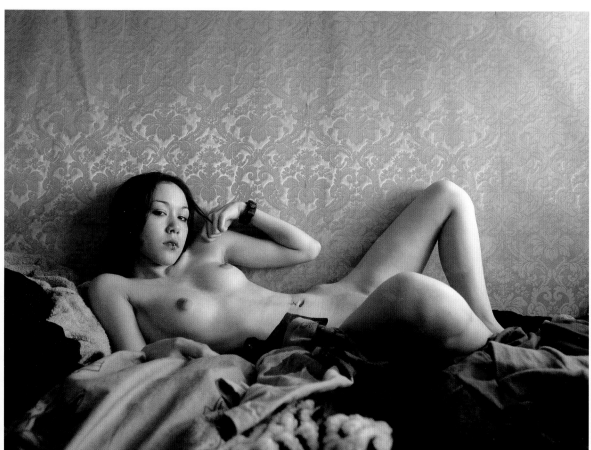

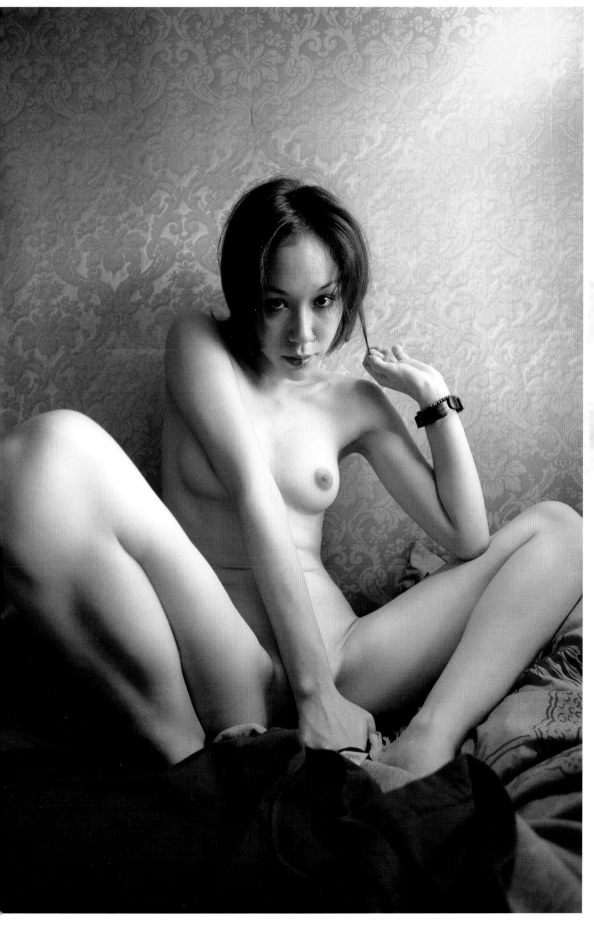

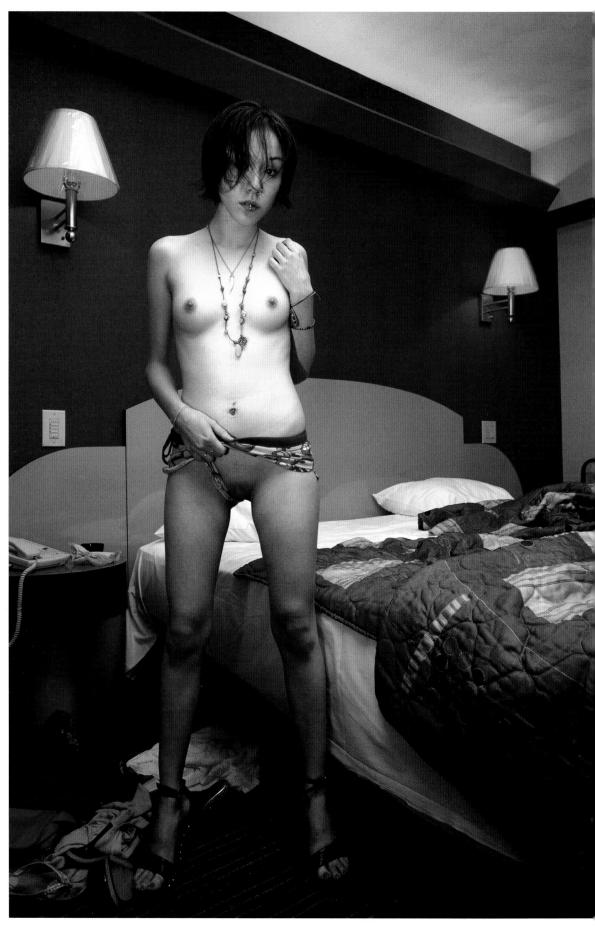

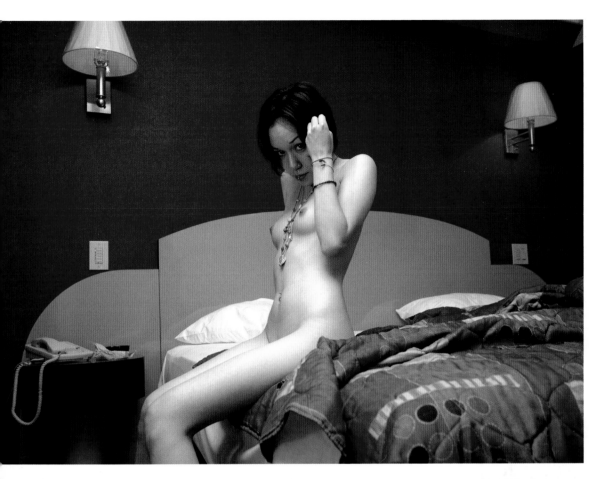

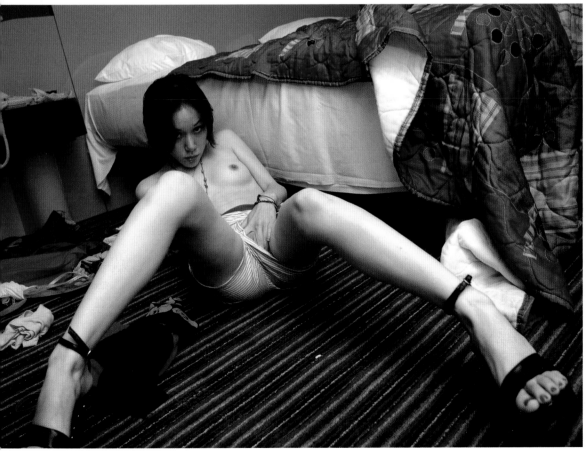

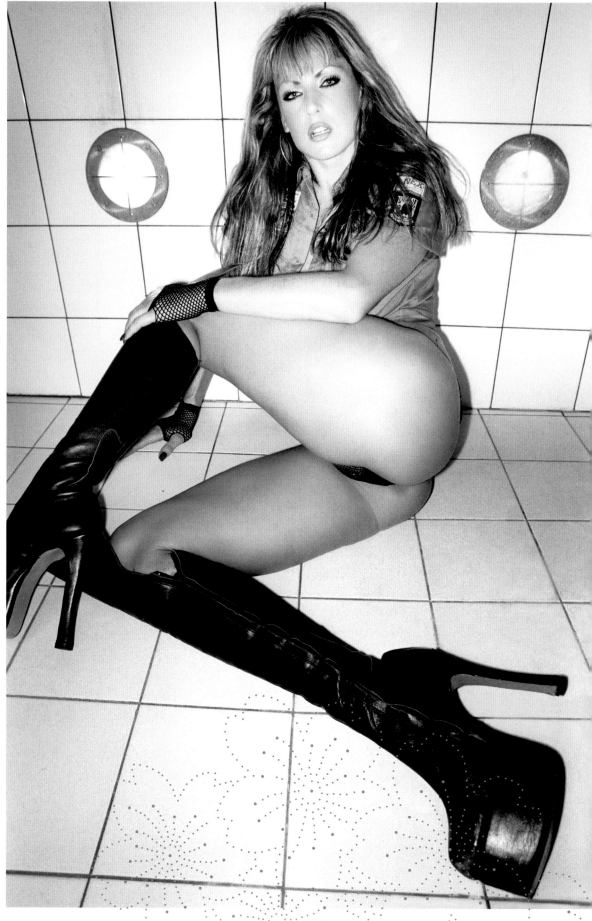

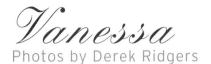

Vanessa

Photos by Derek Ridgers

Name: Vanessa

Birthday: It's in October.

Birthplace: Bermondsey, London

What was your childhood ambition? To be a performer

Where do you live? Croydon, UK

Where would you like to live? In France and I am moving there next month.

How did you become a model? My boyfriend took some pictures of me into an agency. They turned him down twice. Then I went to see them and they took me on. My first photo were on "page 3" of THE SUN when I was 17.

Where do you see yourself in ten years time? I am doing some property development and I am a shit hot tiler (roofing) and I am planning on having loads of kids.

VIP from movie or music biz would you like to date? A one night stand with either Angelina Jolie or Pamela Anderson.

What vice can you never forgive? Child cruelty

Daily sins, I cannot resist: Chocolate

Favorite Band: I don't really have a favorite band, I'm more into electro break beats.

Turn-ons: Girls in fishnets and watching my boyfriend with girls in fishnets

Turn-offs: Men with lots of hair gel and big egos

Is there anything you would never do again? I don't regret anything I've ever done.

What good advice could you give to other models? Don't try to look like anyone else. When posing, if it hurts its working. Don't just face the camera and hope for the best.

Democrat, Republican, Green Party or other? I think they're all a load of bollocks.

Things that make me happy: Mountain climbing

Website/Myspace: −

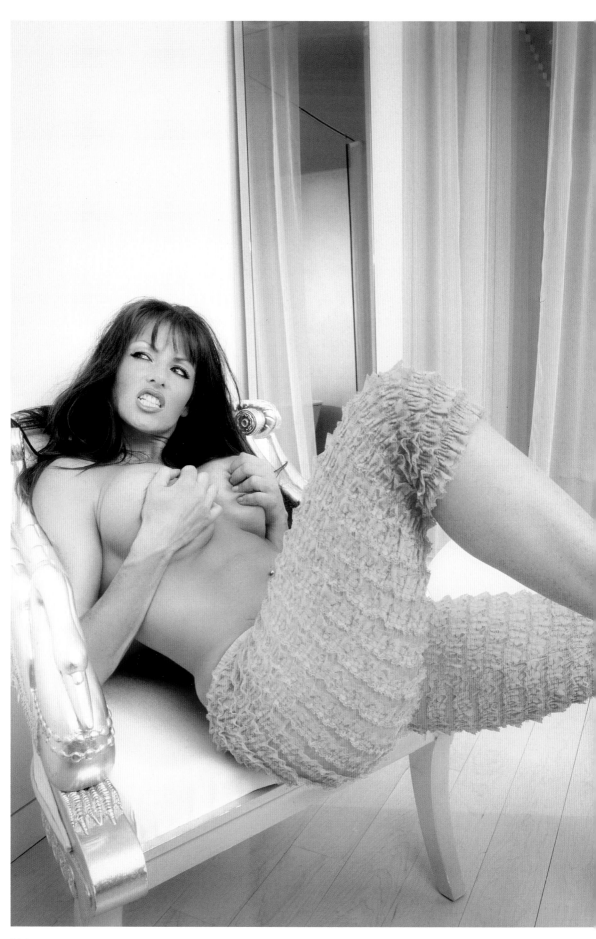

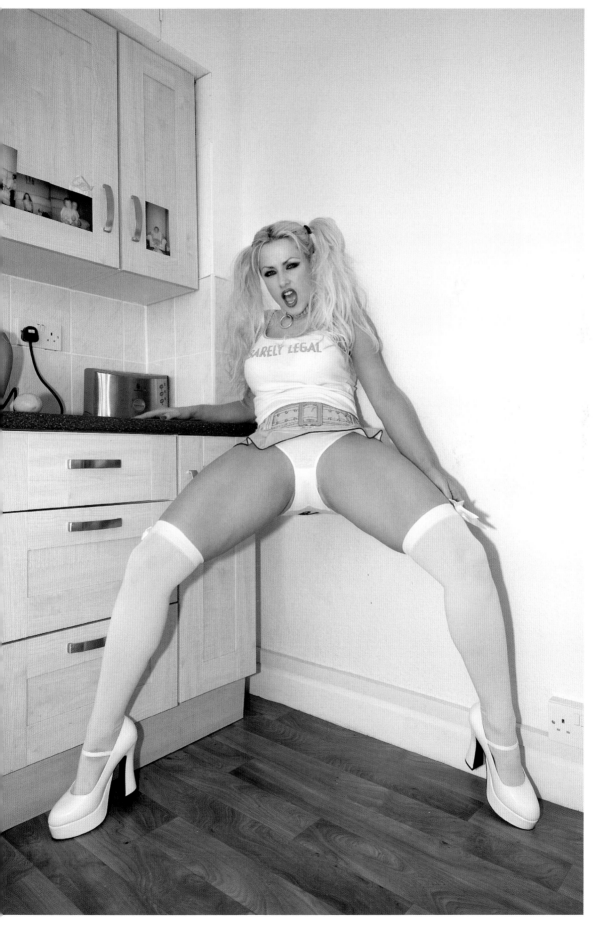

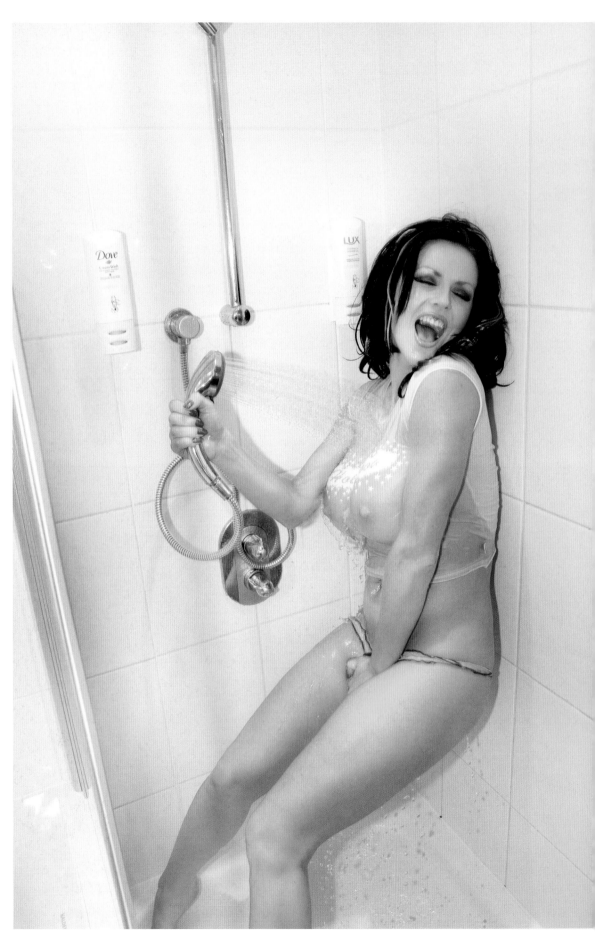

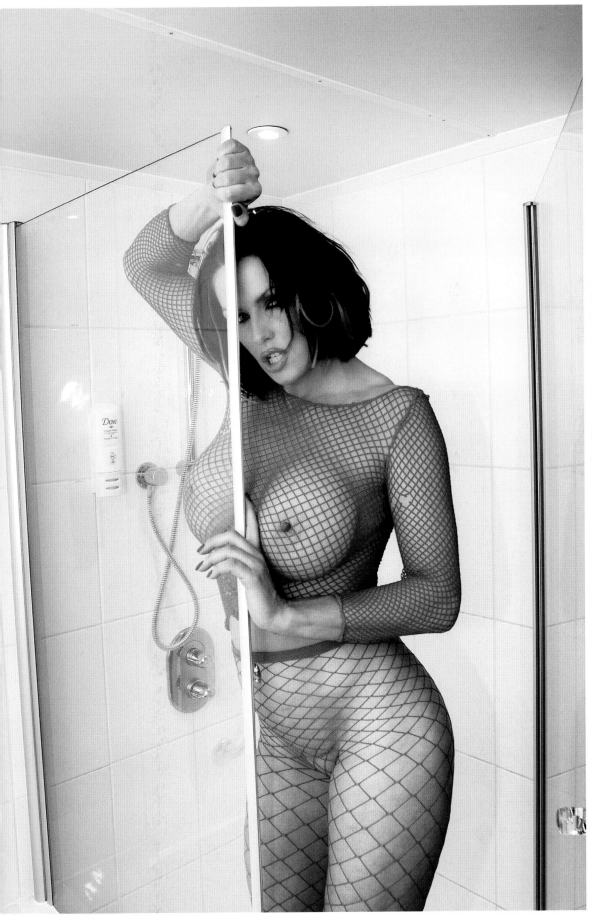

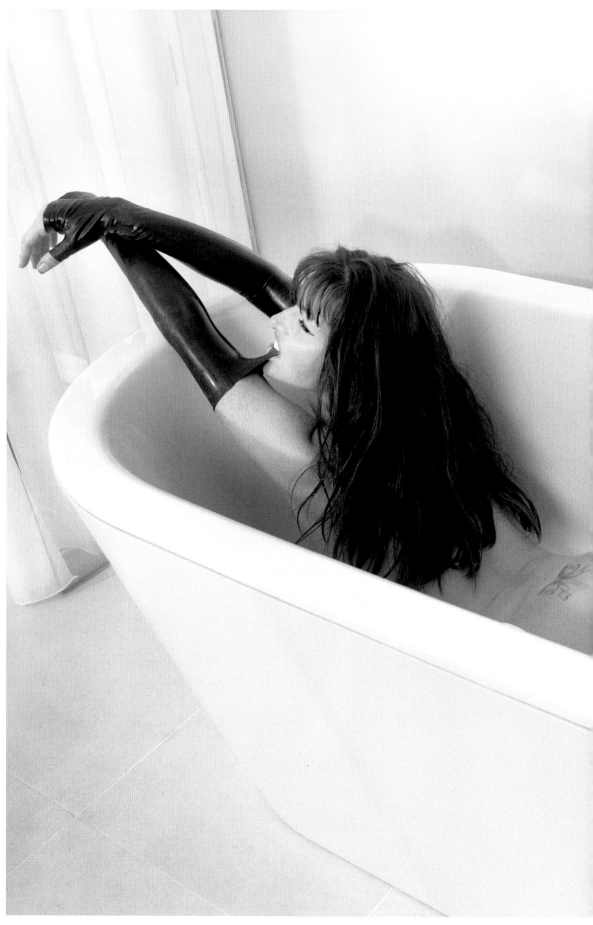

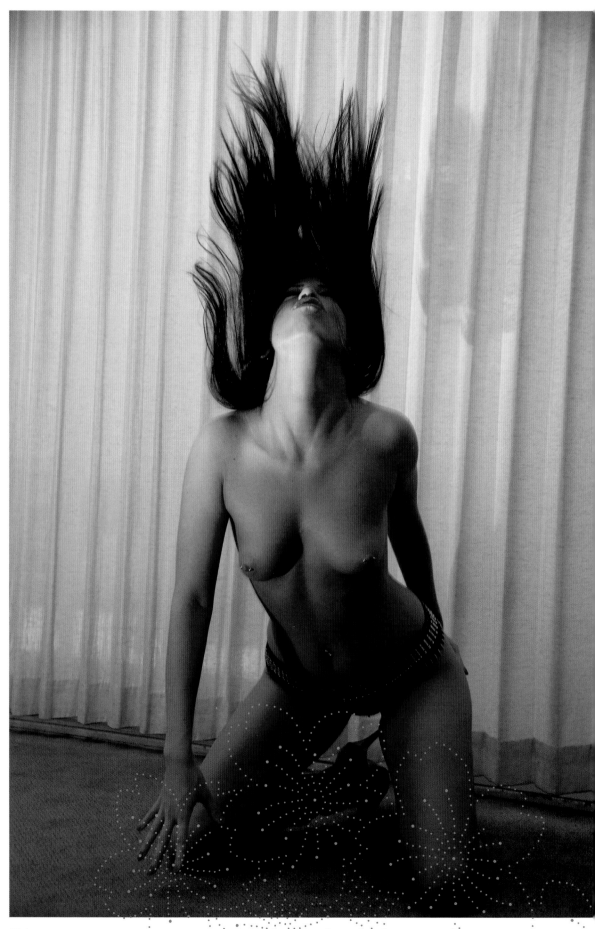

Roxy DeVille

Photos by Sexkicks

Name: Roxy DeVille

Birthday: November 8, 1982

Birthplace: Chicago, IL, USA

What was your childhood ambition? I wanted to work in a beauty shop.

Where do you live? Los Angeles, CA

Where would you like to live? Someplace tropical

How did you become a model? I started dancing, then I wanted to move into fetish-modeling. Unfortunately, there is very little money to be made in fetish, so I moved into adult.

Where do you see yourself in ten years time? Hopefully married with a few kids, owning a beauty shop.

VIP from movie or music biz would you like to date? Bob Saget, Glenn Danzig

What vice can you never forgive? I'm a very unforgiving person. I hate booze and drugs and I don't tolerate cheaters.

Daily sins, I cannot resist: Expensive coffee and sweatpants

Favorite Band: Smoking Popes

Turn-ons: A man who knows how to fix stuff.

Turn-offs: Men who care about fashion or dye their hair.

Is there anything you would never do again? Go camping.

What good advice could you give to other models? Beauty won't last forever. Have a backup plan.

Democrat, Republican, Green Party or other? N/a

Things that make me happy: My family, my dogs and a good make-up artist

Website/Myspace: www.myspace.com/RoxyDeVille

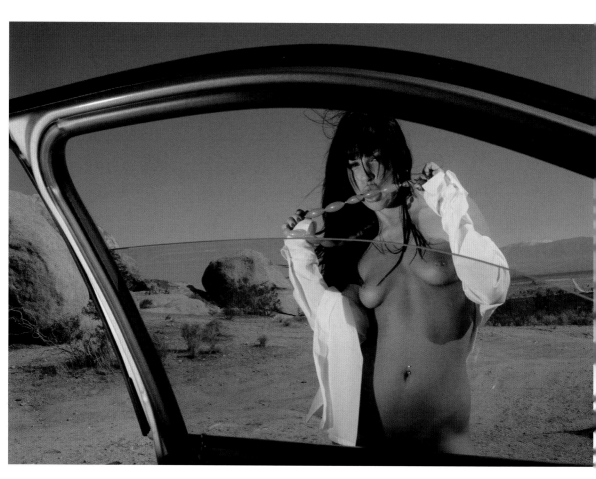

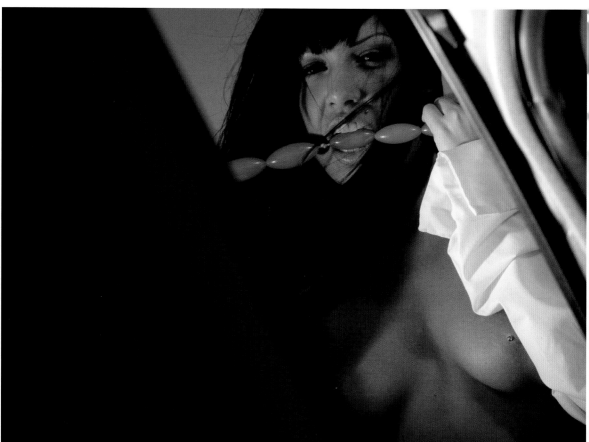

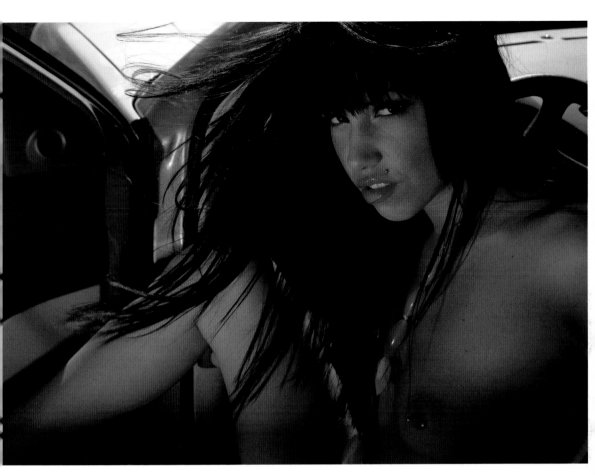

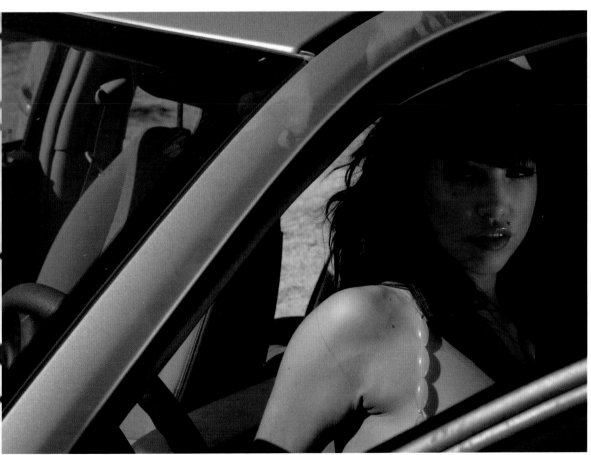

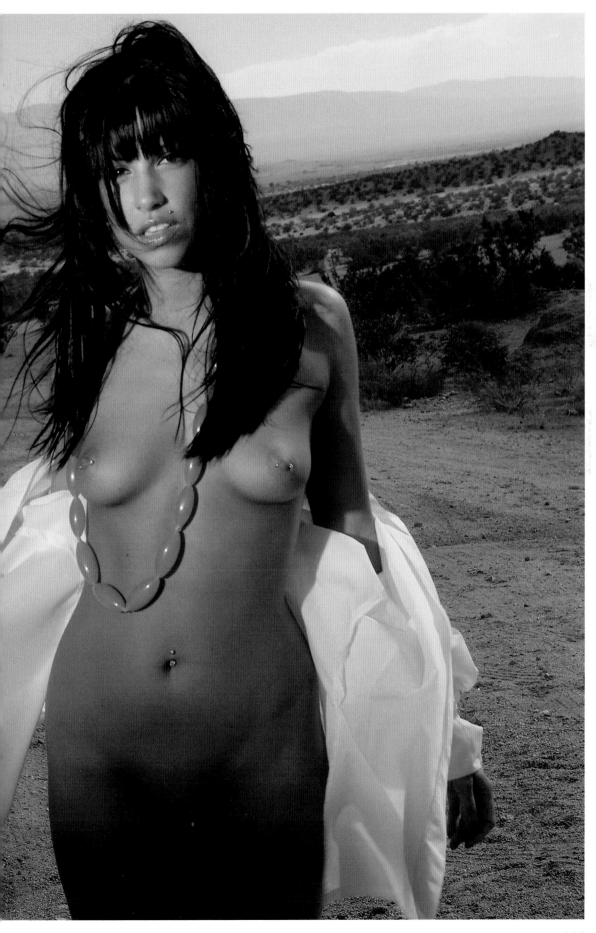

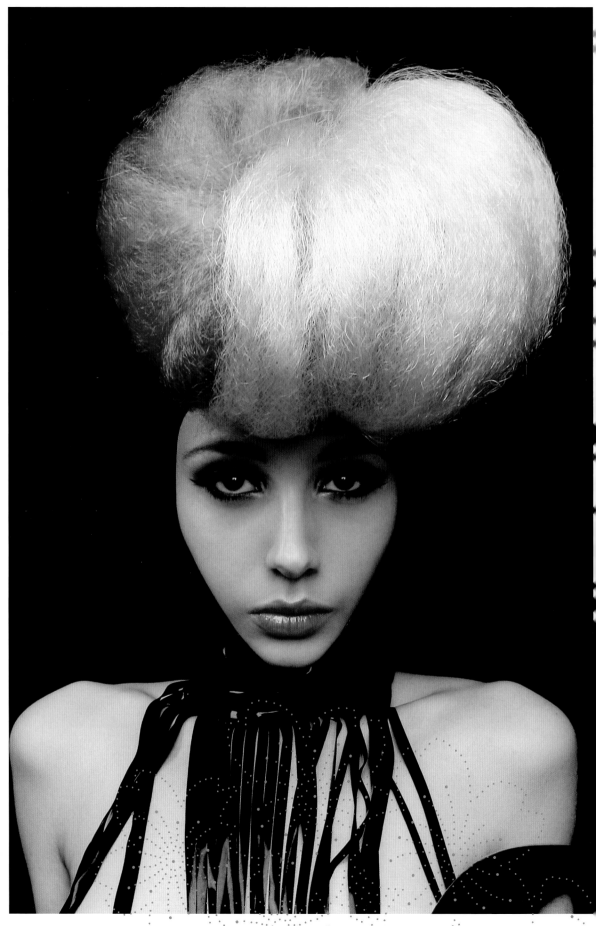

Ulorin Vex

Photos by Katja Ehrhardt

Name: Ulorin Vex

Birthday: August 5

Birthplace: Newcastle, UK

What was your childhood ambition? I think, I wanted to be a vet or something involving horse riding.

Where do you live? Somerset, UK

Where would you like to live? I like it where I am but I want to travel more, see more of the USA and Far East

How did you become a model? I just thought it would be fun! I contacted a local photographer to shoot me, then I put the pictures online and eventually people started asking me to model for them.

Where do you see yourself in ten years time? I don't really plan that far ahead, I'll just see what happens.

VIP from movie or music biz would you like to date? Nobody really... but maybe Al Pacino, he is really sexy!

What vice can you never forgive? I would probably forgive most things once, except prejudice and racism.

Daily sins, I cannot resist: I have an awful habit of eating really unhealthy food, does that count?

Favorite Band: Q Lazzarus, Adam Ant, New Order, Dolly Parton

Turn-ons: Wearing latex and high heels, of course :-)

Turn-offs: Smoking, dishonesty, excessive arrogance

Is there anything you would never do again? Eat pizza with pineapple on it. Yuk!

What good advice could you give to other models? Be prepared to invest in your career and portfolio quality is better than quantity! Also keep another job until you are established, so you can be selective about who you work with.

Democrat, Republican, Green Party or other? Uninterested!

Things that make me happy: Drawing and painting, friends and family

Website/Myspace: www.ulorinvex.com

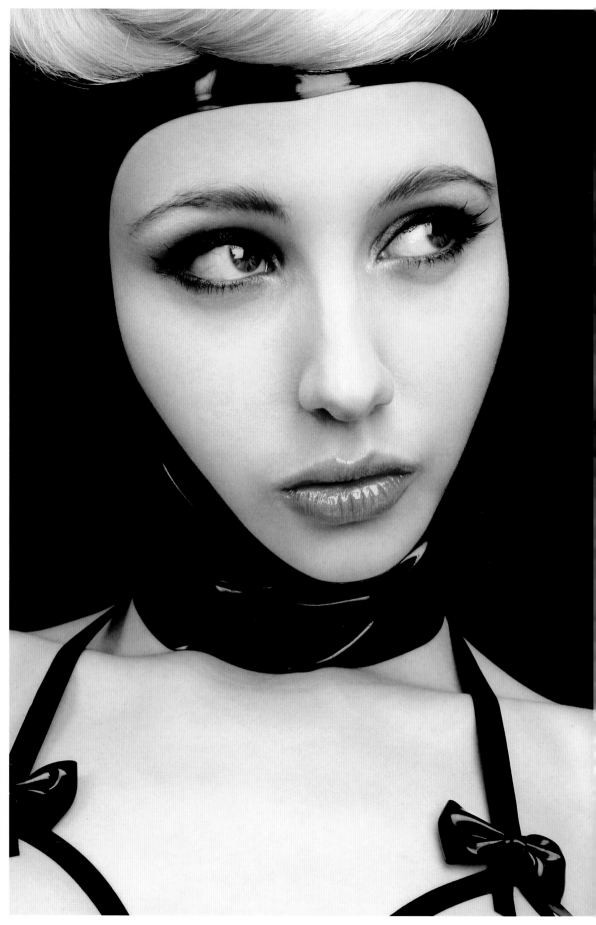

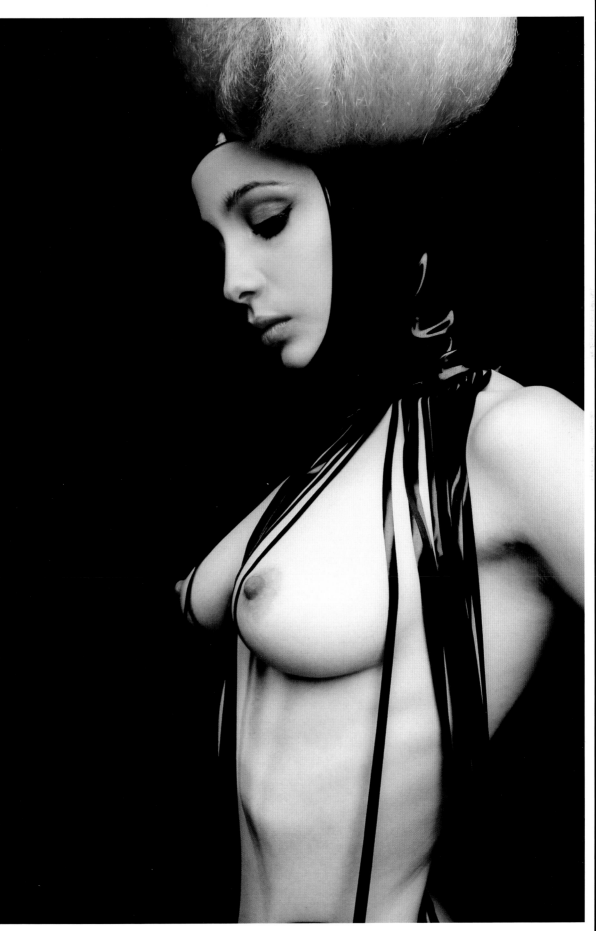

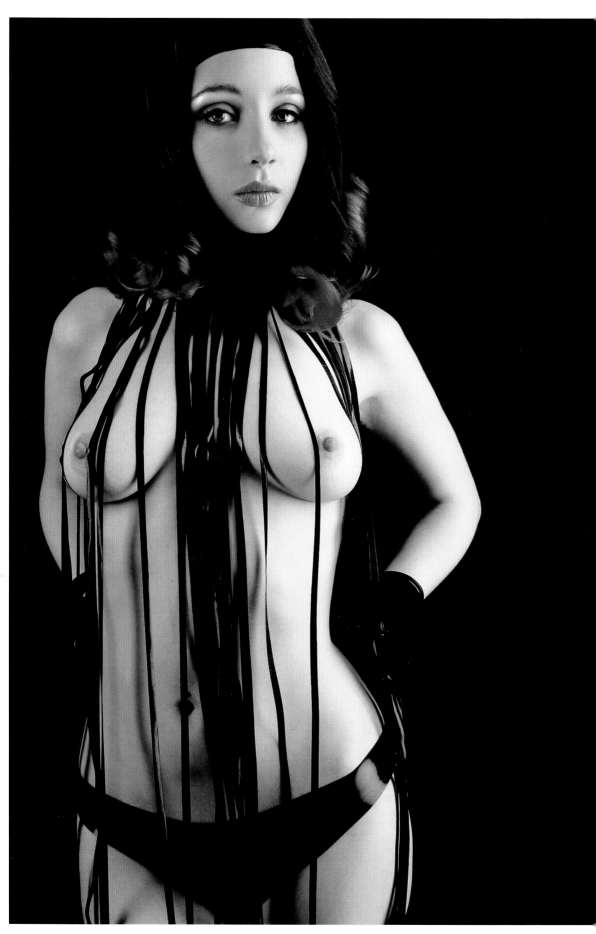

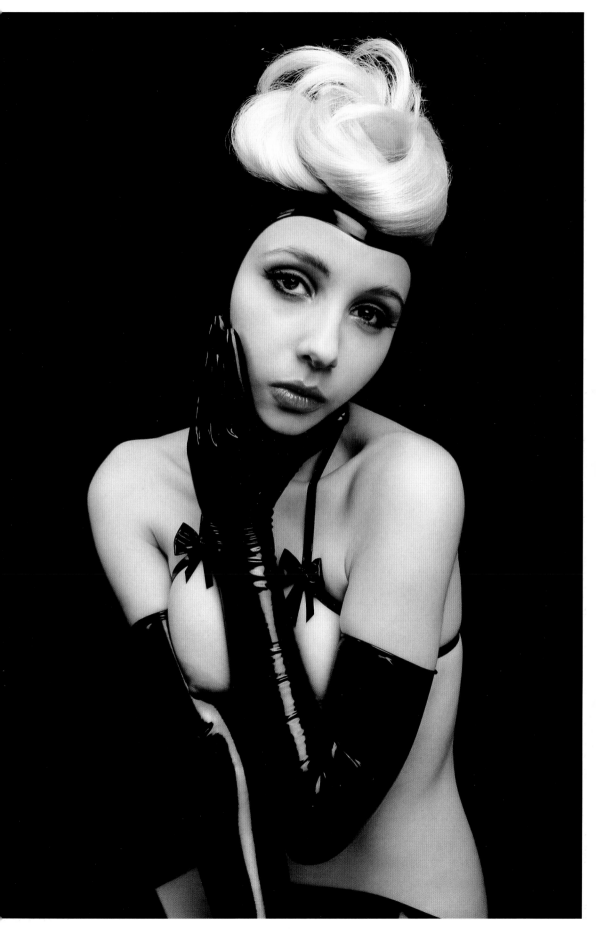

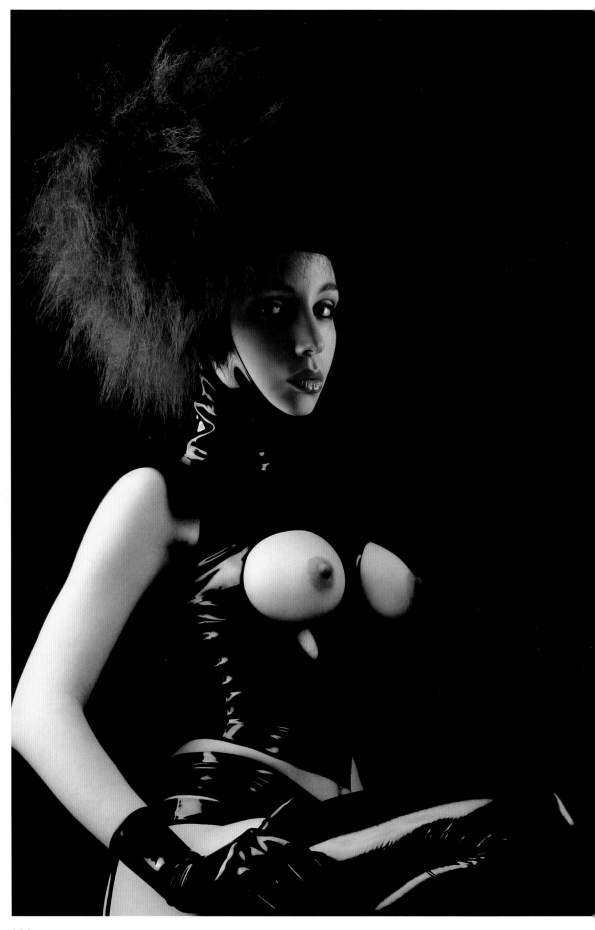

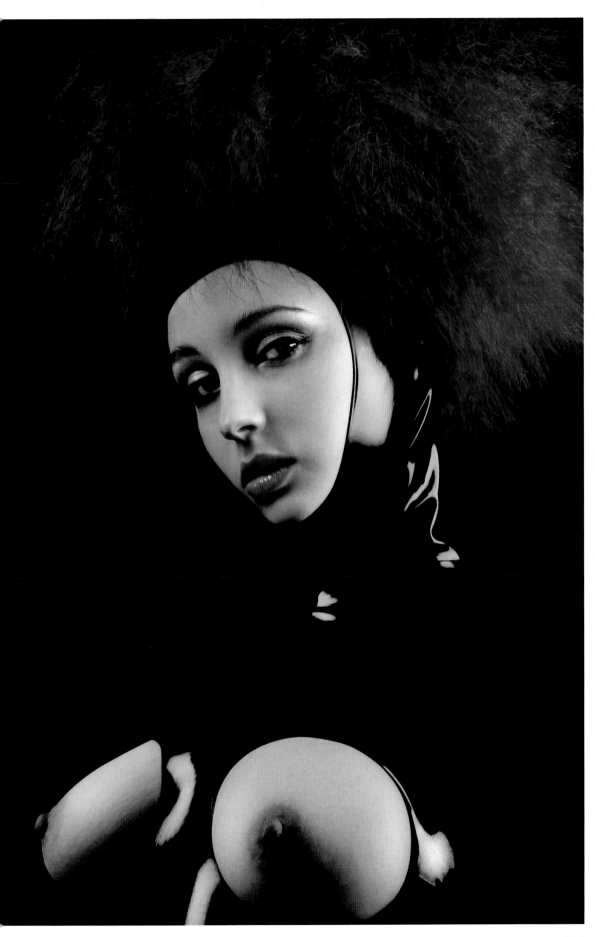

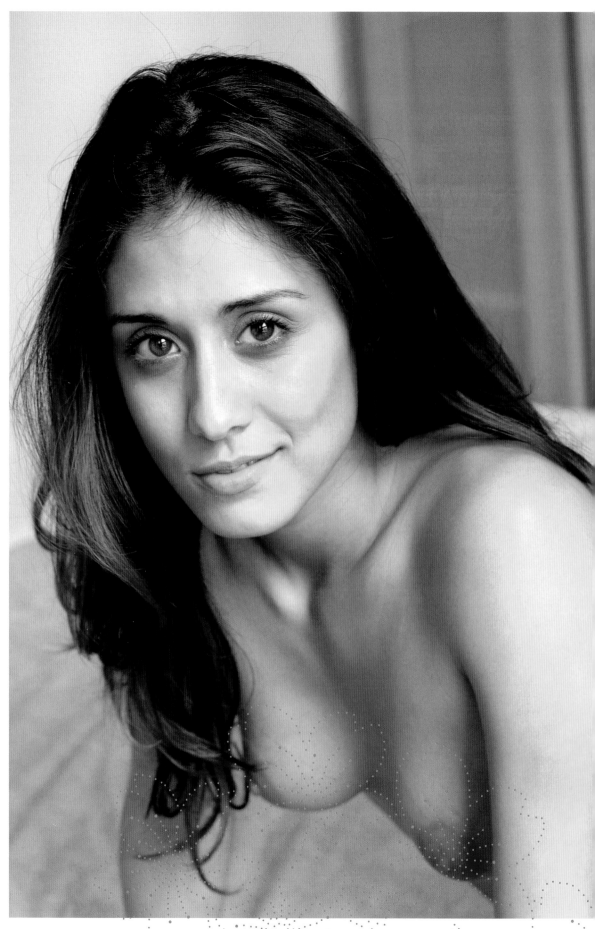

Lorina
Photos by Andrew Einhorn

Name: Lorina

Birthday: July 28, 1984

Birthplace: Fort Lewis, WA — I'm an army brat!

What was your childhood ambition? I've always wanted to teach elementary school, but there was a period where I really wanted to be a truck driver. Weird, I know...

Where do you live? I live in the now infamous Hamptons. It's actually kind of funny, because when I tell people where i'm from, they automatically assume that I'm a little rich girl. The truth of the matter, though, is that if you come here you're rich — if you're from here you're one of those who serve the rich, haha.

Where would you like to live? California!! I'm a total jeans-and-hoodies-and-socks-with-sandals type.

How did you become a model? Actually, it happened by accident. One of my roommates about two summers ago was a photographer. We did some shoots for him to practice his figure studies and lighting techniques and it sort of took off from there.

Where do you see yourself in ten years time? On the west coast with my man & my two cats and maybe a dog & a perfect little house and a herb garden (wink, wink) & a shitload of tattoos. Was that a run-on sentence?

VIP from movie or music biz would you like to date? I think i'm pretty good with who I have right now... except maybe Angelina Jolie — bitch is SMOKIN!!

What vice can you never forgive? The ol' Mary J. Love the ho.

Daily sins, I cannot resist: I must admit, I talk a lot of shit — It's always about the people who summer in the Hamptons. But it's really not that bad, because if you saw them you'd SO understand.

Favorite Band: No favorite band, but favorite singer is Erykah Badu. I'm not really a fan of her performances — they're a little too intense for me, but the music she makes is amazing.

Turn-ons: Long hair and sketchiness

Turn-offs: People who can't make fun of themselves or who have the need to feel like an authority on EVERYTHING.

Is there anything you would never do again? No, not really. There's always the chance that things will be better the next time you do them.

What good advice could you give to other models? Always have a backup plan. You don't want to end up old and ugly AND stupid.

Democrat, Republican, Green Party or other? D: None of the above

Things that make me happy: Kids, animals, muscle cars and intelligent design/gadgets.

Website/Myspace: www.myspace.com/blizzyface

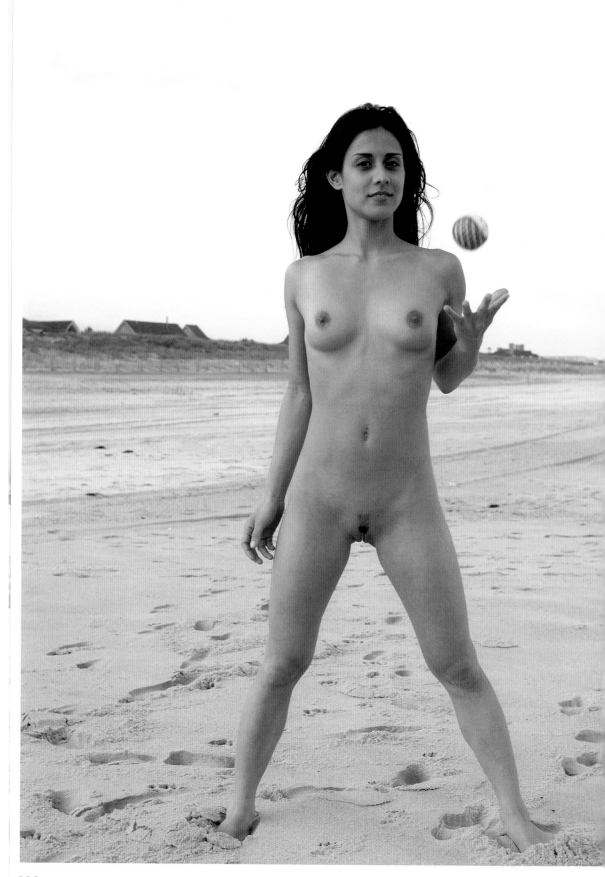

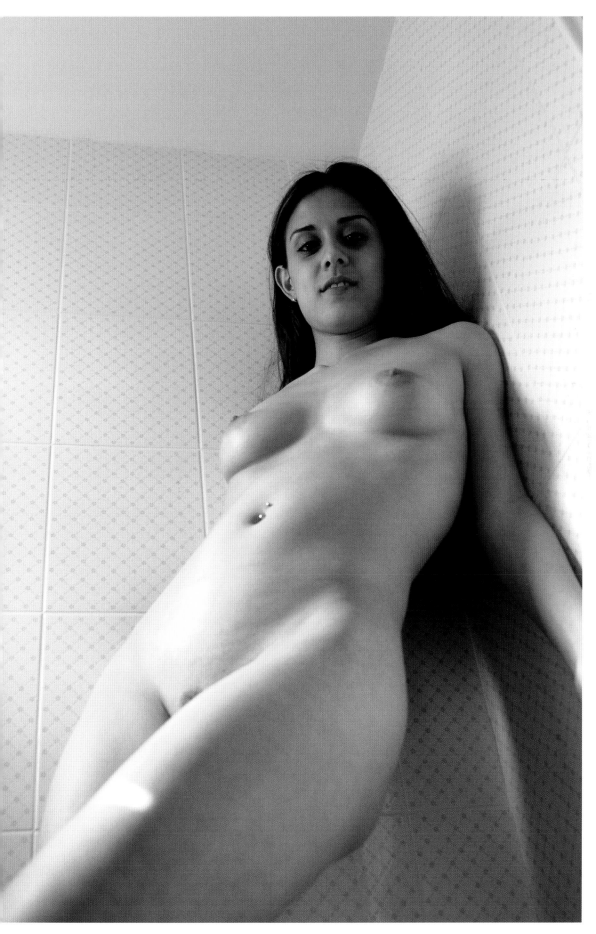

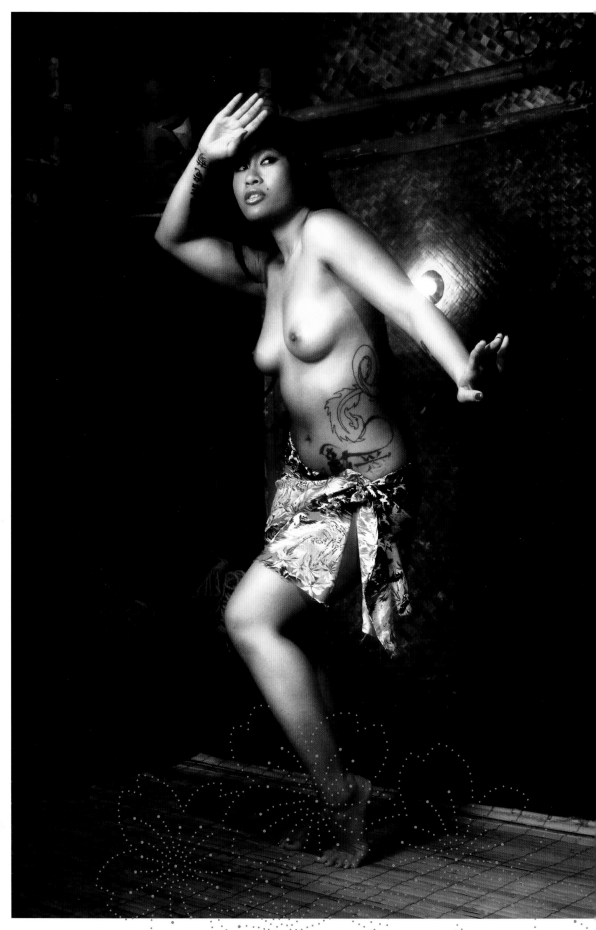

Dragonlily
Photos by Octavio Arizala

Name: Dragonlily

Birthday: August 1, 1979

Birthplace: Honolulu, Hawaii

What was your childhood ambition? I've always wanted to be an artist and be surrounded by art.

Where do you live? Las Vegas, Nevada

Where would you like to live? I would love to live in France. Everytime I visit I'm fascinated by the culture and the people.

How did you become a model? After moving to Las Vegas, I worked a few crap jobs here in Vegas and then out of boredom and lack of monetary funding before the holidays, I turned to the naked good times of online private cams. From there, well, my site is what has come of all of that.

Where do you see yourself in ten years time? Happily founded with family

VIP from movie or music biz would you like to date? Wentworth Miller

What vice can you never forgive? I cannot tolerate nor forgive child abuse and sexual assault.

Daily sins, I cannot resist: I absolutely love dried fruit ... pineapple and coconut, papayas

Favorite Band: The Silence and Portishead

Turn-ons: Open mindedness. Multi-dimensional personalities. Sense of Humor (understands sarcasm/not the obnoxious clowning type). Someone who can appreciate the freedom of not knowing where your next meal is coming from, but still manages to dream. Creativity.

Turn-offs: Racists. Bigots. Sexists. Obnoxiousness. Fabricated personalities

Is there anything you would never do again? Denying myself the company of friends and the good people I meet. It's easy to become reclusive in this business.

What good advice could you give to other models? To never lose their own individuality and style.

Democrat, Republican, Green Party or other? Independent

Things that make me happy: Friends, family and my two dogs.

Website/Myspace: www.dragonlily.net, www.myspace.com/dragonlilydotnet

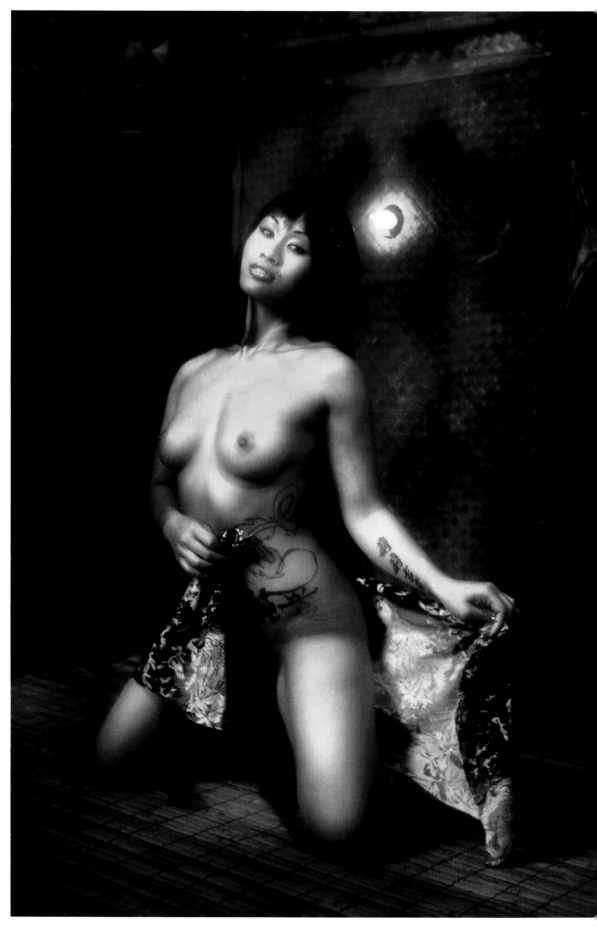

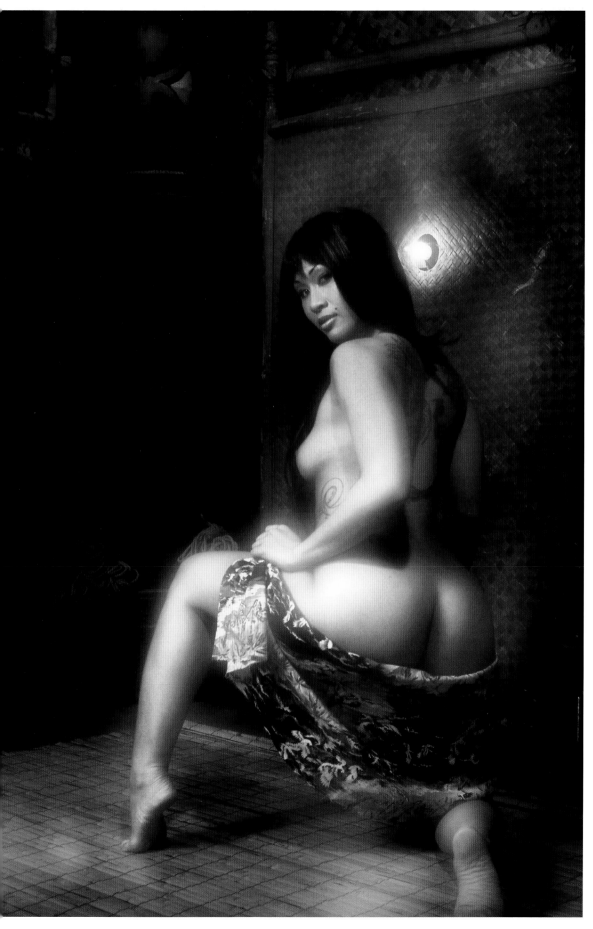

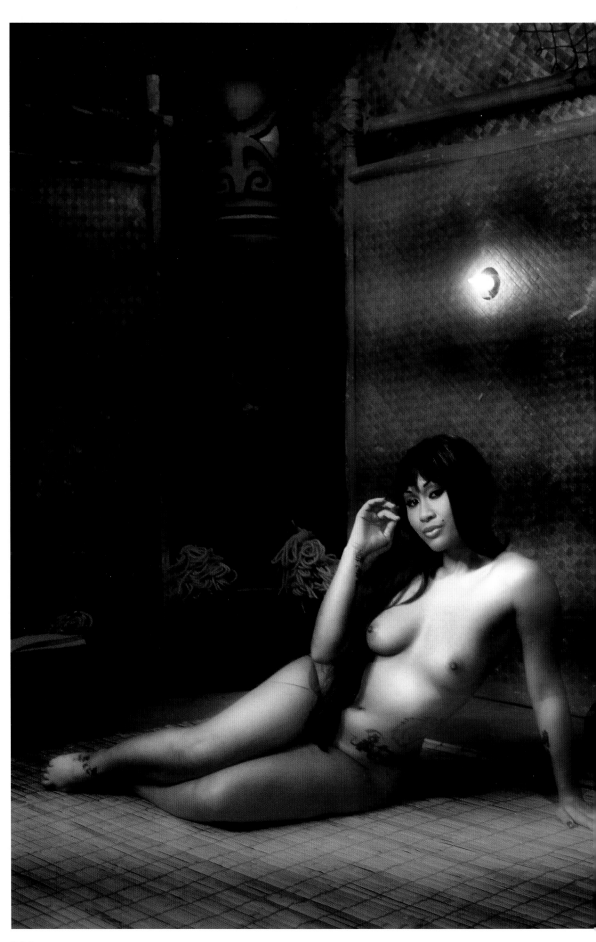

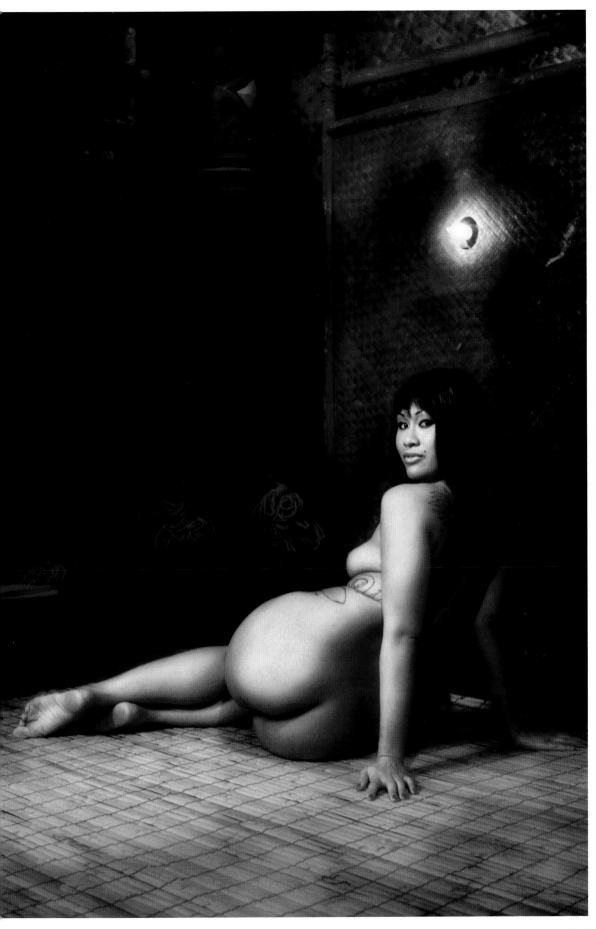

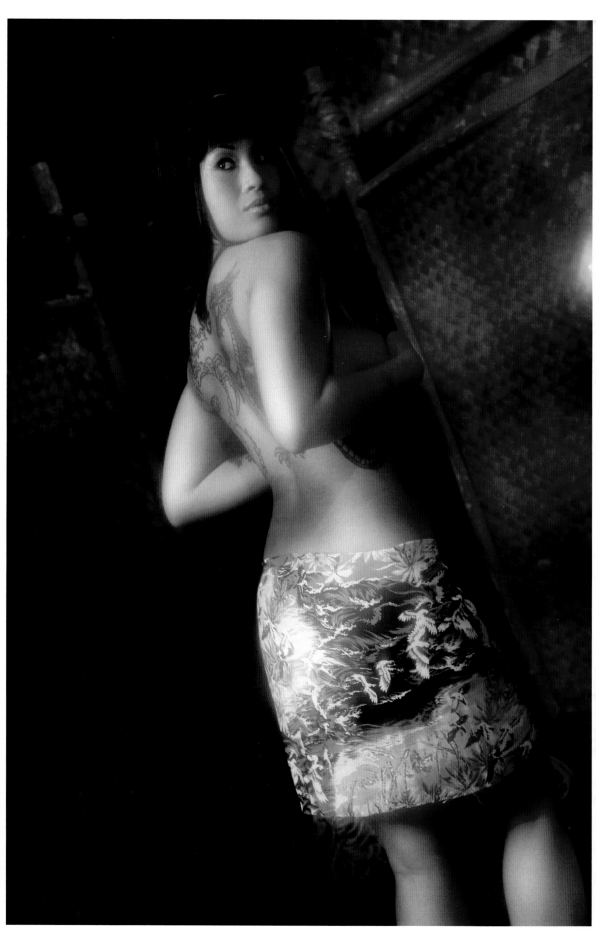

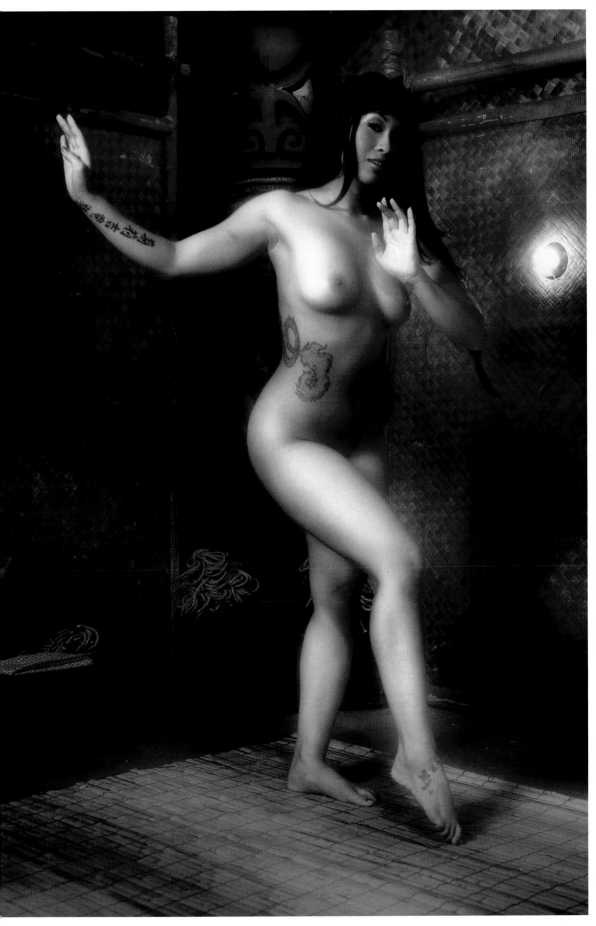

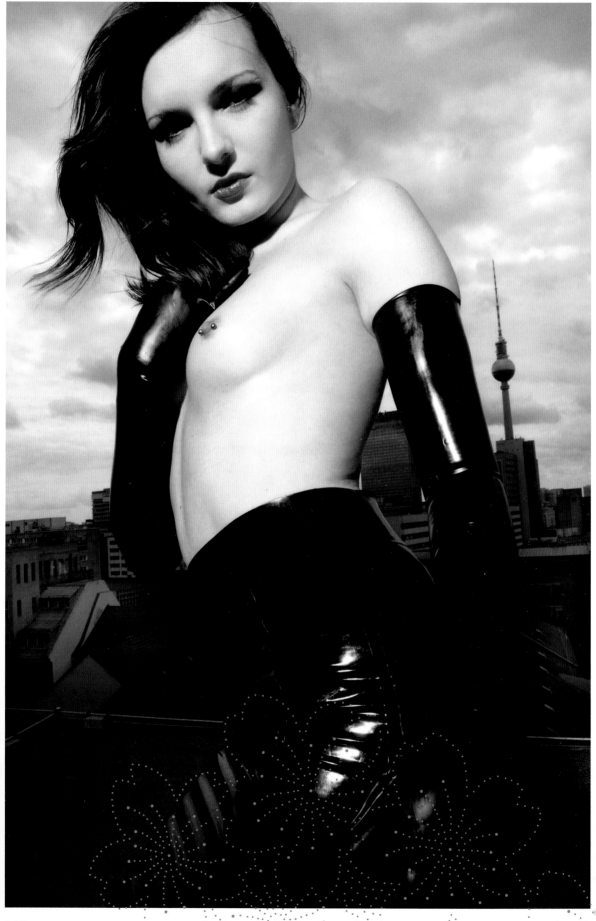

Nola

Photos by Gili Shani

Name: Nola

Birthday: August 2, 1986

Birthplace: Kyritz, Germany

What was your childhood ambition? Flight attendant, because of the uniforms

Where do you live? Berlin

Where would you like to live? Italy, because of the landscape and the food.

How did you become a model? I was interested in getting images of me from a professional photographer, that's how it started.

Where do you see yourself in ten years time? Not in front of the camera anymore.

VIP from movie or music biz would you like to date? Johnny Depp

What vice can you never forgive? Any kind of lies

Daily sins, I cannot resist: Cigarettes

Favorite Band: At the moment: The Beatsteaks

Turn-ons: Latex, a good cold beer, interesting conversations, travelling, good books and movies

Turn-offs: Bad weather, waiting for something, war, some TV-shows

Is there anything you would never do again? I can't remember or maybe I don't want to.

What good advice could you give to other models? Have fun, be reliable, stay grounded

Democrat, Republican, Green Party or other? Green

Things that make me happy: My boyfriend, my family and friends, my cute cats

Website/Myspace: www.nola-nola.com - www.myspace.com/nolabln

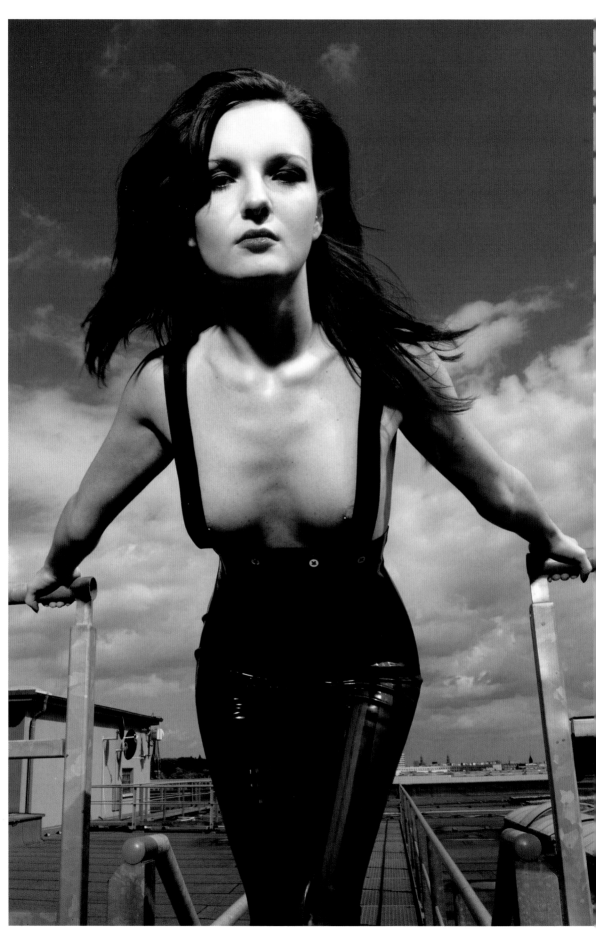

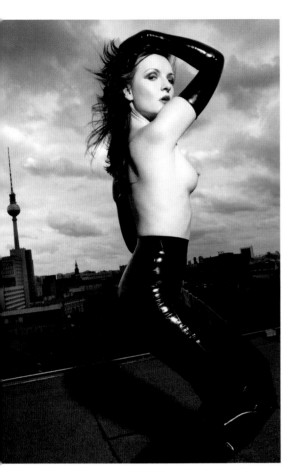
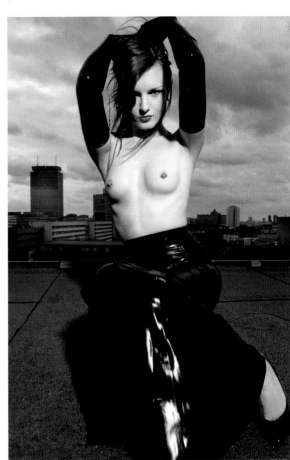
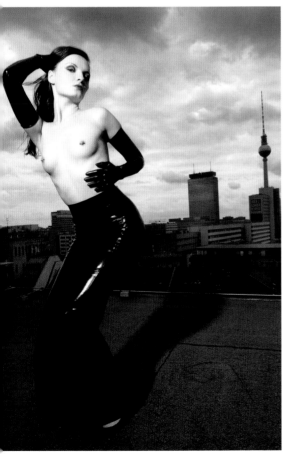
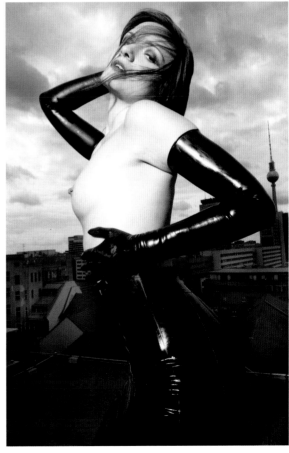

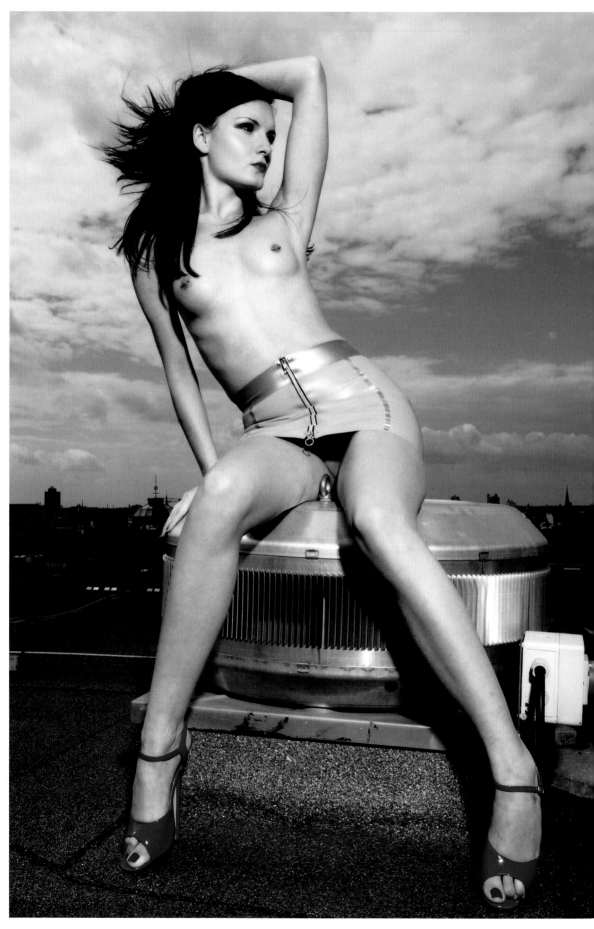

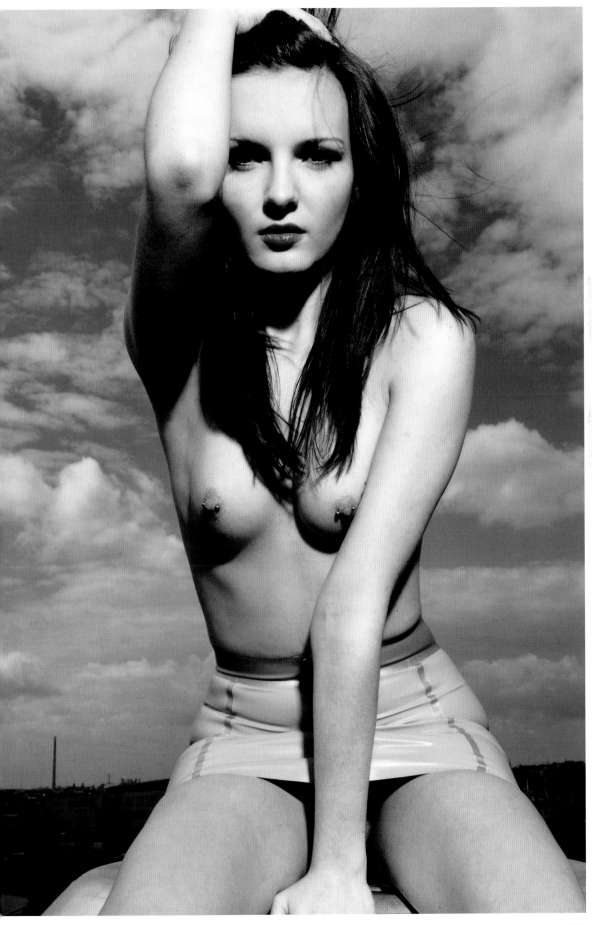

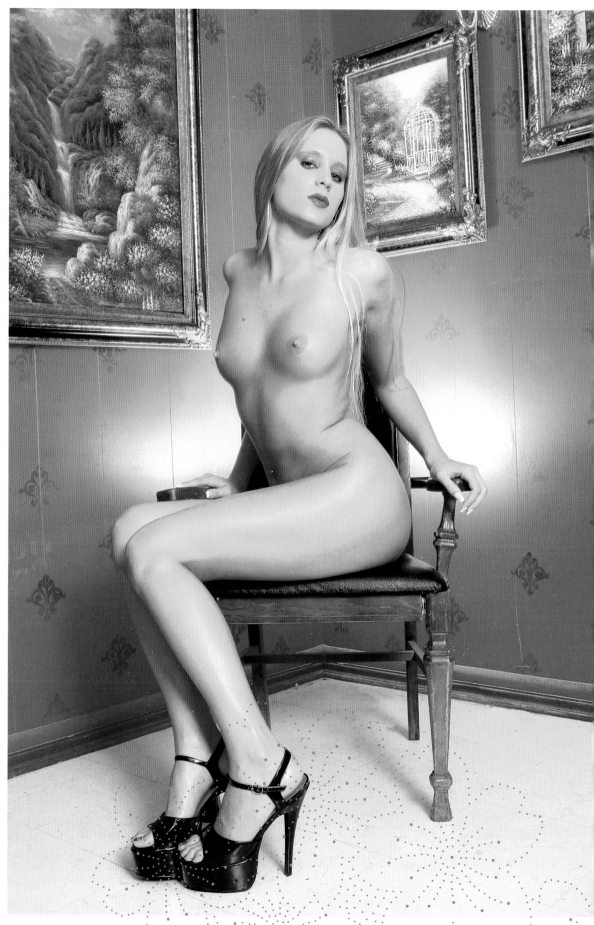

Layley

Photos by John Donegan

Name: Layley

Birthday: December 1, 1982

Birthplace: England

What was your childhood ambition? To be famous

Where do you live? England

Where would you like to live? All over the world

How did you become a model? Photographer John Donegan discovered me

Where do you see yourself in ten years time? Wherever life's journey takes me

VIP from movie or music biz would you like to date? Brad Pitt

What vice can you never forgive? Unkindness.

Daily sins, I cannot resist: Chocolate

Favorite Band: Beyoncé

Turn-ons: Music, the beach, politeness, a great sense of humor

Turn-offs: People, who do not appreciate and respect erotic beauty, bad manners, fake people

Is there anything you would never do again? Maybe

What good advice could you give to other models? Always be yourself. Do not pose.

Democrat, Republican, Green Party or other? Liberal

Things that make me happy: Family and friends

Website/Myspace: www.discoveringlayley.com

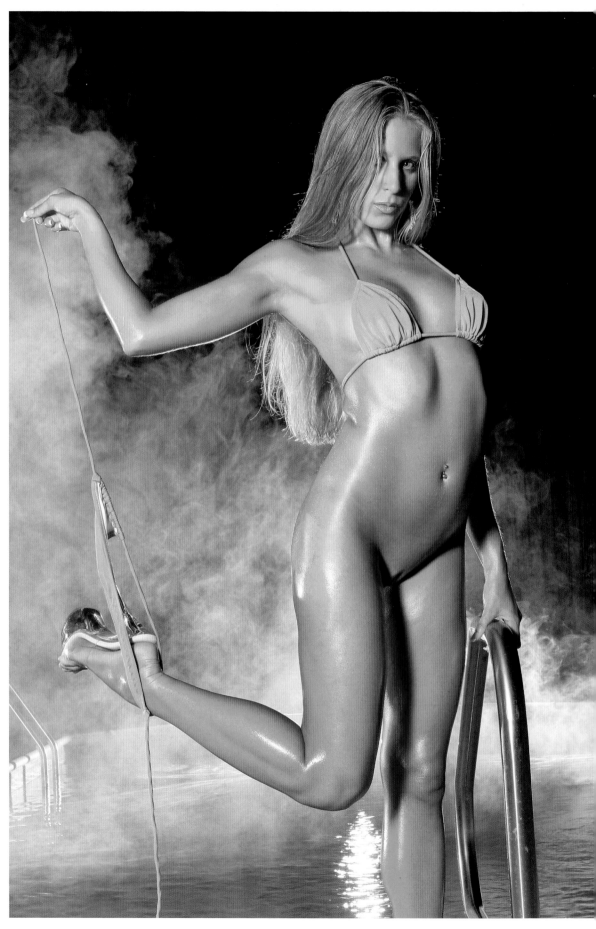

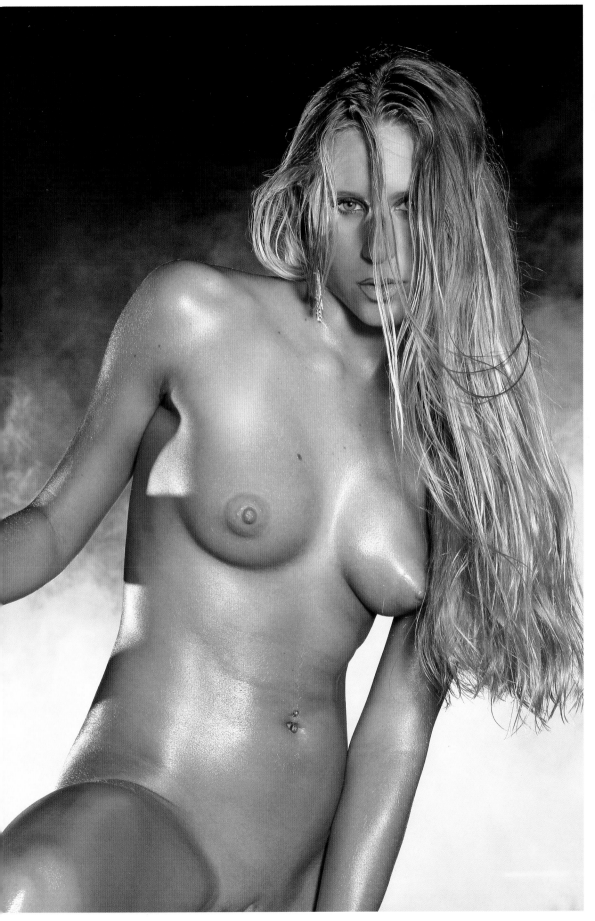

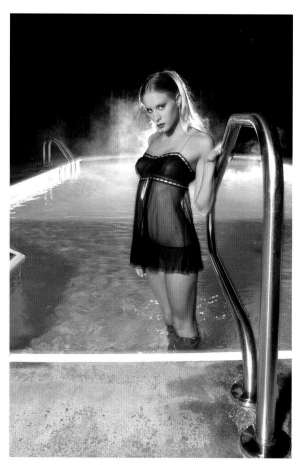

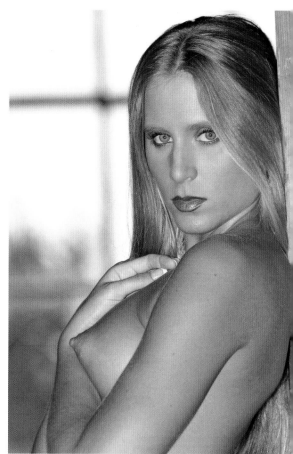

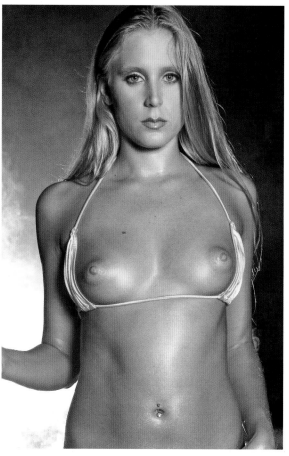

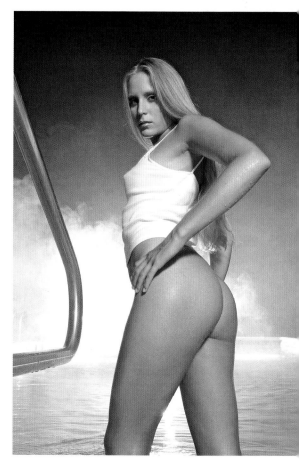

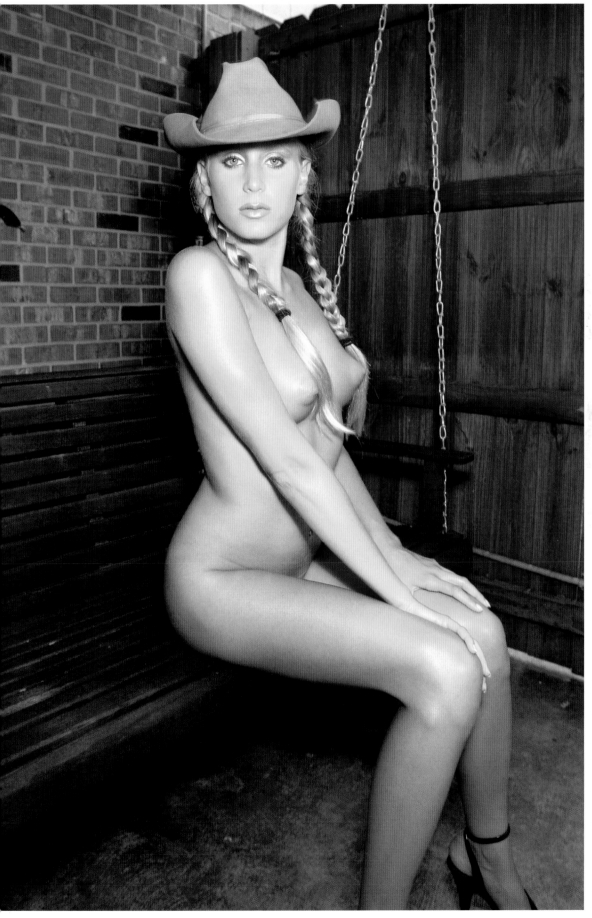

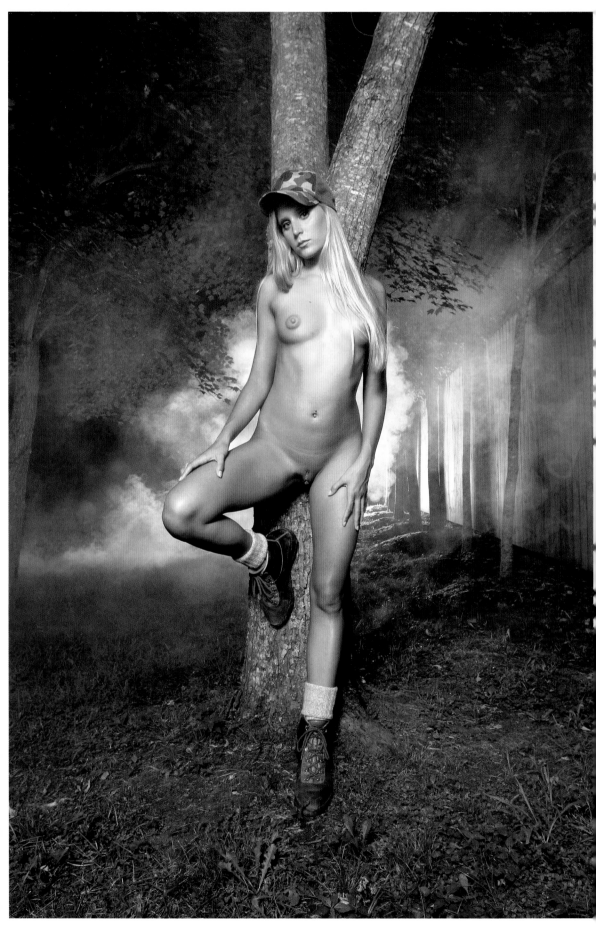

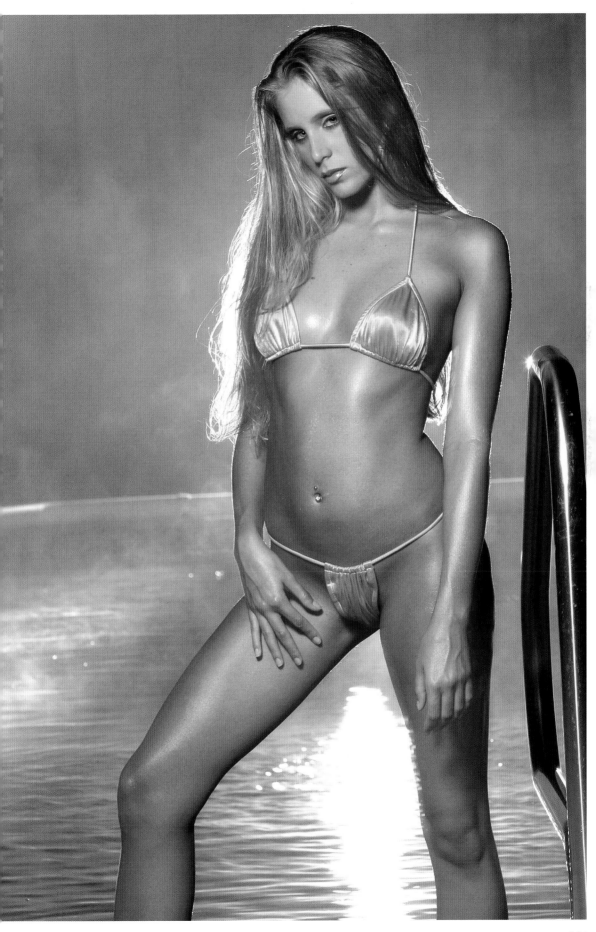

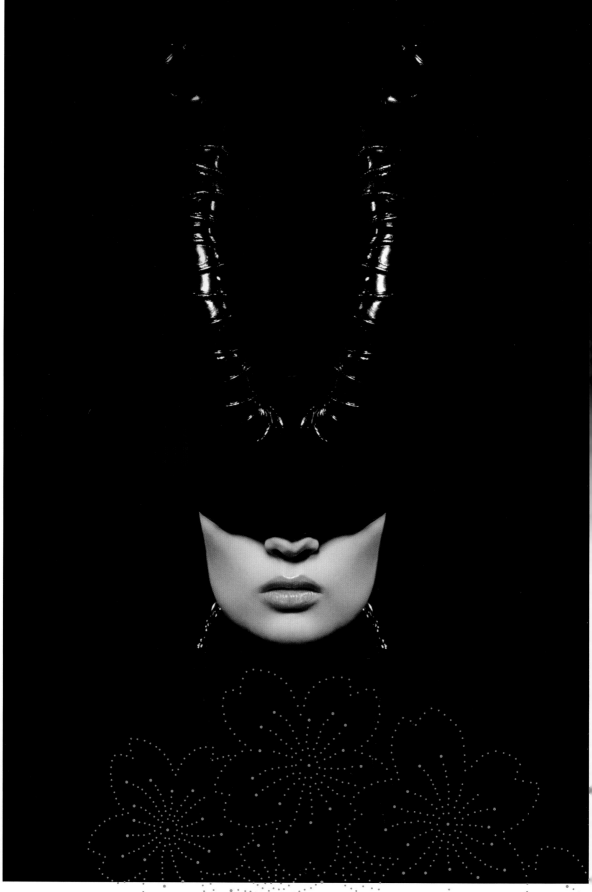

Ulorin Vex

Photos by Russel Coleman

Name: Ulorin Vex

Birthday: August 5

Birthplace: North East, UK

What was your childhood ambition? Something to do with caring for animals

Where do you live? South West, UK

Where would you like to live? In a large beautiful country estate with it's own stables. I don't mind location, I enjoy traveling.

How did you become a model? I just asked someone to take my photo, then I put the pictures online. Eventually people started to ask me to model for them.

Where do you see yourself in ten years time? I don't really plan that far ahead right now. Hopefully I will have my own country estate and travel the world regularly. :-)

VIP from movie or music biz would you like to date? Marc Warren

What vice can you never forgive? I'm a pretty forgiving person as long as you are genuinely sorry!

Daily sins, I cannot resist: Junk food and excessive use of the internet

Favorite Band: Adam and The Ants

Turn-ons: Honesty, sense of humour, high heels and pretty lingerie

Turn-offs: Arrogance and poor hygiene

Is there anything you would never do again? Shave off all the underside of my hair

What good advice could you give to other models? Take good care of yourself and always pay attention to detail in shoots.

Democrat, Republican, Green Party or other? Apathetic

Things that make me happy: Traveling, good food, good books and artwork / drawing

Website/Myspace: www.ulorinvex.com

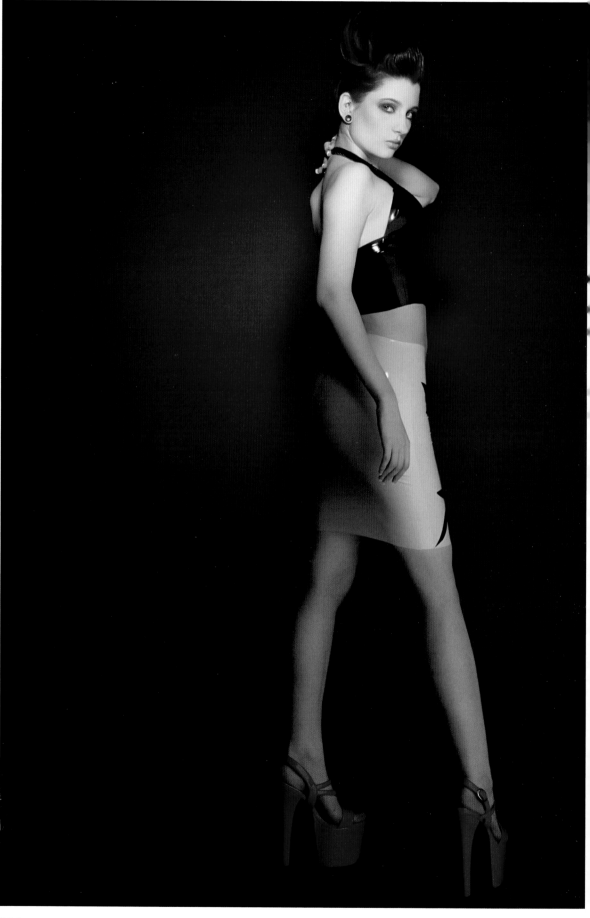

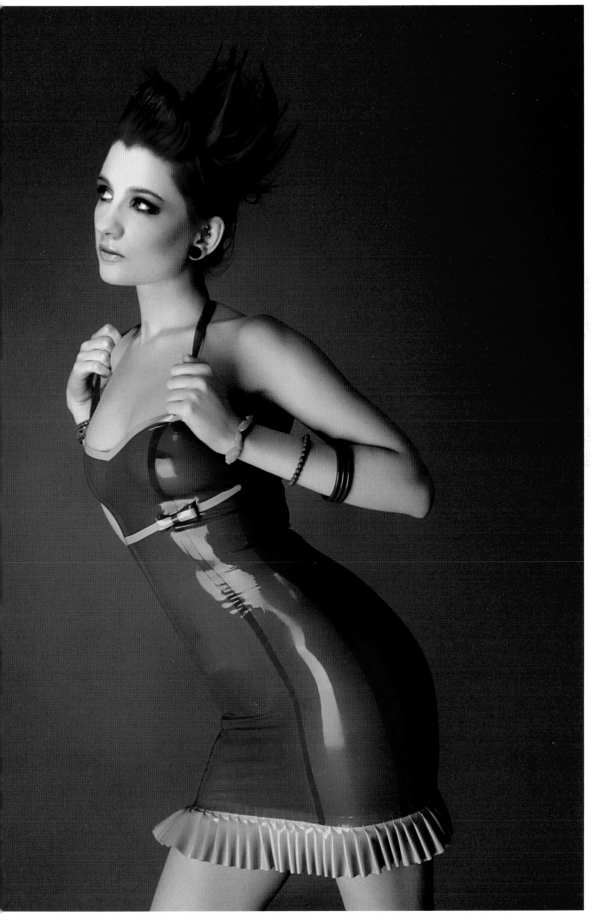

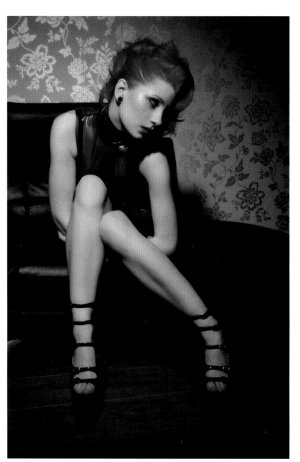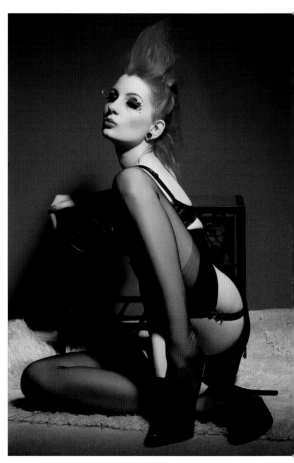

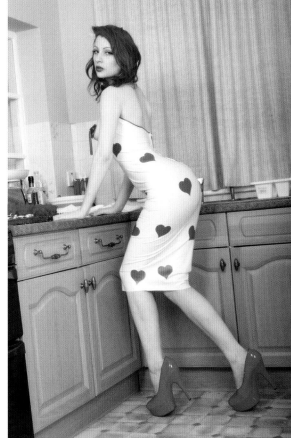

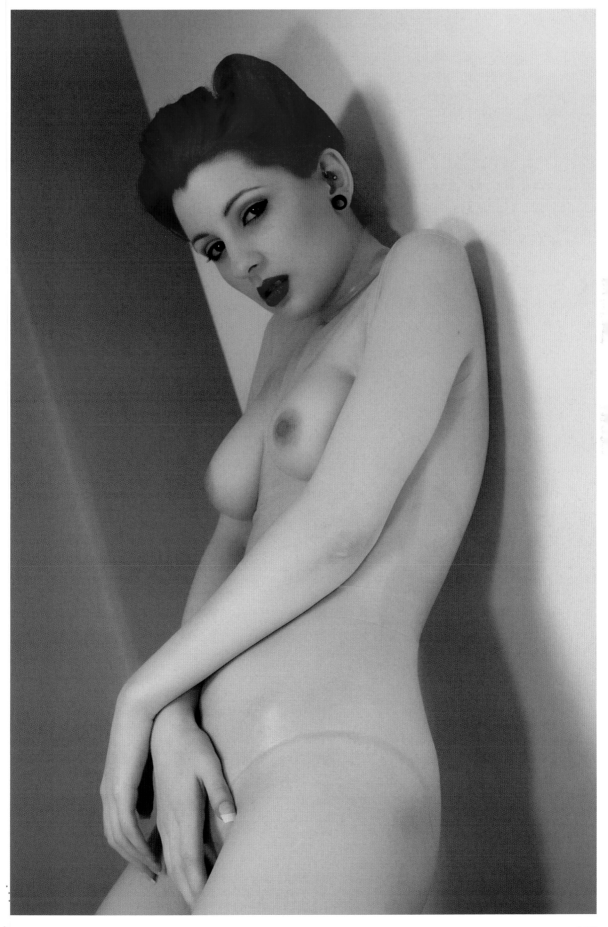

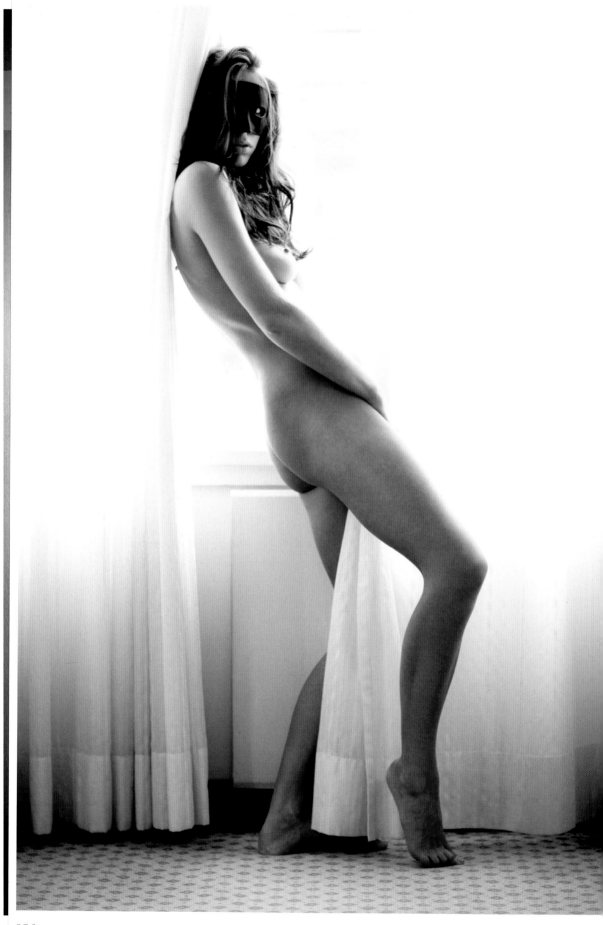

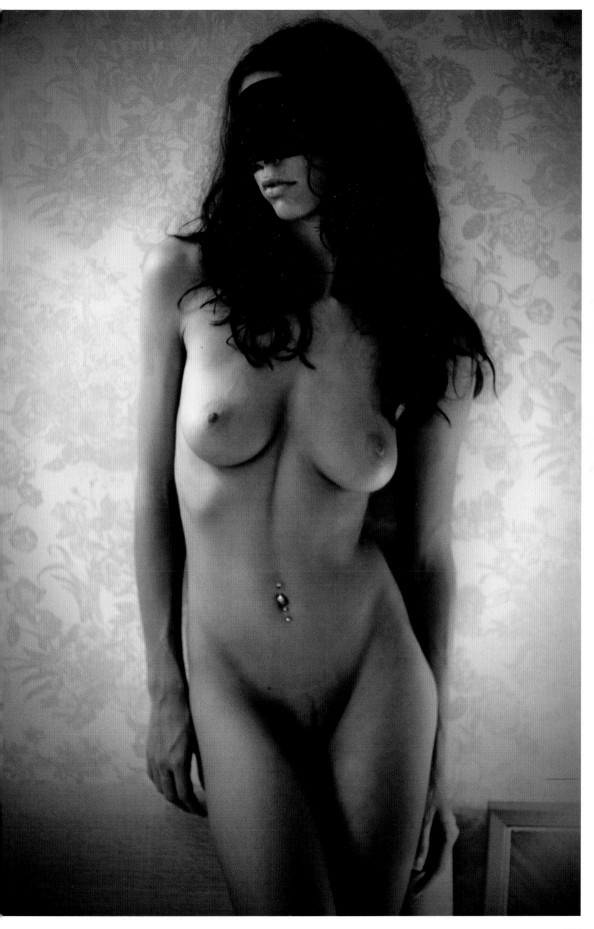

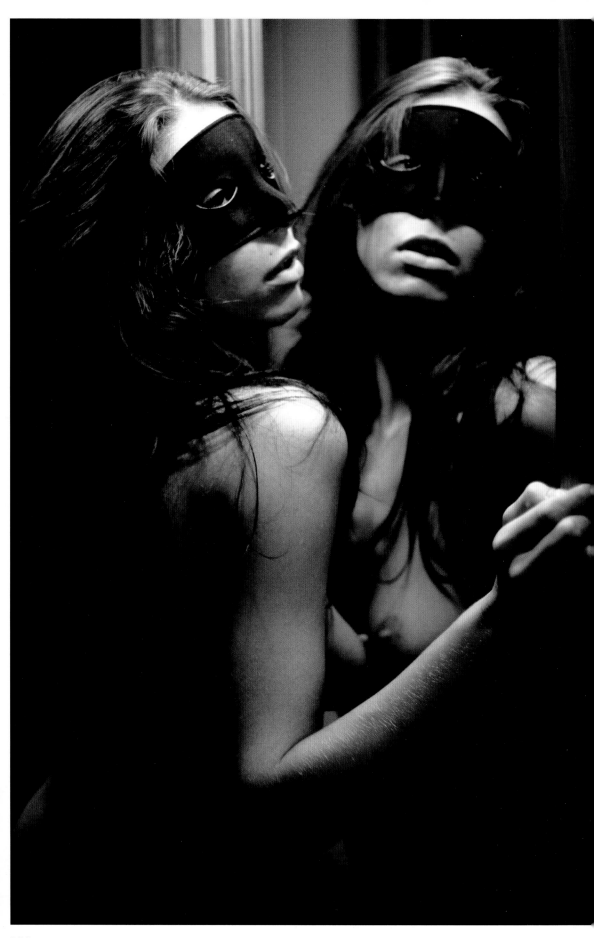

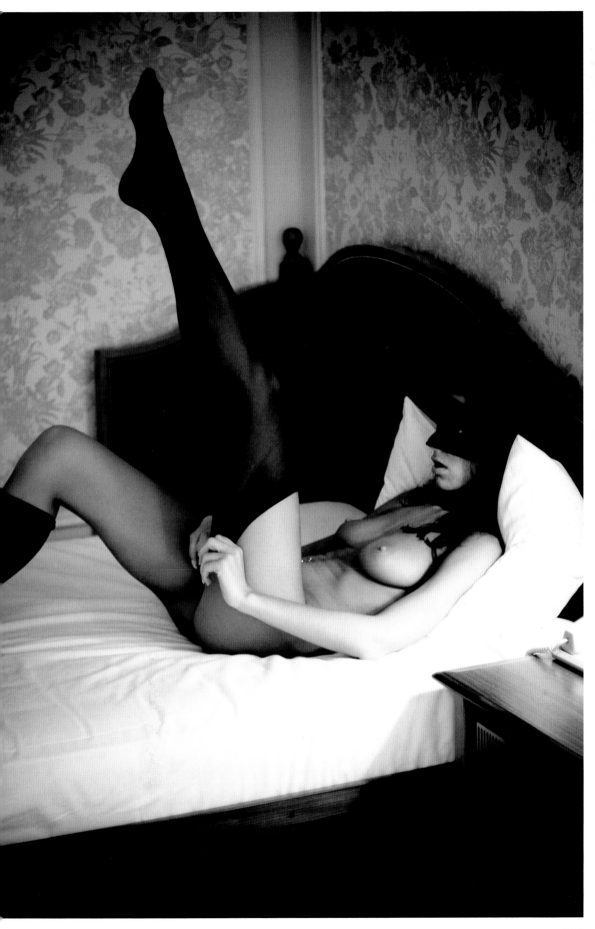

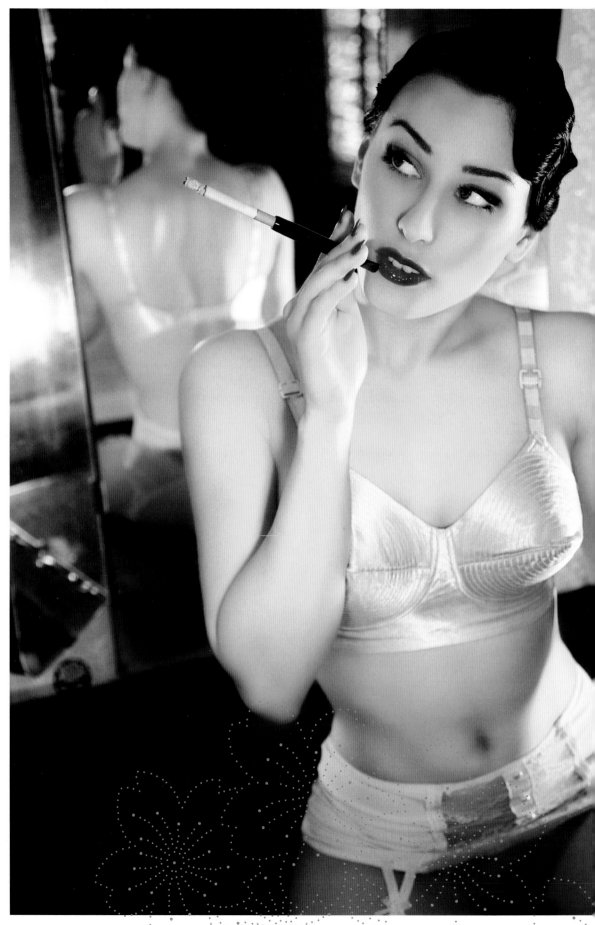

Eden
Photos by Sabine Schoenberger

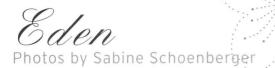

Name: Eden

Birthday: June 17, 1983

Birthplace: Düsseldorf, Germany

What was your childhood ambition? Being a painter.

Where do you live? Berlin

Where would you like to live? Berlin

How did you become a model? I saw photos of pinup girls and wanted to look like them.

Where do you see yourself in ten years time? I try to live now and not think about what 'll be in 10 years.

VIP from movie or music biz would you like to date? The VIP I date at the moment suffices me.

What vice can you never forgive? Betrayal

Daily sins, I cannot resist: Lipstick

Favorite Band: Marilyn Manson

Turn-ons: High heels, seemed stockings, corsets, pin-ups, Burlesque, 30's and 40's style, Rock'n'Roll music

Turn-offs: Envy, narrow-mindedness

Is there anything you would never do again? Eat sushi

What good advice could you give to other models? Be whoever you want to be!

Democrat, Republican, Green Party or other? No comment

Things that make me happy: Animals make me laugh most.

Website/Myspace: www.glam-o-rama.de, myspace/edenglamorama

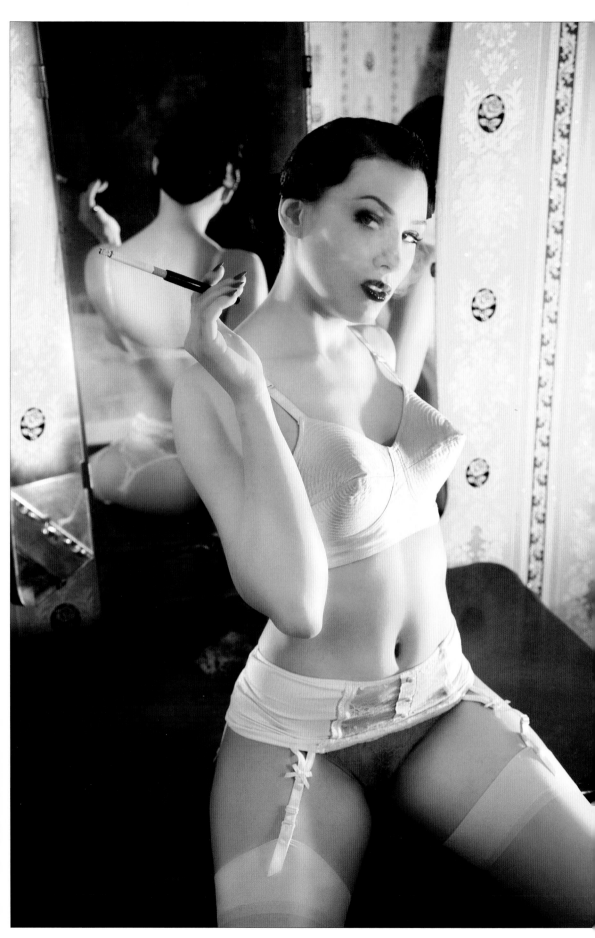

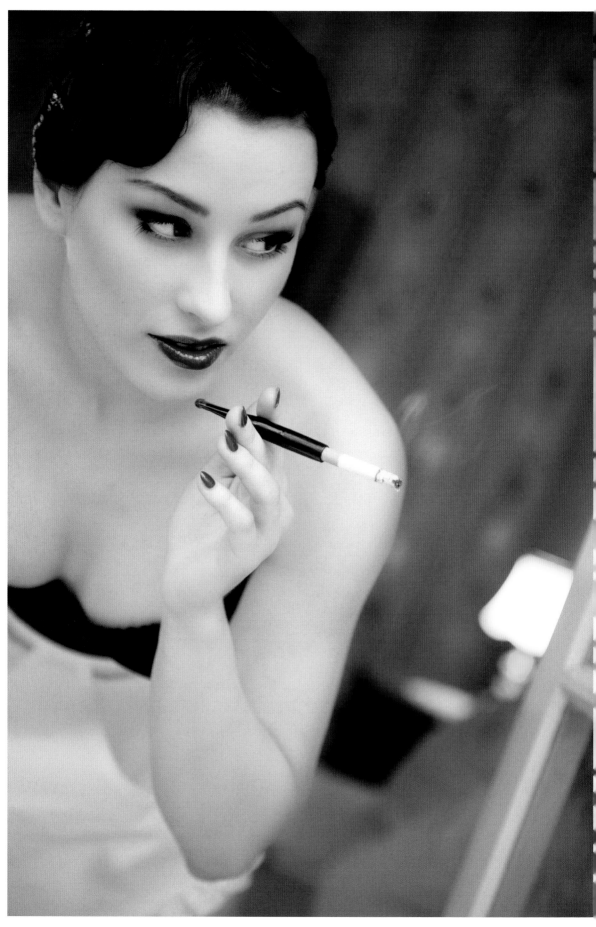

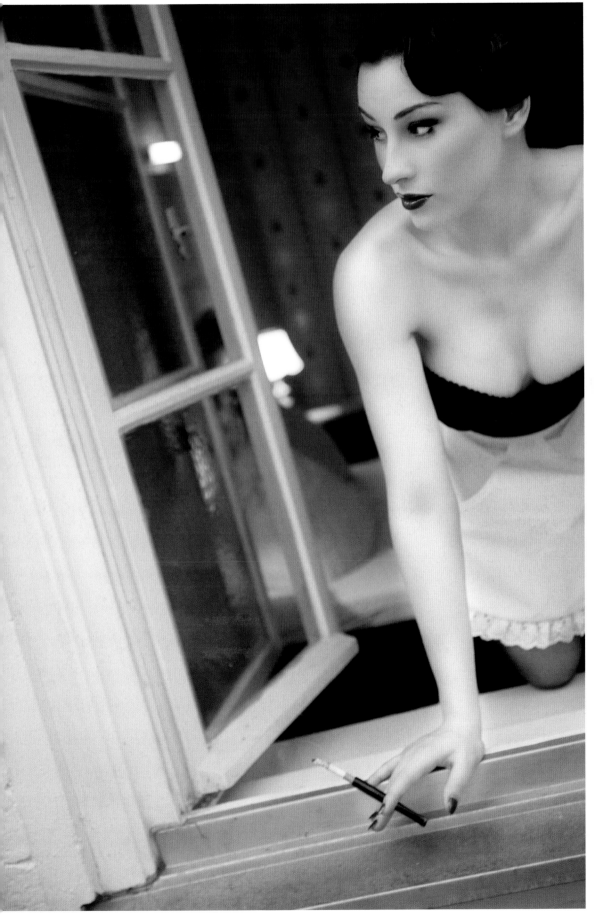

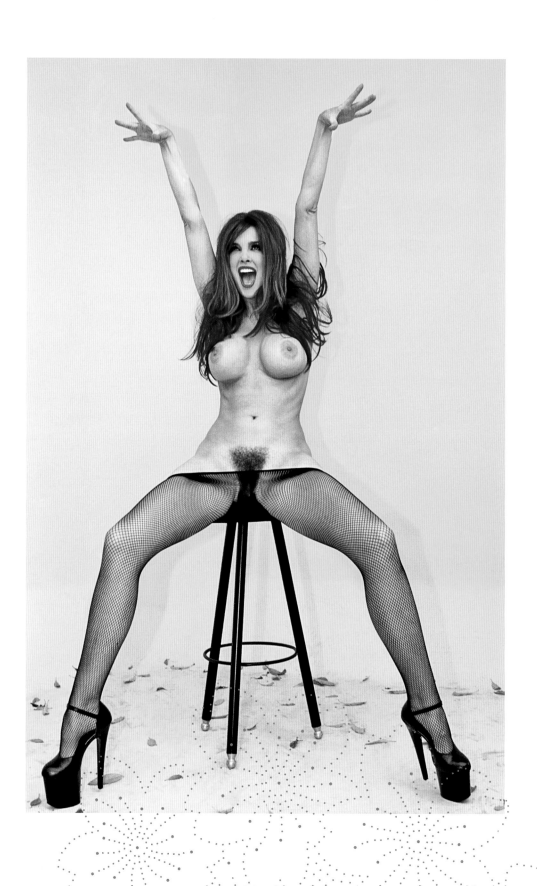

Julie Strain

Photos by Renard F. Garr

Name: Julie Strain

Birthday: February 18, 1962

Birthplace: Concord Calif. Earth.

What was your childhood ambition? To ride as many horses as possible.

Where do you live? Mulholland Dr. – with a lovely view of sunrises and sunsets

Where would you like to live? Here! This is heaven on earth.

How did you become a model? As a child I went to modeling school. I did want to become a model badly. Bodybuilding led me to body fit type modeling.

Where do you see yourself in ten years time? Watching Reality-TV and going to my son Shane's baseball games and cooking!

VIP from movie or music biz would you like to date? Josh Duhmel

What vice can you never forgive? Sins against animals or kids are unforgivable.

Daily sins, I cannot resist: Cursing, having a beer

Favorite Band: Police, Aerosmith, Temptations

Turn-ons: Cleanliness, honesty, hard work, Eau de Cologne and muscles don't hurt

Turn-offs: Dirty, bragging, liers, laziness

Is there anything you would never do again? Shoplifting, cocaine, anal sex

What good advice could you give to other models? Your body is your weapon. Learn how to use it - get real high heels. Ha ha.

Democrat, Republican, Green Party or other? Save The Fucking Earth Party.

Things that make me happy: My 1 yr. old son Shane, my 6 lovely doggies and not working. I'm retired now. Yeahhhh!

Website/Myspace: www.juliestrain.com

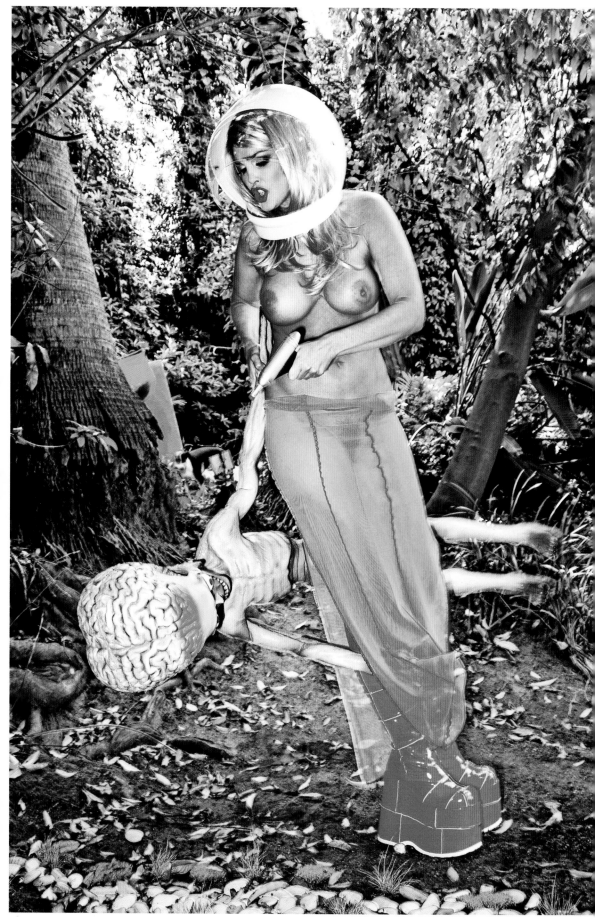

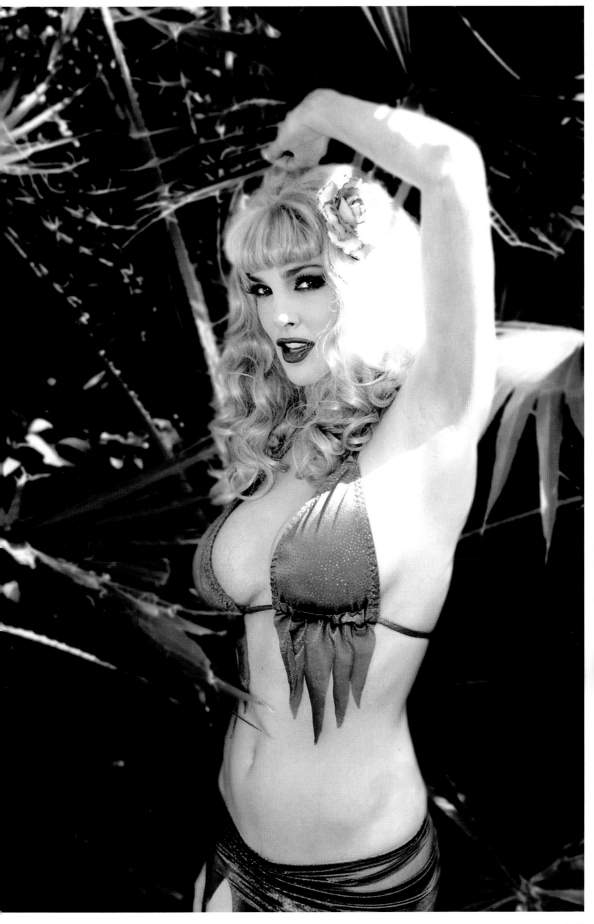

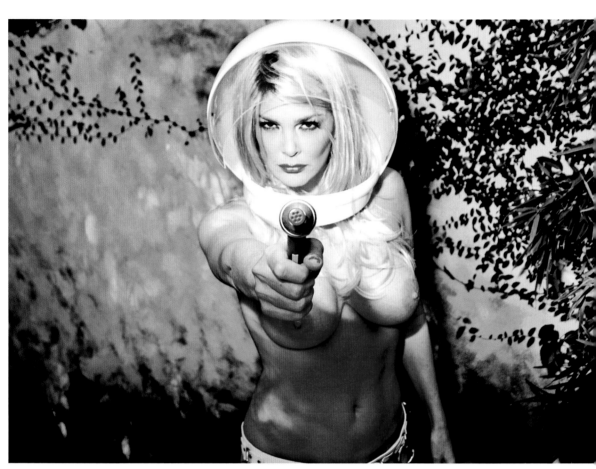

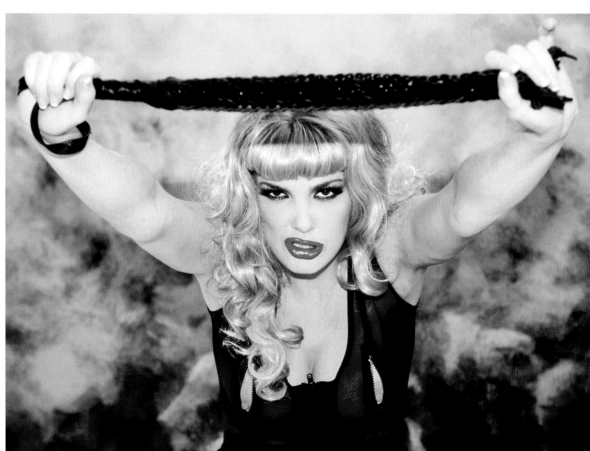

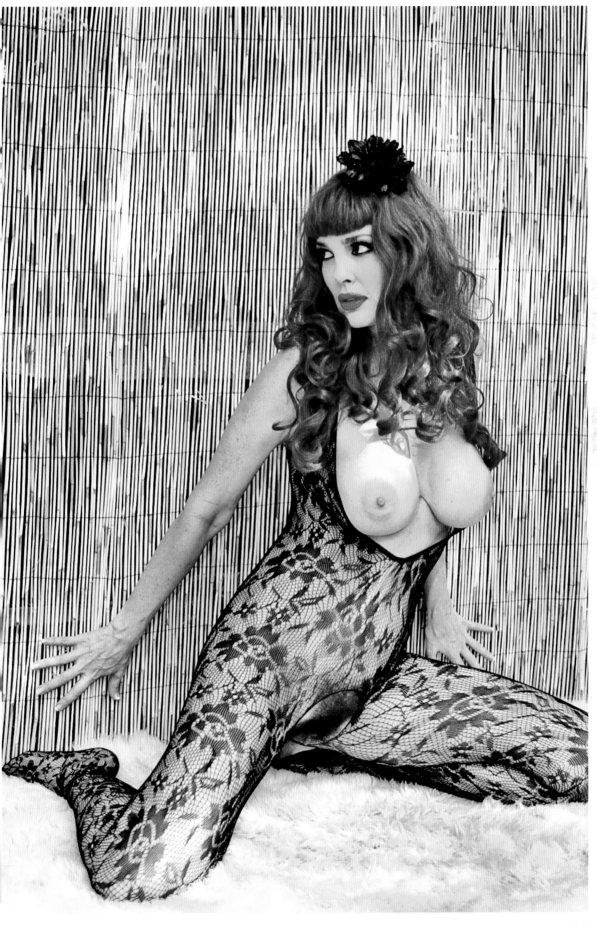

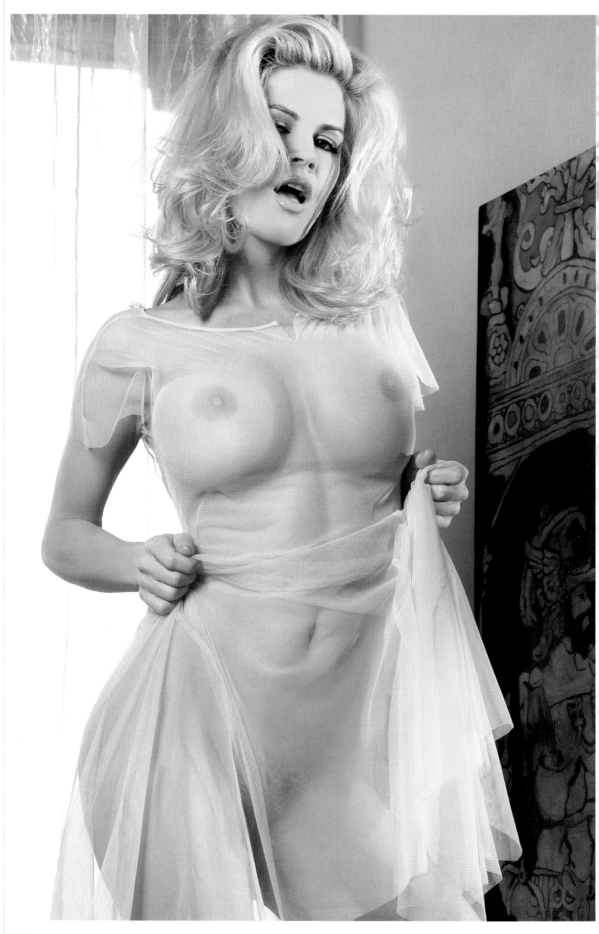

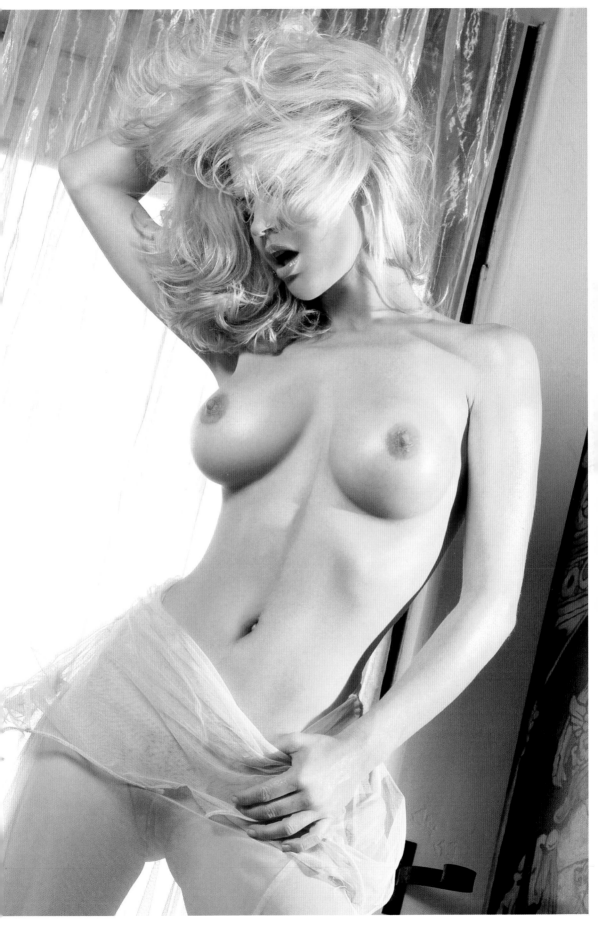

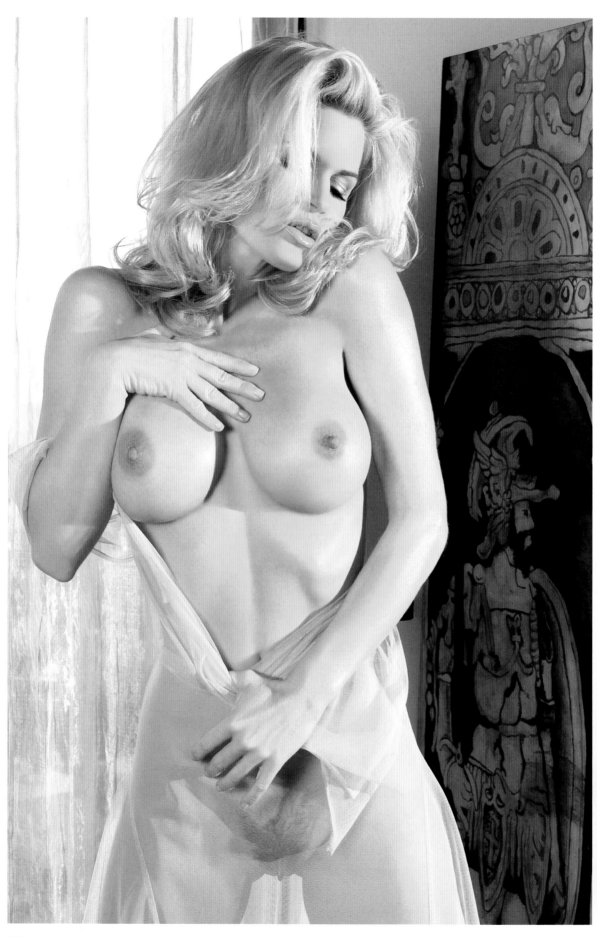

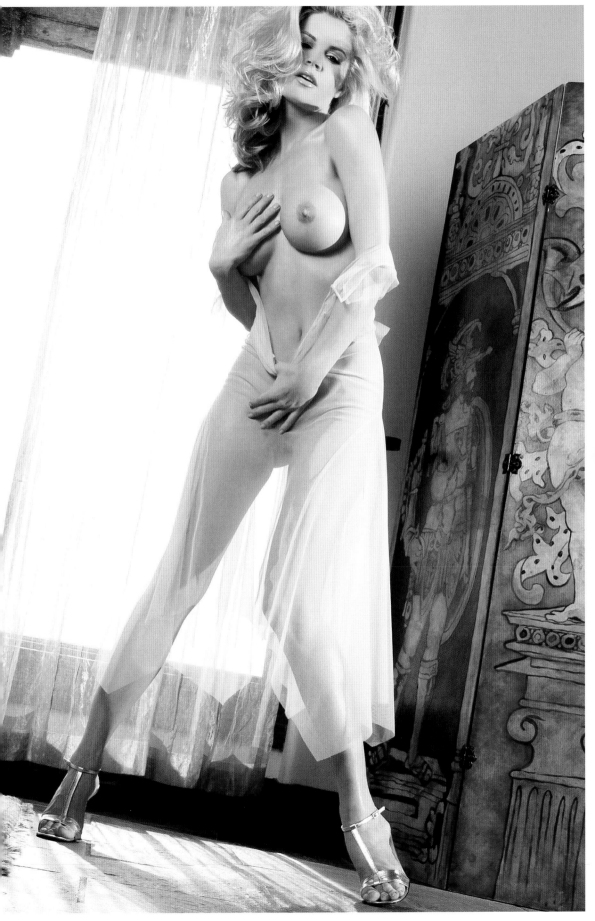

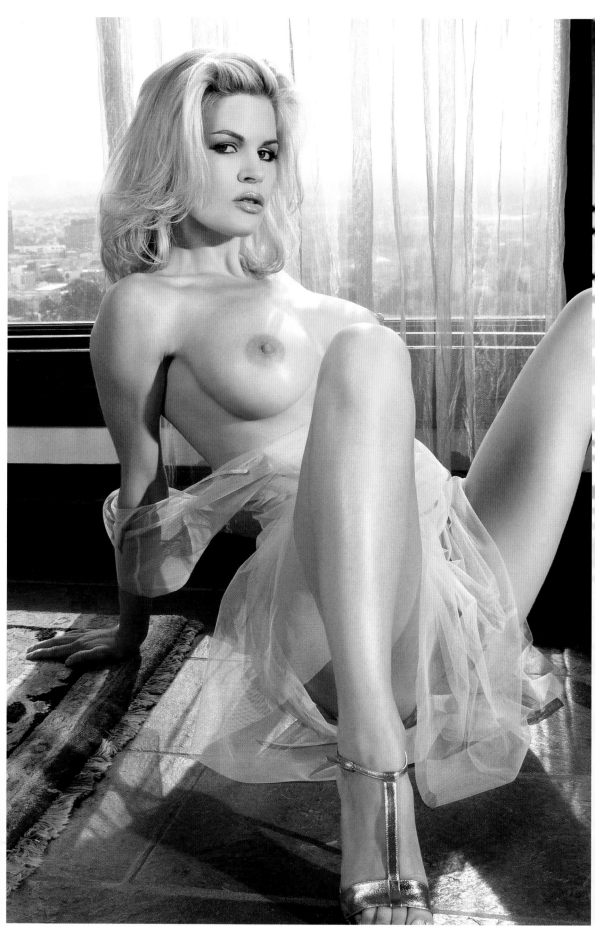

292

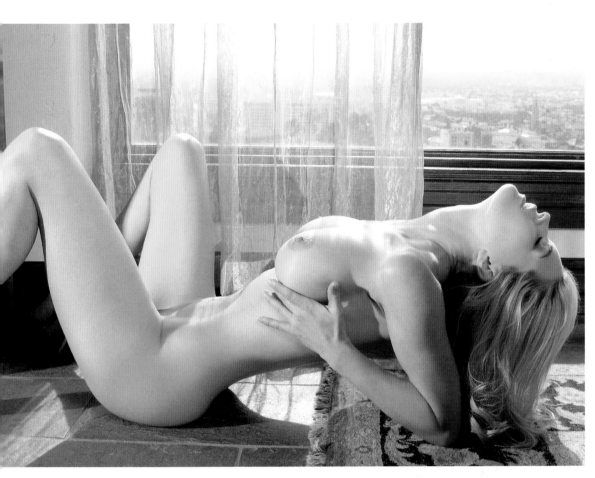

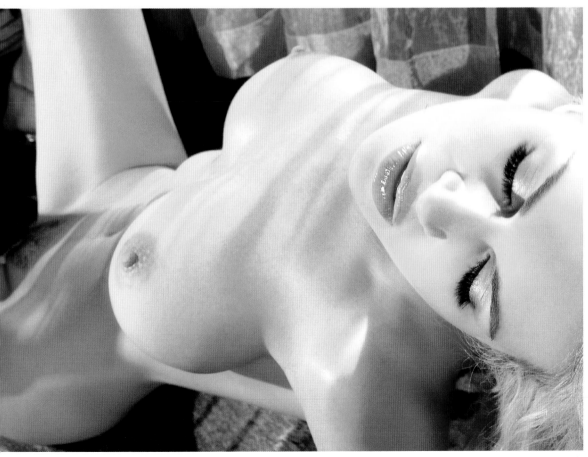

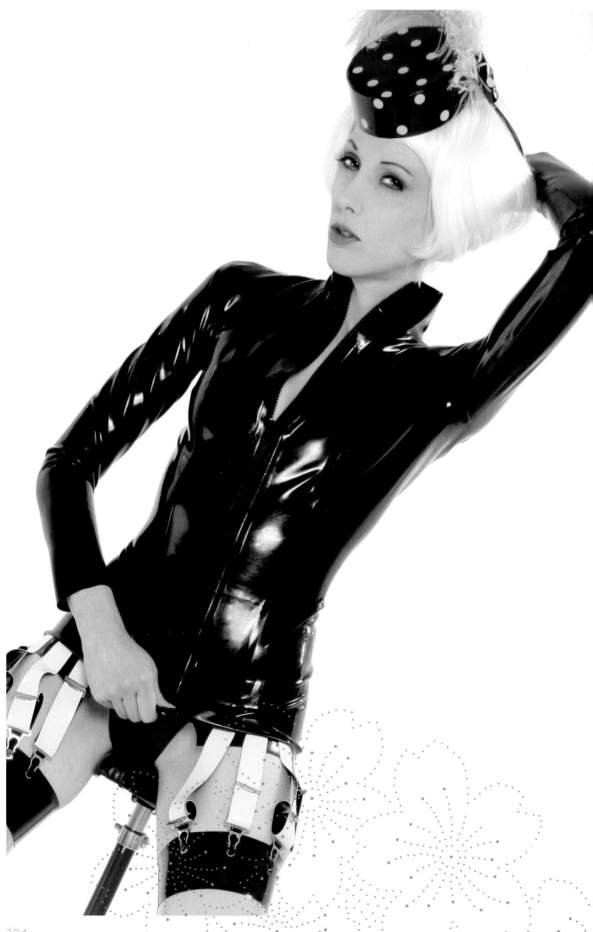

Feisty Diva

Photos by Kathleen Elizabeth

Name: My name is Feisty Diva.

Birthday: My birthday is October 30th.

Birthplace: I was born in Pennsylvania.

What was your childhood ambition? When I was a child, I wanted to become a cartoon artist.

Where do you live? I live in Washington DC.

Where would you like to live? California, near the beach

How did you become a model? I started modeling back in the early 1990's doing some work for local photographers who wanted to use a model who could provide a "gothic subculture" look for their projects.

Where do you see yourself in ten years time? Within the next ten years I hope to gain more notoriety for my retail business, Peacock Blue Design Studio, as well as become a partner at my day job.

VIP from movie or music biz would you like to date? I would not want to date a celebrity . I prefer to date people who are a little more down-to-earth.

What vice can you never forgive? The vices I cannot forgive are dishonesty and infidelity.

Daily sins, I cannot resist: I cannot resist caffeine and the prospect of great sex with my lover.

Favorite Band: My favorite bands are Feindflug, VNV Nation, Rasputina and Goldfrapp.

Turn-ons: My turn-ons include high fashion, gender bending, big men, little women, military uniforms, sex toys, perverse jokes and BDSM.

Turn-offs: My turn-offs are righteousness, egomania, religious zealotry, lack of empathy and insincerity

Is there anything you would never do again? I would never again leave my day job without making sure I have sufficient savings for things like health insurance coverage, funds equivalent to three years' worth of salary and a good investment plan.

What good advice could you give to other models? Find your own sense of style; don't copy other artists' work; be professional at all times; learn how to do your own make-up and styling; don't expect people to give you clothing and services for free; and, always strive to improve on your past work.

Democrat, Republican, Green Party or other? I am a registered Democrat.

Things that make me happy: The things that make me happiest are finding time to create new works of at and making wonderful memories with my true love.

Website/Myspace: www.feistydiva.com, www.peacock-blue.com

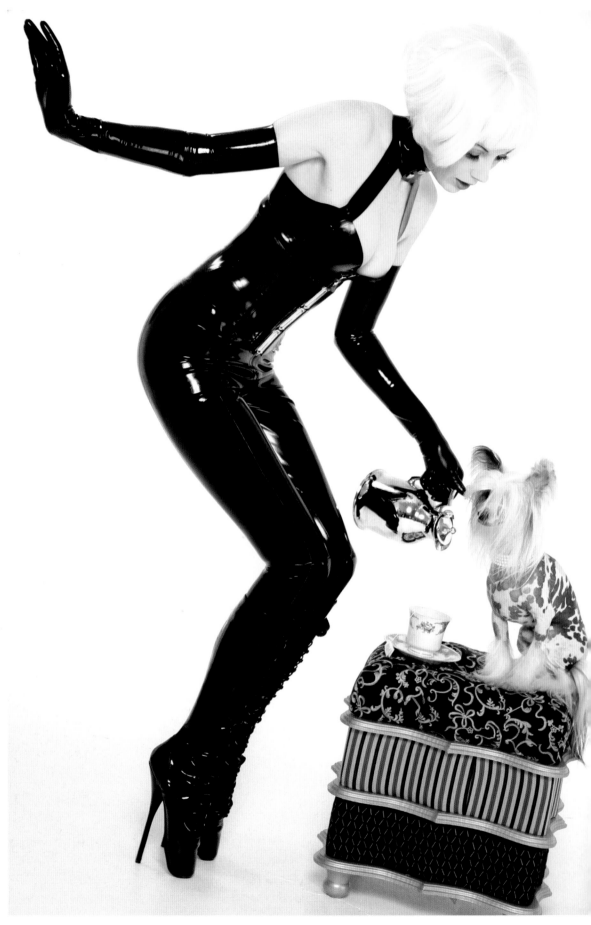

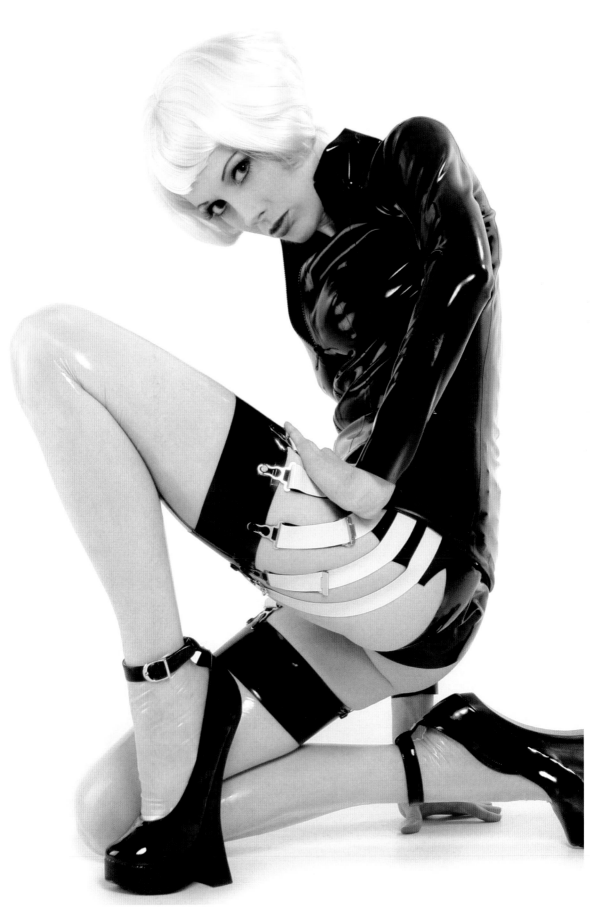

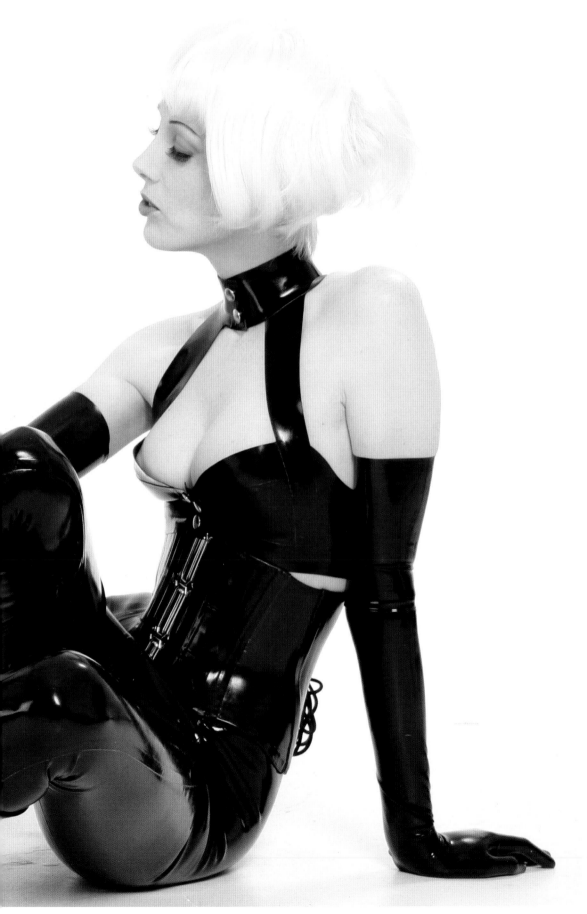

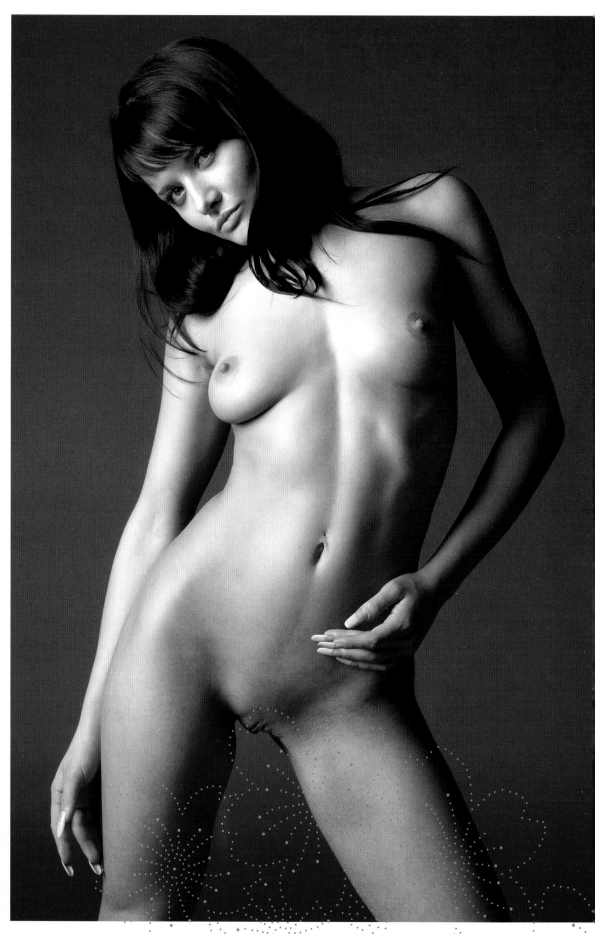

Maria
Photos by Peter Janhans

Name: Maria

Birthday: August 2, 1986

Birthplace: Omsk in Sibiria

What was your childhood ambition? To become a fashion designer

Where do you live? Sankt-Petersburg, Russia

Where would you like to live? In different big cities all over the world.

How did you become a model? A photographer took some pictures of me, and I liked it.

Where do you see yourself in ten years time? Having my own model agency

VIP from movie or music biz would you like to date? No one, they are not better than regular people.

What vice can you never forgive? Betrayal

Daily sins, I cannot resist: To spoil myself

Favorite Band: I listen to house music.

Turn-ons: Sun and music

Turn-offs: Alcohol, bad company

Is there anything you would never do again? Yes, but I don't tell what it is.

What good advice could you give to other models? Enjoy what you do!

Democrat, Republican, Green Party or other? Vladimir Putin

Things that make me happy: Laughter

Website/Myspace: I am working on it.

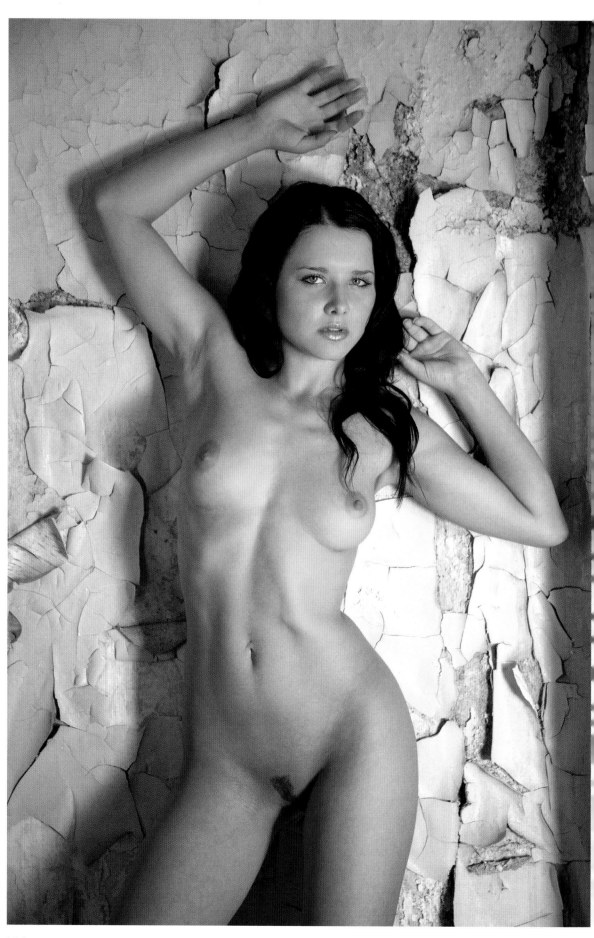

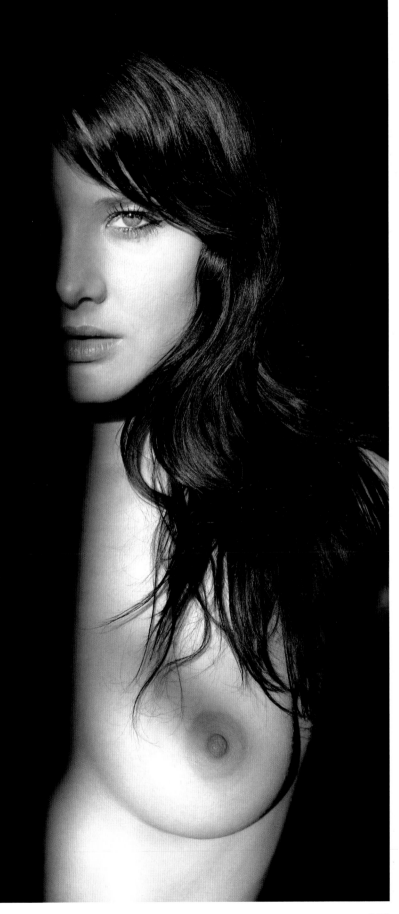

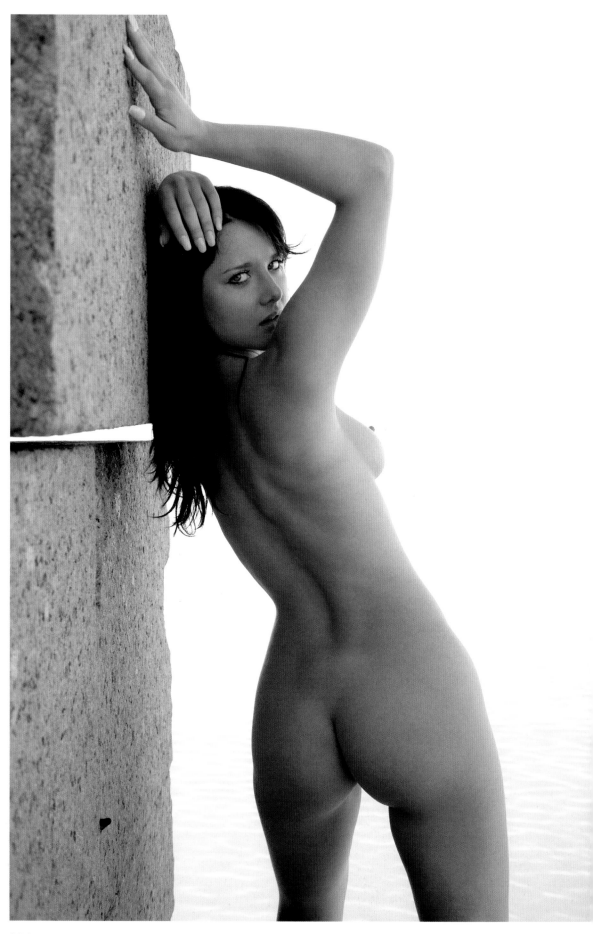

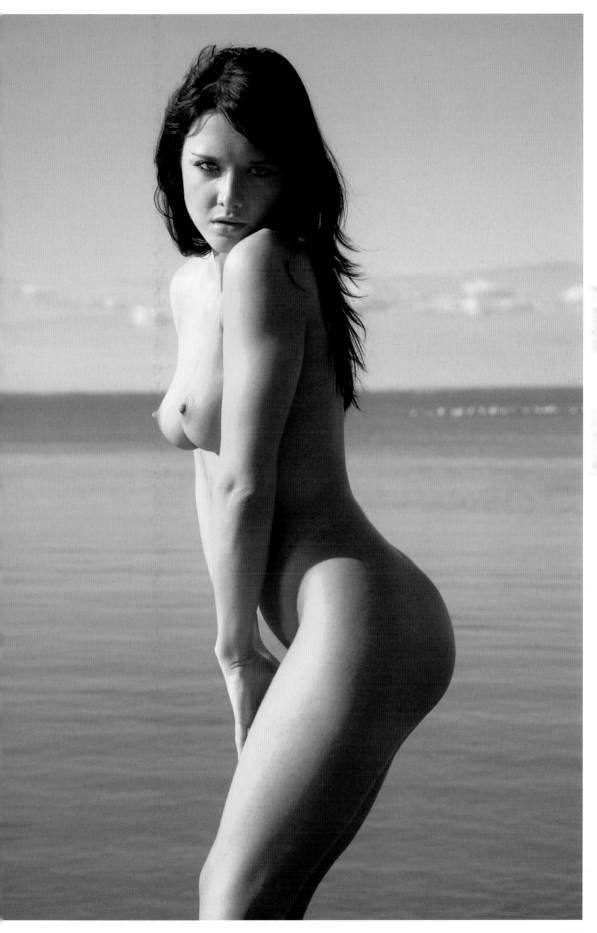

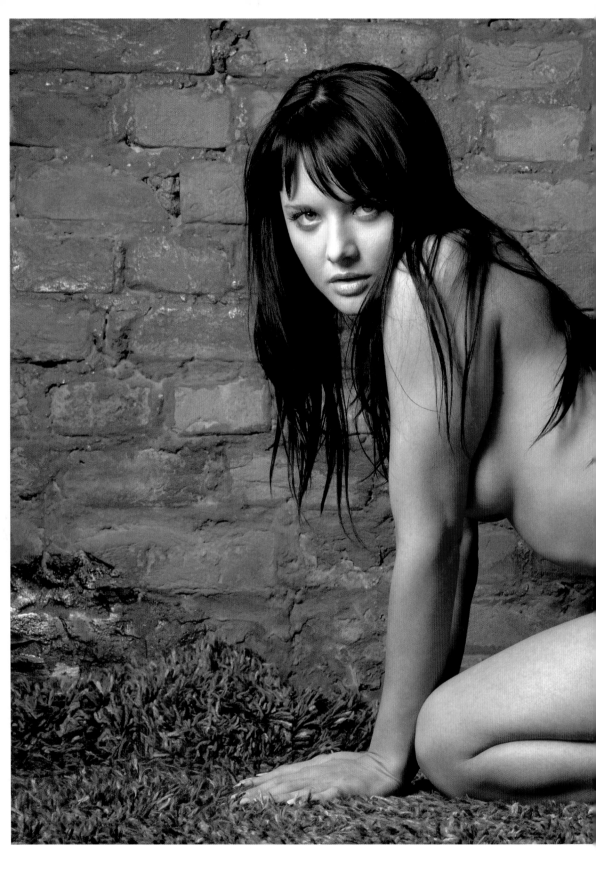

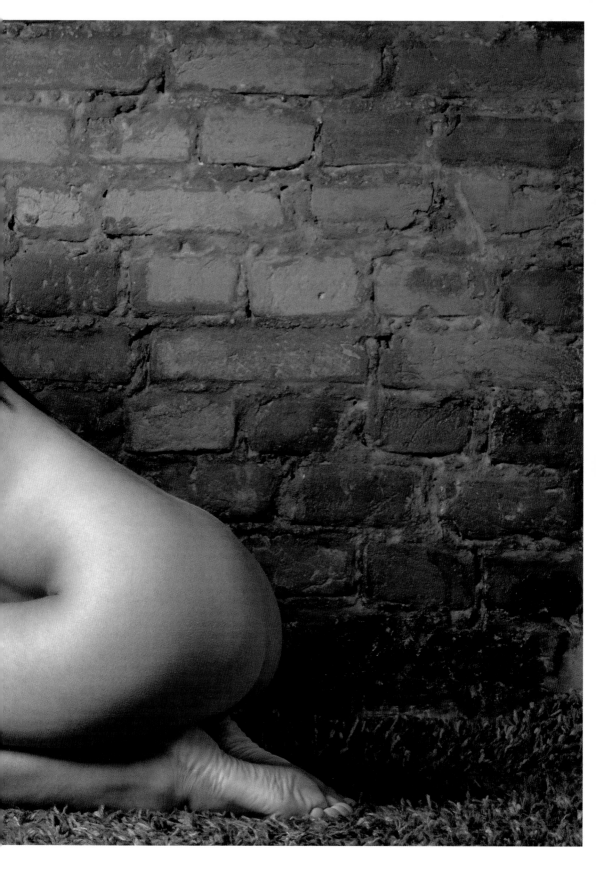

Name: Octavio Arizala - AKA Winkytiki
Birthplace: Manila, Philippines
Live in: Los Angeles, CA
Website: www.winkytki.com
Books : Modern Vixens (Goliath)
Camera: Canon 30D
Light: Norman 900 series

Name: Fred Berger
Birthplace: New York City
Live in: Long Island, New York
Magazines: Propaganda Magazine, Lui, Discipline
Books: Desperados (Goliath), Pulp Fetish (Goliath)
Camera: Nikon FM10
Light: incandescent studio lights

Name: Josef Botello
Birthplace: Texas
Live in: Texas
Website: www.viciousnudes.com,
www.myspace.com/girlsgunsandropes
Magazines: Secret, Marquis, Femme Fatales,
Eros, Zine, Laufmasche
Books: Girls, Guns and Ropes (Mix of Pix)
Camera: Olympus and Canon
Light: Hot lights

Name: Derek Caballero
Birthplace: Los Angeles, California
Live in: Los Angeles, California
Website: www.caballerophotography.com
Magazines: American Photo Magazine,
Rangefinder Magazine, Digital Media World, Nerve
Magazine, Glue Magazine
Books: Erotic Digitale, The New Erotic Photography
Camera: Nikon D100
Light: Photoflex USA

Name: Jean van Cleemput

Birthplace: Belgium, Antwerp

Live in: Belgium, Antwerp

Website: www.isawyou.be,
www.myspace.com/jeanvancleemput

Magazines: Ché, Flair, Feeling, Milo

Books: Beluga (Goliath), The New Erotic
Photography (Taschen)

Camera: Hasselblad, Canon, Cambo

Light: Hensel & Bowens

Name: Russel Coleman

Birthplace: Oxford

Live in: Somerset

Website: www.rootofsilence.com

Magazines: Skin Two, Gothic Beauty, Tatouage
Magazine, Erotica Show Guide, Max Power

Camera: Canon 30D

Light: Bowens

Name: Bob Coulter

Birthplace: Powell River, BC Canada

Live in: New York City

Website: www.crazybabe.com,
www.myspace.com/hrhbobcoulter

Magazines: Bizarre, Loaded, Maxim, Umbigo,
Penthouse, Hustler

Books: Crazy Babe (Goliath), Bad Girls Hotel
(Goliath), The New Erotic Photography

Camera: Canon 5D

Light: Canon Flash

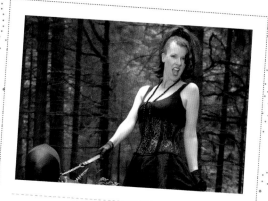

Name: Emma Delves-Broughton

Birthplace: Bath, UK

Live in: Bath

Website: www.emmadelvesbroughton.com

Magazines: Professional Photographer, Practical
Photography, Skin Two, Loaded, Maxim

Books: Kinky Couture (Goliath)

Camera: Mamiya RB67 & 645AF, Canon EOS 1DS

Light: Bowens flash, or natural light

Name: John Donegan
Birthplace: Tennessee, USA
Live in: Nashville, Tennessee, USA
Website: www.johndoneganphoto.com
Magazines: Hustler's Taboo, Nugget, Leg Sex, Gallery, Fox
Books: Layley (Mix of Pix)
Camera: Canon 5D, Canon 20D, all Canon lenses
Light: Strobes, Kinoflo, natural light

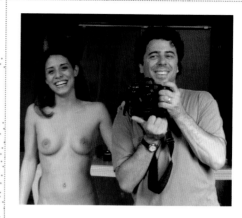

Name: Andrew Einhorn
Birthplace: Philadelphia, PA
Live in: New York City
Website: www.nakedhappygirls.comt
Books: Naked happy Girls (Goliath), Bubble Bath Girls (Goliath), Nerve: the New Nude, The New Erotic Photography
Camera: Nikon D1X, 24mm and 35mm lens
Light: Natural

Name: Kathleen Elizabeth
Birthplace: Los Angeles, California
Live in: New York
Website: www.Fetishfatales.com
Magazines: Massad, DDI, Prick, LOTL, Secret
Books: Fetish Photo Anthology Vol 5
Camera: Canon

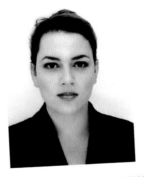

Name: Katja Ehrhardt
Birthplace: Hamburg, Germany
Live in: Hamburg, Germany
Website: www.highglossdoll.com
Magazines: Playboy Germany, Playboy Netherlands, SkinTwo, FetX
Books: Fetish (Feierabend-Verlag)
Camera: Digital Depends
Light: Depends

Name: Peter Franck

Birthplace: Überlingen

Live in: Stuttgart

Website: www.peterfranck.de

Magazines: view, das magazin, visuell, der blaue reiter

Books: The New Erotic Photography (Taschen), Fetish (Feierabend verlag)

Technical Material as: Mac

Camera: Canon

Light: Bron

Name: Mark Frank

Birthplace: Cleveland, Ohio, USA

Live in: Chagrin Falls, Ohio

Website: www.markfrankimages.com

Magazines: B&W Black & White Magazine

Books: Exhalations Exhalaciones, edited by Joyce Tenneson; Women On The Verge; By Mark Frank

Camera: Canon EOS 1DS

Light: Sigma

Name: Rafael Fuchs

Birthplace: Tel Aviv, Israel

Live in: NYC

Website: www.rafaelfuchs.com

Magazines: Time, Newsweek, Maxim, Detail, Allure

Camera: Canon SLR digital 35 mm

Name: Renard F. Garr

Birthplace: Downey, California

Live in: Mar Vista, California

Website: www.renardgarr.com & myspace.com/renardgarr

Magazines: Playboy, BPM Magazine, Geek Magazine, Femme Fatales Magazine, Vibe Magazine 2005

Books: Julie Strain's "Nightmare On Pin Up Street " The Sandman Endless Nights - Vertigo - DC Comics Virgin Books/Nexus Publications - "Scarlet Vice" Twin Peaks Special Edition DVD

Camera: Nikon D2X

Light: Metz

Name: Peter Gorman
Birthplace: Binghamton, NY, USA
Live in: New York City
Website: www.petergorman.com
Magazines: Black+White, Maxium, Men's Health, Lui, Blackbook
Books: Stripped Naked, Naked Rooms, Naked in Apartment 7, Touch - all published by Goliath
Camera: Canon 5D
Light: Vivitar 285, Canon 550 EX

Name: Aaron Hawks
Birthplace: Seattle
Live in: Berlin
Website: www.aaronhawks.net
Magazines: 7x7 magazine, American Photo Magazine, Juxtapoz
Books: New Erotic Photography (Taschen), Mammoth Book of Erotica (Skylight)
Camera: Hasselblad

Name: Andrew Thomas Hunt
Birthplace: Whitby, Canada
Live in: Toronto, Canada
Website: www.andrewthomashunt.com
Magazines: Photo Stern, Quo
Books: Erotic Websites (Feierabend Verlag publisher)
Camera: Canon 30D
Light: Studio Flash

Name: Hikari Kesho
Birthplace: Padova, Italy
Live in: Selvazzano, Italy
Website: www.hikarikesho.com
Magazines: Secret Magazine, "A" magazine
Books: Mein heimliches Auge, Fetish Photo Anthology Vol 5
Camera: Nikon D2X
Light: Flash Bowens

Name: James Green
Birthplace: Manchester
Live in: London
Website: www.jamesandjames.net
Magazines: The Independent,
Penthouse, New Woman, Marquis, FHM
Books: Latex and Nudes (Goliath)
Camera: Hasselblad H1d canon eos digital
Light: Kinos (Diva lights)

Name: Hyperion
Birthplace: France
Live in: London, UK
Website: www.hyperionphotography.com
Magazines: Kera Maniyx, Skin Two, Marquis,
Alternative mag, Hairdresser
Books: Fetish Anthology V
Camera: Mamiya RZ, Sinar
Light: Bowens, Profoto

Name: Mike James
Birthplace: September 13, 1952
Live in: Northeast Pennsylvania, USA
Website: www.jamesart.com
Magazines: Playboy, Cooltoys, Amazing
Figure Modeler, SciFi Stories
Books: New Erotic Photography (Taschen)
Technical Meterial: Retouched "photo-
illustrations"
Camera: Nikon digital, (various models)
Light: Outdoors: Available light with bounce
cards and camera flash, In Studio: Hotlights
and umbrellas, no flash

Name: Peter Janhans
Birthplace: Gävle, Sweden
Live in: Gävle, Sweden
Website: www.peterjanhans.com
Magazines: Eve, B magazine,
Monday London Times
Technical Meterial: I am a no thrills photographer
Camera: Canon 1Ds MkII
Light: Flash and daylight

Name: Christine Kessler
Birthplace: Los Angeles, CA
Live in: Los Angeles, CA
Website: www.ChristineKessler.com
Magazines: Skin Two, Bizzare, Penthouse, Playboy
Special Edition, Marquis
Books: Pervy Girls (Goliath)
Camera: I primarily shoot with a Canon 20D,
though I've been known to wield a Mamiya 645
and a Holga
Light: Most of my shoots are lit with Dynalite
strobes and a variety of modifiers (softboxes,
umbrellas, etc.)

Name: Thorsten Klapsch
Birthplace: Darmstadt
Live in: Berlin
Website: www.thorstenklapsch.de
Magazines: Wallpaper*, Quest, blond
Camera: Canon EOS digital, Hasselblad
Light: Broncolor

Name: Dave Naz
Birthplace: Los Angeles
Live in: Los Angeles
Website: www.davenaz.com
Magazines: Taboo, Barely
Legal, Leg Show,
Leg World, Maxim
Books: Lust Circus (2002),
Panties (2003), Legs (2004),
and Fresh: Girls Of Seduction
(2006) - all Goliath books
Camera: Leica MP
Light: Dynalights

Name: Eric Martin
Birthplace: Troyes, 150 km from Paris
Live in: Paris, France
Website: www.num-eric.com,
www.myspace.com/ericmartinphoto
Magazines: Marquis, Whiplash, Sonic
Seducer, Elegy, Secrett
Technical Material: eyes and ears
Camera: Nikon D1X and D200
Light: 2 Balcar Flashes, a flash on
battery for outdoor shootings

Name: Marco Di Marco
Birthplace: Gioia del Colle (Bari), Italy
Live in: Rome
Website: www.marcodimarco.com
Magazines: maxim, GQ, Max, esquire,
interview spain
Camera: Nikon D2X, Pentax 645,
Mamiya 6x7
Light: Flash, continus, natural

Name: Craig Morey

Birthplace: Ft.Wayne, Indiana, USA

Live in: San Francisco

Website: www.moreystudio.com, www.lsgmodels.com

Magazines: Penthouse Magazine (US), Journal of Erotica (UK), Secret (Belgium), La Fotografia (Spain), Newsweek (US)

Books: Studio Nudes (Penthouse - US), Body/Expression/Silence (Private - Japan), Linea (Korinsha - Japan), 20th Century Studio Nudes (Glaspalast - Germany)

Camera: Nikon D2x, Hasselblad

Light: Natural or studio strobes

Name: Richard Murrian

Birthplace: Chicago, USA

Live in: I have homes in Paris, France and in Prague, Czech Republic

Website: www.m-u-s-e.org

Magazines: FHM, Photo, Stern, Eleela, Quo

Books: Babydoll, See Me, Feel Me, Reanna's Diaries – all Edition Skylight

Camera: Pentax K10D, Pentax 645NII

Light: Hensel EH-Series monolights

Name: Martin Pelzer

Birthplace: Bonn

Live in: Berlin

Website: www.martinpelzer.com

Magazines: Skin Two, Secret Magazine, Zillo, Orkus, Buckle Magazine

Books: Jambe de femmes, Voyeur Secrets, Fetish Photo Anthology 4

Technical Material: MacBook, some HDDs, lightmeter

Camera: Canon EOS 5D

Light: 2 Bowens Esprit 500 W/s, lightformers like softboxes and tubes with honeycombs

Name: Derek Ridgers

Birthplace: Chiswick, West London

Live in: Twickenham, West London

Website: www.derekridgers.com

Magazines: NME, The Face, Loaded, The Independent on Sunday, Time Out

Books: 'When We Were Young' (Photoworks), 'Stare' (Goliath)

Technical Material: My favourite film was Ilford Delta and, for colour, Velvia. Now I shoot totally digital.

Camera: Nikon FM2, Hasselblad 503cw, Mamiya RB67, Mamiya 7 II and Nikon D2X

Light: All Elinchrom

Name: Tammy Sanborn

Birthplace: Orlando, Florida

Live in: Manhattan Beach, CA

Website: www.TammySanborn.com

Magazines: Penthouse, GQ, Front, LOADED, People, Maxim

Camera: CANON MARK II

Light: Profoto

Name: Gili Shani

Birthplace: Tel Aviv, Israel

Live in: Berlin, Germany

Website: www.gilishani.com, www.myspace.com/gilishani

Magazines: Blond magazine, 360 degree, Bounce, 030

Camera: Digital Camera Nikon D200

Light: Flash

Name: Sabine Schoenberger

Birthplace: Öringen/Germany

Live in: Friedrichsruhe

Website: www.sabine-schoenberger.de

Magazines: Quo, Astan, Fotoheft, Digital Photo, Photographie

Books: Women by Women (Prestel)

Camera: Canon EOS 5D

Light: Softbox

Name: Rüdiger Schestag

Birthplace: Germany, Kirchheim unter Teck (near Stuttgart)

Live in: Germany Stuttgart

Website: www.ruediger-schestag.de

Magazines: headmagazine.co.uk, Docma, Fineatprinter, Art-photo-Akt, Photomagazin

Books: "Jazz in Stuttgart" (Jazz photography)

Camera: Canon EOS 1 mark 2

Light: Broncolor flash system

Name: Thomas Sing

Birthplace: Augsburg

Live in: Augsburg

Website: www.thomas-sing.de, www.xtremerotix.com

Magazines: 'A' magazine, Schlagzeilen, Pornosophica.

Camera: Nikon

Light: Broncolor

Name: Sexkicks
Birthplace: Germany
Live in: Berlin
Website: www.sexkicks.com
www.myspace.com/sexkicks
Magazines: Hustler's Taboo,
High Society, Private's Pirate
Camera: Canon Mark II 1DS
Light: Sun + 2 flashes

Name: James Stafford
Birthplace: Cardiff
Live in: London
Website: www.jamesandjames.net
Magazines: The Times, Playgirl,
Cosmopolitan, Skin 2, Attitude
Books: Latex & Nudes (Goliath)
Camera: Hasselblad HD2 and
several digital canons
Light: Multiblitz or Elinchrome

Name: Julischka Stengele
Birthplace: Small village in the
south of Germany
Live in: Berlin
Website: www.fotoportfolio.de
Magazines: Expand, brennpunkt
Camera: SX-70 (instant camera)
Light: natural

Name: Nathan Strausse
Birthplace: Somerset, New Jersey U.S.A.
Live in: Los Angeles, CA U.S.A.
Website: www.nathanstrausse.com
Magazines: Appeal Magazine March 2007,
The Boulevard Oct. 2006
Camera: Nikon D70, sometimes a Holga, modified
polaroid with graflex lense from friend Rafa
Light: I use a lot of natural light. If not natural, then
mostly film lights. I rarely use strobes unless a
desired effect is wanted. Hate waiting for them to
recycle. I'm a motion picture guy, so I light in that
manner.

Name: Richard Warren
Birthplace: Houston, Texas
Live in: New York City
Website: www.richardwarrenphotos.com
Magazines: Zink, Style Monte Carlo,
Muse, Australian Vogue
Camera: Canon Eos 1Ds Mark II Digital
Light: Tungsten

BADLANDS - Charles Gatewood
448 b&w pages/ ISBN 978-3-9805876-4-8
language: ⑱ ⑪ ⑫ ⑬ ⑭
Gatewood's world is **freakish, earthy, blunt, erotic** - most of all **terribly and beautifully alive.**

Messy Girls! - Charles Gatewood
368 color pages/ hardcover
ISBN 978-3-936709-00-1/ language: ⑱ ⑪ ⑫ ⑬ ⑭
The new book of famous Photographer Charles Gatewood, showing over 340 **"Sploshing"** photographs of beautiful young fetish girls, naked and proud, smearing their nubile young bodies with pudding, honey and whipped cream, plus every messy substance imaginable.

Modern Vixens - Octavio Arizala
368 color pages/ ISBN 978-3-936709-17-9
hardcover/ language: ⑱ ⑪ ⑫ ⑬ ⑭
Pinup Girlies, Glamour Hunnies, Fetish Vixens and the naughtiest rawker chickies.... all Jam packed into the pages of this cool book. You can't get a better deal than this, whether you bought it, stole it or just borrowed it.

Kinky Couture - Emma Broughton
112 color pages/ ISBN 978-3-936709-07-0
padded hardcover/ language: ⑱ ⑪ ⑫ ⑬ ⑭
"Emma Delves-Broughton brings a fresh female eye to the modern fetish aesthetic, as can be seen in the beautiful work she has done for many of the rising stars of fetish fashion."

Sexcats - Christopher Mealie
368 b&w pages/ ISBN 978-3-936709-06-3
hardcover/ language: ⑱ ⑪ ⑫ ⑬ ⑭
A collection of tawdry, yet titilating pictures from a sinful past. One would be hard pressed to find a greater collection of curvaceous kittens. Seductive, dark and always fun, over 350 fantastic images abound in this book of rare, vintage pinup and girly photos from the 1950s and 1960s. **Purrrfect.**"

UFO - Richard Brunswick
320 pages/ ISBN 978-3-9805876-3-1
color and b&w/ language: ⑱ ⑪ ⑫ ⑬ ⑭
Just landed! The ultimate picture bible for every UFO fan, the **most sensational and encompassing photo documentary** of the UFO century. Over **300 "never before publicized" pictures** of UFOs, scenes, contacts, evidence.... **Fantastic !!!**

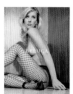

Beluga - Jean V. Cleemput
174 color pages/ ISBN 978-3-936709-11-7
hardcover/ language: ⑱ ⑪ ⑫ ⑬ ⑭
Beluga, a ravissant mixture of exquisite snapshots of gorgeous nude models with tastebud-dazzling recipes. "Bon appetit!"High pro photography and absolute crazy!

Desperado - **Fred Berger**
144 color pages/ ISBN 978-3-936709-25-4
padded hardcover/ language: ⑱ ⑪ ⑫ ⑬ ⑭
DESPERADO features the queer-fetish photography of Fred H. Berger, the man behind the "Propaganda", New York's legendary subculture zine. Famous for its drop-dead gorgeous androgyns wrapped in scandalous leather outfits and military uniforms, his body-of-work spans three decades and three continents.

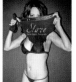

Stare - Derek Ridgers (getting away with it)
160 b&w pages/ ISBN 978-3-936709-21-6
hardcover/ language: ⑱ ⑪ ⑫ ⑬ ⑭
Derek Ridgers subjects present themselves as alternately sexy, dramatic, unabashed, assertive, confrontational and at times just plain weird. They are the superstars of a shameless 'look at me'generation, from those places where the bad girls are the good ones, and beauty adopts many different faces.

Pulp Fetish - Fred Berger
176 color pages/ ISBN 978-3-936709-27-8/
hardcover/ language: ⑱ ⑪ ⑫ ⑬ ⑭
Inspired by the pulp comic books of his youth, legendary photographer & provocateur Fred Berger has compiled a body of work which fetishizes this vintage all-American genre to the point of orgasmic overload. Tales of the Wild West, of close-quarter combat, of cops and gangsters, pirates, super heroines and super villains – this is the stuff of PULP FETISH.

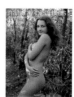

natural beauties - E. Stobblehouse
368 color pages/ ISBN 978-3-936709-08-7
hardcover/ language: ⑱ ⑪ ⑫ ⑬ ⑭
"Everyone needs inspiration from time to time, and I often turn to this wonderful collection for this purpose. I always feel refreshed and invigorated - the image selection is superb, the bodies and the faces are perfect, and the world is a –better place while I'm looking at these beautiful women."

Wild - Harley, Bikes & Babes - Horst Rösler
448 pages/softcover/ISBN 978-3-9805876-5-5
language: ⑱ ⑪ ⑫ ⑬ ⑭
Wild, wild bike! The illustrated book of the biker generation – 30 years after "Easy Rider"! 448 pages packed with **ball-busting photographs** of biker-events, **crazy dudes**, the **wildest chicks** and **hottest bikes** from all around the world. Simply: **WILD!**

Bondage - Laura M.Stansfield
516 b&w pages/ ISBN 978-3-9805876-1-7
language: ⑱ ⑪ ⑫ ⑬ ⑭
30 years of bondage photos; over 500 pages and how it all came about; unique. One subject - one collection: captivating, thrilling, provocative.

Legs - Dave Naz
160 color pages/ ISBN 978-3-936709-12-4
hardcover/ language: ⑱ ⑪ ⑫ ⑬ ⑭
"Flexible Toes, High Arches, Full Thighs and the Stockings and Seamless Sheer Pantyhose that adorn them. "Legs" are the focus and The Ladies that grace each page will keep you salivating for more."

Erotic Flashback - Michael Berkowitz
288 pages/ ISBN 978-3-936709-14-8/ Duotone
slipcover & hardcover/ language: ⑱ ⑪ ⑫ ⑬ ⑭
Beautiful women recline languorously on pillowed divans, stand challengingly beside elaborate screens or sprawl in comfortable chairs as if awaiting approach. It's difficult to discern whether these photos were taken last week or last century.

Champion - Walter Kundzicz
360 color pages/ISBN 978-3-936709-05-6
hardcover/ language: ⑱ ⑪ ⑫ ⑬ ⑭
"During the late 1950s and early '60s, in the world of male physique photography the name Champion became synonymous with images of handsome, athletic young men captured in vivid color. Walter Kundzicz, the photographer who was Champion Studios created a diverse and fantasy-rich body of work.

Berlin Gay Mates - Karim Konrad
360 color pages/ ISBN 978-3-936709-23-0
hardcover/ language: ⑱ ⑪ ⑫ ⑬ ⑭
"Karim Konrad's visual assault on the senses is overwhelming, and his models are ripe with their luscious youth. The artist's orgy of color explodes with sexiness and energy, pushing the viewer ever closer to a mental climax as he turns each page of this wonderful collection by this gifted newcomer."

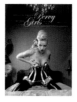

Pervy Girls - Christine Kessler
112 color pages/ ISBN 978-3-936709-22-3
padded hardcover/ language: ⑱ ⑪ ⑫ ⑬ ⑭
The view of contemporary female glamour and sexuality offered by Christine Kessler's work is more than just a collaboration – it's a 100-percent inside job, and all the better for it.

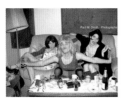

Art /Photography - Paul M. Smith
112 color pages/ ISBN 978-3-936709-10-0
hardcover/ language: (GB)(D)(F)(E)(I)
The sincerity and authority of the documentary is manipulated and questioned by Paul M Smith. Acting out Cindy Sherman for boys, he looks at the traditions of war and photography and the recreational aspects of life.

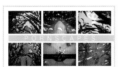

Pornscapes - Pierre Radisic
128 b&w pages/ ISBN 978-3-936709-24-7
hardcover/ language: (GB)(D)(F)(E)(I)
Fascinatingly ambiguous though it is, Radisic's work remains eminently photographic. (...) The connection with reality, a crucial subject in photography is perverted in a controlled way, while the actual stucture of the picture is never altered. (...)

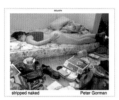

Stripped Naked - Peter Gorman
160 color pages/ ISBN 978-3-936709-13-1
hardcover/ language: (GB)(D)(F)(E)(I)
Models Stripped Naked of their inhibitions, exposing themselves once again for Gorman's camera. Raw, real and sexually charged. Powerful photographs of beautiful women.

asia bondage -Steven Speliotis
160 b&w pages/ ISBN 978-3-9807602-6-3
hardcover/ language: (GB)(D)(F)(E)(I)
Asia Bondage, a highly erotic, exciting and thrilling journey through the light and shade of traditional black and white photography. **An arousing shadow show of the senses.**

Naked Girls Smoking Weed - Robert Griffin
160 color pages/ ISBN 978-3-936709-26-1
hardcover/ language: (GB)(D)(F)(E)(I)
...features photos of naked girls smoking Marijuana from bongs, joints, blunts, pipes, hookahs, vaporizers, posing with plants, covered in buds and more. Each page includes an important fact about Hemp and/or Marijuana.

Guzzi Girls - Moe Moore
160 pages/ISBN 978-3-936709-30-8
hardcover/language: (GB)(D)(F)(E)(I)
Guzzi Girls are a dream come true. Moe Moore's two favorite obsessions –vintage Moto Guzzis and beautiful girls - melt into each other perfectly ashe picks up the camera and shoots in his garage the hottest women around. The soft curves and bumps of the bike blend right into soft curves and bumpsof these women. Born to be wild, sexy and fun!

TOUCH - Naked girls home alone - Peter Gorman
224 color pages/150 photos/hardcover/ISBN 978-3-936709-29-2
language: (GB)(D)(F)(E)(I)
Peter Gorman has been invited to join young, sexy women and watch them while they are home alone. The photos he took of these meetings are so intense, they make you feel like you were there. Join in and share these hot, yet intimate, private yet seductive moments.

Naked happy Girls - Andrew Einhorn
368 b&w pages/ ISBN 978-3-936709-03-2
hardcover/ language: (GB)(D)(F)(E)(I)
Twisting and turning, lounging and laughing; I've never seen so many New York's girls, so happy to be naked at home. Andrew has a special way of bringing out the real hidden sexy side every New York girl next door. This book made me feel good.

Bubble Bath Girls - Andrew Einhorn
368 color pages/ ISBN 978-3-936709-15-5
hardcover/ language: (GB)(D)(F)(E)(I)
Lather up and jump in !! Bubble Bath Girls drops you straight into a tub full of : naked, happy, soapy, sudsy New York Girls.

Bad Girls Hotel - Bob Coulter
368 color pages/ ISBN 978-3-936709-18-6
hardcover/ language: (GB)(D)(F)(E)(I)
Bob Coulter is back, down on his hands and knees shooting more of his Crazy Babes, this time at New York City's wildly unique Carlton Arms Hotel. Check out his colorful and explicit, humorous and bizarre photos in his long anticipated second book.

Real Girls - Scott Lanes
160 color pages/ ISBN 978-3-936709-20-9
hardcover / language: (GB)(D)(F)(E)(I)
Scott F. Lanes gives us a peek at the beautiful girl next door that you won't soon forget. Lanes takes you on a sexy, seductive and naked exploration of the pure beauty of his natural, young models.

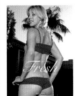

Fresh - Dave Naz
368 color pages/ ISBN 978-3-936709-19-3
hardcover/ language: (GB)(D)(F)(E)(I)
"The mystique of the young girl receives a sustained erotic performance of innocence and sexual frankness in "Fresh." Naz compounds the intensity through a tight range of setups, that enables these adult women, who exude the Lolita type, to playfully suggest or display their sexual allure.

L.A.Bondage - Dave Naz
176 color pages/hardcover/ISBN 978-3-936709-28-5
language: (GB)(D)(F)(E)(I)
"Gorgeous women beautifully bound and photographed in sunny Los Angeles. Dave Naz manages to capture the deliciously erotic, seducing his delightful subjects into being playfully naughty. Classy, sexy, hot!" One subject: Bondage the L.A. way- captivating, thrilling, provocative.

For information about a **free catalog** of other Goliath books, **distribution** in your country, **dealer** information, or if you are interested in publishing a book with us as a **photographer** or **collector,** please contact:

USA: Goliath
P.O.Box 136
NY , NY 10035; USA
www.goliathbooks.com

Europe: Goliath Verlag mbH
Eschersheimer Landstr. 353
D 60320 Frankfurt/M Germany
www.goliath.eu

Or send an e-mail to **contact@goliathbooks.com**

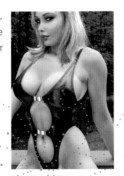

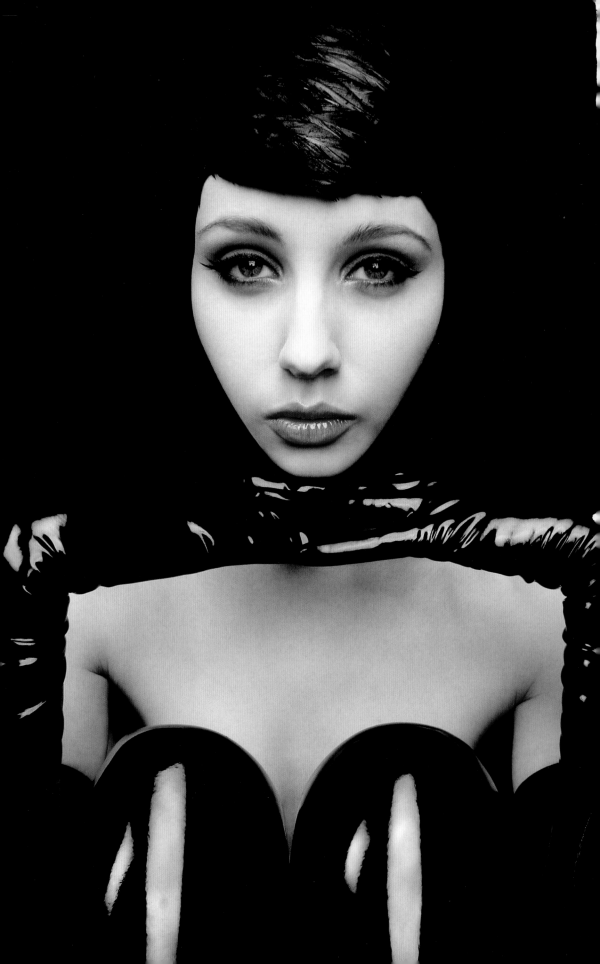